Nikon[®] D3400

Nikon[®] D3400

by Julie Adair King

Nikon[®] D3400 For Dummies[®]

Published by: John Wiley & Sons, Inc., 111 River Street, Hoboken, NJ 07030-5774, www.wiley.com

Copyright © 2017 by John Wiley & Sons, Inc., Hoboken, New Jersey

Published simultaneously in Canada

No part of this publication may be reproduced, stored in a retrieval system or transmitted in any form or by any means, electronic, mechanical, photocopying, recording, scanning or otherwise, except as permitted under Sections 107 or 108 of the 1976 United States Copyright Act, without the prior written permission of the Publisher. Requests to the Publisher for permission should be addressed to the Permissions Department, John Wiley & Sons, Inc., 111 River Street, Hoboken, NJ 07030, (201) 748–6011, fax (201) 748–6008, or online at http://www.wiley.com/go/permissions.

Trademarks: Wiley, For Dummies, the Dummies Man logo, Dummies.com, Making Everything Easier, and related trade dress are trademarks or registered trademarks of John Wiley & Sons, Inc. and may not be used without written permission. Nikon and D3400 are trademarks of Nikon Corporation. All other trademarks are the property of their respective owners. John Wiley & Sons, Inc. is not associated with any product or vendor mentioned in this book.

LIMIT OF LIABILITY/DISCLAIMER OF WARRANTY: THE PUBLISHER AND THE AUTHOR MAKE NO REPRESENTATIONS OR WARRANTIES WITH RESPECT TO THE ACCURACY OR COMPLETENESS OF THE CONTENTS OF THIS WORK AND SPECIFICALLY DISCLAIM ALL WARRANTIES, INCLUDING WITHOUT LIMITATION WARRANTIES OF FITNESS FOR A PARTICULAR PURPOSE. NO WARRANTY MAY BE CREATED OR EXTENDED BY SALES OR PROMOTIONAL MATERIALS. THE ADVICE AND STRATEGIES CONTAINED HEREIN MAY NOT BE SUITABLE FOR EVERY SITUATION. THIS WORK IS SOLD WITH THE UNDERSTANDING THAT THE PUBLISHER IS NOT ENGAGED IN RENDERING LEGAL, ACCOUNTING, OR OTHER PROFESSIONAL SERVICES. IF PROFESSIONAL ASSISTANCE IS REQUIRED, THE SERVICES OF A COMPETENT PROFESSIONAL PERSON SHOULD BE SOUGHT. NEITHER THE PUBLISHER NOR THE AUTHOR SHALL BE LIABLE FOR DAMAGES ARISING HEREFROM. THE FACT THAT AN ORGANIZATION OR WEBSITE IS REFERRED TO IN THIS WORK AS A CITATION AND/OR A POTENTIAL SOURCE OF FURTHER INFORMATION DOES NOT MEAN THAT THE AUTHOR OR THE PUBLISHER ENDORSES THE INFORMATION THE ORGANIZATION OR WEBSITE MAY PROVIDE OR RECOMMENDATIONS IT MAY MAKE. FURTHER, READERS SHOULD BE AWARE THAT INTERNET WEBSITES LISTED IN THIS WORK MAY HAVE CHANGED OR DISAPPEARED BETWEEN WHEN THIS WORK WAS WRITTEN AND WHEN IT IS READ.

For general information on our other products and services, please contact our Customer Care Department within the U.S. at 877-762-2974, outside the U.S. at 317-572-3993, or fax 317-572-4002. For technical support, please visit https://hub.wiley.com/community/support/dummies.

Wiley publishes in a variety of print and electronic formats and by print-on-demand. Some material included with standard print versions of this book may not be included in e-books or in print-on-demand. If this book refers to media such as a CD or DVD that is not included in the version you purchased, you may download this material at http://booksupport.wiley.com. For more information about Wiley products, visit www.wiley.com.

Library of Congress Control Number: 2016959685

ISBN 978-1-119-33624-2 (pbk); ISBN 978-1-119-33623-5 (ebk); ISBN 978-1-119-33632-7 (ebk)

Manufactured in the United States of America

10 9 8 7 6 5 4 3 2 1

Contents at a Glance

Introduction 1
Part 1: Fast Track to Super Snaps5CHAPTER 1: Getting Up and Running7CHAPTER 2: Reviewing Five Essential Picture-Taking Options43CHAPTER 3: Taking Great Pictures, Automatically75
Part 2: Beyond the Basics.89CHAPTER 4: Taking Charge of Exposure.91CHAPTER 5: Controlling Focus and Depth of Field.125CHAPTER 6: Mastering Color Controls.153CHAPTER 7: Putting It All Together.171CHAPTER 8: Shooting, Viewing, and Trimming Movies.187
Part 3: After the Shot211CHAPTER 9: Playback Mode: Viewing Your Photos213CHAPTER 10: Working with Picture and Movie Files239
Part 4: The Part of Tens
Appendix: Intro to Nikon SnapBridge
Glossary of Digital Photography Terms
Index

Table of Contents

	1
About This Book	2
PART 1: FAST TRACK TO SUPER SNAPS	5
CHAPTER 1: Getting Up and Running. Preparing the Camera for Initial Use	.7 11 19 23 25 28 29 30 35 37
CHAPTER 2: Reviewing Five Essential Picture-Taking Options. 4 Choosing an Exposure Mode. 4 Fully automatic exposure modes . 4 Semiautomatic modes (P, S, and A) 4 Manual exposure mode (M). 4 Specialty modes (Effects and Guide modes) 4 Setting the Release Mode. 4 Single Frame and Quiet Shutter Release modes 4 Self-timer shooting 4 Self-timer shooting 5 Wireless remote control modes 5 Checking Image Size and Image Quality 5 Understanding Image Quality options (JPEG or Raw). 5 Setting Image Size and Image Quality 6 Adding Flash. 6 Choosing a Flash mode. 6 Adjusting the flash output (P, S, A, and M modes only). 7	14 14 14 15 16 17 18 19 100 110 110 110 1111 1111 1111 1111 </th

Taking Great Pictures, Automatically.75Shooting in Auto and Auto Flash Off Modes75Viewfinder photography in Auto and Auto Flash Off modes76Live View photography in Auto and Auto Flash off modes79Taking Advantage of Scene Modes82Portrait mode83Landscape mode84Child mode84Sports mode85Close Up mode87Night Portrait mode88
2: BEYOND THE BASICS
Taking Charge of Exposure 91
Introducing the Exposure Trio: Aperture, Shutter Speed,
and ISO.92Aperture affects depth of field.94Shutter speed affects motion blur.96ISO affects image noise.96Doing the exposure balancing act.99Stepping Up to Advanced Exposure Modes (P, S, A, and M).100Checking the Exposure Meter.102Choosing an Exposure Metering Mode.105Setting Aperture, Shutter Speed, and ISO.108Adjusting aperture and shutter speed.108Controlling ISO.111Solving Exposure Problems.115Applying Exposure Compensation.115Expanding tonal range with Active D-Lighting.122Using autoexposure lock.124
Controlling Focus and Depth of Field125
Choosing Automatic or Manual Focusing

CHAPTER 6:	Mastering Color Controls.	.153 .155 .158 .159 .163
CHAPTER 7:	Putting It All Together Recapping Basic Picture Settings Shooting Still Portraits Capturing Action Capturing Scenic Vistas. Capturing Dynamic Close-Ups.	.171 .172 .178 .181
CHAPTER 8:	Shooting, Viewing, and Trimming Movies Shooting Movies Using Default Settings Adjusting Video Settings. Controlling Audio. Choosing the Microphone setting (volume control). Reducing wind noise. Exploring Other Recording Options Manipulating Movie Exposure. Screening Your Movies. Trimming Movies. Saving a Movie Frame as a Still Image.	.188 .193 .197 .200 .201 .203 .205 .207
	B: AFTER THE SHOT Playback Mode: Viewing Your Photos Picture Playback 101. Choosing Which Images to View. Adjusting Playback Timing. Enabling Automatic Picture Rotation Shifting from Single-Image to Thumbnails Display Displaying Photos in Calendar View. Magnifying Photos During Playback. Viewing Picture Data. File Information mode Highlights ("blinkies") display mode RGB Histogram mode. Shooting Data mode. Overview mode. Creating a Digital Slide Show. Viewing Your Photos on a Television	.213 .214 .215 .216 .217 .219 .220 .221 .223 .224 .227 .228 .231 .232 .234

CHAPTER 1	Working with Picture and Movie Files	239
	Rating Photos and Movies	240
	Deleting Files	
	Deleting files one at a time	
	Deleting all files	
	Deleting a batch of selected files Protecting Photos and Movies	
	Taking a Look at Nikon's Photo Software	240 247
	Downloading Pictures to the Computer.	
	Connecting via USB	
	Starting the file-transfer process	
	Downloading using Nikon Transfer 2	
	Processing Raw (NEF) Files	
	Processing Raw images in the camera	
	Processing Raw files in Capture NX-D	
	Prepping online photos using ViewNX-i	
	Resizing pictures from the Retouch menu.	
DADT		
PARI	4: THE PART OF TENS	269
	The Free (Areal Description 1) Manual Area	
CHAPTER 1	Ten Fun (And Practical) Ways to	
CHAPTER 1	Manipulate Your Photos	
CHAPTER 1	Manipulate Your Photos Applying the Retouch Menu Filters	272
CHAPTER 1	Manipulate Your Photos Applying the Retouch Menu Filters. Removing Red-Eye.	272 275
CHAPTER 1	Manipulate Your Photos Applying the Retouch Menu Filters. Removing Red-Eye. Straightening Tilting Horizon Lines.	272 275 275
CHAPTER 1	Manipulate Your Photos Applying the Retouch Menu Filters. Removing Red-Eye.	272 275 275 275 277
CHAPTER 1	Manipulate Your PhotosApplying the Retouch Menu Filters.Removing Red-Eye.Straightening Tilting Horizon Lines.Removing (Or Creating) Lens DistortionCorrecting PerspectiveAdjusting Exposure and Color.	272 275 275 277 278 278 279
CHAPTER 1	Manipulate Your PhotosApplying the Retouch Menu Filters.Removing Red-Eye.Straightening Tilting Horizon Lines.Removing (Or Creating) Lens DistortionCorrecting PerspectiveAdjusting Exposure and Color.Cropping Your Photo	272 275 275 277 278 278 279 282
CHAPTER 1	Manipulate Your PhotosApplying the Retouch Menu Filters.Removing Red-Eye.Straightening Tilting Horizon Lines.Removing (Or Creating) Lens DistortionCorrecting PerspectiveAdjusting Exposure and Color.Cropping Your PhotoApplying Effects to Existing Photos.	272 275 275 277 278 279 282 282
CHAPTER 1	Manipulate Your PhotosApplying the Retouch Menu Filters.Removing Red-Eye.Straightening Tilting Horizon Lines.Removing (Or Creating) Lens DistortionCorrecting PerspectiveAdjusting Exposure and Color.Cropping Your PhotoApplying Effects to Existing Photos.Shooting in Effects Mode	272 275 275 277 278 279 282 284 288
CHAPTER 1	Manipulate Your PhotosApplying the Retouch Menu Filters.Removing Red-Eye.Straightening Tilting Horizon Lines.Removing (Or Creating) Lens DistortionCorrecting PerspectiveAdjusting Exposure and Color.Cropping Your PhotoApplying Effects to Existing Photos.	272 275 275 277 278 279 282 284 288
	Manipulate Your PhotosApplying the Retouch Menu Filters.Removing Red-Eye.Straightening Tilting Horizon Lines.Removing (Or Creating) Lens DistortionCorrecting PerspectiveAdjusting Exposure and Color.Cropping Your PhotoApplying Effects to Existing Photos.Shooting in Effects Mode	272 275 275 277 278 279 282 284 288
	Manipulate Your PhotosApplying the Retouch Menu Filters.Removing Red-Eye.Straightening Tilting Horizon Lines.Removing (Or Creating) Lens DistortionCorrecting PerspectiveAdjusting Exposure and Color.Cropping Your PhotoApplying Effects to Existing Photos.Shooting in Effects ModeCombining Two Photos with Image Overlay	272 275 275 277 278 279 282 284 288 288 293
	Manipulate Your Photos Applying the Retouch Menu Filters. Removing Red-Eye. Straightening Tilting Horizon Lines. Removing (Or Creating) Lens Distortion Correcting Perspective Adjusting Exposure and Color. Cropping Your Photo Applying Effects to Existing Photos. Shooting in Effects Mode Combining Two Photos with Image Overlay	272 275 275 277 278 279 282 284 288 293
	Manipulate Your Photos Applying the Retouch Menu Filters. Removing Red-Eye. Straightening Tilting Horizon Lines. Removing (Or Creating) Lens Distortion Correcting Perspective Adjusting Exposure and Color. Cropping Your Photo Applying Effects to Existing Photos. Shooting in Effects Mode Combining Two Photos with Image Overlay 2: Ten Special-Purpose Features to Explore on a Rainy Day Adding Hidden Image Comments. Adding a Copyright Notice	272 275 275 277 278 279 282 288 293 295 295 295
	Manipulate Your Photos Applying the Retouch Menu Filters. Removing Red-Eye. Straightening Tilting Horizon Lines. Removing (Or Creating) Lens Distortion Correcting Perspective Adjusting Exposure and Color. Cropping Your Photo Applying Effects to Existing Photos. Shooting in Effects Mode Combining Two Photos with Image Overlay Ten Special-Purpose Features to Explore on a Rainy Day Adding Hidden Image Comments. Adding a Copyright Notice Creating Custom Image Folders	272 275 275 277 278 279 282 284 288 293 295 295 295 295 295
	Manipulate Your Photos Applying the Retouch Menu Filters. Removing Red-Eye. Straightening Tilting Horizon Lines. Removing (Or Creating) Lens Distortion Correcting Perspective Adjusting Exposure and Color. Cropping Your Photo Applying Effects to Existing Photos. Shooting in Effects Mode Combining Two Photos with Image Overlay Ten Special-Purpose Features to Explore on a Rainy Day Adding Hidden Image Comments. Adding a Copyright Notice Creating Custom Image Folders Turning Off the AF-Assist Illuminator	272 275 275 277 278 279 282 282 284 293 295 295 295 297 298 300
	Manipulate Your Photos Applying the Retouch Menu Filters. Removing Red-Eye. Straightening Tilting Horizon Lines. Removing (Or Creating) Lens Distortion Correcting Perspective Adjusting Exposure and Color. Cropping Your Photo Applying Effects to Existing Photos. Shooting in Effects Mode Combining Two Photos with Image Overlay Ten Special-Purpose Features to Explore on a Rainy Day Adding Hidden Image Comments. Adding a Copyright Notice. Creating Custom Image Folders Turning Off the AF-Assist Illuminator. Adjusting Automatic Shutdown Timing	272 275 275 277 278 279 282 284 288 293 295 295 295 297 298 800 800
	Manipulate Your Photos Applying the Retouch Menu Filters. Removing Red-Eye. Straightening Tilting Horizon Lines. Removing (Or Creating) Lens Distortion Correcting Perspective Adjusting Exposure and Color. Cropping Your Photo Applying Effects to Existing Photos. Shooting in Effects Mode Combining Two Photos with Image Overlay Ten Special-Purpose Features to Explore on a Rainy Day Adding Hidden Image Comments. Adding a Copyright Notice Creating Custom Image Folders Turning Off the AF-Assist Illuminator	272 275 275 277 278 279 282 284 293 295 295 295 297 298 300 300 300

Changing the Function Button's Function
APPENDIX: INTRO TO NIKON SNAPBRIDGE
GLOSSARY OF DIGITAL PHOTOGRAPHY TERMS
INDEX

Introduction

ikon. The name has been associated with top-flight photography equipment for generations. And the introduction of the D3400 has only enriched Nikon's well-deserved reputation, offering all a terrific blend of features for capturing both still photos and high-definition digital movies. You even get tools for cropping, resizing, and enhancing pictures right in the camera. The D3400 even has built-in Bluetooth technology, which enables you to transfer photos wirelessly to certain smartphones, tablets, and other devices.

In fact, the D3400 offers so *many* features that sorting them all out can be more than a little confusing, especially if you're new to digital photography, SLR photography, or both. For starters, you may not even be sure what SLR means or how it affects your picture-taking, let alone have a clue about all the other techie terms you encounter in your camera manual — *resolution, aperture, white balance,* and so on. And if you're like many people, you may be so overwhelmed by all the controls on your camera that you haven't yet ventured beyond fully automatic picture-taking mode.

Therein lies the point of *Nikon D3400 For Dummies*. With the help of this book, you can take full advantage of everything the D3400 has to offer.

About This Book

Unlike many photography books, this one doesn't require any previous knowledge of photography or digital imaging to make sense of things. In classic *For Dummies* style, everything is explained in easy-to-understand language, with lots of illustrations to help clear up any confusion.

Even if you have some photography experience — or quite a bit of experience, for that matter — this book has plenty to offer, however. I provide detailed information about all the camera's advanced exposure, focus, and color controls, explaining not just what each feature does but why and how to put it to best use.

In short, what you have in your hands is the paperback version of an in-depth photography workshop tailored specifically to your Nikon picture-taking powerhouse.

How This Book Is Organized

This book is organized into four parts, each devoted to a different aspect of using your camera. Although chapters flow in a sequence that's designed to take you from absolute beginner to experienced user, I've also made each chapter as self-standing as possible so that you can explore the topics that interest you in any order you please. Here's a brief preview of what you can find in each part of the book:

- >> Part 1: Fast Track to Super Snaps: Part 1 contains three chapters to help you get up and running. Chapter 1 guides you through initial camera setup and shows you how to view and adjust camera settings. Chapter 2 introduces you to basic picture options such as Exposure mode, Release mode, Image Size (resolution), and Image Quality (JPEG or Raw) and also provides information on flash photography with the D3400. Chapter 3 walks you through the steps of taking your first pictures using the Auto and Auto Flash Off exposure modes as well as the Scene modes (Portrait, Landscape, Sports, and so on).
- >> Part 2: Beyond the Basics: Chapters in this part help you unleash the full creative power of your camera by detailing the advanced shooting modes (P, S, A, and M). Chapter 4 covers the critical topic of exposure; Chapter 5 explains how to manipulate focus; and Chapter 6 discusses color controls. Chapter 7 summarizes techniques explained in earlier chapters, providing a quick-reference guide to the camera settings and shooting strategies that produce the best results for portraits, action shots, landscape scenes, and close-ups. Chapter 8 shifts gears, moving from still photography to HD movie recording.
- >> Part 3: After the Shot: This part offers two chapters, both dedicated to tasks you do after you press the shutter button. Chapter 9 explains how to review your pictures on the camera monitor and connect your camera to a TV for large-screen playback. Chapter 10 topics include rating, deleting, and protecting photos, downloading images to your computer, processing Raw files, and preparing pictures for online sharing. Chapter 10 also introduces you to two free Nikon photo programs, Nikon ViewNX-i and Capture NX-D.
- Part 4: The Part of Tens: In keeping with For Dummies tradition, this book concludes with two top-ten lists containing additional bits of information and advice. Chapter 11 covers the photo-editing and effects tools found on the camera's Retouch menu and also shows you how to use the Effects exposure mode to add special effects to movies and photos as you record them. Chapter 12 wraps up the book by detailing some features that, although not found on most "Top Ten Reasons I Bought My D3400" lists, are nonetheless interesting, useful on occasion, or a bit of both.

- >> Appendix: Intro to Nikon SnapBridge: Nikon SnapBridge is an app that you can install on certain Android- and Apple iOS smartphones, tablets, and other smart devices. It's this app that enables you to use the camera's Bluetooth wireless technology to connect your D3400 to your smart device. After making the connection, you can transfer photos to the device for viewing or easy uploading to your favorite social media site. Check out the appendix for an overview of the app, an explanation of camera menu options related to it, and details on how to access the online SnapBridge help site, which provides full information about using the app on various devices.
- Solution Section 2017 Section 2
- Cheat sheet: When you have a minute or two, visit www.dummies.com and enter the name of this book in the search box. You'll find a link to a cheat sheet, which provides a handy reference guide to important camera settings and terms.

Icons and Other Stuff to Note

If this isn't your first *For Dummies* book, you may be familiar with the large, round icons that decorate its margins. If not, here's your very own icon-decoder ring:

The Tip icon flags information that will save you time, effort, money, or some other valuable resource, including your sanity. Tips also point out techniques that help you get the best results from specific camera features.

When you see this icon, look alive. It indicates a potential danger zone that can result in much wailing and teeth-gnashing if ignored. In other words, this is stuff that you really don't want to learn the hard way.

WARNING

STILEE

Lots of information in this book is of a technical nature — digital photography is a technical animal, after all. But when I present a detail that is useful mainly for impressing your tech-geek friends, I mark it with this icon.

I apply this icon either to introduce information that is especially worth storing in your brain's long-term memory or to remind you of a fact that may have been displaced from that memory by another pressing fact.

Additionally, replicas of some of your camera's buttons and onscreen graphics appear in the margins and in some tables. I include these images to provide quick reminders of the appearance of the button or option being discussed.

Where to Go from Here

To wrap up this preamble, I want to stress that if you initially think that digital photography is too confusing or too technical for you, you're in very good company. *Everyone* finds this stuff mind-boggling at first. So take it slowly, experimenting with just one or two new camera settings or techniques at first. Then, every time you go on a photo outing, make it a point to add one or two more shooting skills to your repertoire.

I know that it's hard to believe when you're just starting out, but it really won't be long before everything starts to come together. With some time, patience, and practice, you'll soon wield your camera like a pro, dialing in the necessary settings to capture your creative vision almost instinctively.

So without further ado, I invite you to grab your camera, a cup of whatever it is you prefer to sip while you read, and start exploring the rest of this book. Your D3400 is the perfect partner for your photographic journey, and I'm grateful for the opportunity to act as your tour guide.

Fast Track to Super Snaps

IN THIS PART

Familiarize yourself with the basics of using your camera, from attaching lenses to navigating menus.

Find out how to select the exposure mode, Release mode, Image Size (resolution), and Image Quality (JPEG or Raw file type).

Discover options available for flash photography.

Get step-by-step help with shooting your first pictures in Auto Mode, Flash Off Mode, and the Scene modes.

IN THIS CHAPTER

- » Preparing the camera for its first outing
- » Getting acquainted with camera features
- » Viewing and adjusting camera settings
- » Setting a few basic preferences
- » Restoring original camera settings

Chapter **1** Getting Up and Running

hooting for the first time with a camera as sophisticated as the Nikon D3400 can produce a blend of excitement and anxiety. On one hand, you can't wait to start using your new equipment, but on the other, you're a little intimidated by all its buttons, dials, and menu options.

Well, fear not: This chapter provides the information you need to start getting comfortable with your D3400. The first section walks you through initial camera setup; following that, you can get an overview of camera controls, discover how to view and adjust camera settings, and get my take on some basic setup options.

Preparing the Camera for Initial Use

After unpacking your camera, you have to assemble a few parts. In addition to the camera body and the supplied battery (be sure to charge it before the first use), you need a lens and a memory card. Later sections in this chapter provide details about working with lenses and memory cards, but here's what you need to know up front:

Lens: You can mount a wide range of lenses on your D3400, but some aren't compatible with all camera features. For example, to enjoy autofocusing, you

need an AF-P or AF-S lens. (The 18-55mm lens featured in this book and sold in a kit with the D3400 body is an AF-P lens.) Your camera manual offers details about lens compatibility.

The *AF* in AF-S and AF-P stands for *autofocus*. The *S* in AF-S stands for a *silent wave* focusing motor; the *P* refers to an autofocusing technology known as a "stepping motor." Both are designed to deliver faster and quieter autofocusing. How you implement autofocusing differs between the two types, however. Read more about this issue later in this chapter, in the section "Familiarizing Yourself with the Lens."

>> SD (Secure Digital) memory card: Your camera accepts only this type of card. A card with the simple SD designation is an older, lower capacity card that holds a maximum of 4GB of data. Newer SD cards carry the designation SDHC (for *High Capacity*) or SDXC (for *eXtended Capacity*), depending on how many gigabytes (GB) of data they hold. SDHC cards hold from 4GB to 32GB of data; the SDXC moniker is assigned to cards with capacities greater than 32GB.

With camera, lens, battery, and card within reach, take these steps:

- **1.** Turn off the camera.
- Install the battery into the compartment on the bottom of the camera.
- 3. Attach a lens.

First, remove the caps that cover the front of the camera and the back of the lens. Then align the *mounting index* (white dot) on the lens with the one on the camera body, as shown in Figure 1-1. After placing the lens on the camera mount, rotate the lens toward the shutter-button side of the camera. You should feel a solid click as the lens locks into place.

4. Insert a memory card.

Open the card-slot cover on the right side of the camera and orient the card, as shown in Figure 1-2. (The label faces the back of the camera.) Push the card gently into the slot and close the cover. The memory-card access light, labeled in the figure, illuminates briefly to let you know that the camera recognizes the card.

5. Turn on the camera.

6. If using a retractable lens, unlock and extend the lens.

The lens barrels of AF-P kit lenses, as well as some AF-S lenses, extend and retract. When you're not shooting, you can retract the lens so that it takes up less space in your camera bag. But before you can take a picture or even access most camera menu items, you must unlock and extend the lens. A message appears on the camera monitor to remind you of this step.

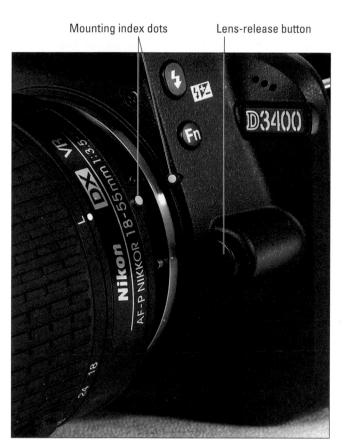

FIGURE 1-1: Align the white dot on the lens with the one on the camera body.

To extend the lens, press the retractable-lens barrel button, highlighted in Figure 1-3, while rotating the lens barrel toward the shutter-button side of the camera. To retract the lens, press the button while rotating the lens in the other direction.

7. Set the camera language, time zone, date, and time.

When you power up the camera for the first time, the monitor displays a message asking you to select the menu language and set the time zone, date, and time. Navigate the screens and adjust the settings by using the Multi Selector and the OK button (refer to Figure 1-2):

- Press the edge of the Multi Selector up and down to move the highlight cursor vertically; press right/left to travel horizontally. Press OK or press the Multi Selector right to reveal options related to the highlighted setting.
- When a value box is highlighted, press the Multi Selector up/down to change the value. Press left/right to jump to the next value box.
- After making your selections on a screen, press OK.

(The later section "Ordering from camera menus" provides more help with using menus.)

The date/time information is included as *metadata* (hidden data) in the picture file. You can view metadata in some playback display modes (see Chapter 9) and in certain photo programs, including Nikon ViewNX-i and Nikon Capture NX-D. (Refer to Chapter 10.)

8. Adjust the viewfinder to your eyesight.

Tucked behind the right side of the rubber eyepiece that surrounds the viewfinder is a dial that enables you to adjust the viewfinder focus to accommodate your eyesight. I highlighted the dial in Figure 1-4.

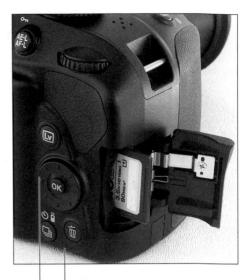

Memory-card access light

Multi Selector/OK button

FIGURE 1-2:

Insert the memory card with the label facing the back of the camera.

This step is critical: If you don't adjust the viewfinder to your

eyesight, subjects may appear sharp in the viewfinder when they aren't actually in focus, and vice versa.

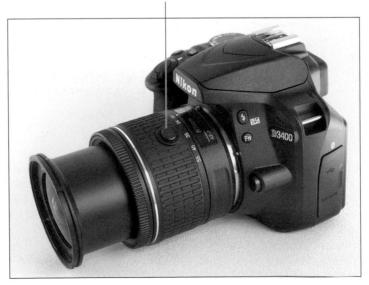

Retractable-lens barrel button

FIGURE 1-3: Press this button while rotating the lens barrel to extend and retract the lens. To set the viewfinder focus, remove the lens cap, look through the viewfinder, and then press the shutter button halfway to display data at the bottom of the viewfinder. (In dim lighting, the flash may pop up; ignore it for now and close the unit after you adjust the viewfinder.) Now rotate the dial until the data appears sharpest. The markings in the center of the viewfinder, which relate to autofocusing, also become more or less sharp. Rotate dial to adjust viewfinder

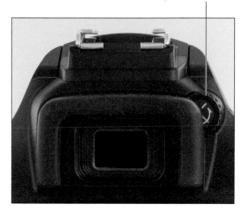

That's all there is to it — the camera is now ready to go. From here, my recommendation is that you keep

FIGURE 1-4: Rotate this dial to set the viewfinder focus for your eyesight.

reading the rest of this chapter to familiarize yourself with the main camera features. But if you're anxious to take a picture right away, I won't think any less of you if you skip to Chapter 3, which guides you through the process of using the camera's automatic shooting modes. Just promise that at some point, you'll read the pages in between, because they actually do contain important information.

Exploring Basic Camera Features

If you're new to dSLR photography, some aspects of using your camera, such as working with the lens, may be unfamiliar to you. But even if this isn't your first dSLR, it pays to take some time before your first shoot to get familiar with its controls. To that end, the upcoming pages provide an overview of the D3400's main features and also offer a primer on working with lenses and memory cards.

Checking out external controls

Scattered across your camera's exterior are numerous controls that you use to change picture-taking settings, review your photos, and perform various other operations. In later chapters, I discuss all camera functions in detail and provide the exact steps to follow to access them. This section provides just a basic "what's this thing do?" guide to each control. (Don't worry about memorizing the button names; throughout the book, I show pictures of buttons in the page margins to help you know exactly which one to press.)

Topside controls

Your virtual tour begins with the bird's-eye view shown in Figure 1-5. There are a number of features of note here:

>> On/Off switch and shutter button: Okay, I'm pretty sure you've already figured out this combo button. But you may not be aware that you need to press the shutter button in two stages: Press and hold the button halfway and wait for the camera to initiate exposure metering and, if you're using autofocusing, to set the focusing distance. Then press the button the rest of the way to take the picture.

Exposure Compensation button: This button activates Exposure Compensation, a feature that enables you to tweak exposure when working in the P (programmed autoexposure), A (aperture-priority autoexposure), or S (shutter-priority autoexposure) modes. I cover this feature in Chapter 4. To set the amount of Exposure Compensation, press the button while rotating the Command dial (the black dial on the upper-right corner of the camera back). In M (manual exposure) mode, press this button while rotating the Command dial to adjust the aperture setting, another exposure control explained in Chapter 4.

- Info button: This button performs two functions depending on whether you're using the viewfinder to frame shots or taking advantage of Live View, the feature that enables you to see the live scene on the monitor.
 - *Viewfinder photography:* Press the Info button to display the Information screen, which displays the most critical picture-taking settings. To turn off the screen, press the Info button again.

You also can display the screen by pressing the shutter button halfway and releasing it.

- Live View photography: After you press the LV (Live View) button on the back of the camera, the viewfinder goes dark, and the live scene appears on the monitor. During Live View photography, press the Info button to change the amount and type of data displayed along with the live scene. You can turn the monitor off only by exiting Live View mode (press the LV button again).
- 0
- Movie-Record button: After shifting to Live View mode, press this button to start recording a movie. Press again to stop recording. (You can't use the viewfinder when recording movies.)
- Mode dial: With this dial, you choose the *exposure mode*, which determines how much control you have over camera settings. For normal shooting, you can choose from fully automatic, semiautomatic, or manual exposure control; I introduce you to the auto modes in Chapter 3 and cover the semiautomatic and manual modes (P, S, A, and M) in Chapter 4.

Exposure Compensation button

On/Off switch/shutter button Movie-record button AF-assist lamp

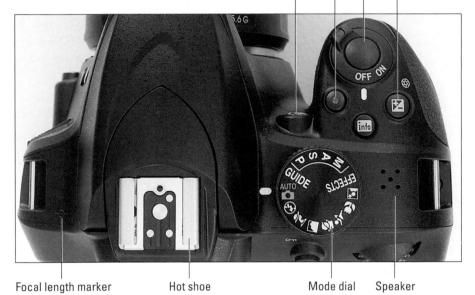

FIGURE 1-5: Rotate the Mode dial to choose an exposure mode.

By turning the dial to Effects, you can apply special effects as the image or movie is captured, a feature you can explore in Chapter 11.

Select the Guide setting to access guided menus, covered later in this chapter.

- AF-assist lamp: When you use autofocusing, the camera may emit a beam of light from this lamp in dim lighting; the light helps the camera find its focus target. The lamp also lights when you use Red-Eye Reduction flash and the Self-Timer shutter-release mode, both covered in Chapter 2.
- Flash hot shoe: A hot shoe is a connection for attaching an external flash head. See Chapter 2 for an introduction to flash photography.
- Speaker: When you play a movie, the sound comes wafting out of these holes.

Focal plane indicator: If you need to document the exact distance that exists between your subject and the camera, the focal plane mark is the key. The mark indicates the plane at which light coming through the lens is focused onto the camera's image sensor. Basing your measurement on this mark produces a more accurate camera-to-subject distance than using the end of the lens or another external point on the camera body as your reference point.

Back-of-the-body controls

On the back of the camera, shown in Figure 1-6, you find these features:

>> Viewfinder adjustment dial: Rotate this dial to adjust the viewfinder focus to your eyesight; see the first section of this chapter for details.

>> AE-L/AF-L button: Pressing this button initiates autoexposure lock (AE-L) and autofocus lock (AF-L). Chapter 4 explains autoexposure lock; Chapter 5 talks about autofocus lock.

In playback mode, pressing the button activates the Protect feature, which locks the picture file — hence the little key symbol that appears above the button so that it isn't erased if you use the picture-delete functions. See Chapter 10 for details. (The picture is erased if you format the memory card, however.)

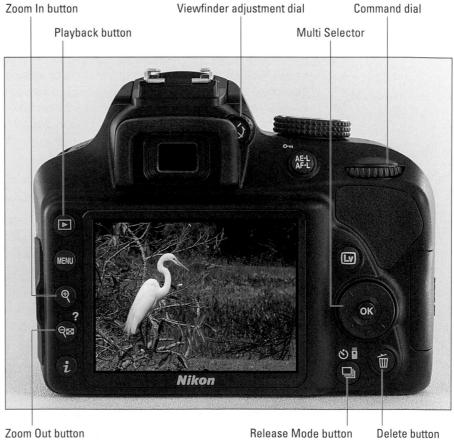

FIGURE 1-6: Use the Multi Selector to navigate menus and access certain other camera options.

Command dial: After you activate certain camera features, you rotate this dial to select a setting. For example, to choose a shutter speed when shooting in shutter-priority (S) mode, you rotate the Command dial.

- Playback button: Press this button to switch the camera into picture review mode. Chapter 9 details playback features.
- Menu button: Press this button to access menus of camera options. See "Ordering from camera menus," later in this chapter, for details.

Zoom In button: In playback mode, pressing this button magnifies the currently displayed image. Note the plus sign in the middle of the magnifying glass — plus means enlarge.

- >> Zoom Out button: As you can probably deduce from the three symbols that mark this button, it has not one, but three primary functions:
 - *Reduce image magnification during playback:* If you magnify an image during playback, pressing the button reduces the magnification amount. The magnifying glass with the minus sign tips you off to this function.
 - *Display thumbnails during playback:* After you press the Playback button to shift to playback mode, pressing the Zoom Out button enables you to switch from single-image view, which shows one photo or movie at a time, to thumbnails view, which displays multiple images on the screen. Press once to display 4 thumbnails; press again to display 9 thumbnails; and press a third time to see 72 itty-bitty thumbnails. A fourth press shifts the display to Calendar playback, which makes it easy for you to locate pictures taken on a particular day.

To cycle back to thumbnails view, press the Zoom In button; keep pressing to reduce the number of thumbnails until you get to single-image view.

 Display help screens: The question mark symbol above the button is a reminder that you can press this button to display helpful information about certain menu options. See the section "Displaying Help Screens," later in this chapter, for details.

i button: During shooting, pressing this button activates a control strip on the Information and Live View displays, enabling quick access to certain picture settings. See the upcoming section "Adjusting settings via the control strip" for details.

- >> LV (Live View) button: As its name implies, this button turns Live View on and off. In Live View mode, the scene in front of the lens appears on the monitor, and you can't see anything through the viewfinder. You then can compose a still photo using the monitor or begin recording a movie. I provide additional guidelines about using Live View later in this chapter.
- >> Multi Selector/OK button: This dual-natured control plays a role in many camera functions. You press the outer edges of the Multi Selector left, right,

up, or down to navigate camera menus and access certain other options. At the center of the control is the OK button, which you press to finalize a menu selection or another camera adjustment.

In this book, the instruction "Press the Multi Selector left" simply means to press the left edge of the control. "Press the Multi Selector right" means to press the right edge, and so on.

- ৩ []
- Release Mode button: Press this button to display a screen where you can select the shutter-release mode. By default, the option is set to Single Frame, which results in one picture each time you press the shutter button. You can explore other settings in Chapter 2.

Delete button: Sporting a trash can icon, the universal symbol for delete, this button enables you to erase pictures from your memory card. Chapter 10 explains the steps.

Front-left features

The front-left side of the camera, shown in Figure 1-7, sports these features:

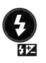

Flash button: In the advanced exposure modes (P, S, A, and M), pressing this button raises the built-in flash. In other modes, the camera controls whether flash is enabled.

By holding the Flash button down and rotating the Command dial, you can adjust the Flash mode (Fill Flash, Red-Eye Reduction, and so on). In advanced exposure modes, you also can adjust the flash power by pressing the button while simultaneously pressing the **Exposure Compensation button** and rotating the Command dial. The little plus/minus symbol that appears below the Flash button the same symbol that's on the Exposure Compensation button is a reminder of the button's role in flash-power adjustment.

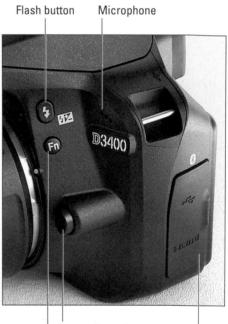

Lens-release button

Function button

Port cover

FIGURE 1-7: Press the Flash button to use the built-in flash in P, S, A, or M mode. Check out Chapter 2 for details on flash options.

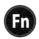

>> Function (Fn) button: By default, this button gives you quick access to the ISO setting, which controls the camera's sensitivity to light. (Chapter 4 explains.) If you don't adjust that setting often, you can use the button to perform other operations; Chapter 12 shows you how. Note that you can't control ISO in the Auto and Auto Flash Off exposure modes or Night Vision Effects mode, so pressing the Fn button has no result in those modes.

- Microphone: The three little holes just above the silver D3400 label lead to the camera's internal microphone. See Chapter 8 to find out how to disable the microphone if you want to record silent movies.
- >> Lens-release button: Press this button to disengage the lens from the camera's lens mount so that you can remove the lens. Don't confuse this lock button with the one on the kit lens (and other retractable lenses) you press the button on the lens to unlock it so that you can extend or retract the lens barrel. (See the first section of this chapter for help.)
- Connection port door: Open this little door to expose the camera's USB and HDMI connection ports, explained next.

Connection ports and a few final features

Hidden under the cover on the left side of the camera are the following connection ports, labeled in the photo shown on the left side of Figure 1-8:

USB port: Through this port, you can connect your camera to a USB port on a computer for picture downloading and to connect the camera to certain printers for direct printing of photos on the memory card. However, Nikon does not supply the USB cable with the camera; if you want to download or print via USB, buy the UC-E21 USB cable, which sells for about \$12.

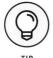

Before you rush out to get the cable, though, consider whether you really need it. Instead of connecting the camera directly to your computer for picture transfer, you can use a memory card reader. Chapter 10 explains more about the picture-download options. As for printing, many printers have built-in card readers, so you may not need the cable to enjoy that function, either. In addition, only printers that offer a technology called *PictBridge* support direct printing from the camera via a USB connection.

HDMI port: You can use this port to connect your camera to a high-definition TV, but again, you need to buy the required cable. Look for a Type C mini-pin HDMI cable. Chapter 9 offers details on television playback.

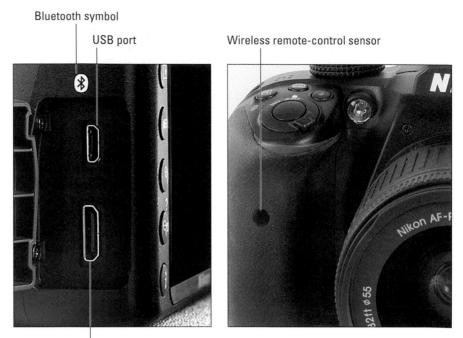

FIGURE 1-8: Look on the left side of the camera for USB and HDMI ports; the wireless remote-control sensor is on the front of the camera.

HDMI port

If you turn the camera over, you find a tripod socket, which enables you to mount the camera on a tripod that uses a 1/4-inch screw, plus the battery chamber. At the right edge of the battery-chamber cover, you also see a tab that you lift to expose the connector for the optional AC power supply. (More about that accessory momentarily.)

Two final features to note that relate to available accessories for your camera:

- Wireless remote control: Although the D3400 doesn't work with a wired remote shutter-release cable, you can use the Nikon ML-L3 wireless remote. The camera has a single sensor for picking up the remote signal; the sensor is on the front of the camera, as shown on the right side of Figure 1-8.
- AC adapter: If you regularly use your camera for extended periods, you may want to invest in an AC adapter, which enables you to power the camera via AC electrical power rather than the supplied battery. You need two components to make this work: the EP-5a power connector and the EH-5b AC adapter. The power connector goes into the battery compartment on the camera; the AC adapter plugs into the connector. The supply connector runs about \$50; the AC adapter, about \$120. Another option, of course, is to simply buy a spare battery (part EN-EL14a), which sells for about \$60.

As for the Bluetooth symbol printed above the port cover door, it's just there to remind you that the camera can connect via Bluetooth wireless technology to compatible smart devices. This feature requires that you install a Nikon app, SnapBridge, on your device. The app is available only for certain versions of Android and Apple iOS operating systems. The appendix introduces you to SnapBridge and Bluetooth basics.

Ordering from camera menus

Pressing the Menu button gives you access to a slew of options in addition to those you control via the external buttons and dials. But what type of menu screens you see depends on the setting of the Mode dial:

- Solution: Pressing the Menu button brings up the first screen of the guided menus, which provide a simple, walk-me-through-it approach to using the camera.
- All other settings: Pressing the Menu button brings up the normal, textbased menus.

The next two sections provide an overview of using both types of menus.

Using the guided menus

The guided menus work much like interactive menus you encounter in other areas of your life — on cellphones, bank machines, and the like — except that instead of pressing buttons on the screen, you use the Multi Selector and OK button to make your menu selections. And thankfully, your camera also doesn't nag you to hurry up and "please place the item in the bagging area!" every 3 seconds like the self-checkout machines in some grocery stores.

To explore the guided menu feature, set the Mode dial to Guide, as shown in Figure 1–9.

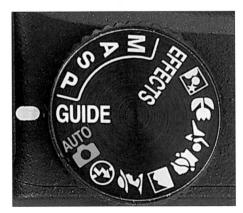

FIGURE 1-9: Set the Mode dial to Guide to use the guided menus.

You see the initial guided menu screen, shown on the left in Figure 1–10. Using the Multi Selector, highlight one of these options:

- Shoot: Select this icon to access screens that walk you through the process of choosing basic picture-taking settings and shooting pictures.
- View/Delete: Select this category to access picture-playback functions and erase pictures from your memory card.
- Retouch: This choice takes you to the built-in photo editing functions, such as red-eye removal and cropping.
- Set Up: Choose this icon to access camera setup options things like setting the date and time, adjusting monitor brightness, and so on.

After choosing an option, press OK to display the first screen associated with that category. For example, if you choose Set Up, you see the screen shown on the right in Figure 1–10. From there, use the Multi Selector to choose a task and press OK to move on to the next screen. Just keep highlighting your choice and pressing OK to make your way through the menus. To return to the preceding screen, press the Multi Selector left (the Back symbol at the bottom of the screen reminds you of this trick).

FIGURE 1-10: Use the Multi Selector to highlight an option and then press OK to display the next guided screen.

> Although I appreciate the idea of the guided menus, I have a few quibbles about how they're implemented on the D3400. First, you can't access all your camera's features through the guided menus. Second, some choices Nikon made for the arrangement of the guided menus set you up for confusion down the line. For example, the Image Size and Image Quality options, which control resolution and file type (see Chapter 2), are found in the Set Up section of the guided menus but live on the Shooting menu in the regular menus. So if you get used to selecting those options in one place when you use guided menus, you have to learn a whole new organization when you move on to the regular menus. Additionally, when you adjust certain settings, including Image Size and Image Quality, your changes apply only in Guide mode. So when you return to another shooting mode, you have to adjust those settings again.

Don't get me wrong: If you like the guided menus, by all means, take advantage of them. But my guess is that you don't need much help from me to do so, which is why this is the last you'll read of them in this book.

Ordering off the main menus

To display regular menus, rotate the Mode dial to any setting but Guide and then press the Menu button. You then see a screen similar to the one shown in Figure 1-11. The icons along the left side of the screen represent the available menus. (Table 1-1 labels the icons and includes a brief description of the goodies found on each menu.) In the menu screens, the icon that's highlighted or appears in color is the active menu; options on that menu automatically appear to the right. In the figure, the Shooting menu is active, for example.

TABLE 1-1 D3400 Menus

Symbol	Open This Menu	To Access These Functions
	Playback	Viewing, deleting, and protecting pictures
۵	Shooting	Basic photography settings
Y	Setup	Additional basic camera operations
	Retouch	Built-in photo-retouching options
1	Recent Settings	Your 20 most recently used menu options

I explain all menu options elsewhere in the book; for now, just familiarize yourself with the process of navigating menus and selecting options therein:

>> To select a different menu: Press the Multi Selector left to jump to the column containing the menu icons. (Refer to Figure 1-6 if you need help finding the Multi Selector.) Then press up or down to highlight the menu you want to display. Finally, press right to jump over to the options on the menu.

A color detail to mention here: When the icon list is active, the selected menu icon appears yellow, as in Figure 1-11. After you press the Multi Selector right to access the selected menu's options, the icon changes color, with each menu having its own color scheme. The Shooting menu icon, for example, turns green, as shown in Figure 1-12.

>> To select and adjust a function on the current menu: Again, use the Multi Selector to scroll up or down the list of options to highlight the feature you want to adjust and then press OK. Settings available for the

Menu icons

 =	SHOOTING MEN	U
Re	eset shooting menu	
o In	age quality	NORM
I In	age size	
IS	O sensitivity settings	
W	hite balance	AUTO
Se	t Picture Control	⊡SD
Co	olor space	sRGB
A	tive D-Lighting	eton

FIGURE 1-11:

Highlight a menu in the left column to display its contents.

selected item then appear. For example, if you select the Image Quality item from the Shooting menu, as shown on the left in Figure 1-12, and press OK, the available Image Quality options appear, as shown on the right in the figure. Repeat the up-and-down scroll routine until the choice you prefer is highlighted. Then press OK to return to the previous screen.

SHOOTING MEN		Image quality
Reset shooting menu Image quality	NORM	
Image size	HORM Y	
ISO sensitivity settings		
White balance	AUTO	JPEG fine
Set Picture Control	ESD .	JPEG normal
Color space	sRGB	JPEG basic
Active D-Lighting	SROB 晤古ON ?	

FIGURE 1-12: Select the option you prefer and press OK again to return to the active menu.

> In some cases, you see a right-pointing arrowhead instead of the OK symbol next to an option. That's your cue to press the Multi Selector right to display a submenu or other list of options. (Although, most of the time, you also can just press the OK button if you prefer.) If any menu options are dimmed in the menu, you can't access them in the current exposure mode; remember, to use all the camera's features, you must set the Mode dial to P, S, A, or M. Some settings also become off-limits when you enable options that conflict with those settings. (I explain these conflicts when discussing the affected features.)

>> To quickly access your 20 most recent menu items: The Recent Settings menu lists the 20 menu items you ordered most recently. So if you want to adjust those settings, you don't have to wade through all the other menus looking for them — just head to this menu instead. Again, press the Multi Selector right to jump to the menu-icon strip and then highlight the Recent Settings icon, as shown in Figure 1-13. Press the Multi Selector right to access the options on the menu. You can remove an

FIGURE 1-13:

The Recent Settings menu offers quick access to the last 20 menu options you selected.

item from the menu by highlighting it and pressing the Delete (trash can) button twice.

Exit menus and return to shooting: Just give the shutter button a quick half-press and then release it. You also can press the Menu button (you may need to press the button twice to back out of all the menu screens).

Switching to Live View mode

Like many dSLR cameras, the D3400 offers Live View, a feature that enables you to use the monitor instead of the viewfinder to compose photos. Turning on Live View is also the first step in recording a movie; using the viewfinder isn't possible when you shoot movies.

To shift to Live View mode, press the LV button. You hear a clicking sound as the internal mirror that normally sends the image from the lens to the viewfinder flips up. The viewfinder goes dark, and the scene in front of the lens appears on the monitor. To exit Live View mode, press the LV button again.

Here are a few pointers about using Live View mode:

- Press the Info button (on top of the camera) to change the type of data displayed on the monitor. You can choose from the displays shown in Figure 1-14:
 - Show Photo Indicators: Reveals extensive shooting data for still photography. The camera uses this display mode by default.

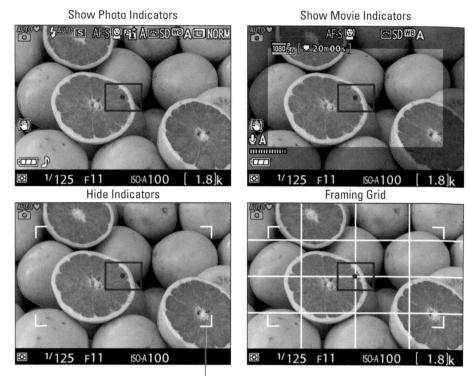

FIGURE 1-14: Press the Info button to change the Live View display data.

- Show Movie Indicators: Displays data related to movie recording, as shown in the upper-right screen in Figure 1-14. At some recording settings, including the default movie resolution and frame rate, a *crop frame* (gray borders) appears to show you how much of the screen area will be included in the movie. I discuss movie settings in Chapter 8.
- *Hide Indicators:* Displays only the basic shooting data shown in the lowerleft example in Figure 1-14. The gray movie-crop frame is replaced by four corner markings; I labeled one of them in the figure.
- Framing Grid: Adds a grid and the movie-crop framing marks.
- >> Cover the viewfinder to prevent light from seeping into the camera and affecting exposure. You can cover the viewfinder with your hand or a small piece of paper or you can invest in an official Nikon eyepiece cover, which has the part number DK-5 and sells for under \$5. This same practice is suggested for self-timer photography or other occasions in which your eye won't be on the viewfinder when you take the shot.
- The monitor turns off by default after 10 minutes of inactivity. When monitor shutdown is 30 seconds away, a countdown timer appears in the

Movie crop marks

upper-left corner of the screen. You can adjust the shutdown timing via the Auto Off Timers option on the Setup menu; Chapter 12 has details.

>> Using Live View for an extended period can harm your pictures and the camera. In Live View mode, the camera heats up more than usual, which can create the proper electronic conditions for *noise*, a defect that gives your pictures a speckled look. Perhaps more importantly, the increased temperatures can damage the camera. For that reason, Live View is automatically disabled if the camera detects a critical heat level. In extremely warm environments, you may not be able to use Live View mode for long before the system shuts down.

When the camera is 30 seconds or fewer from shutting down, the countdown timer appears to let you know how many seconds remain for shooting. The warning doesn't appear during picture playback or when menus are active, however.

- Aiming the lens at the sun or another bright light also can damage the camera. Of course, you can cause problems by doing this even during viewfinder shooting, but the possibilities increase when you use Live View. You can harm not only the camera's internal components but also the monitor (not to mention your eyes).
- Some lights may interfere with the Live View display. The operating frequency of some types of lights, including fluorescent and mercury-vapor lamps, can create electronic interference that causes the monitor display to flicker or exhibit odd color banding. Changing the Flicker Reduction option on the Setup menu may resolve this issue. At the default setting, Auto, the camera gauges the light and chooses the right setting for you. But you also can choose from two specific frequencies: 50 Hz and 60 Hz. (In the United States and Canada, the standard frequency is 60 Hz; in Europe, it's 50 Hz.)

Viewing critical picture settings

Your D3400 gives you the following ways to monitor the most important picturetaking settings:

- Information screen (viewfinder photography): The left screen in Figure 1-15 gives you a look at the Information screen available for viewfinder photography. The screen appears when you first turn on the camera and then disappears after a few seconds. To redisplay it, take any of these steps:
- info
- *Press the Info button.* Press once to display the screen; press again to turn off the monitor.

 Press the shutter button halfway and release it. Pressing and holding the button halfway down turns off the screen and fires up the autofocusing and exposure metering systems. Because those two systems use battery power, avoid this technique when the battery is running low.

In this book, I explain the display as it works by default. But you can modify its behavior via the Setup menu; look for details in Chapter 12. Note that by default, the screen background is light gray, as in Figure 1-15, which you shoot in any exposure mode except P, S, A, or M. In those advanced exposure modes, the background is dark gray, as shown in many figures later in the book.

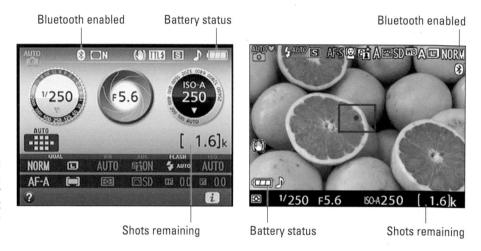

FIGURE 1-15: Press the Info button to view picture-taking settings on the monitor.

- >> Live View display: When you press the LV button to switch to Live View mode, the shooting data appears atop the live preview. (Refer to the right side of Figure 1-15.) You can vary the type of data displayed by pressing the Info button; Figure 1-15 shows the default display style.
- Viewfinder: You also can view some settings at the bottom of the viewfinder, as shown in Figure 1-16. The information that appears depends on the exposure mode.

FIGURE 1-16: Picture settings also appear at the bottom of the viewfinder. If what you see in Figures 1-15 and 1-16 looks like a confusing mess, don't worry. Many settings relate to options that won't mean anything to you until you explore later chapters. But make note of the following bits of data that are helpful from the get-go:

Battery status indicator: A full-battery icon (refer to Figure 1-15) shows that the battery is fully charged; if the icon appears empty, look for your battery charger.

Just for good measure, the camera also displays a low-battery symbol in the viewfinder, as shown in Figure 1-16. If the symbol blinks, the camera won't take more pictures until you charge the battery.

Shots remaining: Labeled in Figures 1-15 and 1-16, this value indicates how many more pictures you can store on the memory card. If the number exceeds 999, the initial *K* appears, indicating that the value is in the thousands. For example, 1.6K means that you can store 1,600 more pictures. (*K* is a universally accepted symbol indicating 1,000 units.) The number is rounded down to the nearest hundred. So if the card has room for, say, 1,230 more pictures, the value reads 1.2K.

WHAT DOES [R 04] IN THE DISPLAY MEAN?

TECHNICAL STUFF When you look in your viewfinder to frame a shot, the initial value shown in brackets at the right end of the viewfinder display indicates the number of additional pictures that can fit on your memory card. But as soon as you press the shutter button halfway, which kicks the autofocus and exposure mechanisms into action, that value changes to instead show you how many pictures can fit in the camera's *memory buffer*. For example, [r 04] value tells you that four pictures can fit in the buffer.

So what's the *buffer*? It's a temporary storage tank where the camera stores picture data until it has time to fully record that data onto the camera memory card. This system exists so that you can take a continuous series of pictures without waiting between shots until each image is fully written to the memory card.

When the buffer is full, the camera automatically disables the shutter button until it catches up on its recording work. Chances are, though, that you'll rarely, if ever, encounter this situation; the camera is usually more than capable of keeping up with your shooting rate.

For more information about rapid-fire photography, see the section on action photography in Chapter 7. Bluetooth symbol: By default, the camera's Bluetooth feature, which enables you transfer photos wirelessly to certain smartphones and other devices, is disabled. When you do turn on the feature, you see the symbol labeled in Figure 1-15.

Adjusting settings via the control strip

Found on the lower-left corner of the camera back, the *i* button activates a control strip that gives you quick access to some critical shooting settings. Here's how to use the control strip for viewfinder photography:

- 1. Make sure that the camera is in any shooting mode except Guide.
- 2. Display the Information screen, shown on the left in Figure 1-15.

If the camera is in playback mode or you're viewing a menu screen, press and release the shutter button halfway to display the Information screen. You also may need to take this step if the camera has "gone to sleep," turning off the monitor automatically to save battery power. You also can press the Info button on top of the camera to turn the screen on and off.

3. Press the *i* button.

The top part of the display dims, and you see the *control strip* — the two rows of settings at the bottom of the screen — as shown on the left in Figure 1-17. The currently selected setting appears highlighted, and its name is displayed above the control strip. For example, in the left screen in Figure 1-17, the Image Size option is selected. Options that are dimmed in the control strip aren't available in the current exposure mode (Auto, P, Effects, and so on).

FIGURE 1-17: Press the *i* button to activate the control strip (left); highlight the option you want to adjust and press OK to display the available settings (right).

AUTO	1/10	00 F	(0) II 4.5 !	13 E		Ima
Image size						JPEC
NORM		AUTO	seion	🗲 AUTO	AUTO	
AF-A	()	1	⊡SD	872 O.O	⊠ 0.0	
?					1:5	?

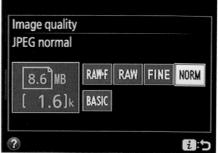

4. Use the Multi Selector to highlight the setting you want to change.

5. Press OK.

A screen displays the available settings for the option, as shown on the right side of Figure 1-17.

6. Use the Multi Selector to highlight the desired option, and press OK.

You're returned to the control strip. You can then adjust another setting, if needed.

7. To exit the control strip, press the *i* button again.

Or just give the shutter button a quick half-press and release it. The Information display returns to its normal appearance.

In Live View mode, the control strip looks and works the same as just described except that the strip overlays the live preview.

Displaying Help Screens

If you see a question mark in the lower-left corner of a menu, as shown in Figure 1-18, press and hold the Zoom Out button — note the question-mark label above the button — to display information about the current menu option. For example, the right screen here shows the Help screen associated with the Lock Mirror Up for Cleaning option on the Setup menu. To scroll the screen, keep the button depressed and press the Multi Selector up and down.

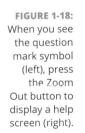

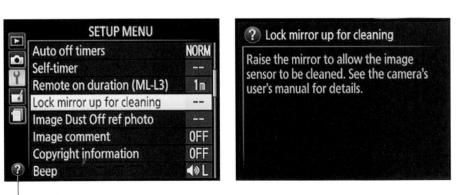

Help symbol

You may spot the question-mark symbol blinking in the lower-left corner of the Information or Live View display; in this case, the camera's alerting you to a potential shooting problem. Again, just press the Zoom Out button to see what solution the camera suggests. When the symbol isn't blinking, pressing the button displays a screen that explains the current exposure mode.

Familiarizing Yourself with the Lens

Because I don't know which lens you're using, I can't give you full instructions on its operation. But the following list provides general information on working with standard AF-P and AF-S lenses. You should explore the lens manual for specifics, of course:

>> Extending/retracting the lens: If you have a retractable lens like the AF-P kit lens, press the Retractable-Lens Barrel button while rotating the lens barrel to extend and retract the lens (see Figure 1-19). The camera won't take a picture with the lens in the retracted position.

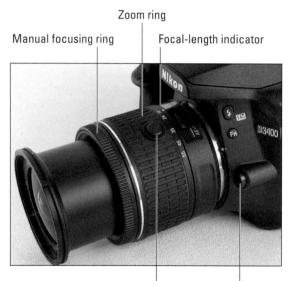

FIGURE 1-19: Here are a few features found on certain AF-P lenses.

Retractable-lens barrel button

Lens-release button

Zooming: If you bought a zoom lens, it has a movable zoom ring. The location of the zoom ring on the kit lens is shown in Figure 1-19. To zoom in or out on this lens, rotate the ring. (Some lenses instead use a push/pull setup, where you push and pull the lens away from you or toward you to zoom.)

You can determine the current focal length of the lens by looking at the number that's aligned with the white dot labeled *focal-length indicator* in Figure 1-19. (If you're new to the term *focal length*, the sidebar "Focal length and the crop factor," elsewhere in this chapter, explains the subject.)

- Setting the focus method (auto or manual): How you switch between autofocusing and manual focusing depends on whether you're using an AF-P lens, like the one featured in this book, or an AF-S lens, which is the other type of lens that works with your camera. Here's the scoop:
 - AF-P lens: Open the Shooting menu and scroll to the second page of the menu. Highlight Focus Mode, as shown on the left in Figure 1-20, and press OK to display the screen shown on the right. Here, you can specify the focus mode separately for viewfinder and Live View shooting. Choose one of those two options and then press the Multi Selector right to reveal the focusing settings shown in Figure 1-21. To switch from automatic to manual focusing, select the MF (Manual Focus) option, as shown in the figure, and press OK.

FIGURE 1-20: With an AF-P lens, you set the focusing method through this Shooting menu option.

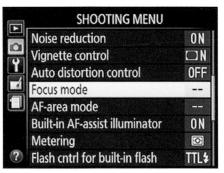

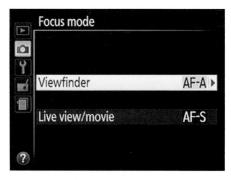

To go back to autofocusing, return to the menu and choose one of the other options. I explain how each autofocusing setting works in Chapter 5; the default settings are AF-A (Autofocus Auto) for viewfinder photography and AF-S (Singleservo autofocus) for Live View and movie photography. Also, whether you have all three viewfinder-autofocusing choices shown in Figure 1-21 depends on

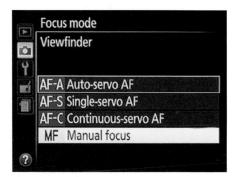

the exposure mode you're using. In Auto mode, for example, you only have access to AF-A.

 AF-S lens: The lenses typically offer an exterior switch for shifting from automatic to manual focusing. Move the switch to the A position for autofocusing and to M for manual focusing. On some lenses, the switches may instead be marked AF and MF; some lenses have a switch position labeled AF/M, which means that you can use autofocusing to set initial focus and then fine-tune focus manually without changing the position of the switch.

Even though you set the basic focus method via the switch, you control the behavior of the autofocusing system via the Focus Mode option on the Shooting menu. Again, visit Chapter 5 for details. *Spoiler alert:* You also can set the Focus mode via the Information display control strip, explained earlier in this chapter.

AF-P lenses also offer the option of autofocusing with manual override. But instead of moving a lens switch to activate or disable the feature, you use the Setup menu option highlighted in Figure 1-22. By default, this option (Manual Focus Ring in AF Mode) is enabled, so you can tweak focus manually after autofocusing. The only potential problem with the feature is that you can accidentally move the focusing ring, changing the focus point without realizing that you did so. I leave it up to you to decide which

	SETUP MENU	
	Flicker reduction	AUTO
•	Buttons	
T	Rangefinder	OFF
	Manual focus ring in AF mode	ON
	File number sequence	OFF
	Storage folder	100
	File naming	DSC
?	HDMI	

FIGURE 1-22:

When this feature is enabled, you can set an AF-P lens to use autofocusing with manual focus override.

setting you prefer. If the menu option is dimmed, your lens doesn't support this feature.

- >> Focusing: With either type of lens, use these techniques to set focus:
 - *Autofocusing:* Frame your shot and press and hold the shutter button halfway down to establish the focusing distance.
 - Manual focusing: Rotate the focusing ring on the lens barrel. The position of the focusing ring varies depending on the lens; I labeled the one found on the AF-P 18-55mm kit lens in Figure 1-19.
- Enabling Vibration Reduction: Many Nikon lenses, including the kit lens, offer Vibration Reduction, which compensates for small amounts of camera

shake that can occur when you handhold the camera. Camera movement during the exposure can produce blurry images, so turning on Vibration Reduction can help you get sharper handheld shots. When you use a tripod, however, turn off the feature so that the camera doesn't try to compensate for movement that isn't occurring.

As with focus method, turning Vibration Reduction on and off is a menu-based affair if you use an AF-P lens. Enable the feature via the Shooting menu, as shown on the left in Figure 1-23; after you do so, you see a shaking hand symbol in the Information screen and Live View displays. I labeled the symbol in the right screen in Figure 1-23. Look for the symbol on the left side of the Live View display.

Vibration Reduction enabled

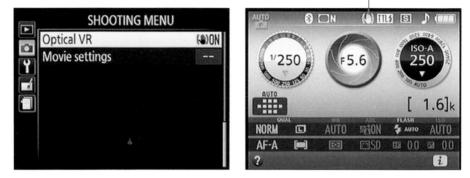

FIGURE 1-23: Some AF-P lenses offer Vibration Reduction.

On an AF-S lens, turn Vibration Reduction on or off by using the VR switch, found near the focusing-method switch. (Refer to Figure 1-22.) The available settings vary depending on the lens, so again, see the lens manual for details.

Vibration Reduction is initiated when you depress the shutter button halfway. If you pay close attention, the image in the viewfinder may appear to be a little blurry immediately after you take the picture. That's a normal result of the Vibration Reduction operation and doesn't indicate a problem with your camera or focus.

>> Removing a lens: After turning off the camera, press the lens-release button on the camera (refer to Figure 1-19) and turn the lens toward that button until it detaches from the lens mount. Put the rear protective cap onto the back of the lens and, if you aren't putting another lens on the camera, cover the lens mount with its cap, too.

Always switch lenses in a clean environment to reduce the risk of getting dust, dirt, and other contaminants inside the camera or lens. Changing lenses on a sandy beach, for example, isn't a good idea. For added safety, point the camera body slightly down when performing this maneuver; doing so helps prevent any flotsam in the air from being drawn into the camera by gravity.

FOCAL LENGTH AND THE CROP FACTOR

The angle of view that a lens can capture is determined by its focal length, or in the case of a zoom lens, the range of focal lengths it offers. Focal length is measured in millimeters.

According to photography tradition, a focal length of 50mm is described as a "normal" lens because it works well for the type of snapshots that users of those kinds of cameras are likely to shoot. A lens with a focal length under 35mm is characterized as a wideangle lens because at that focal length, the camera has a wide angle view, making it good for landscape photography. A short focal length also has the effect of making objects seem smaller and farther away. At the other end of the spectrum, a lens with a focal length longer than 80mm is considered a telephoto lens and is often referred to as a long lens. With a long lens, the angle of view narrows and faraway subjects appear closer and larger, which is ideal for wildlife and sports photographers.

Note, however, that the focal lengths stated here and elsewhere in the book are 35mm equivalent focal lengths. Here's the deal: For reasons that aren't really important, when you put a standard lens on most digital cameras, including the D3400, the available frame area is reduced, as if you took a picture on a camera that uses 35mm film negatives and cropped it.

This crop factor varies depending on the camera, which is why the photo industry adopted the 35mm-equivalent measuring stick as a standard. With the D3400, the crop factor is roughly 1.5x. In the figure here, the red line indicates the image area that results from the 1.5 crop factor.

When shopping for a lens, it's important to remember this crop factor to make sure that you get the focal length designed for the type of pictures you want to take. Just multiply the lens focal length by 1.5 to determine the actual angle of view. Not sure which focal length to choose? Nikon offers a Lens Simulator tool that shows exactly how different focal length lenses capture the same scene. Point your web browser to this address: http://imaging.nikon.com/lineup/lens/simulator/. (If the link doesn't take you to the simulator, just enter the term Nikon Lens Simulator in your browser's search engine. Nikon has a way of moving things around on its websites, which can render the addresses I give you invalid after publication.)

Working with Memory Cards

As the medium that stores your picture files, the memory card is a critical component of your camera. See the steps at the start of this chapter for help installing a card; follow these tips for buying and maintaining cards:

Buying SD cards: Again, you can use regular SD cards, which offer less than 4GB of storage space; SDHC cards (4GB–32GB); and SDXC cards (more than 32GB). Aside from card capacity, the other specification to note is SD speed class, which indicates how quickly data can be moved to and from the card (the read/write speed).

Card speed is indicated in several ways. The most common spec is called SD Speed Class, which rates cards with a number between 2 and 10, with 10 being the fastest. Most cards also carry another designation, UHS-1, -2, or 3; UHS (Ultra High Speed) refers to a new technology designed to boost data transmission speeds above the normal Speed Class 10 rate. The number 1, 2, or 3 inside a little U symbol tells you the UHS rating; UHS-3 is fastest.

Some SD cards also are rated in terms of how they perform when used to record video — specifically, how many frames per second the card can handle. As with the traditional Speed Class rating and UHS rating, a higher video-speed number indicates a faster card.

Formatting a card: The first time you use a new memory card or insert a card that's been used in other devices, you need to *format* it to prepare it to record your pictures. You also need to format the card if you see the blinking letters *FOR* in the viewfinder or if the monitor displays a message requesting formatting.

Formatting erases everything on your memory card. So before you format a card, be sure that you've copied any data on it to your computer. After doing so, get the formatting job done by selecting Format Memory Card from the Setup menu.

Removing a card: After making sure that the memory card access light is off, indicating that the camera has finished recording your most recent photo, turn off the camera. Open the memory card door, push down on the card slightly, and then let go. The card pops halfway out of the slot, enabling you to grab it by the tail and remove it.

If you turn on the camera when no card is installed, the symbol [-E-] blinks in the lower-right corner of the viewfinder. A message on the monitor also nudges you to insert a memory card. If you have a card in the camera and you get these messages, try taking out the card and reinserting it.

- Handling cards: Don't touch the gold contacts on the back of the card. (See the right card in Figure 1-24.) When cards aren't in use, store them in the protective cases they came in or in a memory card wallet. Keep cards away from extreme heat and cold as well.
- Locking cards: The tiny switch on the side of the card, labeled Lock switch in Figure 1-24, enables you to lock your card, which prevents any data from being erased or recorded to the card. If you insert a locked card into the camera, a message on the monitor alerts

Don't touch!

FIGURE 1-24: Avoid touching the gold contacts on the card.

you, and the symbol Cd blinks in the viewfinder.

You can protect individual images from accidental erasure by using the camera's Protect feature, which I cover in Chapter 10. Note, though, that formatting the card *does* erase even protected pictures; the safety feature prevents erasure only when you use the camera's Delete function.

>> Using Eye-Fi memory cards: Your camera works with *Eye-Fi memory cards*, which are special cards that enable you to transmit your files wirelessly to your computer and other devices. That's a cool feature, but, unfortunately, the cards themselves are more expensive than regular cards and require some configuring that I don't have room to cover in this book. For more details, visit www.eye.fi.

If vou do use Eve-Fi cards, enable and disable wireless transmission via the Eve-Fi Upload option on the Setup menu. When no Eve-Fi card is installed in the camera, this menu option disappears.

Taking a Few Final Setup Steps

Your camera offers scads of options for customizing its performance. Later chapters explain settings related to actual picture taking, such as those that affect flash behavior and autofocusing. But there are a few options that I suggest you consider from the get-go; all are found on the Setup menu and described in the following list. (Note: To access this menu and other normal menus, set the Mode dial to any setting except Guide and then press the Menu button.) The Setup menu is a multipage affair; use the Multi Selector to scroll the display to see all the menu options.

>> Date Stamp: Using this option, highlighted in Figure 1-25, you can imprint on the photo the shooting date, the date and time, or the number of days between the day you took the picture and another date that you specify. This feature doesn't work if you set the Image Ouality option to NEF (Raw) or NEF (Raw) + JPEG. See Chapter 2 for details about the Image Quality setting.

The default setting, Off, is the way mar your photos to find out when

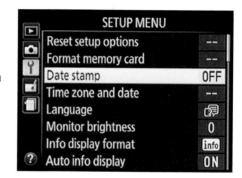

FIGURE 1-25: Basic camera operations are controlled through the Setup menu.

you took them. Every picture file includes a hidden vat of text data, or metadata, that records the shooting date and time as well as all the camera settings you used. You can view this data during playback and, after downloading, in the free software provided with your camera as well as in many photo programs.

- >> Monitor Brightness: This option enables you to make the display brighter or darker. But if you take this step, what you see on the monitor may not be an accurate rendition of the picture exposure. I recommend that you keep the brightness at the default setting (0).
- >> Lock Mirror Up for Cleaning: Scroll to the second page of the Setup menu to find this option and the ones discussed in the next two bullet points. The Lock Mirror Up for Cleaning is, as its name implies, used for cleaning the camera's image sensor. (You have to move the mirror out of the way of the sensor to

do the cleaning.) I don't recommend that you tackle this operation yourself because you can easily damage the camera if you don't know what you're doing. And if you've previously used mirror lock-up on an SLR camera to avoid camera shake when shooting long-exposure images, note that as the menu name implies, this camera's mirror lock-up is provided for cleaning purposes only. You can't take pictures on the D3400 while mirror lock-up is enabled.

- >> Image Dust Off Ref Photo: Dust that gets inside the camera can cause spots to appear on your photos. The best cure is to take your camera to a repair shop for sensor cleaning, but until you have time, this feature may come in handy. In a nutshell, you follow the on-camera instructions to take a reference photo that records the location of the dust spots. That reference data is included in any new pictures you shoot in the NEF (RAW) format. Then, if you process the Raw photos using Nikon Capture NX-D, as I describe in Chapter 10, you can run a dust-busting filter that refers to the reference data and tries to eradicate or at least diminish the flaws created by the dust. (The specific Raw-processing feature is named Image Dust Off and is found with other camera and lens-correction tools.) For information about the NEF (RAW) format, which you select via the Image Quality setting, see Chapter 2.
- Beep: By default, your camera beeps after certain operations, such as after it sets focus when you shoot in autofocus mode. You can adjust the beep volume or disable the beep through this menu option. In the Information display and default Live View display, a musical note icon appears when the beep is enabled. Turn off the beep, and the icon appears in a circle with a slash through it.
- File Number Sequence: This option, found on the third page of the Setup menu and shown in Figure 1-26, controls how the camera names your picture files. When the option is set to Off, as it is by default, the camera restarts file numbering at 0001 every time you format the memory card or insert a new memory card. Numbering is also restarted if a new imagestorage folder is created, a topic you can explore in Chapter 12.

SETUP MENU Flicker reduction AUTO **Buttons** ---**OFF** Rangefinder . Manual focus ring in AF mode ON ON File number sequence 203 Storage folder File naming DSC ? HDMI _

FIGURE 1-26:

Danger, Will Robinson! Change the File Number Sequence option to On to avoid winding up with multiple pictures that have the same filename.

This setup can create a scenario where you wind up with multiple images that have the same

filename — not on the current memory card, but when you download images to your computer. So set the option to On. Note that when you get to picture number 9999, file numbering is still reset to 0001, however. The camera then automatically creates a new folder to hold your next 9,999 images.

As for the Reset option, it enables you to assign the first file number (which ends in 0001) to the next picture you shoot. Then the camera behaves as if you selected the On setting.

Should you be a really, *really* prolific shooter and snap enough pictures to reach image 9999 in folder 999, the camera will refuse to take another photo until you choose that Reset option and either format the memory card or insert a brand-new one.

Airplane Mode: Your D3400 enables you to use Bluetooth, a wireless connection technology, to upload low-resolution copies of photos to a smartphone or tablet so that you can easily share pictures online. You also can use your smart device to remotely trigger the camera's shutter release.

When Airplane Mode is set to Off, as shown in Figure 1-27, the camera broadcasts a Bluetooth signal at all times. If you're traveling on a plane that doesn't allow Bluetooth transmissions or otherwise need to disable the feature, set this option to On.

Turning on Airplane mode also shuts down the wireless transmission feature used by Eye-Fi memory cards.

- Conformity Marking: I bring this one up just so that you know you can ignore it: When you select the option, you see logos indicating that the camera conforms with certain camera-industry standards. I know you'll sleep better at night with that information.
- Slot Empty Release Lock: This feature determines whether the camera lets you take a picture when

FIGURE 1-27:

In Airplane Mode, the camera turns off the wireless signal used to connect the camera to a smartphone or tablet and also disables wireless transmission from Eye-Fi memory cards.

no memory card is installed. If you select Enable Release, you can take a temporary picture, which appears in the monitor with the word *Demo* but isn't recorded anywhere. The feature is provided mainly for use in camera stores, enabling salespeople to demonstrate the camera without having to keep a memory card installed. I can think of no good reason why anyone else would change the setting from the default, Release Locked.

Firmware Version: Select this option and press OK to view which version of the camera *firmware*, or internal software, your camera runs. You see the firmware items LD and LF. At the time this book was written, C was version 1.10; LD was 2.015; and LF was 1.00. (Which firmware items you see depends in part on which lens is attached to the camera.)

WHAT ABOUT BLUETOOTH AND **SNAPBRIDGE?**

Your D3400 enables you to use Bluetooth, a wireless connection technology, to upload low-resolution copies of photos to a smartphone or tablet so that you can easily share pictures online.

In order to take advantage of these features, you must download and install the free Nikon SnapBridge app, which currently is available for devices that run certain versions of the Android and Apple iOS operating systems. I opted to cover SnapBridge functions in the appendix so that if you don't own a device compatible with the app, you don't have to wade through sections related to it as you explore the rest of the chapters.

Keeping your camera firmware up to date is important, so visit the Nikon website (www.nikon.com) regularly to find out whether your camera sports the latest version. You can find detailed instructions at the site on how to download and install any firmware updates.

Restoring Default Settings

You can quickly reset all the options on the Shooting menu by selecting Reset Shooting Menu, as shown on the left in Figure 1-28. Likewise, the Setup menu also has a Reset Setup Options item to restore all settings on that menu, as shown on the right.

FIGURE 1-28: Choose the Reset option to return to the default settings for the respective menu.

For a more drastic camera reset, scroll to the last page of the Setup menu, where you find the Reset All Settings option, shown in Figure 1-29. Choosing this option restores everything except the Language, Time Zone and Date, and Guide mode settings to their factory default.

A few potential flies in the ointment:

>> Resetting the Shooting menu defaults wipes out any customizations you made to a Picture Control setting — for example, if you

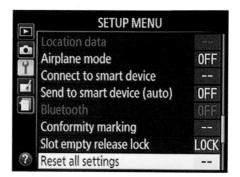

FIGURE 1-29:

Choose this Setup menu option to restore all but a couple camera options to their factorydefault settings.

tweaked the Vivid setting to produce even more saturated colors than it does by default. Chapter 6 talks more about this feature.

Additionally, a Shooting menu reset restores the default settings of a couple options not on the menu, including the Release mode, Exposure Compensation, Flash Compensation, Flash mode, and selected focus point. Finally, the AE-L/AF-L button returns to its normal operation as well. (Chapter 12 explains how to modify the button operation.)

- >> More worrisome is that resetting the Setup menu or choosing Reset All Settings restores the File Number Sequence option to its default, Off, which is most definitely Not a Good Thing. So if you restore the defaults, be sure that you revisit that option and return it to the On setting. See the preceding section for details.
 - >> Choosing Reset Setup Options does not affect the Time Zone and Date, Language, or Storage Folder options. So you need to adjust those settings individually if necessary.

- » Selecting an exposure mode
- » Changing the shutter-release mode
- » Choosing the right Image Size (resolution) setting
- » Understanding the Image Quality setting: JPEG or Raw?
- » Adding flash

Chapter 2 Reviewing Five Essential Picture-Taking Options

very camera manufacturer strives to ensure that your initial encounter with the camera is a happy one. To that end, the D3400's default settings are designed to make it easy to take a good picture the first time you press the shutter button. The camera is set to the Auto exposure mode, which means that all you need to do is frame, focus, and shoot.

Although the default settings deliver acceptable pictures in many cases, they don't produce optimal results in every situation. You may be able to take a decent portrait in Auto mode, for example, but by tweaking a few settings, you can turn that decent portrait into a stunning one.

This chapter helps you start fine-tuning the camera settings by explaining five basic picture-taking options: exposure mode, shutter-release mode, image size, image quality, and flash. They're not the most exciting features (don't think I didn't notice you stifling a yawn), but they make a big difference in how easily you can capture the photo you have in mind. You should review these settings before each photo outing.

Choosing an Exposure Mode

The first setting to consider is the exposure mode, which you select via the Mode dial, shown in Figure 2-1. Your choice determines how much control you have over two critical exposure settings — aperture and shutter speed — as well as many other options, including those related to color settings and flash photography.

The next few sections introduce you to your choices.

Fully automatic exposure modes

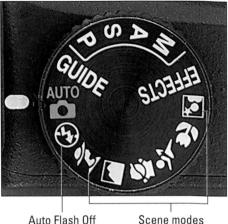

The Mode dial determines how much input you have over exposure, color, and other picture

Auto Flash Off

FIGURE 2-1:

options.

For point-and-shoot simplicity, choose from these modes:

- >> Auto and Auto Flash Off: The camera analyzes the scene and selects what it considers the most appropriate settings to capture the image. The only difference between the two modes is that Auto Flash Off disables flash; in Auto mode, you can choose from several Flash modes, which I detail later in this chapter.
- >> Scene modes: You also get six automatic modes designed to capture specific subjects in ways deemed best according to photography tradition. For example, in Portrait mode, skin tones are manipulated to appear warmer and softer, and the background appears blurry to bring attention to your subject. In Landscape mode, greens and blues are intensified, and the camera tries to maintain sharpness in both near and distant objects. Flash options vary depending on the Scene mode.

Because these modes are designed to make picture-taking simple, they prevent you from accessing many camera features. You can control the settings covered in this chapter and also adjust certain aspects of the camera's autofocusing behavior (Chapter 5 tells you how), but that's about it. Options that are off-limits appear dimmed on the menus and the Information and Live View displays. If you press a button that leads to an advanced setting, the monitor displays a message telling you that the option is unavailable.

That said, these modes enable you to take great pictures until you're ready to step up to the advanced modes. Chapter 3 shows you how to get the best results when you rely on the auto modes.

Semiautomatic modes (P, S, and A)

To take more creative control but still get some exposure assistance from the camera, choose one of these exposure modes, which I cover in Chapter 4:

- >> P (programmed autoexposure): The camera selects the aperture and shutter speed necessary to ensure a good exposure. But you can rotate the Command dial to choose from different combinations of the two to vary the creative results. For example, shutter speed determines whether moving objects appear blurry or sharp. So you might use a fast shutter speed, which freezes action, or you might go in the other direction, choosing a shutter speed slow enough to blur the moving subject, which can create a heightened sense of motion.
- S (shutter-priority autoexposure): You rotate the Command dial to select the shutter speed, and the camera selects the aperture setting that properly exposes the image. This mode is ideal for capturing moving subjects because it gives you direct control over the shutter speed.
- A (aperture-priority autoexposure): In this mode, you rotate the Command dial to choose the aperture, and the camera chooses a shutter speed to properly expose the image. Because aperture affects depth of field (the distance over which objects in a scene remain acceptably sharp), this setting works well for portraits because you can select an aperture that results in a soft, blurry background, putting the emphasis on your subject. For landscape shots, on the other hand, you might choose an aperture that keeps the entire scene sharply focused so that both near and distant objects have equal visual weight.

These modes give you access to all camera features. So even if you're not ready to explore aperture and shutter speed, go ahead and set the Mode dial to P if you need to access a setting that's off-limits in the fully automated modes. The camera then operates pretty much as it does in Auto mode but doesn't limit you to the most basic picture-taking settings.

Manual exposure mode (M)

In manual mode, you take the exposure reins completely, selecting both aperture and shutter speed as follows:

>> To set the shutter speed: Rotate the Command dial.

To set the aperture: Press the Exposure Compensation button while rotating the Command dial.

Even in this mode, the camera offers an assist by displaying an exposure meter to help you dial in the right settings. (See Chapter 4 for details.) You have complete control over all other picture settings, too.

One important and often misunderstood aspect of manual exposure mode: Setting the Mode dial to M has no bearing on focusing. You can still choose manual focusing or autofocusing, assuming that your lens offers autofocusing. Remember that with an AF-P lens, you set the focusing method via the Focus Mode option on the Shooting menu. AF-S lenses typically have an exterior switch for setting the focusing method.

Specialty modes (Effects and Guide modes)

Your camera also offers two special-purpose exposure modes:

Effects: As its name implies, this mode provides access to settings that apply special effects to still photos or movies as you record them. For example, the Night Vision effect creates a black-and-white photo or movie that has a grainy appearance, as if you were viewing the subject through night-vision goggles. After you set the Mode dial to Effects, rotate the Command dial to cycle through the various effects.

Alternatively, you can apply some special effects to a photo after you shoot it. I explain both methods in Chapter 11.

Solution: Rotate the dial to this setting to access the guided-menu feature, which provides step-by-step instructions for taking pictures, setting up the camera, retouching images, and viewing photos and movies. Because this mode is, after all, a self-guided mode, I don't use up much page space in this book explaining how to use it. You can get a general introduction to it in Chapter 1, however.

Setting the Release Mode

By using the Release mode setting, you set the camera whether to capture a single image each time you press the shutter button (Single Frame mode); to record a burst of photos as long as you hold down the shutter button (Continuous mode); or to delay the image capture until a few seconds after you press the shutter but-ton (Self-Timer mode). You also get Quiet Shutter mode, which dampens the normal shutter-release sounds, and two options related to shooting with the Nikon ML-L3 wireless remote control.

Why *Release mode*? It's short for *shutter-release mode*. Pressing the shutter button tells the camera to release the *shutter* — an internal light-control mechanism — so that light can strike the image sensor and expose the image. Your choice of Release mode determines when and how that action occurs.

On the Information screen and Live View display, the current Release mode is indicated by the icons labeled in Figure 2–2. In the figures, the S symbol represents the Single Frame release mode. (See the next several sections for a look at other icons.) Note that the Live View screen in the figure shows the default data-display mode; if your screen shows a different assortment of data, press the Info button to cycle through the available display modes.

FIGURE 2-2: This S represents the Single Frame Release mode, which produces one picture for each press of the shutter button.

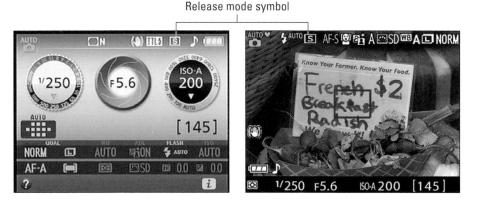

اً ()

To adjust the Release mode setting, press the Release mode button, labeled in Figure 2–3, to display the selection screen shown in the figure. The figure shows the screen as it appears during normal viewfinder photography; in Live View mode, the screen appears superimposed over the live display. Either way, use the Multi Selector to select a setting and then press OK.

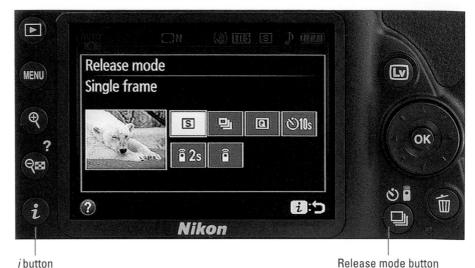

FIGURE 2-3: The Release Mode button offers the fastest access to the setting.

Notice the symbols at the bottom of the screen shown on the monitor in Figure 2–3? Symbols at the bottom of settings screens such as this one represent buttons you can press to perform certain actions. For example, the *i* symbol with the return arrow (refer to the lower-right corner of the display in Figure 2–3) indicates that you can press the camera's *i* button (labeled in the figure) to exit the settings screen. Similarly, the question-mark symbol displayed in the lower-left corner of the Release mode screen tells you that if you press the camera button marked with a question mark (the button just above the *i* button), you can display a screen that offers a bit of information about the setting you're adjusting.

With those basics out of the way, the next few sections explain how each Release mode works.

Single Frame and Quiet Shutter Release modes

Single Frame Release mode captures one picture each time you press the shutter button. It's the default setting for all exposure modes except the Sports Scene mode.

Quiet Shutter mode works just like Single Frame mode but makes less noise as it goes about its business. First, the camera disables the beep that it emits by default when it achieves focus. (You can turn off the beep for other Release modes via the Beep option on the Setup menu.) Additionally, Quiet Shutter mode affects the operation of the internal mirror that causes the scene coming through the lens to be visible in the viewfinder. Normally, the mirror flips up when you press the shutter button and then flips back down after the shutter opens and closes. This mirror movement makes some noise. In Quiet Shutter mode, you can temporarily prevent the mirror from flipping back down by keeping the shutter button fully pressed after the shot. This way, you can delay the sound made by the final mirror movement to a moment when the noise won't be objectionable.

Continuous (burst mode) shooting

Sometimes known as *burst mode*, Continuous mode records a continuous series of pictures as long as you hold down the shutter button, making it easier to capture action. On the D3400, you can capture up to five frames per second.

A few critical details:

- >> Enabling flash disables continuous shooting. Flash isn't compatible with burst mode photography because the time that the flash needs to recycle between shots slows down the capture rate too much. If flash is enabled, the camera operates as if you were using Single Frame mode.
- >> Images are stored temporarily in the memory buffer. The camera has a little bit of internal memory a *buffer* where it stores picture data until it has time to record them to the memory card. The number of pictures the buffer can hold depends on certain camera settings, such as resolution and file type (JPEG or Raw). When you press the shutter button halfway, the shots-remaining value in the lower-right corner of the viewfinder changes to display an *r*. For example, *r24* means that 24 frames will fit in the buffer.

After shooting a burst of images, wait for the memory-card access light on the back of the camera to go out before turning off the camera. That's your signal that the camera has successfully moved all data from the buffer to the memory card. Turning off the camera before that happens may corrupt the image files.

Your mileage may vary. The number of frames per second depends on several factors, including focusing method and shutter speed. To achieve the highest rate, Nikon suggests that you use manual focusing and a shutter speed of 1/250 second or faster. Additionally, although you can capture as many as 100 frames in a single burst, the frame rate can drop if the buffer gets full or when the battery power is low.

Self-timer shooting

10s

You're no doubt familiar with Self-Timer mode, which delays the shutter release for a few seconds after you press the shutter button, giving you time to dash into the picture. Here's how it works on the D3400: After you press the shutter button, the AF-assist lamp on the front of the camera starts to blink, and the camera emits a series of beeps (assuming that you didn't disable its voice via the Beep option on the Setup menu). A few seconds later, the camera captures the image.

By default, the camera waits 10 seconds after you press the shutter button and then records a single image. But you can tweak the delay time and capture as many as nine shots at a time. Set your preferences by using the Self-Timer option, found on the Setup menu and shown in Figure 2-4. Here's what you need to know about the two settings:

FIGURE 2-4: You can adjust the self-timer capture delay and the number of frames taken with each press of the shutter button.

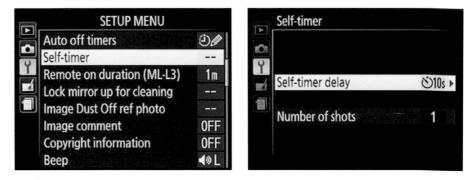

- Self-Timer Delay: Choose a delay time of 2, 5, 10, or 20 seconds. The selected delay time appears with the Self-Timer symbol in the Information and Live View displays. (Refer to Figure 2-3 for help locating the symbol in the displays.)
- >> Number of Shots: Specify how many frames you want to capture with each press of the shutter button; the maximum is nine. When you record multiple frames, shots are taken at 4-second intervals.

Two more points about self-timer shooting:

- After the specified number of shots are captured, the camera resets the Release mode to Single Frame, Quiet, or Continuous. Turning off the camera also resets the Release mode. Either way, the camera selects the Release mode you used before Self-Timer mode.
- Cover the viewfinder during self-timer shooting. Otherwise, light may seep into the camera through the viewfinder and affect exposure. Your can buy a

cover designed for your camera for under \$5; the Nikon part you need is DK-5. To use it, remove the rubber eyepiece that surrounds the viewfinder and then insert the cover in its place. As an alternative, you can just cover the viewfinder with a piece of cloth or card stock — even hanging the camera strap over the viewfinder can work if you're using a tripod.

Wireless remote control modes

Two Release mode settings relate specifically to the Nikon ML-L3 wireless remote control unit and work as follows:

>> Delayed Remote: After you press the shutter-release button on the remote unit, the AF-assist lamp blinks for about 2 seconds, and then the camera takes the picture.

Quick Response Remote: The image is captured immediately. In this mode, the AF-assist lamp blinks after the shot is taken.

When using the wireless remote, aim the transmitter at the remote-control sensor located on the front of the camera, labeled in Figure 2-5.

Normally, the camera cancels out of the remote control modes if it doesn't receive a signal from the remote after about 1 minute. But for viewfinder photography, you can adjust this timing by using the Remote On Duration option, located on the Setup menu. The maximum delay time is 15 minutes; keep in mind that a shorter delay time saves battery life. After the delay time expires, the camera resets itself to either Single Frame, Quiet Shutter, or Continuous mode, depending on which mode you last used. The Release mode is also reset to one of those modes if you turn off the camera.

Wireless remote-control sensor

FIGURE 2-5: Aim the remote transmitter at this sensor.

As with self-timer shooting, it's a good idea to cover the viewfinder when you're using these modes, to prevent exposure problems that can be caused by light entering the camera through the viewfinder.

These Release modes are not meant to be used with a wired remote control. Select one of the other Release mode settings, and then press the shutter-release button on the remote to trigger the shutter. Wired or wireless, see your remote's operating guide for more details on using the unit.

Checking Image Size and Image Quality

Your preflight camera check should also include a look at the Image Size and Image Quality settings. The first option sets picture resolution; the second, file type.

The names of these settings are a little misleading, though, because the Image Size setting also contributes to picture quality, and the Image Quality setting affects the file size of the picture. Because the two work in tandem to determine quality and size, it's important to consider them together. The next few sections explain each option; following that, I offer a few final tips and show you how to select the settings you want to use.

Also check out the section related to ISO in Chapter 4; very high ISO settings can also reduce image quality. In this case, a defect known as *noise* can give the picture a speckled appearance.

Considering the Image Size setting (resolution)

The Image Size setting determines how many pixels are used to create your photo. *Pixels* are the square tiles from which digital images are made; you can see some pixels close up in the right image in Figure 2–6, which shows a greatly magnified view of the eye area in the left image.

STUF

Pixel is short for picture element.

The number of pixels in an image is referred to as *resolution*. You can define resolution in terms of either the *pixel dimensions* — the number of horizontal pixels and vertical pixels — or total resolution, which you get by multiplying those two values. This number is usually stated in *megapixels* (or MP, for short), with one megapixel equal to 1 million pixels.

FIGURE 2-6: Pixels are the building blocks of digital photos.

Your camera offers three Image Size options: Large, Medium, and Small. Table 2–1 lists the resolution values for each setting. The first pair of numbers shown for each setting indicate the pixel dimensions; the second value, the approximate total megapixel (MP) count.

TABLE 2-1

Image Size (Resolution) Options

Setting	Resolution
Large	6000 x 4000 (24.0 MP)
Medium	4496 x 3000 (13.5 MP)
Small	2992 x 2000 (6.0 MP)

However, if you set the Image Quality setting to either Raw (NEF) or Raw+JPEG Fine, which captures one image in the Raw format and one in the JPEG format, images are captured at the Large setting. You can vary the resolution only for pictures taken in the JPEG format. The upcoming section "Understanding Image Quality options (JPEG or Raw)" explains file formats.

To choose the right Image Size setting, you need to understand the three ways that resolution affects your pictures:

>> Print size: Pixel count determines the size at which you can produce a high-quality print. When an image contains too few pixels, details appear muddy, and curved and diagonal lines appear jagged. Such pictures are said to exhibit *pixelation*.

Depending on your photo printer, you typically need anywhere from 200 to 300 pixels per linear inch, or *ppi*, for good print quality. To produce an 8 x 10 print at 200 ppi, for example, you need a pixel count of 1600 x 2000, or about 3.2 megapixels.

Even though many photo-editing programs enable you to add pixels to an existing image — known as *upsampling* — doing so doesn't enable you to successfully enlarge your photo. In fact, upsampling typically makes matters worse.

To give you a better idea of the impact of resolution on print quality, Figures 2-7, 2-8, and 2-9 show you the same image at 300 ppi, at 50 ppi, and then resampled from 50 ppi to 300 ppi (respectively). As you can see, there's no way around the rule: If you want quality prints, you need the right pixel count from the get-go.

300 ppi

FIGURE 2-7: A high-quality print depends on a highresolution original.

50 ppi

FIGURE 2-8: At 50 ppi, the image has a jagged, pixelated look.

50 ppi resampled to 300 ppi

FIGURE 2-9: Adding pixels in a photo editor doesn't rescue a lowresolution original.

- Screen display size: Resolution doesn't affect the quality of images viewed on a monitor or television or another screen device the way it does for printed photos. Instead, resolution determines the *size* at which the image appears. This issue is one of the most misunderstood aspects of digital photography, so I explain it thoroughly in Chapter 10. For now, just know that you need *way* fewer pixels for onscreen photos than you do for prints. In fact, even the Small resolution setting creates a picture too big to be viewed in its entirety in many e-mail programs.
- File size: Every pixel increases the amount of data required to create the picture file. So a higher-resolution image has a larger file size than a low-resolution image.

Large files present several problems:

- You fill up camera memory cards faster. And, after you download images, they consume more space on whatever digital storage closet you set up, whether it's on a computer hard drive or an online storage site (*cloud storage*). If you want to burn copies of your images to DVD, you need to invest in a lot of blank DVDs, given that a standard DVD disc can hold just 4.7GB of data.
- The camera needs more time to process and store the image data on the memory card after you press the shutter button. This extra time can hamper fast-action shooting.
- When you share photos online, larger files take longer to upload and download.
- When you edit photos in your photo software, your computer needs more resources and time to process large files.

As you can see, resolution is a bit of a sticky wicket. What if you aren't sure how large you want to print your images? What if you want to print your photos *and* share them online? I take the better-safe-than-sorry route, which leads to the following recommendations:

- >> Always shoot at a resolution suitable for print. You then can create a low-resolution copy of the image for use online. In fact, your camera offers a built-in resizing option that I cover in Chapter 10.
- >> For everyday images, Medium is a good choice. I find Large to be overkill for casual shooting, creating huge files for no good reason. Keep in mind that even at the Small setting, the pixel count (2992 x 2000) gives you enough resolution to produce an 8 x 10-inch print at 200 ppi.
- >> Choose Large for an image that you plan to crop or print very large, or both. The benefit of maximum resolution is that you have the flexibility to crop your photo and still generate a decently sized print of the remaining image. Figure 2-10 offers an example. When I was shooting this photograph, I couldn't get close enough to fill the frame with my main interest — the two juvenile herons at the center of the scene. But because I had the resolution cranked up to Large, I could later crop the shot to the composition you see on the right and still produce a great-looking print. In fact, I could have printed the cropped image at a much larger size than fits here.

FIGURE 2-10: A highresolution original (left) enabled me to crop the photo and still have enough pixels to produce a quality print (right).

Understanding Image Quality options (JPEG or Raw)

If I had my druthers, the Image Quality option would instead be called File Type because that's what the setting controls. Here's the deal: The file type, sometimes also known as a file *format*, determines how your picture data is recorded and stored. Your choice does affect picture quality, but so does the Image Size setting, as

described in the preceding section, and the ISO setting, covered in the next chapter. In addition, your choice of file type has ramifications beyond picture quality.

At any rate, your camera offers two file types: JPEG and Camera Raw — or Raw, for short, which goes by the specific moniker NEF (Nikon Electronic Format) on Nikon cameras. The next couple of sections explain the pros and cons of each format. If your mind is already made up, skip ahead to the section "Setting Image Size and Image Quality," to find out how to make your selection.

Don't confuse *file format* with the Format Memory Card option on the Setup menu. That option erases all data on your memory card; see Chapter 1 for details.

JPEG: The imaging (and web) standard

Pronounced "jay-peg," this format is the default setting on your D3400, as it is on most digital cameras. JPEG is popular for two main reasons:

- Immediate usability: All web browsers and e-mail programs can display JPEG files, so you can share pictures online immediately after you shoot them. You also can get a JPEG file printed at any retail photo outlet. The same can't be said for Raw (NEF) files, which must be converted to JPEG for online sharing and to JPEG or another standard format, such as TIFF, for retail printing.
- Small files: JPEG files are smaller than Raw files. And smaller files consume less room on your camera memory card and in your computer's storage tank.

The downside (you knew there had to be one) is that JPEG creates smaller files by applying *lossy compression*. This process actually throws away some image data. Too much compression produces a defect called *JPEG artifacting*. Figure 2-11 compares a high-quality original (left photo) with a heavily compressed version that exhibits artifacting (right photo).

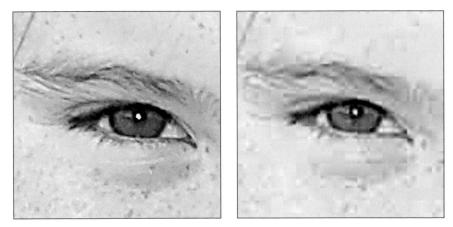

FIGURE 2-11: The reduced quality of the right image is caused by excessive JPEG compression. Fortunately, your camera enables you to specify how much compression you're willing to accept. You can choose from three JPEG settings, which produce the following results:

- >> JPEG Fine: The compression ratio is 1:4 that is, the file is four times smaller than it would otherwise be. Because very little compression is applied, you shouldn't see many compression artifacts, if any.
- >> JPEG Normal: The compression ratio rises to 1:8. The chance of seeing some artifacting increases as well. This setting is the default.
- JPEG Basic: The compression ratio jumps to 1:16. That's a substantial amount of compression that brings with it a lot more risk of artifacting.

Note, though, that even the Basic setting doesn't result in anywhere near the level of artifacting you see in the right image in Figure 2–11. I exaggerated the defect in that example to help you recognize artifacting and understand how it differs from the quality loss that occurs when you have too few pixels. (Refer to Figures 2–7 through 2–9.) In fact, if you keep the image print or display size small, you aren't likely to notice a great deal of quality difference between the Fine, Normal, and Basic compression levels. It's only when you greatly enlarge a photo that the differences become apparent.

Given that the differences between the compression settings aren't that easy to spot until you enlarge the photo, is it okay to stick with the default setting — Normal — or even drop down to Basic to capture smaller files? Well, only you can decide what level of quality your pictures demand. For me, the added file sizes produced by the Fine setting aren't a huge concern, given that the prices of memory cards fall all the time. Long-term storage is more of an issue; if you keep all your original files, it doesn't take long to fill up a hard drive (or DVD) or exceed your online storage capacity. But in the end, I prefer to take the storage hit in exchange for the lower compression level of the Fine setting. You never know when a casual snapshot will be so great that you want to print or display it large enough that even minor quality loss becomes a concern. And of all the defects that you can correct in a photo editor, artifacting is one of the hardest to remove.

If you don't want *any* risk of artifacting, change the file type to Raw (NEF). Or consider your other option, which is to record two versions of each file — one Raw and one JPEG. The next section offers details.

Raw (NEF): The purist's choice

The other picture file type you can create is *Camera Raw*, or just *Raw* (as in uncooked), for short.

Each manufacturer has its own flavor of Raw. Nikon's is NEF, for Nikon Electronic Format, so you see the three-letter extension NEF at the end of Raw filenames.

Raw is popular with advanced, very demanding photographers for three reasons:

- **Solution** Greater creative control: With JPEG, internal camera software tweaks your images, adjusting color, exposure, and sharpness as needed to produce the results that Nikon believes its customers prefer. With Raw, the camera simply records the original, unprocessed image data. The photographer then copies the image file to the computer and uses special software known as a *Raw converter* to produce the actual image, making decisions about color, exposure, and so on at that point. Nikon Capture NX-D, a free program you can download from the Nikon support site, offers a Raw converter, and the D3400 also has a built-in Raw converter. I cover both options in Chapter 10.
- Higher bit depth: Bit depth is a measure of how many distinct color values an image file can contain. JPEG files restrict you to 8 bits each for the red, blue, and green color components, or *channels*, that make up a digital image, for a total of 24 bits. That translates to roughly 16.7 million possible colors. On the D3400, Raw images are captured using 12 bits per channel.

Although jumping from 8 to 12 bits sounds like a huge difference, you may never notice any difference in your photos — that 8-bit palette of 16.7 million values is more than enough for superb images. Where the extra bits can come in handy is if you adjust exposure, contrast, or color in your photo-editing program. When you apply extreme adjustments, the extra bits sometimes help avoid a problem known as *banding* or *posterization*, which creates abrupt color breaks where you should see smooth, seamless transitions. (A higher bit depth doesn't always prevent this problem, however.)

Best picture quality: Because Raw doesn't apply the destructive compression associated with JPEG, you don't run the risk of the artifacting that can occur with JPEG.

But Raw isn't without its disadvantages:

>> You can't do much with your pictures until you process them in a Raw converter. You can't share them online or put them into a text document or multimedia presentation. You can view and print them immediately if you use Nikon Capture NX-D or Nikon ViewNX-i (another of Nikon's free photo programs), and you also can find some apps for viewing Raw images on your smartphone or tablet. But most apps and computer-based photo programs require you to convert the Raw files to a standard format, such as JPEG or TIFF. (The Nikon SnapBridge app, used for connecting a smart device to the D3400, doesn't offer Raw support at this time.) Retail printing outlets typically can't deal with Raw files, either.

Raw files are larger than JPEGs. Unlike JPEG, Raw doesn't apply lossy compression to shrink files. In addition, Raw files are always captured at the maximum resolution. For both reasons, Raw files are significantly larger than JPEGs, so they take up more room on your memory card and on your computer's hard drive or other picture-storage device.

Whether the upside of Raw outweighs the down is a decision that you need to ponder based on your photographic needs and on whether you have the time to, and interest in, converting Raw files.

You do have the option to capture a picture in the Raw and JPEG format at the same time; see the section "Setting Image Size and Image Quality" for details. I often take this route when I'm shooting pictures I want to share right away. I upload the JPEGs to a photo-sharing site where everyone can view them, and then I process the Raw versions when I have time.

My take: Choose JPEG Fine or Raw (NEF)

At this point, you may be finding all this technical goop a bit overwhelming, so allow me to simplify things for you. Until you have the time or energy to completely digest all the ramifications of JPEG versus Raw, here's a quick summary of my thoughts on the matter:

- If you require the absolute best image quality and have the time and interest to do the Raw conversion, shoot Raw.
- If great photo quality is good enough and you don't have time to spend processing images, stick with JPEG Fine.
- If you don't mind the added file-storage space requirement and want the flexibility of both formats, choose the Raw+JPEG Fine option, which stores one copy of the image in each format.
- If you go with JPEG only, stay away from JPEG Normal and Basic. (Remember, Normal is the default setting on your camera.) The trade-off for smaller files isn't, in my opinion, worth the risk of compression artifacts.

Setting Image Size and Image Quality

To sum up the Image Size and Image Quality information laid out in the preceding sections:

- >> Both options affect picture quality and file size.
- Choose a high Image Quality setting Raw (NEF) or JPEG Fine and the maximum Image Size setting (Large) for top-quality pictures and large file sizes.
- Combining the lowest Quality setting (JPEG Basic) with the lowest Size setting (Small) greatly shrinks files, enabling you to fit lots more pictures on your memory card, but it also increases the chances that you'll be disappointed with the quality of those pictures, especially if you make large prints.

Now for the lowdown on how to monitor and adjust the setting: First, to see which options are currently in force, check the Information screen or Live View display, in the areas labeled in Figure 2-12. (Remember that you press the Info button to change the data display in Live View mode.)

Image Quality

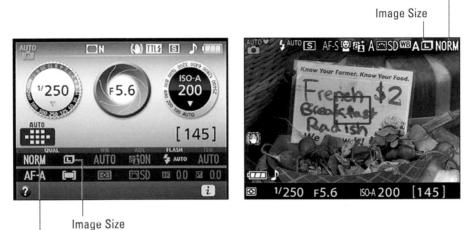

FIGURE 2-12: The current Image Quality and Image Size settings appear here.

To adjust the settings, you have the following choices:

Image Quality

i button: Press the button to access the display control strip, highlight one of the two options, and then press OK to view the screen where you can select the setting you want to use. Figure 2-13 illustrates the process of setting the Image Quality option via the control strip.

Notice that in the screen shown on the right in Figure 2-13, the display shows the file size that will result from your selected setting along with the number of pictures that will fit on the memory card at that size (17MB and 142 images, in the figure). Keep in mind that certain factors other than Image Size and Image Quality also affect file size, such as the level of detail and color in the subject.

Shooting menu: As an alternative, adjust the settings via the Shooting menu, as shown in Figure 2-14. If you select the Image Size setting from the menu, the options screen shows the pixel counts for each setting, as shown on the right in the figure.

When you choose the Raw (NEF) or Raw+JPEG Fine option, all pictures are automatically captured at the Large resolution setting.

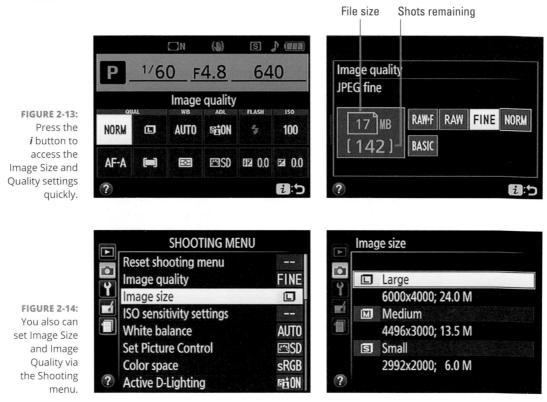

Adding Flash

Another basic picture-taking option to consider is whether you want to add flash to illuminate your subject. With the D3400, you can use the built-in flash or attach an external flash head to the hot shoe, labeled in Figure 2-15.

However, flash options depend on the exposure mode, as follows:

- Flash disabled: Flash isn't available in Auto Flash Off mode and in Landscape and Sports Scene modes. All Effects modes except Pop, Vivid, Toy Camera Effect, and Photo Illustration also prevent you from using flash. (Some modes set the flash to off by default, but you can override this setting by changing the Flash mode, explained later in the chapter.)
- Minimal flash control: In Auto mode as well as in the Portrait, Child, Close-Up, and Night Portrait modes, you can enable or disable flash, and you may be able to choose from a couple different flash modes, such as Red-Eye Reduction mode. You also get some flash flexibility in Effects modes that allow flash.
- Advanced flash control: In P, S, A, and M modes, you can enable or disable flash, choose from a variety of flash modes, and even control flash power.

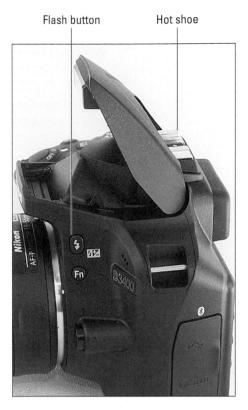

FIGURE 2-15: You can add light via the built-in flash or by attaching an external flash head to the hot shoe.

The rest of this chapter explains how to enable flash, adjust the flash mode, and take advantage of other flash options.

Enabling and disabling flash

In certain exposure modes, flash is set by default to fire automatically if the camera thinks that the ambient light is insufficient; in other modes, you have to manually enable the flash. Here's the breakdown:

>> Auto mode; all Scene and Effects modes that permit flash: Flash is set to Auto by default. After you press the shutter button, the camera assesses the available light and automatically pops up the built-in flash if it finds that light lacking. If you don't want to use flash in these exposure modes, you may be able to disable it via the Flash mode setting, however. See the next section for how-tos.

P, S, A, and M modes: There's no such thing as automatic flash in these modes. Instead, if you want to use the built-in flash, press the Flash button on the side of the camera, labeled in Figure 2-15. Don't want flash? Just press down gently on the top of the flash to close the unit.

The camera does give you a little flash input, though: You see a blinking question mark or a flash symbol, or both, in the displays if the camera thinks you need flash. Press the Zoom Out button (the one with the question mark above it), and a message appears, recommending that you use flash.

Choosing a Flash mode

The *Flash mode* determines how and when the flash fires. The next section introduces the various options; following that, you can find details on how to adjust the setting.

Sorting through your Flash mode options

Your camera offers the following flash modes, represented in the Information and Live View displays by the symbols you see in the margins here. (Skip ahead to Figure 2–19 to see where to find the symbols in the Information and Live View displays.)

Auto: The camera decides whether the flash fires. This mode isn't available in the P, S, A, M modes.

Flash Off: In Auto exposure mode or the Scene and Effects modes that permit flash, choose this Flash mode to prevent the flash from firing. (In the P, S, A, and M modes, simply close the flash unit if you don't want to use flash.)

Fill Flash: You can think of this mode, available in P, S, A, and M modes, as normal flash. You may also hear this mode called *force* flash because the flash fires no matter the amount of available light.

Although most people think of flash as an indoor lighting option, adding flash can improve outdoor photos, too. After all, your main light source — the sun — is overhead, so although the top of the subject may be adequately lit, the front typically needs additional illumination. As an example, Figure 2-16 shows a floral image taken both with and without a flash. The small pop of light provided by the built-in flash is also beneficial when shooting subjects that happen to be slightly shaded. For outdoor portraits, a flash is even more important to properly illuminate the face; the section on shooting portraits in Chapter 7 discusses that subject and offers a look at the difference flash can make.

Shooting with flash in bright light involves a couple of complications, however; see the sidebar "Using flash outdoors," later in this chapter, for help.

With flash

FIGURE 2-16: Adding flash resulted in better illumination and a slight warming effect.

Red-Eye Reduction: Red-eye is caused when light from the flash bounces off a subject's retinas and is reflected back to the camera lens, making the subjects appear possessed by a demon. This flash mode is designed to reduce the chances of red-eye.

When you use Red-Eye Reduction mode, the AF-assist lamp on the front of the camera lights briefly before the flash fires. The subject's pupils constrict in response to the light, allowing less flash light to enter the eye and cause that glowing red reflection. Be sure to warn your subjects to wait for the flash, or else they may step out of the frame or stop posing after they see the light from the AF-assist lamp.

In Auto exposure mode as well as in certain Scene and Effects modes that permit flash, Red-Eye Reduction flash is just a variation of the regular Auto flash setting. That is, if the camera sees the need for flash, it fires the flash with Red-Eye Reduction engaged. In this case, you see the word *Auto* next to the red-eye symbol. Additionally, a few Scene modes use a variation of red-eye reduction, combining that feature with a slow shutter speed. This flash mode displays the little eye icon plus the words *Auto Slow*. It's important to use a tripod and ask your subject to remain still during the exposure to avoid a blurry picture. TECHNICAL

STUFF

Slow-Sync and Rear-Sync: In the flash modes listed so far, the flash and shutter are synchronized so that the flash fires at the exact moment the shutter opens.

Technical types call this flash arrangement *front-curtain sync*, which refers to how the flash is synchronized with the opening of the shutter. Here's the deal: The camera uses a type of shutter involving two curtains that move across the frame. When you press the shutter button, the first curtain opens, allowing light to strike the image sensor. At the end of the exposure, the second curtain draws across the frame to once again shield the sensor from light. With front-curtain sync, the flash fires when the front curtain opens.

Your camera also offers these special sync modes:

SLOW

Slow-Sync: This mode, available only in the P and A exposure modes, also uses front-curtain sync but allows a shutter speed slower than the 1/60 second minimum that's in force when you use Fill Flash and Red-Eye Reduction flash. Because of the longer exposure, the camera has time to absorb more ambient light, which has two benefits: Background areas that are beyond the reach of the flash appear brighter and less flash power is needed, resulting in softer lighting.

The downside of the slow shutter speed is that any movement of your camera or subject during the exposure can blur the picture, and the slower the shutter speed, the greater the chances of camera or subject motion. A tripod is essential to a good outcome, as are subjects that can hold very, very still. I find that the best practical use for this mode is shooting night-time still-life subjects like the one you see in Figure 2-17. However, if you're shooting a nighttime portrait and you have a subject that *can* maintain a motionless pose, Slow-Sync flash can produce softer, more flattering light.

Note that even though the official Slow-Sync mode appears only in the P and A exposure modes, you can get the same result in the M and S modes by simply using a slow shutter speed and the normal, Fill Flash mode. In fact, I prefer using those modes when I want the slow-sync look because I can directly control the shutter speed. You can use a shutter speed as slow as 30 seconds when using flash in those modes. (In M mode, you also can set the shutter speed to Bulb or Time, which permit even longer shutter speeds. See Chapter 4 for details about these shutter speed options.)

SREAR

Rear-Curtain Sync: In this mode, available only in shutter-priority (S) and manual (M) exposure modes, the flash fires at the end of the exposure, just before the shutter closes. The classic use of this mode is to combine the flash with a slow shutter speed to create trailing-light effects like the one you see in Figure 2-18. With Rear-Curtain Sync, the light trails extend behind the moving object (my hand, and the match, in this case), which makes visual sense. If instead you use Slow-Sync flash, the light trails appear in front of the moving object.

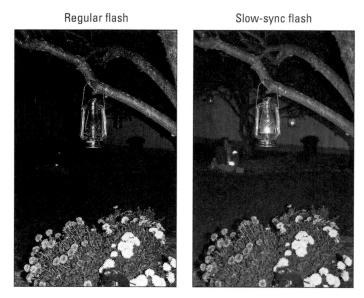

FIGURE 2-17: Slow-Sync flash produces softer, more even lighting than normal flash in nighttime pictures.

- Slow-rear: Hey, not confusing enough for you yet? This mode enables you to produce the same motion trail effects as with Rear-Curtain Sync, but in the P and A exposure modes. The camera automatically chooses a slower shutter speed than normal after you set the f-stop, just as with regular Slow-Sync mode.
- Slow-sync with red-eye reduction: In P and A exposure modes, you can also combine a Slow-Sync flash with the Red-Eye Reduction feature. The symbol that represents this mode is the normal red-eye eyeball combined with the word Slow.

FIGURE 2-18: I used Rear-Curtain Sync Flash mode to create this candle-lighting image.

Setting the Flash mode

You can view the current Flash mode in the Information and Live View displays, as shown in Figure 2–19. (In Live View mode, press the Info button to cycle through the various data-display modes to get to the one shown in the figure.) The symbol shown in the figures represents the Auto flash mode.

IN SYNC: FLASH TIMING AND SHUTTER SPEED

To properly expose flash pictures, the camera has to synchronize the firing of the flash with the opening and closing of the shutter. For this reason, the range of available shutter speeds is limited when you use flash. The maximum shutter speed is 1/200 second; the minimum shutter speed varies, depending on the exposure mode. Here's how things shake out for the exposure modes that permit you to use flash:

- Auto and Effects and Scene modes that permit flash, except Night Portrait: 1/60 second
- Nighttime Portrait: 1 second
- P, A: 1/60 second (unless you use one of the Slow-Sync Flash modes, which permit a slower shutter speed)
- S: 30 seconds
- M: 30 seconds (you can exceed that limit if the shutter speed is set to Bulb or Time, both covered in Chapter 4)

Remember, flash isn't available in certain Scene and Effects modes and is also off-limits when you use the Continuous (burst shooting) Release mode.

Flash Control for Built-in Flash setting

Flash mode

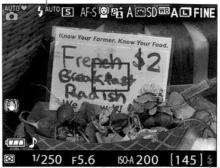

FIGURE 2-19: An icon representing the Flash mode appears in the displays.

Flash mode

Flash ready

In the viewfinder as well as in the lower-right corner of the Live View display, you see a single lightning bolt. This symbol simply tells you that the flash is ready to fire. (You can't view the Flash mode in the viewfinder.) I labeled this symbol *Flash ready* in Figure 2-19.

TECHNICAL STUFF As for the TTL symbol at the top of the Information screen, shown on the left in Figure 2–19, it represents the current setting of the Flash Cntrl for Built-in Flash option on the Shooting menu. TTL, which stands for *through the lens*, represents the normal flash metering operation: The camera measures the light coming through the lens and sets the flash output accordingly. Your other option is to set the flash output manually, as explained in the last section of this chapter. If you take that route, the letter *M* appears in place of *TTL*.

To change the Flash mode, you can go one of two ways:

>> Flash button + Command dial: As soon as you press the Flash button. the Flash mode option in the Information display becomes selected, as shown in Figure 2-20. The same thing happens in the Live View display, but the related symbol is at the top of the screen (refer to Figure 2-19). Either way, keep the Flash button pressed while rotating the Command dial to cycle through the available Flash modes. Luckily, a text label lets you know what mode is in force so that you don't have to memorize all the flashmode symbols.

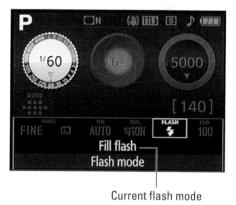

FIGURE 2-20:

The fastest way to change the Flash mode is to hold down the Flash button and rotate the Command dial.

i button: Press the button to activate the control strip in the Information and Live View displays. Highlight the Flash mode option, as shown on the left in Figure 2-21, and press OK to display a screen listing the mode settings, as shown on the right. Remember that the available Flash modes depend on the exposure mode; the figure shows modes available in the P (programmed autoexposure) mode.

USING FLASH OUTDOORS

Adding flash can often improve outdoor photos. But be aware of two "gotchas" when mixing flash and sunlight:

- Colors may need tweaking. When you combine multiple light sources, colors may appear warmer or cooler than neutral. For outdoor portraits, the warming effect is usually flattering, and I often like the result with nature shots as well. But if you prefer a neutral color rendition, see the Chapter 6 section related to the White Balance control to find out how to address this issue. You can adjust white balance only in P, S, A, and M exposure modes.
- Keep an eye on shutter speed. Because of the way the camera needs to synchronize the firing of the flash with the opening of the shutter, the fastest shutter speed you can use with the built-in flash is 1/200 second. In bright sun, you may need to stop down the aperture significantly or lower the ISO to avoid overexposing the image even at 1/200 second. As another option, you can place a neutral density filter over the lens; this accessory reduces the light that comes through the lens without affecting colors. Of course, if possible, you can simply move your subject into the shade.

On the flip side, the camera may select a shutter speed as slow as 1/60 second in the P and A modes, depending on the lighting conditions. If your subject is moving, it's a good idea to work in the S or M mode so that you control the shutter speed.

FIGURE 2-21: You also can adiust the Flash mode by using the normal control-strip method; press the *i* button to activate the control strip.

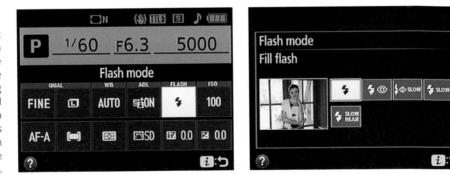

Adjusting the flash output (P, S, A, and M modes only)

TIP

In the P, S, A, or M exposure modes, you have control over flash power via two options, which I outline in the next two sections.

i

Applying Flash Compensation

When you set the Flash Control for Built-in Flash option on the Shooting menu to TTL, which is the default mode, the camera determines how much flash power is needed. But if you want a little more or less flash light than the camera thinks is appropriate, you can turn on *Flash Compensation*.

Flash Compensation settings are stated in terms of *exposure value (EV)* numbers. A setting of EV 0.0 indicates no flash adjustment; you can increase the flash power to EV +1.0 or decrease it to EV -3.0.

As an example of the benefit of this feature, look at the carousel images in Figure 2–22. The first image shows a flash-free shot. Clearly, I needed a flash to compensate for the fact that the horses were shadowed by the roof of the carousel. But at normal flash power, as shown in the middle image, the flash was too strong, creating glare in some spots and blowing out the highlights in the white mane. By dialing the flash power down to EV -1.0, I got a softer flash that straddled the line perfectly between no flash and too much flash.

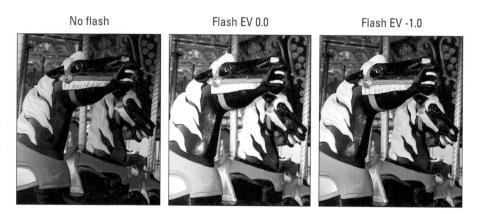

FIGURE 2-22: When normal flash output is too strong, dial in a lower Flash Compensation setting.

As for boosting the flash output, you may find it necessary on some occasions, but don't expect the built-in flash to work miracles even at a Flash Compensation of +1.0. The built-in flash simply isn't capable of illuminating faraway objects. Flash range varies depending on your ISO and aperture setting; for example, at ISO 100 and an aperture of f/5.6, the flash range is just 2 to 5 feet. If you raise the ISO to 400, the flash range extends to nearly 10 feet. You can find a chart listing all the variables in the full version of the camera manual, which is downloadable from the Nikon support site. But if you don't care to dive that deep into flash specifics, you should be okay if you assume a flash range of about 2 to 10 feet. Of course, taking a few test shots before you shoot your final images is always a good idea.

Back to Flash Compensation: The current setting appears in the Information display, as shown on the left in Figure 2-23. In the Live View display, you see only a symbol indicating that the feature is enabled, as shown on the right side of the figure. Note that if the feature is turned off (set to EV 0.0), the symbol doesn't appear in the Live View display.

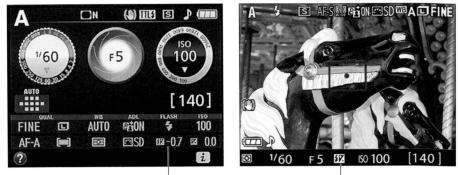

FIGURE 2-23: These symbols represent Flash Compensation.

Flash Compensation symbol —

To adjust the amount of Flash Compensation, use either of these tricks:

>> Use the two-button-plus-Command-dial maneuver. First, press the Flash button to pop up the built-in flash, if it's not already up. Then press and hold the Flash button and the Exposure Compensation button simultaneously. When you press the buttons, the Flash Compensation value becomes highlighted in the Information and Live View displays, as shown in Figure 2-24. In the viewfinder, the current setting takes the place of the usual Frames Remaining value. While keeping both buttons pressed, rotate the Command dial to adjust the setting. I find that any technique that involves coordinating this many fingers a little complex, but you may find it easier than I do.

FIGURE 2-24: Rotate the Command dial while pressing the Flash and Exposure Compensation buttons to adjust the flash power.

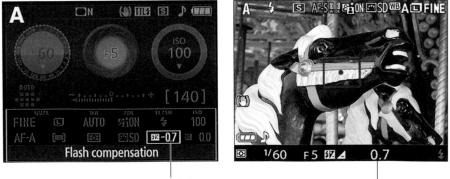

>> Use the control strip. Just press the *i* button to activate the control strip, and highlight the Flash Compensation setting, as shown on the left in Figure 2-25. Press OK to display a screen where you can set the compensation amount, as shown on the second screen of the figure.

FIGURE 2-25: You also can adjust the setting by using the normal control-strip method.

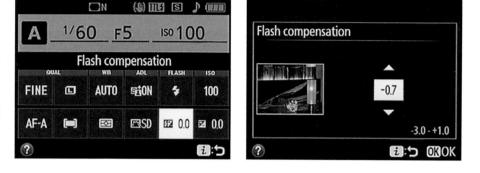

Any flash-power adjustment remains in force until you reset the value, even if you turn off the camera. So be sure to check the setting before you next use the flash.

Controlling flash output manually

If you're experienced in the way of the flash, you can manually set flash output via the Flash Cntrl for Built-in Flash option, found on the Shooting menu and featured in Figure 2-26. As with Flash Compensation, this feature is available only in the P, S, A, and M exposure modes.

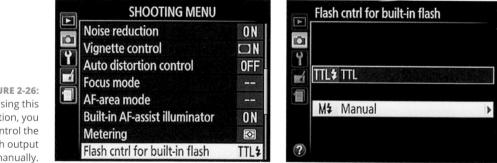

FIGURE 2-26: Using this option, you can control the flash output manually.

The normal setting is TTL (for automatic, through-the-lens metering), but if you select Manual, as shown on the right in the figure, and then press the Multi Selector right, you can access the power settings, which range from Full to 1/32 power.

When flash is set to manual control, the TTL icon that normally appears in the upper-right corner of the Information display (refer to Figure 2-19) is replaced by the letter *M*. In the viewfinder and Live View display, you see an icon that looks just like the Flash Compensation symbol (lightning bolt with a plus-minus sign). But when manual flash power is engaged, the symbol blinks.

IN THIS CHAPTER

- » Shooting your first pictures in Auto mode
- » Trying Live View photography
- » Getting creative by using Scene modes
- » Understanding the limitations of the auto modes

Chapter **3 Taking Great Pictures, Automatically**

our camera is loaded with features for the advanced photographer, giving you precise control over f-stop, shutter speed, ISO, flash power, and much more. But you don't have to wait until you understand those options to take great pictures, because your camera also offers shooting modes that provide point-and-shoot simplicity. This chapter shows you how to get the best results in those modes: Auto, Auto Flash Off, and the Scene modes. For help with using the automated Effects modes, visit Chapter 11.

Shooting in Auto and Auto Flash Off Modes

For the simplest camera operation, set the camera to Auto mode, as shown in Figure 3–1. Or, in a location that doesn't permit flash, choose Auto Flash Off, represented by the symbol labeled in the figure.

In both modes, you need to consider a few shooting settings, starting with whether you want to use the viewfinder to compose the photo or enable Live View, which sends a live preview of the subject to the camera monitor. Your choice makes a difference in how the camera's autofocusing system works and, therefore, how you need to take the picture. The next section shows you how things work for viewfinder photography; following that, I show you how to take a picture in Live View mode.

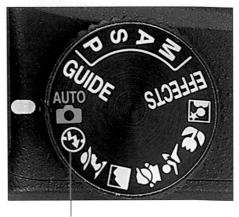

Auto Flash Off

Both sets of instructions assume that you're using the camera's default settings; visit the end of Chapter 1 to find out how to restore those defaults.

FIGURE 3-1: Set the Mode dial to Auto or Auto Flash Off for point-and-shoot simplicity.

Viewfinder photography in Auto and Auto Flash Off modes

Here's how to take a picture using the default Auto and Auto Flash Off modes and autofocusing:

1. Set the Mode dial to Auto, as shown in Figure 3-1.

Or choose Auto Flash Off for flash-free photography.

2. Set the Focus mode option to AF-A.

This setting is the default for the Auto exposure mode, but it never hurts to check. So take a peek at the Information screen, shown in Figure 3-2, and verify that the Focus mode setting (labeled in the figure) is set to AF-A. (To wake up the screen, you may need to press the Info button or give the shutter button a quick half press and release.)

To change the Focus mode setting, press the *i* button to bring up the control strip, as shown on the right in the figure. Use the Multi Selector to highlight the Focus mode option, press OK, and select AF-A on the next screen. Press OK to lock in your choice and then press the *i* button again to exit the control strip.

If you're using an AF-S lens or other lens that has a focusing-method switch, you also need to set that switch to the automatic focusing position. Usually, it's labeled A or AF.

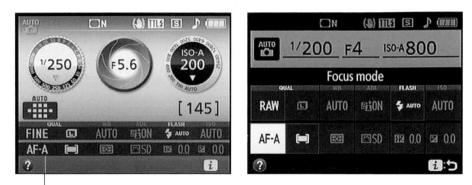

FIGURE 3-2: The fastest way to set the Focus mode to AF-A is via the control strip; press the *i* button to activate the strip.

Focus mode setting

With either type of lens, you also can set the Focus mode through the Shooting menu. After selecting Focus mode from the menu, select Viewfinder to access the focusing options for viewfinder shooting.

3. Frame your subject so that it appears within the area covered by the focus points.

The focus points are the 11 little dots scattered around the center of the viewfinder; I labeled three of them in Figure 3-3.

4. Press and hold the shutter button halfway down.

The autofocus system begins to do its thing. At the same time, the autoexposure meter analyzes the light and selects the initial exposure settings. The camera continues monitoring the light up to the time you take the picture, however, and

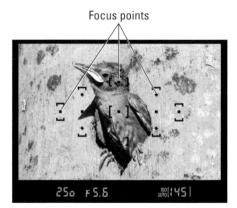

FIGURE 3-3: Frame your subject so that it's within the area covered by the autofocus points.

may adjust the exposure settings if lighting conditions change. In Auto mode, the built-in flash pops up if the camera thinks additional light is needed.

5. Check the focus indicators in the viewfinder.

When the camera has established focus, one or more of the focus points turns red for a split second, as shown in Figure 3-4. The red points represent the areas of the frame used to set the focusing distance. In my example, the camera set focus on the bird's chest. At the bottom of the viewfinder, the green focus indicator, labeled in the figure, lights to give you further notice that focus has been achieved.

If the subject isn't moving, autofocus remains locked as long as you hold the shutter button halfway down. But if the camera detects subject motion, it adjusts focus up to the time you press the button fully to record the picture. As your subject moves, keep it within the area covered by the focusing points to ensure correct focusing.

For stationary subjects, you also hear a beep when the camera achieves focus. The beep doesn't sound if you turned it off (via the Beep option on the Setup menu) or the camera detects subject movement and shifts into continuous autofocusing. Selected focus points

Focus indicator

FIGURE 3-4:

The selected focus points flash red, and then the green light appears to indicate that the camera is done setting focus.

6. Press the shutter button the rest of the way.

A few final notes about the Auto and Auto Flash Off modes:

Exposure and flash: If an exposure meter blinks in the viewfinder or Information display, the camera can't select settings that will properly exposure the picture. See Chapter 4 for details about reading the exposure meter and coping with exposure problems. If you're shooting in Auto Flash Off mode, changing to Auto and enabling flash may provide a solution, however.

In Auto mode, you can adjust the Flash mode setting in order to disable flash or change to Red-Eye Reduction flash. The easiest way to get the job done is to press the Flash button while rotating the Command dial, but you also can set the Flash mode via the Information screen control strip. (Press the *i* button to activate the strip.) See Chapter 2 for more about flash photography in Auto mode.

>> Autofocusing: By default, the camera selects which autofocus points to use when establishing focus. Typically, focus is set on the closest object. Chapter 5 explains how to modify this autofocusing behavior, which you control through the AF-Area Mode setting. You can access the setting on the Shooting menu or via the Information screen's control strip. On the control strip, the AF-Area Mode setting lives just to the right of the Focus mode option, labeled in Figure 3-2. The solid rectangle you see in the figure represents the default option, named Auto-Area AF.

HELP! MY CAMERA WON'T TAKE THE PICTURE!

If the camera doesn't release the shutter to take the picture when you press the shutter button, don't panic. This error is likely related to autofocusing: The D3400 insists on achieving focus before it releases the shutter to take a picture. You can press the shutter button all day, and the camera just ignores you if it can't set focus. Try backing away from your subject a little — you may be exceeding the minimum focusing distance of the lens. If that doesn't work, the subject just may not be conducive to autofocusing. Highly reflective objects, scenes with very little contrast, and subjects behind fences are some of the troublemakers. The easiest solution? Switch to manual focusing and set focus yourself.

By default, the camera also refuses to release the shutter when you don't have a memory card installed; this feature is controlled by the Slot Empty Release Lock option on the Setup menu. (If you set the option to OK/Enable Release, the camera records a temporary image that disappears a few seconds after you shoot it.) You also can't take a picture if there's insufficient space on the memory card to hold the file. In that case, the camera displays a message telling you that the card is full.

>> Manual focusing: To use manual focusing instead of autofocusing, set the Focus mode to MF in Step 2. Then rotate the focusing ring on the lens to bring the scene into focus. (Remember, if you use an AF-S lens or other lens with an exterior focusing-method switch, you need to set that switch to the manual position, too.)

By default, moving the focusing ring on an AF-P lens also adjusts focus even when the Focus mode is set to autofocusing. The idea is that you can use autofocus to set the initial focusing distance and then tweak focus by using the manual focusing ring (you need to keep the shutter button pressed halfway down as you do so). If you prefer to turn this feature off, open the Setup menu, select Manual Focus Ring in AF Mode, and change the setting to Disable.

Live View photography in Auto and Auto Flash off modes

Most aspects of shooting in Live View are the same as for viewfinder photography. Autofocusing, however, works quite differently. Here are the steps to take a pic-ture in the Auto or Auto Flash Off mode using autofocusing:

1. To engage Live View, press the LV button, labeled in Figure Figure 3-5.

The viewfinder goes dark, and the scene in front of the lens appears on the monitor, along with some shooting data, as shown in Figure 3-5. The figure

shows the default Live View display; press the Info button to cycle through the various display modes. (Note that one of the displays shows movie settings, not still photography settings.)

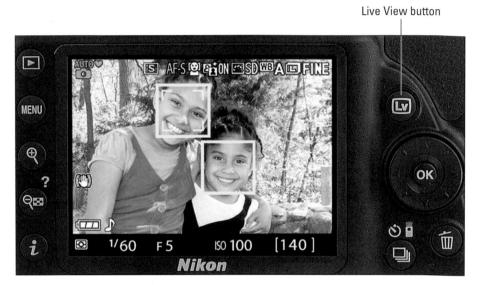

FIGURE 3-5: Press the LV button to engage the Live View display.

- 2. Frame your subject in the monitor.
- **3.** Check the position of the focusing frame; if necessary, recompose or adjust the frame so that it's over your subject.

REMEMBER

- The autofocus frame that appears depends on your subject:
- Portraits: By default, the camera uses an autofocusing option called Face
 Priority AF-area mode. If it detects a face, it displays a yellow focus box over
 it. In a group portrait, you may see several boxes, as shown on the left in
 Figure 3-6. The one that includes the interior corner marks indicates the
 face that will be used to set the focusing distance. You can use the Multi
 Selector to move the box over a different face, which is then used to
 determine the focusing distance. When your subjects are the same
 distance from the camera, as in my example, it doesn't really matter which
 one you choose as the focus point, however.
- Other subjects: Anytime the camera can't detect a face, it switches to Wide Area AF-area mode, with the focus point indicated by a red box in the center of the screen. (Refer to the image on the right in Figure 3-6.) Again, you can use the Multi Selector to move the focus box over your subject. Press OK to move the focus box quickly back to the center of the frame.

Note that the only indication that the autofocus system has switched from Face Priority to Wide Area mode is the appearance of the focus frame. The symbol representing Face Priority AF-area mode, located near the top center of the display and labeled in Figure 3-6, remains the same.

Exposure mode symbol

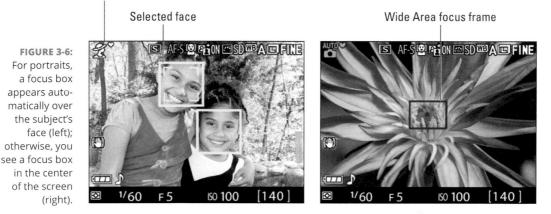

Press the shutter button halfway to set focus and initiate exposure metering.

When focus is set, the focus box turns green, and you hear a beep. In Auto mode, the built-in flash pops up if the camera thinks flash is needed. (You can disable flash or set it to Red-Eye Reduction mode by pressing the Flash button while rotating the Command dial.)

In Live View mode, the camera always locks focus when you press the shutter button halfway, even if the subject is moving. If you want the camera to track focus on a moving subject, you must shift from the default Focus mode option AF-S (for single-servo autofocus) to AF-F (full time servo) mode. Chapter 5 explains the details.

5. Press the shutter button all the way down.

The photo appears briefly on the monitor, and then the live preview reappears.

After you press the shutter button halfway, the camera may shift automatically to one of four Scene modes that are designed to capture specific types of subjects. The exposure-mode symbol labeled on the left in Figure 3-6 is your cue that this switch was made. For example, in the picture of the two girls, the camera shifted to Portrait mode, represented by the lady with a hat. The other three Scene modes that the camera may select are Landscape (mountain symbol); Close Up (flower symbol); and Night Portrait (head-and-shoulders with a star). If you see the word *Auto* with a heart, as on the right screen of the figure, the camera is sticking with ordinary Auto mode. For Auto Flash Off mode, you also see the heart next to the "no flash" symbol. If you prefer to select a Scene type directly, the next section shows you how.

Taking Advantage of Scene Modes

Your camera offers six *Scene modes*, which select settings designed to capture specific scenes using traditional characteristics. For example, most people prefer portraits that have softly focused backgrounds. So in Portrait mode, the camera selects settings that can produce that type of background. Scene modes are represented on the Mode dial by the symbols shown in Figure 3-7. (See the upcoming list for a look at which mode each symbol represents.)

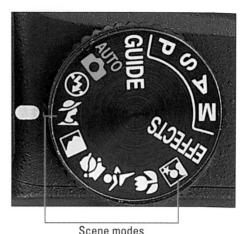

A few general tips before I get into the specifics of Scene modes:

FIGURE 3-7: These symbols represent the Scene modes.

- Autofocusing: For the most part, autofocusing in Scene modes works as outlined for the Auto and Auto Flash Off exposure modes. To recap:
 - Autofocusing during viewfinder shooting: The camera uses the AF-A Focus mode setting, which means that focus is locked at the time you press the shutter button halfway unless the camera senses a moving subject. In that case, focus is adjusted up to the time you press the shutter button to take the shot.

For the AF-area mode, which is the setting that controls which focus point is used, the camera uses a different default setting depending on your Scene mode, so see the upcoming descriptions for details. In all Scene modes, you can dump out of the default AF-area mode if you choose, but before you do so, check out the Chapter 5 section that explains each option.

- Autofocusing during Live View shooting: By default, the Focus mode is set to AF-S, and focus is set when you press the shutter button halfway. However, you can change to AF-F mode, which provides full-time, continuous autofocusing. As with viewfinder photography, you get the option to use the default AF-area mode, which varies depending on the scene mode, or to choose one of the other Live View AF-area mode settings. Again, check out Chapter 5 for more information.
- >> ISO Sensitivity: This option determines how much the camera's image sensor reacts to light and, therefore, how much light you need to expose the image.

setting quickly, press and hold the Fn button (located on the left side of the camera, underneath the Flash button) while rotating the Command dial.

Flash: Flash is disabled in Landscape and Sports modes. In other modes, you may be able to choose a Flash mode that disables flash or a special flash setting, such as Red-Eye Reduction mode. The fastest way to change the Flash mode is to press the Flash button while rotating the Command dial, but you also can access the setting via the control strip. (Press the *i* button to activate the strip.)

Release mode: The default Release mode is Single Frame for all modes except Sports, which uses Continuous (burst) mode shooting. However, you don't have to stick with the default; to change the setting, press the Release mode button, located just under the Multi Selector on the back of the camera and labeled with the symbol shown in the margin here.

Finally, understand that the results you get from any Scene mode vary depending on the lighting, your subject, and the range of aperture settings available on your lens. Those factors determine which exposure settings the camera can select, which in turn affects how much of the scene appears in focus and whether moving objects appear blurry. (To fully understand how exposure settings affect these aspects of your pictures, check out Chapter 4.)

With those preliminaries out of the way, the next sections provide a bit more detail about each Scene mode.

Portrait mode

Choose this mode to produce the classic portrait look, with the subject set against a softly focused background, as shown on the left in Figure 3-8. Colors are adjusted to produce natural-looking skin tones.

How the camera finds its focusing target depends on whether you're using the viewfinder or Live View mode:

- >> Viewfinder autofocusing: By default, the camera sets the AF-area mode to the Auto Area setting, which means that the camera selects the focus point for you. The closest object typically is chosen as the focus point.
- >> Live View autofocusing: In Live View mode, Face Priority autofocusing is in force, and the camera outlines any faces it detects with yellow selection boxes, just as it does in Auto mode. (Refer to the left side of Figure 3-6.) Remember that the box with the interior corner marks indicates the selected face; use the Multi Selector to move that box to a different face. Keep in mind that the face-detection feature works best when your subject is looking directly into the lens. If your subject is looking away from the camera, the face may not be

detected. In that case, you see the red rectangular focus box (refer to the right screen in Figure 3-6). Use the Multi Selector to move the frame over the spot where you want the camera to set focus.

Landscape mode

FIGURE 3-8: Portrait mode produces soft backgrounds to help emphasize your subject (left); Landscape mode produces bold colors and a large depth of field (right).

Landscape mode

Rotate the Landscape mode to produce crisp images with vivid blues and greens and a large *depth of field* — that is, one in which both foreground and background objects appear sharp. See the right side of Figure 3–8 for an example.

In Landscape mode, flash is disabled. If you use autofocusing, the focus point is set just as described for Portrait mode, in the preceding section. Remember that in Live View mode, you need to move the red focus box over the area of the frame you want to use to set the focusing distance. If you're using the viewfinder, the camera sets the focusing distance automatically.

Child mode

A variation of Portrait mode, Child mode tries to use a slightly faster shutter speed than Portrait mode. The idea is that a faster shutter speed, which freezes action, helps you get a sharp picture of children who aren't sitting perfectly still. That's the upside; the downside is that to properly expose the image at that faster shut-ter speed — which reduces the exposure time — the camera has to raise the ISO setting, which makes the camera more sensitive to light. And as ISO goes up, you increase the chances of *noise*, a defect that looks like speckles in your photo. (Chapter 4 discusses this issue in more detail.)

Like Portrait mode, Child mode also aims for a blurry background and natural skin tones. Colors of clothing and other objects, however, are rendered more vividly. That's a picture characteristic I dislike: I don't want background objects or clothing to take the eye away from the face of my subject. But shoot some samples in both Portrait and Child to see which one you prefer. Depending on the subject's attire and the background, you may not see much difference between the two modes.

Flash and autofocusing work as they do for Portrait mode, described a few paragraphs ago.

Sports mode

Select Sports mode to have a better chance of capturing a moving target without blur, as I did in Figure 3-9. To accomplish this outcome, the camera selects a fast shutter speed, if possible. (A fast shutter speed freezes action; a slow shutter speed blurs it.)

Keep these Sports mode pointers in mind:

Sports mode works best in bright daylight. As with Child mode, the camera may amp up the ISO (light sensitivity) to allow a faster shutter speed, increasing the chances of image noise. In very dim lighting, even the ISO increase may not allow a fast enough shutter speed to stop action.

>> The Release mode is set to Continuous by default. In this mode, the camera captures as many as five frames per second, continuing to record images as long as you hold down the shutter button. How many frames per second you can record per second varies depending on a number of factors, which you can explore in Chapter 2. The camera will stop taking pictures if its memory buffer (temporary data storage tank) becomes full. Just give the camera a moment to write the current data to the memory card, and you should be able to start clicking off frames again.

If you prefer, you can change the Release mode to Single Frame or any other mode you choose. For fast access to this setting, press the Release mode button on the back of the camera.

FIGURE 3-9: Try Sports mode to capture action.

Flash is disabled. Flash is incompatible with Continuous mode, for a couple of reasons. First, when flash is enabled, the fastest shutter speed is 1/200 second, which may not be fast enough to freeze your subject in place. Additionally, the flash needs time to recycle between shots, reducing the number of frames you can capture per second.

>> You need to use a special technique to set the focus point during viewfinder photography. Autofocusing works a little differently in this mode than the other Scene modes: The default AF-area mode setting is Dynamic Area instead of Auto Area. In Dynamic Area mode, you start by using the Multi Selector to choose a focus point. To see which point is active, look through the viewfinder and press the shutter button halfway — the active point turns red for a moment. You can then release the shutter button and press the Multi Selector up, down, left, and right to choose a different point. As you press the Multi Selector button, the selected point flashes red.

After choosing a point, frame the picture with your subject under that point and press the shutter button halfway. The camera sets focus on that point initially, but if your subject moves out of that point, the camera looks to the other focus points for focusing information and adjusts focus as necessary. Your responsibility is to reframe the shot as needed to keep the subject within the area covered by the focus points.

For Live View shooting, focus tracking is turned off by default. Instead, the camera locks focus when you press the shutter button halfway. But you can enable continuous focusing by changing the Focus mode from AF-S to AF-F. See Chapter 5 to find out how this Focus mode works and how you can modify its behavior by also adjusting the AF-Area Mode setting.

Close Up mode

Like Portrait and Child modes, Close Up mode is designed to produce a blurry background to keep background objects from competing for attention with your subject, as shown in Figure 3-10.

FIGURE 3-10: Close Up mode helps emphasize the subject by throwing the background out of focus. Close Up mode requires an autofocusing approach that varies depending on whether you're using the viewfinder or Live View shooting:

- >> Autofocusing during viewfinder photography: Close Up mode uses an AF-area mode called Single Point, which simply means that only one of the camera's 11 autofocus points is active. The center point is selected by default, but you can use the Multi Selector to choose a different point. Press the shutter button halfway to light up the selected point in the viewfinder; then release the shutter button and press the Multi Selector up, down, left, or right to cycle through the points. Frame your subject so that it falls under the selected point and then press the shutter button halfway to focus. You do have the option of changing the focusing behavior — you can choose to have all focus points active, for example.
- >> Autofocusing during Live View shooting: In Close Up mode, the normal red rectangle that appears as the focus frame (refer to Figure 3-6) is replaced with a smaller red box. The idea is to limit the focusing area to a smaller portion of the frame, hopefully to permit more accurate focusing. You use the smaller focus frame just like the larger one: Use the Multi Selector to move the frame over your subject and then press the shutter button halfway to establish focus. You do have the option of switching to another AF-area mode (the setting that controls this aspect of autofocusing). See Chapter 5 for help understanding your choices and for some other tips on Live View autofocusing.

By default, Flash is set to Auto mode, but you can switch to Flash Off or Red-Eye Reduction mode if you prefer. Just press the Flash button and rotate the Command dial to change the Flash mode. You also can change the Flash mode via the control strip; press the *i* button to display the control strip.

Night Portrait mode

This mode is designed to deliver a better-looking flash portrait at night (or in any dimly lit environment). It does so by constraining you to using Auto Slow-Sync, Auto Slow-Sync with Red-Eye Reduction, or Flash Off modes. In the first two Flash modes, the camera selects a shutter speed that results in a long exposure time. That slow shutter speed enables the camera to rely more on ambient light and less on the flash to expose the picture, which produces softer, more even lighting. If you disable flash, an even slower shutter speed is used.

A slow shutter speed means that any movement of the subject or the camera may result in a blurry image. Always use a tripod and ask your subjects to stay still.

WARNING

Autofocusing works the same as for regular Portrait mode, described earlier in this chapter.

Beyond the Basics

IN THIS PART ...

Find out how to control exposure and shoot in the advanced exposure modes (P, S, A, and M).

Master the focusing system and discover how to control depth of field.

Manipulate color by using white balance and other color options.

Get pro tips for shooting portraits, action shots, landscapes, close-ups, and more.

Take advantage of your camera's HD movie-recording features.

IN THIS CHAPTER

- » Understanding the basics of exposure
- » Choosing the right exposure mode: P, S, A, or M?
- » Reading meters and other exposure cues
- » Setting f-stop, shutter speed, and ISO
- » Solving exposure problems

Chapter **4** Taking Charge of Exposure

nderstanding exposure is one of the most intimidating challenges for a new photographer. Discussions of the topic are loaded with technical terms — *aperture, metering, shutter speed, ISO,* and the like. Add the fact that your camera offers many exposure controls, all sporting equally foreign names, and it's no wonder that most people throw up their hands and decide that their best option is to stick with the Auto exposure mode and let the camera take care of all exposure decisions.

You can, of course, turn out good shots in Auto mode, and I fully relate to the confusion you may be feeling — I've been there. But I can also promise that when you take things nice and slow, digesting a piece of the exposure pie at a time, the topic is *not* as complicated as it seems on the surface. I guarantee that the payoff will be worth your time, too. You'll not only gain the know-how to solve just about any exposure problem but also discover ways to use exposure to put your creative stamp on a scene.

To that end, this chapter provides everything you need to know about controlling exposure, from a primer in exposure terminology (it's not as bad as it sounds) to

tips on using the P, S, A, and M exposure modes, which are the only ones that offer access to all exposure features.

Note: The one exposure-related topic not covered in this chapter is flash; I discuss flash in Chapter 2 because it's among the options you can access even in Auto mode and some other point-and-shoot modes. Also, this chapter deals with still photography; see Chapter 8 for information on movie-recording exposure issues.

Introducing the Exposure Trio: Aperture, Shutter Speed, and ISO

Any photograph is created by focusing light through a lens onto a light-sensitive recording medium. In a film camera, the film negative serves as that medium; in a digital camera, it's the *image sensor*, which is a sophisticated electrical component

that measures the light in a scene and then passes that information to the camera's data-processing center so that an image can be created. (Yes, a digital camera is essentially a computer with a lens.)

Between a digital camera's lens and sensor are two barriers — the aperture and shutter — which work in concert to control how much light makes its way to the sensor. In the digital world, the design and arrangement of the aperture, shutter, and sensor vary depending on the camera; Figure 4-1 offers an illustration of the basic concept.

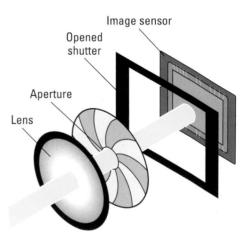

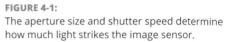

The aperture and shutter, along with

a third feature — ISO — determine *exposure*, which is basically the picture's overall brightness and contrast. This three-part exposure formula works as follows:

Aperture (controls amount of light): The aperture is an adjustable hole in a diaphragm inside the lens. You change the aperture size to control the size of the light beam that can enter the camera.

Aperture settings are stated as *f-stop numbers*, or simply *f-stops*, and are expressed by the letter *f* followed by a number: f/2, f/5.6, f/16, and so on. The lower the f-stop number, the larger the aperture, and the more light is permitted into the camera, as illustrated by Figure 4-2. (If it seems backward to use a higher number for a smaller aperture, think of it this way: A higher value creates a bigger light barrier than a lower value.) The range of available aperture settings varies from lens to lens.

FIGURE 4-2: A lower f-stop number means a larger aperture, allowing more light into the camera.

> >> Shutter speed (controls duration of light): The shutter works something like, er, the shutters on a window. The camera's shutter stays closed, preventing light from striking the image sensor (just as closed window shutters prevent sunlight from entering a room) until you press the shutter button. Then the shutter opens briefly to allow light that passes through the aperture to hit the sensor. The exception to this scenario is when you compose in Live View mode: When you enable Live View, the shutter opens and remains open so that the image can form on the sensor and be displayed on the monitor. When you press the shutter button, the shutter first closes and then reopens for the actual exposure.

Either way, the length of time that the shutter opens to produce the exposure is the *shutter speed*, which is measured in seconds: 1/250 second, 1/60 second, 2 seconds, and so on.

ISO (controls light sensitivity): ISO, which is a digital function rather than a mechanical structure on the camera, enables you to adjust how responsive the image sensor is to light.

The term *ISO* is a holdover from film days, when a photography group called International Organization for Standards rated each film stock according to light sensitivity: ISO 200, ISO 400, ISO 800, and so on. No, I don't know why the settings aren't called IOS values instead of ISO, but it turned out to be a good thing because now iOS is used to refer to the Apple operating system. At any rate, a higher ISO rating means greater light sensitivity. On a digital camera, the sensor itself doesn't actually get more or less sensitive when you change the ISO. Instead, the light "signal" that hits the sensor is either amplified or dampened through electronics wizardry, sort of like how raising the volume on a radio boosts the audio signal. The upshot is the same as changing to a more light-reactive film stock. Using a higher ISO means that less light is needed to produce the image, enabling you to use a smaller aperture, faster shutter speed, or both.

Distilled to its essence, the image-exposure formula is this simple:

- Together, aperture and shutter speed determine how much light strikes the image sensor.
- ISO determines how much the sensor reacts to that light and thus how much light is needed to expose the picture.

The tricky part of the equation is that aperture, shutter speed, and ISO settings affect pictures in ways that go beyond exposure:

- Aperture affects *depth of field*, or the distance over which focus remains acceptably sharp.
- Shutter speed determines whether moving objects appear blurry or sharply focused.
- ISO affects the amount of image *noise*, which is a defect that looks like specks of colored sand.

Understanding these side effects is critical to choosing the combination of aperture, shutter speed, and ISO that will work best for your subject, so the next three sections explore each issue. If you're already familiar with this stuff and just want to know how to adjust exposure settings, skip ahead to the section "Setting Aperture, Shutter Speed, and ISO."

Aperture affects depth of field

The aperture setting, or f-stop, affects *depth of field*, which refers to how far in front of and behind your point of focus — which, presumably, is your subject — things appear acceptably sharp. With a shallow depth of field, your subject appears more sharply focused than background and foreground objects; with a long depth of field, the sharp-focus zone spreads over a greater distance from your subject.

As you reduce the aperture size by choosing a higher f-stop number — *stop down the aperture* in photo lingo — you increase the depth of field. For an example, see Figure 4–3. In both shots, I established focus on the fountain statue. Notice that the background in the first image, taken at f/13, is sharper than in the right example, taken at f/5.6. Aperture is just one contributor to depth of field, however; the focal length of the lens and the distance between that lens and your subject also affect how much of the scene stays in focus. See Chapter 5 for the complete story on depth of field.

f/5.6, 1/125 second, ISO 200

f/13, 1/25 second, ISO 200

FIGURE 4-3: Widening the aperture (choosing a lower f-stop number) decreases depth of field.

One way to remember the relationship between f-stop and depth of field is to think of the f as standing for *focus*. A higher f-stop number produces a longer depth of field, so if you want to extend the zone of sharp focus to cover a greater distance from your subject, you set the aperture to a higher f-stop. Higher *f*-stop number, greater zone of sharp focus. (Please *don't* share this tip with photography elites, who will roll their eyes and inform you that the *f* in *f*-stop most certainly does *not* stand for focus but for the ratio between the aperture size and lengt focal length — as if *that's* helpful to know if you're not an optical engineer. Chapter 1 explains focal length, which *is* helpful to know.)

Shutter speed affects motion blur

At a slow shutter speed, moving objects appear blurry; a fast shutter speed captures motion cleanly. This phenomenon has nothing to do with the actual focus point of the camera but rather on the movement occurring — and being recorded by the camera — while the shutter is open.

Compare the photos in Figure 4-3, for example. The static elements are perfectly focused in both images although the background in the left photo appears sharper because I shot that image using a higher f-stop, increasing the depth of field. But how the camera rendered the moving portion of the scene — the fountain water was determined by shutter speed. At 1/25 second (left photo), the water blurs, giving it a misty look. At 1/125 second (right photo), the droplets appear more sharply focused, almost frozen in mid-air. How high a shutter speed you need to freeze action depends on the speed of your subject.

If your picture suffers from overall blur, as in Figure 4-4, the camera itself moved during the exposure, which is always a danger when you handhold a camera. The slower the shutter speed, the longer the exposure time and the longer you have to hold the camera still to avoid the blur

FIGURE 4-4: If both stationary and moving objects are blurry, camera shake is the usual cause.

that's caused by camera shake. Use a tripod to avoid this issue.

Freezing action isn't the only way to use shutter speed to creative effect. When shooting waterfalls, for example, many photographers use a slow shutter speed to give the water even more of a blurry, romantic look than you see in my fountain example. With colorful moving subjects, a slow shutter can produce some cool abstract effects and create a heightened sense of motion. Chapter 7 offers examples of both effects.

ISO affects image noise

As ISO increases, making the image sensor more reactive to light, you increase the risk of producing noise. *Noise* is a defect that looks like sprinkles of sand and is similar in appearance to film *grain*, a defect that often mars pictures taken with high ISO film. Figure 4–5 offers an example.

HANDHOLDING THE CAMERA: HOW LOW CAN YOU GO?

TIP

My students often ask how slow they can set the shutter speed and still handhold the camera rather than use a tripod. Unfortunately, there's no one-size-fits-all answer. The slow-shutter safety limit varies depending on a couple factors, including your physical abilities and your lens — the heavier the lens, the harder it is to hold steady. Camera shake also affects your picture more when you shoot with a lens that has a long focal length. You may be able to use a slower shutter speed with a 55mm lens than with a 200mm lens, for example. Also, it's easier to detect slight blurring in an image that shows a close-up view of a subject than in one that captures a wider view.

A standard photography rule is to use the inverse of the lens focal length as the minimum handheld shutter speed. For example, with a 50mm lens, use a shutter speed no slower than 1/50 second. That rule was developed before the advent of today's modern lenses, though, which tend to be significantly lighter and smaller than older lenses, as do cameras themselves. For example, I have a very light, superzoom lens that I can handhold at speeds as low as 1/80 second even when I zoom to focal lengths way beyond 80mm. The best idea is to do your own tests to see where your handholding limit lies. See Chapter 9 to find out how to select the picture-playback mode that enables you to see the shutter speed you used for each picture.

Remember, too, that some lenses offer Vibration Reduction, which can compensate for small amounts of camera shake. If you're using an AF-P lens that offers Vibration Reduction, turn the feature on via the Optical VR setting on the Shooting menu. With AF-S lenses that offer Vibration Reduction, you should find a VR switch on the lens itself. Move the switch to the On position to enable the feature. With other lenses, check the lens instruction manual to find out whether your lens offers this feature and, if so, how to enable it. (The feature may go by another name, such as Vibration Compensation, Optical Stabilization, or Image Stabilization.)

Ideally, then, you should always use the lowest ISO setting on your camera to ensure top image quality. Sometimes, though, the lighting conditions don't permit you to do so and still use the aperture and shutter speeds you need. Take my rose image as an example. When I shot these pictures, I didn't have a tripod, so I needed a shutter speed fast enough to allow a sharp handheld image. I opened the aperture to f/6.3, which was the widest setting on the lens I was using, to allow as much light as possible into the camera. At ISO 100, I needed a shutter speed of 1/40 second to expose the picture, and that shutter speed wasn't fast enough for a successful handheld shot. You see the blurred result on the left in Figure 4–6. By raising the ISO to 200, I was able to use a shutter speed of 1/80 second, which enabled me to capture the flower cleanly, as shown on the right in the figure.

FIGURE 4-5: Caused by a very high ISO or long exposure time, noise becomes more visible as you enlarge the image.

ISO 100, f/5.6, 1/40 second

Fortunately, you don't encounter serious noise on the D3400 until you really crank up the ISO. In fact, you may even be able to get away with a fairly high ISO if you keep the print or display size small. Some people probably wouldn't even notice the noise in the left image in Figure 4–5 unless they were looking for it. But as with other image defects, noise becomes more apparent as you enlarge the photo, as shown on the right in that same figure. Noise is also easier to spot in shadow areas of the picture and in large areas of solid color.

FIGURE 4-6: For this image, raising the ISO allowed me to bump up the shutter speed enough to capture a blurfree shot while handholding the camera. How much noise is acceptable — and, therefore, how high of an ISO is safe — is your choice. Even a little noise isn't acceptable for pictures that require the highest quality, such as images for a product catalog or a travel shot that you want to blow up to poster size.

It's also important to know that a high ISO isn't the only cause of noise: A long exposure time (slow shutter speed) can also produce the defect. Combining a high ISO with a long exposure time, then, increases noise risk.

Doing the exposure balancing act

As you change any of the three exposure settings — aperture, shutter speed, or ISO — one or both of the other two must also shift to maintain the same image brightness. Say that you're shooting a soccer game and you notice that although the overall exposure looks great, the players appear slightly blurry at the current shutter speed. If you raise the shutter speed, you have to compensate with a larger aperture (to allow in more light during the shorter exposure) or a higher ISO setting (to make the camera more sensitive to the light) — or both.

Again, changing these settings impacts the image in ways beyond exposure:

- Aperture affects depth of field, with a higher f-stop number increasing the distance over which objects appear sharp.
- Shutter speed affects whether motion of the subject or camera results in a blurry photo. A faster shutter "freezes" action and also helps safeguard against all-over blur that can result from camera shake when you're handholding the camera.
- ISO affects the camera's sensitivity to light. A higher ISO makes the camera more responsive to light but also increases the chance of image noise.

Going back to the soccer situation, if you want to boost the shutter speed to freeze the action, you have to decide whether you prefer the shallower depth of field that comes with a larger aperture or the increased risk of noise that accompanies a higher ISO.

Everyone has his or her own approach to finding the right combination of aperture, shutter speed, and ISO, and you'll no doubt develop your own system as you become more familiar with these concepts. In the meantime, here's how I handle things:

 I use ISO 100, the lowest setting on the camera, unless the light is so dim that I can't use the aperture and shutter speed I want without raising the ISO.

- If my subject is moving, I give shutter speed the next highest priority in my exposure decision. I might choose a fast shutter speed to ensure a blur-free photo or, on the flip side, select a slow shutter to intentionally blur that moving object, an effect that can create a heightened sense of motion.
- For nonmoving subjects, I make aperture a priority over shutter speed, setting the aperture according to the depth of field I have in mind. For portraits, for example, I use a large aperture — say, in the range of f/2.8 to f/5.6 — so that I get a shallow depth of field, creating a nice, soft background for my subject. For landscapes, I usually go the opposite direction, stopping down the aperture as much as possible to capture the subject at the greatest depth of field. (Again, remember that the range of f-stops you can choose depends on your lens.)

Be careful not to go too shallow with depth of field when shooting a group portrait. Unless all the subjects are the same distance from the camera, some may be outside the zone of sharp focus. A shallow depth of field also makes action shots more difficult because you have to be absolutely spot on with focus. With a greater depth of field, the subject can move farther toward or away from you before leaving the sharp-focus area, giving you a bit of a focusing safety net.

Keeping all this straight is a little overwhelming at first, but the more you work with your camera, the more the whole exposure equation will make sense to you. You can find tips for choosing exposure settings for specific types of pictures in Chapter 7; keep moving through this chapter for details on how to actually adjust aperture, shutter speed, and ISO.

Stepping Up to Advanced Exposure Modes (P, S, A, and M)

In the fully automatic exposure modes, you have little control over exposure. You may be able to choose from one or two Flash modes, and you can adjust ISO in the Scene modes and in all Effects modes except Night Vision.

But to gain full control over exposure, set the Mode dial to one of the advanced modes highlighted in Figure 4–7: P, S, A, or M. You also need to use these modes to take advantage of many other camera features, including some of its color and autofocus options.

I introduce the P, S, A, and M modes in Chapter 2, but because they're critical to your control over exposure, I want to offer some additional information here. First, a recap of how the four modes differ:

- >> P (programmed autoexposure): The camera selects both aperture and shutter speed to deliver a good exposure at the current ISO setting. But you can choose from different combinations of the two for creative flexibility, which is why the official name of this mode is flexible programmed autoexposure.
- >> S (shutter-priority autoexposure): You set the shutter speed. and the camera chooses the aperture setting that produces a good exposure at that shutter speed and the current ISO setting.

Advanced exposure modes

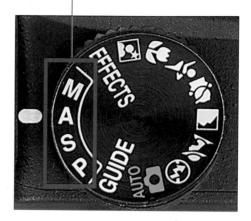

>> A (aperture-priority autoexposure): The opposite of shutterpriority autoexposure, this mode

asks you to select the aperture setting. The camera then selects the appropriate shutter speed — again, based on the selected ISO setting.

>> M (manual exposure): In this mode, you specify both shutter speed and aperture.

REMEMBER

To sum up, the first three modes are semiautomatic modes that are designed to offer exposure assistance while still providing you with some creative control. Note one important point about P, S, and A modes, however: In extreme lighting conditions, the camera may not be able to select settings that will produce a good exposure, and it doesn't stop you from taking a poorly exposed photo. You may be able to solve the problem by using features designed to modify autoexposure results, such as Exposure Compensation (explained later in this chapter) or by adding flash, but you get no guarantees.

Manual mode puts all exposure control in your hands. If you're a longtime photographer who comes from the days when manual exposure was the only game in town, you may prefer to stick with this mode. If it ain't broke, don't fix it, as they say. And in some ways, manual mode is simpler than the semiautomatic modes — if you're not happy with the exposure, you just change the aperture, shutter speed, or ISO setting and shoot again. By contrast, when you use the P, S, and A modes, you have to experiment with features that modify autoexposure results, such as the aforementioned Exposure Compensation.

My choice is to use aperture-priority autoexposure when I'm shooting stationary subjects and want to control depth of field — aperture is my *priority* — and to switch to shutter-priority autoexposure when I'm shooting a moving subject and I'm most concerned with controlling shutter speed. Frankly, my brain is taxed enough by all the other issues involved in taking pictures — what my Release mode setting is, what resolution I need, where I'm going for lunch as soon as I make this shot work — that I appreciate having the camera do some of the exposure "lifting."

However, when I know exactly what aperture and shutter speed I want to use or I'm after an out-of-the-ordinary exposure, I use manual exposure. For example, sometimes when I'm doing a still life in my studio, I want to create a certain mood by underexposing a subject or even shooting it in silhouette. The camera will always fight you on that result in the P, S, and A modes because it so dearly wants to provide a good exposure. Rather than dial in all the autoexposure tweaks that could eventually force the result I want, I simply set the mode to M, adjust the shutter speed and aperture directly, and give the autoexposure system the afternoon off.

But even when you use the M exposure mode, you're never really flying without a net: The camera assists you by displaying the exposure meter, explained next.

Checking the Exposure Meter

Before explaining how to adjust aperture, shutter speed, and ISO, I want to introduce you to your camera's most important exposure guide: the *exposure meter*. The meter tells you whether the camera thinks your picture will be properly exposed at your chosen exposure settings.

However, if and when the meter appears depends on whether you shoot in the M, P, S, or A exposure mode:

M mode: The meter is always present in the Information and Live View displays, as shown in Figure 4-8. You also can see a simplified version of the meter in the viewfinder data display; Figure 4-9 offers a close-up look at that meter design.

By default, the Information display uses a different color scheme in the P, S, A, and M exposure modes than in the Auto, Scene, and Effects modes. You get a black background in P, S, A, and M modes instead of the silver background used in the other modes. I have absolutely no idea why this design decision was implemented, but if you don't care for it, you can change the background color via the Info Display Format option on the Setup menu. You can even switch to a blue background if that floats your boat. Chapter 12 has details. In this book, I show the displays in their default styles.

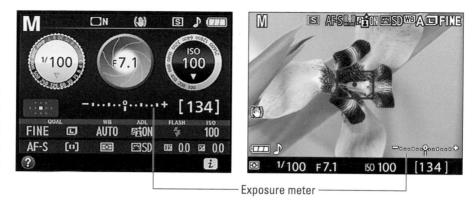

FIGURE 4-8: In M exposure mode, the exposure meter appears in the Information and Live View displays.

FIGURE 4-9: The viewfinder offers a simplified meter design, with bars under the meter indicating the amount of under or overexposure.

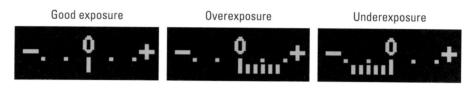

>> P, S, and A modes: The meter doesn't appear unless the camera anticipates an exposure problem — for example, if you're shooting in S (shutter-priority autoexposure) mode, and the camera can't select an f-stop that will properly expose the image at your chosen shutter speed and ISO. The meter also shows up if you enable Exposure Compensation. Through this feature, which I detail toward the end of this chapter, you can request a brighter or darker exposure on your next shot. The meter indicates the level of adjustment you request through the Exposure Compensation setting.

Either way, here's what you need to know about using the meter:

Waking up the meter: By default, the meter appears when you press the shutter button halfway, and then the meter turns off automatically after 8 seconds of inactivity to save battery power. To wake up the meter, just give the shutter button another half-press.

You can adjust the meter's auto shutdown timing via the Auto Off Timers option, found on the Setup menu. Chapter 12 has details, if you need help.

Reading the meter: The minus-sign end of the meter represents underexposure; the plus sign, overexposure. If you see just a single vertical bar under the 0 on the meter, as in Figure 4-8 and the left example in Figure 4-9, you're good to go. But if small bars appear to the left or right of the zero mark, you have a problem. If the bars appear to the right of 0, as shown in the middle example in Figure 4-9, the image will be overexposed. If the bars appear to the left of zero, as in the right example in Figure 4-9, the photo will be underexposed.

A few details to note:

The markings on the meter indicate exposure stops. A stop is an increment of
exposure adjustment. To increase exposure by one stop means to adjust
the aperture or shutter speed to allow twice as much light into the camera
as the current settings permit. To reduce exposure a stop, you can use
settings that allow half as much light. Doubling or halving the ISO value
also adjusts exposure by one stop.

On the viewfinder meter (refer to Figure 4-9), the squares on either side of the 0 represent one full stop each. The small lines below, which appear only when the meter needs to indicate over- or underexposure, break each stop into thirds. So the middle readout in Figure 4-9, for example, indicates an overexposure of 1 and 2/3 stop. The right readout indicates the same amount of underexposure.

On the Information and Live View meters, the concept is the same, but because these screens have room for a larger meter display, the third-stop meter positions appear along with the full-stop markings. The taller bars on the meter represent the full-stop position; the smaller bars between, the third-stop positions. Again, if the camera anticipates an exposure problem, bars appear *under* the meter to indicate the extent of the problem.

- If a triangle appears at the end of the meter, the amount of over- or underexposure exceeds the two-stop range of the meter. In other words, you have a serious exposure problem.
- Don't forget that when Exposure Compensation is enabled, the meter indicates how much exposure adjustment is in force. For example, if you ask the camera for a brighter picture on your next shot and you request a one-stop adjustment, the meter will indicate an overexposure of one stop. That's because the camera thinks that its original exposure settings were dead on — and you're overriding that decision through Exposure Compensation.
- >> Understanding how exposure is calculated: The information the meter reports is based on the *Metering mode*, which determines which part of the frame the camera considers when calculating exposure. At the default setting, exposure is based on the entire frame, but you can select two other Metering modes. See the next section for details.

There's one metering quirk to note with respect to Live View photography: In Live View mode, metering may be calculated differently for some scenes than when you use the viewfinder. The rationale is to produce an exposure that's close to what you see in the live preview, which gets darker or lighter as you change exposure settings in an attempt to simulate the exposure you'll get. However, I don't recommend that you trust the preview, because it can be deceiving depending on the ambient light in which you're viewing the monitor. In addition, when you apply Exposure Compensation, an option that produces a brighter or darker image in the P, S, and A modes, the monitor can't adjust itself to accommodate the full range of Exposure Compensation settings. Long story short: The meter is a more accurate indication of exposure than the live preview.

Finally, keep in mind that the meter's suggestion on exposure may not always be the one you want to follow. For example, you may want to shoot a backlit subject in silhouette, in which case you *want* that subject to be underexposed. So consider the meter a guide, not a dictator.

Choosing an Exposure Metering Mode

To interpret what the exposure meter tells you, you need to be aware of the current *Metering mode*, which determines which part of the frame the camera analyzes to calculate exposure. The Metering mode affects the meter reading in M mode as well as the exposure settings that the camera chooses in the fully automatic shooting modes as well as in the P, S, and A modes.

The Information display and Live View screen both contain a symbol representing the current metering mode; look in the areas labeled in Figure 4–10. You can choose from three modes, described in the following list and represented in the displays by the icons shown in the margins:

				1
L	1	-		I
		ų		I
				I

Matrix: The camera analyzes the entire frame and selects an exposure that's designed to produce a balanced exposure.

()	

Center-weighted: The camera bases exposure on the entire frame but puts extra emphasis — or weight — on the center of the frame. Specifically, the camera assigns 75 percent of the metering weight to an 8mm circle in the center of the frame.

Spot: In this mode, the camera bases exposure entirely on a circular area that's about 3.5mm in diameter, or about 2.5 percent of the frame. The location used for this pinpoint metering depends on an autofocusing option called the AF-area mode. Detailed in Chapter 5, this option determines which of the camera's focus points the autofocusing system uses to establish focus. Here's how the setting affects exposure:

- *If you choose the Auto Area mode,* in which the camera chooses the focus point for you, exposure is based on the center focus point.
- If you use any of the other AF-area modes, which enable you to select a specific focus point, the camera bases exposure on that point.

Because of this autofocus/autoexposure relationship, it's best to switch to one of the AF-area modes that allow focus-point selection when you want to use spot metering. In Auto Area mode, exposure may be incorrect if you compose your shot so that the subject isn't at the center of the frame.

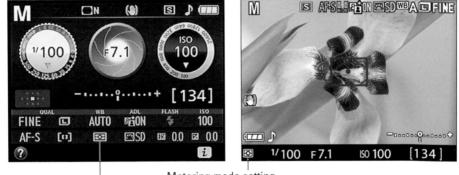

FIGURE 4-10: This symbol represents the Matrix metering mode.

- Metering mode setting

As an example of how Metering mode affects exposure, Figure 4-11 shows the same image captured in each mode. With matrix metering, the bright background caused the camera to select an exposure that left the statue quite dark. Switching to center-weighted metering helped somewhat but didn't quite bring the statue out of the shadows. Spot metering produced the best result as far as the statue goes, although the resulting increase in exposure left the sky a little washed out.

Matrix metering is the default setting, and you can change the Metering mode only in the P, S, A, and M exposure modes. You can get the job done in two ways:

Control strip: Press the *i* button to display the control strip and then highlight the Metering mode symbol, as shown on the left in Figure 4-12. Press OK to display the screen shown on the right, select the setting you want to use, and press OK again.

Shooting menu: You also can adjust the setting via the Metering option on the Shooting menu, as illustrated in Figure 4-13.

(4)

S 🕽 📶

Center-weighted metering

Spot metering

FIGURE 4-12: Press the *i* button to activate the control strip and access the Metering mode setting.

> FIGURE 4-13: You also can change the Metering mode via the Shooting menu.

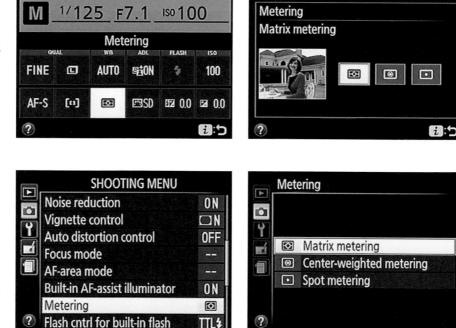

In theory, the best practice is to check the Metering mode before you shoot and choose the one that best matches your exposure goals. But that's a bit of a pain, not just in terms of having to adjust yet one more capture setting but also in terms of having to *remember* to adjust one more capture setting. Here's my advice: Until you're really comfortable with all the other controls on your camera, just stick with

the default setting, which is matrix metering. That mode produces good results in most situations, and after all, you can see in the monitor whether you disagree with how the camera metered or exposed the image and simply reshoot after adjusting the exposure settings to your liking. This option, in my mind, makes the whole Metering mode issue a lot less critical than it is when you shoot with film.

The one exception might be when you're shooting a series of images in which a significant difference in lighting exists between subject and background. Then, switching to center-weighted or spot metering may save you the time spent having to adjust the exposure for each image. (Don't worry about the background coming out too bright or too dark in those metering modes if your subject is properly exposed.)

Setting Aperture, Shutter Speed, and ISO

The next sections detail how to view and adjust the critical exposure settings — Aperture, Shutter Speed, and ISO. For a review of how each setting affects your pictures, check out the first part of this chapter.

Adjusting aperture and shutter speed

You can view the current aperture (f-stop) and shutter speed in the Information display and Live View display, as well as in the viewfinder, as shown in Figures 4-14 and 4-15. (If you don't see this data in Live View mode, press the Info button to cycle through the various display options until your screen looks similar to the one in the figure.)

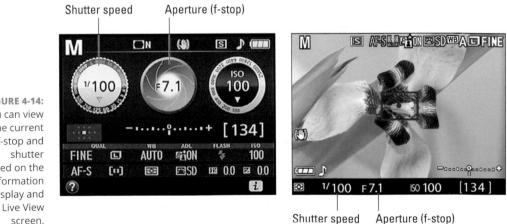

FIGURE 4-14: You can view the current f-stop and speed on the Information display and screen.

In the viewfinder, shutter speeds are presented as whole numbers, even if the shutter speed is set to a fraction of a second. For example, the number 100 indicates a shutter speed of 1/100 second. When the shutter speed slows to 1 second or more, quote marks appear after the number — 1" indicates a shutter speed of 1 second, 4" means 4 seconds, and so on.

To select aperture and shutter speed, start by pressing the shutter button halfway to kick the exposure system into gear. You can then release the button. The next step depends on the exposure mode, as follows:

Shutter speed Aperture (f-stop)

FIGURE 4-15: The settings also appear in the viewfinder.

P (programmed autoexposure): The camera displays its recommended f-stop and shutter speed when you press the shutter button halfway. But you can rotate the Command dial to select a different combination of settings. The number of possible combinations depends on the aperture settings the camera can select, which depends on your lens.

An asterisk (*) appears next to the P symbol in the upper-left corner of the Information and Live View displays if you adjust the aperture/shutter speed settings. You see a tiny P* symbol at the left end of the viewfinder display as well. To get back to the initial combo of shutter speed and aperture, rotate the Command dial until the asterisk disappears from the displays and the P* viewfinder symbol turns off.

S (shutter-priority autoexposure): Rotate the Command dial to set the shutter speed. As you do, the camera automatically adjusts the aperture as needed to maintain proper exposure.

Available shutter speeds range from 30 seconds to 1/4000 second *except* when flash is enabled. When you use flash, the top shutter speed is 1/200 second; minimum shutter speeds vary depending on the exposure mode. (See Chapter 2 for flash details.) This limitation is due to the way the camera must time the flash with the opening of the shutter.

As the aperture shifts, so does depth of field — so even though you're working in shutter-priority mode, keep an eye on the f-stop, too, if depth of field is important to your photo. Also note that in extreme lighting conditions, the camera may not be able to adjust the aperture enough to produce a good exposure at the current shutter speed. So you may need to compromise on shutter speed or ISO. >> A (aperture-priority autoexposure): Rotate the Command dial to adjust the f-stop setting. The camera automatically selects the appropriate shutter speed needed to expose the image at your chosen aperture.

The range of available f-stop settings depends on your lens. For zoom lenses, the range typically also changes as you zoom in and out. For example, a lens may offer a maximum aperture of f/3.5 when set to its widest angle (shortest focal length) but limit you to f/5.6 when you zoom in to a longer focal length. Check your lens manual for details on the minimum and maximum aperture settings.

The aperture symbol that surrounds the f-stop value in the Information display is designed to remind you about what the f-stop setting does: The center of the graphic grows or shrinks as you change the f-stop value, indicating that the setting is opening or closing the aperture. Note that this graphic disappears if you switch from the default Information display style (called Graphic) to a simpler display (Classic). You adjust this setting via the Info Display Format option on the Setup menu, which is the same option that enables you to alter the display background color. Chapter 12 tells all.

When you raise the f-stop value, be careful that the shutter speed doesn't drop so low that you risk camera shake if you handhold the camera. And if your scene contains moving objects, make sure that the shutter speed the camera selects is fast enough to stop action (or slow enough to blur it, if that's your creative goal). These same warnings apply when you use P mode.

>> M (manual exposure): Set aperture and shutter speed like so:

• To adjust shutter speed: Rotate the Command dial.

In Manual mode, you can access two shutter speed settings not available in the other modes: Rotate the dial one notch past the slowest speed (30 seconds) to access the *Bulb* setting, which keeps the shutter open as long as the shutter button is pressed. Rotate the dial one more time to display the *Time* setting. When you select the Time setting, press the shutter button once to begin the exposure and a second time to end it; maximum exposure time is 30 minutes. If you set the shutter speed to either of these options and then change the Mode dial to S, an alert appears in the Information and Live View displays to let you know that you can't use those options in S mode; you must shift back to M mode to take advantage of them.

When you use Bulb and Time modes, the pressure of your finger on the shutter button may create enough vibration to blur the photo. So for best results, use a remote control to trigger the shutter release in these modes.

• *To adjust aperture:* Press the Exposure Compensation button (on top of the camera) while rotating the Command dial. Notice the little aperture-like symbol found above the button? That's your reminder of the button's role in setting the f-stop in M mode.

In P, S, or A mode, the settings that the camera selects are based on what it thinks is the proper exposure. If you don't agree, you can switch the camera to manual exposure mode and dial in the aperture and shutter speed that deliver the exposure you want. Or, if you want to stay in P, S, or A mode, you can tweak exposure using the features explained in the section "Solving Exposure Problems," later in this chapter.

Controlling ISO

The ISO setting adjusts the camera's sensitivity to light. A higher ISO enables you to use a faster shutter speed or a smaller aperture (higher f-stop number) because less light is needed to expose the image. But a higher ISO also increases the possibility of noise. (Refer to Figure 4-5.)

You can't adjust ISO in Auto and Auto Flash Off exposure modes; the camera sets the ISO automatically. In any other exposure mode except Night Vision mode, you can choose ISO values ranging from 100 to 25600. You also have the option of sticking with Auto ISO and letting the camera select the ISO it feels is appropriate for your chosen aperture and shutter speed.

To see the ISO setting, look in the Information and Live View displays, in the areas labeled in Figure 4–16. The viewfinder displays ISO information only when the option is set to Auto. In that case, the words ISO AUTO appear on the right end of the viewfinder, just to the left of the Shots Remaining value. Otherwise, the ISO area of the viewfinder is empty.

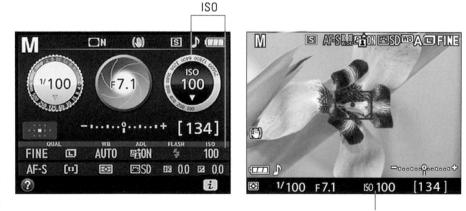

ISO

FIGURE 4-16: The ISO setting appears in the Information and Live View displays. To adjust ISO, you have these options:

Fn (Function) button: By default, pressing the Fn button (left front side of the camera) highlights the ISO setting in the displays. Hold the button while rotating the Command dial to change the setting.

- i button: You also can adjust the setting via the control strip, as illustrated in Figure 4-17.
- Shooting menu: Finally, you can change the setting via the ISO Sensitivity Settings option on the Shooting menu, shown on the left in Figure 4-18. The screen on the right shows options available in the P, S, A, and M modes; you can access only the top option (ISO Sensitivity) in the other exposure modes. Either way, that's the option that sets the ISO level.

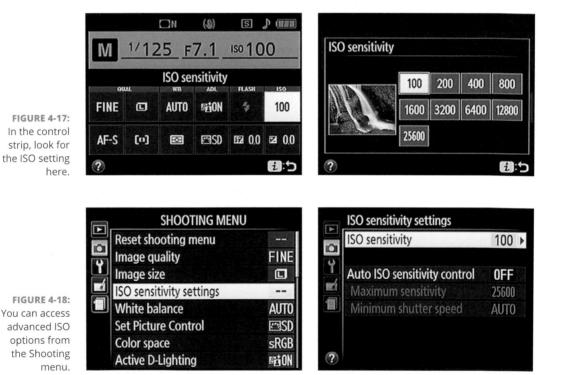

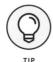

So what's up with the special menu options provided for the P, S, A, and M modes? Well, in those modes, Auto ISO doesn't appear as an option when you select an ISO setting. But by way of the Shooting menu options, you can enable Auto ISO as a backup. Here's how it works: You dial in a specific ISO setting — say, ISO 100.

If the camera decides that it can't properly expose the image at that ISO given the current aperture and shutter speed, it automatically adjusts ISO as necessary.

To enable this option, select ISO Sensitivity Settings on the Shooting menu, as shown on the left in Figure 4–18, and press OK. On the next screen, set the Auto ISO Sensitivity Control option to On, as shown in Figure 4–19.

Next, use these two menu options to tell the camera when it should step in and offer ISO assistance:

Maximum Sensitivity: This option sets the highest ISO that the camera can use when it overrides the selected setting — a great feature

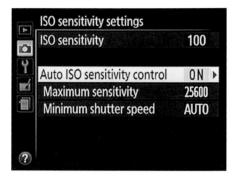

because it enables you to decide how much noise potential you're willing to accept in order to get a good exposure. By default, this value is set to ISO 25600 (the maximum level on the D3400).

Minimum Shutter Speed: Set the minimum shutter speed at which the ISO override engages when you use the P and A exposure modes. (In the M and S exposure modes, ISO is always adjusted as needed to match your selected shutter speed and the current f-stop setting.)

If you set the Minimum Shutter Speed option to Auto instead of to a specific shutter speed, the camera selects the minimum shutter speed at which ISO override occurs based on the focal length of your lens. The idea is that with a longer lens, you need a faster shutter speed to avoid the blur that camera shake can cause when you handhold the camera.

When the camera is about to override your ISO setting, it alerts you by blinking the ISO Auto label in the viewfinder and in the Live View display. The message "ISO-A" blinks in the ISO graphic in the Information display as well. When you view your pictures in the monitor, the ISO value appears in red if you use certain playback display modes. (Chapter 9 has details.)

To disable Auto ISO override, set the Auto ISO Sensitivity Control option to Off.

DAMPENING NOISE

High ISO settings can result in *noise*, the digital defect that gives your pictures a speckled look. (Refer to Figure 4-5.) Long exposure times (slow shutter speeds) also create a noise potential. To help solve these problems, your camera offers the Noise Reduction filter, found on the Shooting menu. I highlighted the menu option in the figure here.

Before you enable noise reduction, be aware that doing so has a few disadvantages. First, the filter is applied after you take the picture, as the camera processes the image data. For pictures taken at a very slow shutter speed or at a very high ISO, the time needed to finish the noise removal can significantly slow down your shooting speed in fact, it can double the time the camera needs to record the file to the memory card. While the noise-removal is in process, you see the message "Job nr" in the viewfinder, and you can't take any pictures.

Second, although long-exposure noise filters do a fairly good job, those that attack high ISO noise work primarily by applying a slight blur to the image. Don't expect this process to totally eliminate noise, and do expect some resulting image softness. You may be able to get better results by using the blur tools or noise-removal filters found in many photo editors because you can blur just the parts of the image where noise is most noticeable — usually in areas of shadows, flat color, or little detail, such as skies.

Unfortunately, you can't totally disable the Noise Reduction feature on the D3400. Even when the option is set to Off, the camera continues to perform noise reduction if and when it deems appropriate. (Don't ask me why they didn't name the settings On and Still On.) Nikon does promise that the amount of adjustment that's applied when you turn the filter off is less than what occurs when you turn Noise Reduction on, so that's something.

	SHOOTING MENU	
	Noise reduction	ON
	Vignette control	
	Auto distortion control	OFF
	Focus mode	
	AF-area mode	
	Built-in AF-assist illuminator	ON
	Metering	\mathbf{O}
?	Flash cntrl for built-in flash	TTL\$

TIP

Solving Exposure Problems

Along with controls over aperture, shutter speed, and ISO, your camera offers a collection of tools designed to solve tricky exposure problems.

If the problem is underexposure due to a lack of ambient light, your camera's builtin flash is at the top of the list of exposure aids to consider. Chapter 2 explains how to get good flash results. But you also have several other exposure-correction features at your disposal, whether your subject appears under- or overexposed. The next several sections introduce you to these features. Also check out Chapter 11, which shows you how to tweak the exposure of existing photos by applying tools found on the Retouch menu.

Applying Exposure Compensation

In the P, S, and A exposure modes, you have some input over exposure: In P mode, you can rotate the Command dial to choose from different combinations of aperture and shutter speed; in S mode, you can dial in the shutter speed; and in A mode, you can select the aperture setting. But because these are semiautomatic modes, the camera ultimately controls the final exposure. If your picture turns out too bright or too dark in P mode, you can't simply choose a different f-stop/ shutter speed combo, because they all deliver the same exposure — which is to say, the exposure that the camera has in mind. And changing the shutter speed in S mode or adjusting the f-stop in A mode won't help either. In S mode, as soon as you change the shutter speed, the camera automatically adjusts the f-stop to produce the same exposure it initially delivered. In A mode, changing the f-stop causes the camera to compensate by adjusting the shutter speed.

Not to worry: You actually do have final say over exposure in P, S, and A modes. The secret is Exposure Compensation, a feature that tells the camera to produce a brighter or darker exposure on your next shot, whether or not you change the aperture or shutter speed (or both, in P mode).

As an example, see the left image in Figure 4-20. The initial exposure selected by the camera left the balloon too dark; I used Exposure Compensation to produce the brighter image on the right.

How the camera arrives at the brighter or darker image depends on the exposure mode: In A mode, the camera adjusts the shutter speed but leaves your selected f-stop in force. In S mode, the camera adjusts the f-stop and keeps its hands off the shutter speed control. In P mode, the camera decides whether to adjust aper-ture, shutter speed, or both. In all three modes, the camera may also adjust ISO if you enable Auto ISO Sensitivity Control. Keep in mind, though, that the camera

can adjust f-stop only so much, according to the aperture range of your lens. And the range of shutter speeds, too, is limited by the camera itself. So there's no guarantee that the camera can actually deliver a better exposure when you dial in Exposure Compensation. If you reach the end of the f-stop or shutter speed range, you either have to adjust ISO or compromise on your selected f-stop or shutter speed. (Remember that when you use the built-in flash, the fastest shutter speed allowed is 1/200 second.)

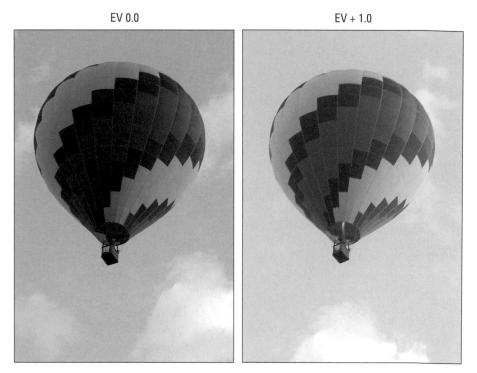

FIGURE 4-20: For a brighter exposure, raise the Exposure Compensation value.

With that background out of the way, here are the details about using Exposure Compensation:

- You also can apply Exposure Compensation in the Scene modes and Night Vision Effects mode. In these modes, the camera decides which exposure setting to adjust to produce a brighter or darker picture.
- Exposure Compensation settings are stated in terms of EV numbers, as in EV +2.0. Possible values range from EV +5.0 to EV nd5.0. (EV stands for exposure value.) Each full number on the EV scale represents an exposure shift of one stop. A setting of EV 0.0 results in no exposure adjustment. For a brighter image, raise the Exposure Compensation value; for a darker image, lower the value. For my balloon image, I set the value to EV +1.0.

>>> Where and how you check the current setting depends on the display, as follows:

• Information display: This one's straightforward: The setting appears in the area labeled on the left in Figure 4-21. In addition, the meter shows the amount of compensation being applied. In Figure 4-21, for example, the meter indicator appears one stop toward the positive end of the meter, reflecting the EV +1.0 setting. Again, don't get confused by the fact that the meter is indicating that the camera thinks your picture will be too bright or too dark — if you liked the results the camera produced at the settings that would put the exposure indicator at the 0 mark, you wouldn't be turning on Exposure Compensation.

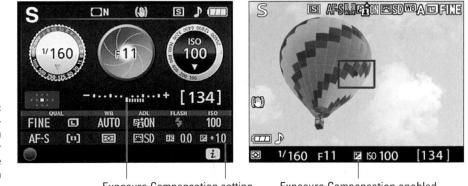

FIGURE 4-21: These indicators tell you whether Exposure Compensation is enabled.

Exposure Compensation setting

Exposure Compensation enabled

 Live View display: If Exposure Compensation is turned on, you see the plus/ minus symbol labeled on the right in the figure; otherwise, that area of the display appears empty.

To view the selected adjustment amount in Live View mode, press the Exposure Compensation button. While the button is pressed, the EV value appears next to the plus/minus symbol.

Viewfinder: The viewfinder also displays the plus/minus symbol only, but again, you can press the Exposure Compensation button to temporarily view the EV setting. Or just look at the exposure meter: As in the Information display, the exposure meter tells you how much exposure shift is in force.

>> You can change the Exposure Compensation setting in two ways:

- Press and hold the Exposure Compensation button while rotating the Command dial. Pressing the button automatically activates the setting, as

shown in Figure 4-22, and you can just spin the Command dial to enter the amount of adjustment you want to apply. (Although the figure shows the Information display, this technique also works in Live View mode.) Remember to keep pressing the button while rotating the Command dial; when you release the button, you can no longer adjust the setting.

Use the control strip. You know

the drill: Press the *i* button to

activate the strip, highlight the

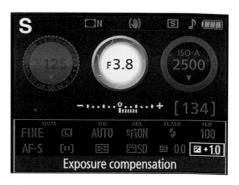

FIGURE 4-22:

Hold down the Exposure Compensation button and rotate the Command dial to adjust the setting.

Exposure Compensation value, and then press OK to display the screen where you can set the amount of adjustment, as shown in Figure 4-23.

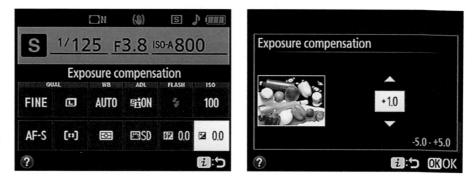

FIGURE 4-23: You can also change the setting via the control strip.

- ➤ As you adjust the setting in Live View mode, the monitor brightness updates to show you how the change will affect exposure. However and this is a biggie, so stop texting and pay attention — the preview can show an adjustment only up to +/- EV 3.0, even though you can set the adjustment as high as +/- EV 5.0. The Exposure Compensation value in the display shows the actual setting; the display just doesn't get any brighter or darker when you request more than a +/- EV 3.0 adjustment.
- When you use flash, the Exposure Compensation setting affects both background brightness and flash power. But you can further modify the flash power through a related option, Flash Compensation. You can find out more about that feature at the end of Chapter 2.

>> Exposure Compensation affects the meter in M exposure mode. Although the camera doesn't change your selected exposure settings in M (manual) exposure mode if Exposure Compensation is enabled, the exposure *meter* is affected: It indicates whether your shot will be properly exposed based on the Exposure Compensation setting. So if you don't realize that Exposure Compensation is enabled, you may mistakenly adjust your exposure settings when they're actually on target.

>> Whether the Exposure Compensation setting is retained when you turn the camera off depends on your exposure mode. In P, S, A, and M exposure modes, the camera doesn't reset the value to EV 0.0 when you power down the camera. In other modes, the value is reset to EV 0.0 when you turn off the camera and also when you choose a different exposure mode.

Expanding tonal range with Active D-Lighting

A scene like the one in Figure 4-24 presents the classic photographer's challenge: Choosing exposure settings that capture the darkest parts of the subject appropriately causes the brightest areas to be overexposed. And if you instead *expose for the highlights* — that is, set the exposure settings to capture the brightest regions properly — the darker areas are underexposed.

In the past, you had to choose between favoring the highlights or the shadows. But with the D3400, you can expand the possible *tonal range* — that's photo-speak for the range of brightness values in an image — through the Active D-Lighting feature. It's designed to give you a better chance of keeping your highlights intact while better exposing the darkest areas.

STUFF

The *D* in Active D-Lighting is a reference to the term *dynamic range*, which is used to describe the range of brightness values that an imaging device can capture. By turning on this feature, you enable the camera to produce an image with a slightly greater dynamic range than usual.

In my seal scene in Figure 4-24, turning on Active D-Lighting produced a brighter rendition of the darkest parts of the rocks and the seals, for example, and yet the color in the sky didn't get blown out as it did when I captured the image with Active D-Lighting turned off. The highlights in the seal and in the rocks on the lower-right corner of the image also are toned down a tad in the Active D-Lighting version.

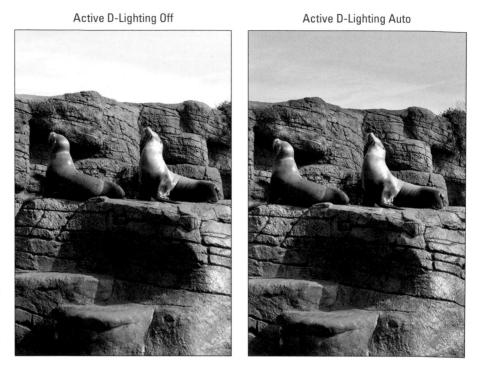

FIGURE 4-24: Active D-Lighting captured the shadows without blowing out the highlights.

Active D-Lighting actually does its thing in two stages. First, it selects exposure settings that result in a slightly darker exposure than normal. This half of the equation guarantees that you retain details in your highlights. After you snap the photo, the camera brightens the darkest areas of the image. This adjustment rescues shadow detail.

The Information and Live View displays both display a symbol to show the current status of the Active D-Lighting setting. Figure 4-25 shows where to find the symbol. You can control whether the feature is activated only in the P, S, A, and M modes.

I usually keep this option set to Off so that I can decide for myself whether I want any adjustment instead of having the camera apply it to every shot. Even with a high-contrast scene that's designed for the Active D-Lighting feature, you may decide that you prefer the "contrasty" look that results from disabling the option.

By default, Active D-Lighting is turned on for the P, A, S, and M exposure modes. You can disable it via the Shooting menu or the Information or Live View control strip, as shown in Figure 4-26. In addition, you have the option of setting the Function (Fn) button to toggle the feature on and off; Chapter 12 shows you how.

Active D-Lighting symbol

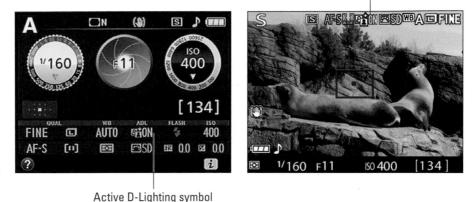

FIGURE 4-25: This symbol tells you whether Active D-Lighting is turned on or off.

FIGURE 4-26: You can adjust the Active D-Lighting setting in the P, S, A, and M exposure modes.

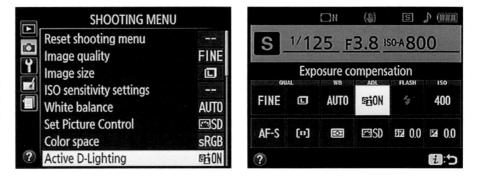

A few final pointers on Active D-Lighting:

- >> You get the best results in matrix metering mode.
- Although Nikon doesn't recommend that you use Active D-Lighting in the M exposure mode, the setting is enabled by default. So remember to turn the option off if you don't want the camera to futz with your selected exposure settings. However, it's worth taking a test shot with the featured turn on if you can't get the results you like with the feature turned off. In M mode, the camera doesn't change the shutter speed or f-stop to achieve the darker exposure it needs for Active D-Lighting to work; instead, the meter readout guides you to select the right settings unless you have automatic ISO override enabled. In that case, the camera may instead adjust ISO to manipulate the exposure.

If you opt out of Active D-Lighting, remember that the camera's Retouch menu offers a D-Lighting filter that applies a similar adjustment to existing pictures. (See Chapter 11 for help.) Some photo-editing programs, including the Nikon programs that I discuss in Chapter 10, have good shadow and highlight recovery filters. If you plan on using these after-the-shot tools instead of

Active D-Lighting, your best bet is to shoot the picture using exposure settings that record the highlights as you want them. It's very difficult to bring back lost highlight detail after the fact, but you typically can unearth at least a little bit of detail from the darkest areas of the image.

Eliminating vignetting

Because of some optical science principles that are too boring to explore, some lenses produce pictures that appear darker around the edges of the frame than in the center, even when the lighting is consistent throughout. This phenomenon goes by several names, but the two heard most often are *vignetting* and *light fall-off.* How much vignetting occurs depends on the lens, your aperture setting, and the lens focal length.

To help compensate for vignetting, your camera offers a Vignette Control feature, which adjusts image brightness around the edges of the frame. Figure 4-27 shows an example. In the left image, just a slight amount of light fall-off occurs at the corners, most noticeably at the top of the image. The right image shows the same scene with Vignette Control enabled.

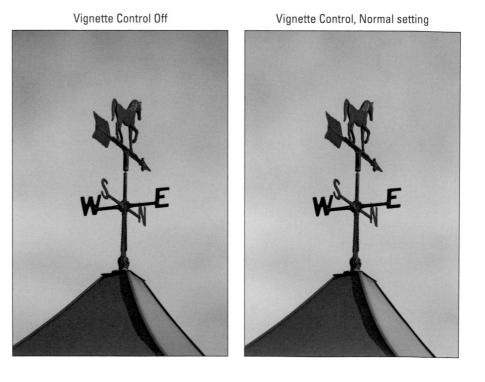

FIGURE 4-27: Vignette Control tries to correct the corner darkening that can occur with some lenses. Now, this "before" example hardly exhibits serious vignetting — it's likely that most people wouldn't even notice if it weren't shown next to the "after" example. But if you're a stickler for this sort of thing or your lens suffers from stronger vignetting, it's worth trying the feature. The adjustment is available in all your camera's exposure modes.

The only way to enable Vignette Control is via the Shooting menu, as shown on the left in Figure 4–28. You can choose from four settings, High, Normal, Low, and Off. (Normal is the default.)

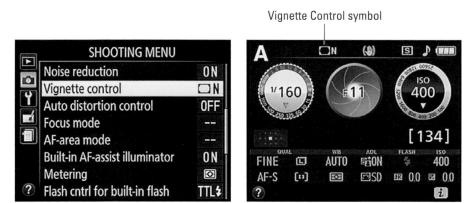

FIGURE 4-28: If you enable Vignette Control (left), a symbol indicating the setting appears in the Information display (right).

When the feature is enabled, the Information display contains a symbol showing the setting at the top of the screen, as shown on the right in Figure 4-28. The Live View display and viewfinder don't offer any indication of the Vignette Control status.

You also need to understand the following points about Vignette Control:

- The correction is available only for still photos. Sorry, video shooters; this feature doesn't apply in Movie mode.
- >> Vignette Correction works only with certain lenses. First, your lens must be Nikon Type G or E. In addition, the feature doesn't work with lenses that support the Nikon FX format, which refers to lenses made for so-called *full-frame* image sensors (sensors that are the same size as a 35mm film negative). The D3400 uses a DX format sensor, which is smaller than a full-frame sensor.

In some circumstances, the correction may produce increased noise at the corners of the photo. This problem occurs because exposure adjustment can make noise more apparent.

Using autoexposure lock

To help ensure a proper exposure, your camera continually meters the light until the moment you depress the shutter button fully. In autoexposure modes, it also keeps adjusting exposure settings as needed to maintain a good exposure.

For most situations, this approach works great, resulting in the right settings for the light that's striking your subject at the moment you capture the image. But on occasion, you may want to interrupt the continuous adjustment and lock in a certain combination of exposure settings.

The easiest way to lock in exposure settings is to switch to M (manual) exposure mode and use the f-stop, shutter speed, and ISO settings that work best for your subject. But if you prefer to stay with an autoexposure mode, you can press the AE-L/AF-L button to lock exposure before you reframe. This feature is known as *autoexposure lock*, or AE Lock for short. You can take advantage of AE Lock in any autoexposure mode except Auto or Auto Flash Off.

A few fine points about using this feature:

- >> While AE Lock is in force, the letters AE-L appear in the displays. Look for this indicator at the left end of the viewfinder. It's next to the Metering mode icon at the bottom of the Live View display, and it appears just beneath the shutter speed setting in the Information display.
- >> By default, focus is also locked when you press the button if you're using autofocusing. The focus lock occurs even if you have the Focus mode set to AF-C (continuous autofocusing, explained in the next chapter). You can change this behavior by customizing the AE-L/AF-L button function, as outlined in Chapter 12.
- For the best results, pair this feature with the spot metering and autofocus settings that enable you to select a single focus point. Then, if you frame your subject under that focus point, exposure is set and locked based on your subject. You can find out how to use spot metering earlier in this chapter; see Chapter 5 for help with autofocus settings.
- Keep holding the AE-L/AF-L button until you release the shutter button. If you want to use the same focus and exposure settings for your next shot, just keep the AE-L/AF-L button pressed.

IN THIS CHAPTER

- » Understanding autofocusing options
- » Choosing a specific autofocusing point
- » Using continuous autofocusing to track a moving subject
- » Taking advantage of manualfocusing aids
- » Manipulating depth of field

Chapter **5** Controlling Focus and Depth of Field

o many people, the word *focus* has just one interpretation when applied to a photograph: Either the subject is in focus or it's blurry. But an artful photographer knows that there's more to focus than simply getting a sharp image of a subject. You also need to consider *depth of field*, or the distance over which other objects in the scene appear sharply focused. This chapter explains how to manipulate both aspects of an image.

After a reminder of how to set your lens to auto or manual focusing, the first part of the chapter details focusing options available for viewfinder photography; following that, you can get help with focusing during Live View photography and movie recording. A word of warning: The two systems are quite different, and mastering them takes time. If you start feeling overwhelmed, simplify things by following the steps laid out at the beginning of Chapter 3, which show you how to take a picture in the Auto exposure mode, using the default autofocus settings. Then return another day to study the focusing options discussed here. Things get easier (and more fun) at the end of the chapter, where I explain how to control depth of field. Thankfully, the concepts related to that subject apply whether you're using the viewfinder, taking advantage of Live View photography, or shooting movies.

Choosing Automatic or Manual Focusing

Regardless of whether you're using the viewfinder or Live View, your first focusing task is to set the lens to operate using automatic focusing or manual focusing. How you take this step depends on whether you're using an AF-P or AF-S lens:

➤ AF-P: If the lens is in its retracted position, hold down the button labeled on the left in Figure 5-1 and rotate the lens barrel to extend it as shown in the figure. You can't access focusing options (or do much of anything else) while the lens is collapsed. After extending the lens, choose the focusing method (automatic or manual) via the Focus mode option on the Shooting menu or via the control strip provided on the Information and Live Screen displays. (I provide details in upcoming sections.)

The 18–55mm AF-P lens featured in this book offers *autofocus with manual override*. That means when the camera is set to autofocus mode, you can press the shutter button halfway to set focus initially using autofocusing and then fine-tune focus by rotating the lens focusing ring. (I labeled the focusing ring in Figure 5-1.) Two important points to note about manual-focus override:

FIGURE 5-1: On an AF-P lens (left), you must extend the lens to access focus options; on an AF-S lens (right), you can use external controls to set the lens to automatic or manual focusing.

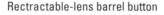

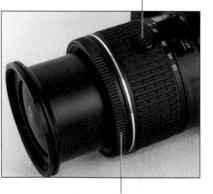

Manual focusing ring

Auto/Manual focus switch

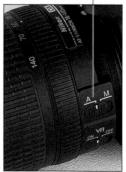

- *Keep the shutter button pressed halfway while turning the manual focusing ring.* If you release the button, there's a chance that when you press it to take the picture, the camera will reset autofocus, undoing your manual adjustment.
- You can disable manual focus override via the Setup menu. Having the option to tweak focus manually without officially changing the Focus mode is great. Problem is, it's easy to inadvertently move the manual focusing ring when you don't realize it, thereby changing the focusing distance. If you prefer not to run this risk, open the Setup menu, locate the Manual Focus Ring in AF Mode option, and change the setting to Off (Disable).
- AF-S: On AF-S lenses, you usually find an external switch that sets the lens to manual or automatic focusing. For example, on the lens shown on the right in Figure 5-1, setting the switch to the A position enables autofocusing; you move the switch to M for manual focusing. The switches may vary depending on your lens, however. On some lenses, the switch labels are AF and MF (for autofocus and manual focus). Your lens may also offer autofocus with manual override, usually indicated by a switch labeled AF/M. The position of the manual focus ring also varies depending on the lens, so see your lens instruction guide for details.

Note that some newer AF-S lenses are the collapsible type, so you may need to extend the lens, just as with an AF-P lens, before you can use the camera.

Whichever lens type you use, here are two important notes about autofocusing:

- When you use autofocusing, the camera won't release the shutter to take a picture until focus is achieved. If you can't get the camera to lock onto your focusing target, switching to manual focusing is the easiest solution. (Just know that the camera *does* let you take the picture even if focus is off when you use manual focusing.) Also be sure that you're not too close to your subject; if you exceed the minimum focusing distance of the lens, you can't focus manually, either.
- In Night Vision Effects mode, you can autofocus only in Live View mode. If you use the viewfinder, you're limited to manual focusing. Chapter 11 covers Night Vision and other Effects modes.

Exploring Standard Focusing Options (Viewfinder Photography)

In case you're the type who doesn't read chapter introductions (I bring this up only because I'm that type), I want to reiterate that the D3400 uses different

focusing technologies depending on whether you're using the viewfinder or taking advantage of Live View. This part of the chapter deals with viewfinder photography. For help with the other half of the focusing equation, skip to the section "Focusing During Live View and Movie Shooting."

Mastering the autofocusing system

The most important thing to remember about autofocusing is that how the camera sets focus is determined by the two settings, Focus mode and AF-area mode. Upcoming sections offer details, but here's the short story:

- Focus mode: This setting determines whether the camera uses automatic or manual focusing. In some exposure modes, the Focus mode setting offers you a choice of autofocusing options: You can set the camera to lock focus when you press the shutter button halfway; to adjust focus continually up to the moment you depress the button fully to take the picture; or to decide for you which option is best.
- >> AF-area mode: This setting determines which focus points the camera uses to establish focus. You can tell the camera to choose a point (or multiple points) for you or to base focus on a specific point that you select.

Symbols representing both settings appear in the Information display, as shown in Figure 5–2. The symbols in the figure represent AF–A for the Focus mode and Auto Area for the AF–area mode, which are the default settings for most exposure modes. At these set– tings, the camera decides whether to lock focus when you press the shut– ter button halfway and also selects the focus point for you.

The next sections describe the effect of each Focus mode and AF-area mode setting and offer advice on which combination of the two works best for different subjects. Following that, you can

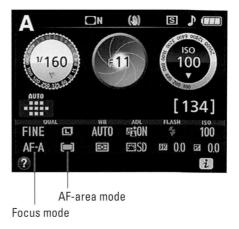

FIGURE 5-2: The Focus mode and AF-area mode settings appear here.

find step-by-step focusing recipes for shooting stationary subjects and moving subjects.

Changing the Focus mode setting

The D3400 offers the four Focus mode settings described in the following list. But you can access all four only in the P, S, A, and M exposure modes. In other exposure modes, you can choose only the AF-A and MF options. (The exception, again, is the Night Vision Effects mode, which limits you to manual focusing when you use the viewfinder.)

Here's how things work in each of the Focus modes:

- AF-S (single-servo autofocus): Designed for shooting stationary subjects, this setting tells the camera to lock focus when you depress the shutter button halfway.
- AF-C (continuous-servo autofocus): Geared to photographing moving subjects, this mode adjusts focus continuously as needed while the shutter button is pressed halfway.
- AF-A (auto-servo autofocus): This mode, which is the default, gives the camera control over whether focus is locked when you press the shutter button halfway or continuously adjusted until you snap the picture. The camera bases its decision on whether it detects motion in front of the lens.

AF-A mode works pretty well but can get confused. If your subject is motionless but other people are moving in the background, the camera may mistakenly switch to continuous autofocus. By the same token, if the subject is moving only slightly, the camera may not make the switch. So my advice is to choose AF-S or AF-C instead when you shoot in the P, S, A, and M exposure modes.

MF (manual focus): Choose this setting to shut off the autofocusing system and focus manually.

On Nikon AF-S lenses, moving the switch on the lens to M automatically sets the Focus mode to MF. However, the opposite isn't true: Choosing MF as the Focus mode does not free the lens focusing ring so that you can set focus manually; you must set the lens switch to the M position. For other lenses, check the lens instruction manual for focusing details.

You have two ways to choose the Focus mode you want to use:

- Control strip: After pressing the *i* button to activate the control strip, highlight the Focus mode option, as shown on the left in Figure 5-3. Press OK to display the available settings, as shown on the right. Highlight your choice and press OK to lock it in.
- Shooting menu: Select Focus mode, as shown on the left in Figure 5-4. Then choose Viewfinder, as shown on the right in the figure. Press the Multi Selector right to display a screen that lists the available Focus modes. Highlight your choice and press OK.

FIGURE 5-3: The fastest route to the Focus mode setting is the Information display control strip; press the *i* button to activate it.

A	1/1	<u>0 F</u>	14	15020	0
QU	AL	Focus	mode	FLASH	ISO
FINE	٦	AUTO	写 古 ON	\$	200
AF-A	()	8	⊠SD	972 O.O	⊠ 0.0
?					<i>i</i> :5

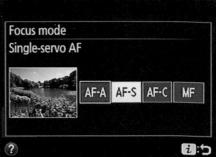

FIGURE 5-4: You also can access the Focus mode setting via the Shooting menu.

	SHOOTING MENU			Focus mode	
	Noise reduction Vignette control Auto distortion control	ON DN OFF	- D	Viewfinder	AE A .
	Focus mode		EC!	Viewfinder	AF-A ►
	AF-area mode Built-in AF-assist illuminator Metering	 0 N		Live view/movie	AF-S
?	Flash cntrl for built-in flash	TTL\$?		

Choosing an AF-area mode: One focus point or many?

The D3400 has 11 focus points, which are represented by tiny rectangles in the viewfinder. I labeled a focus point in Figure 5–5.

The AF-area mode tells the camera which autofocus points to consider when establishing focus. You have these choices:

Single Point: This mode is designed to quickly and easily lock focus on a still subject. You select a focus point, and the camera bases focus on that point only. This option is best paired with the single-servo (AF-S) Focus mode, which is also geared to still subjects. Autofocus point

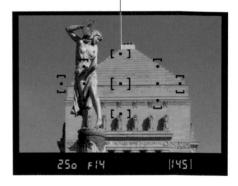

FIGURE 5-5:

The AF-area mode setting determines which of the 11 autofocus points the camera uses to set the focusing distance.

>> Dynamic Area: Dynamic Area autofocusing is designed for capturing moving subjects. You select an initial focus point, but if your subject moves away from that point before you snap the picture, the camera looks to surrounding points for focusing information.

To use Dynamic Area autofocusing, you must set the Focus mode to AF-C or AF-A. In fact, the Dynamic Area option doesn't even appear as an AF-area mode option when the Focus mode is set to AF-S.

3D Tracking: This one is a variation of Dynamic Area. As in that mode, you start by selecting a single focus point and then press the shutter button halfway to set focus. But the goal of the 3D Tracking mode is to maintain focus on your subject if you recompose the shot after you press the shutter button halfway to lock focus.

The problem with 3D Tracking is that the camera detects your subject by analyzing the colors of the object under the selected focus point. If not much difference exists between the subject and its background, the camera can get fooled. And if your subject moves out of the frame, you must release the shutter button and press it halfway again to reset focus.

As with Dynamic Area mode, if you want to use 3D Tracking autofocus, you must set the Focus mode to AF-C or AF-A.

Auto Area: At this setting, the camera automatically chooses which of the 11 focus points to use, usually locking on the object closest to the camera.

Although Auto Area mode requires the least input from you, it's typically the slowest option because of the technology it uses. First, the camera analyzes all 11 focus points. Then it consults an internal database to try to match the information reported by those points to a huge collection of reference photographs. From that analysis, it makes an educated guess about which focus points are most appropriate for your scene. Although it's amazingly fast considering what's happening in the camera's brain, it's slower than the other AF-area options.

Frankly, I don't use Auto Area mode unless I'm handing the camera over to someone who's inexperienced and who wouldn't know how to use the other two modes. Otherwise, I stick with Single Point for still subjects and Dynamic Area for moving subjects.

The Miniature Effects exposure mode always uses Single-Point mode. For all other modes that permit viewfinder autofocusing — that is, all modes except Night Vision mode — you can select from the full complement of AF-area mode settings.

Here's how to dial in the setting you want to use and specify a focus point:

>> Selecting the AF-area mode setting: You have two options:

Control strip: Press the *i* button to get the job done via the control strip, as shown in Figure 5-6.

FIGURE 5-6: The fastest way to select the AF-area mode setting is via the Information display control strip.

A	1/1	0 F	14	ISO 20	0	AF-a	rea mode				
QU/	T.	AF-are	a mode		150	Dyna	mic-area	AF 1			
FINE		AUTO	seion	\$	200			[17]	[0]	(30)	
AF-A	(=)	$\overline{\mathbf{X}}$	⊡SD	5 2 0.0	⊠ 0.0						
?					1:5	?					i

 Shooting menu: You also can access this setting from the Shooting menu, as illustrated in Figure 5-7. After selecting the option from the menu, press OK to display the screen shown on the left in Figure 5-8. Then choose Viewfinder and press the Multi Selector right to access the screen shown on the right. Highlight your choice and press OK.

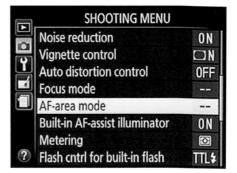

Either way, when you return to the Information display, notice the

FIGURE 5-7: You also can adjust the AF-area mode setting through the Shooting menu.

graphic labeled *Selected autofocus points symbol* in Figure 5-9. This symbol gives you information about which focus points are active. A solid square indicates the selected focus point. A fuzzy square indicates that the point is active, meaning that if the camera can't establish focus based on the selected point, it may consider the other active points. Any other points are inactive. In the figure, the symbol reflects the Single Point setting, with the center point selected. (Flip ahead to Figure 5-13 to see how this graphic compares with the one representing the Dynamic Area mode, which displays the fuzzy squares.)

FIGURE 5-8: Select Viewfinder (left) and then press the Multi Selector right to display the viewfinder AF-area mode options (right).

AF-area mode		AF-area mode
		Viewfinder
Viewfinder	[•••] >	<pre> [□□] Single-point AF </pre>
		[::] Dynamic-area AF
Live view/movie	WIDE	[3D] 3D-tracking (11 points)
		[III] Auto-area AF
		?

Selecting a single focus point: To choose a focus point in the Single Area, Dynamic Area, or 3D Tracking modes, look through the viewfinder and press the shutter button halfway and release it. When you press the button, the selected focus point turns red. For example, in Figure 5-10, I selected a point near the middle of the green statue. Use the Multi Selector to cycle through the available focus points until the one you want to use turns red. (It turns black again after a second or two.)

You can quickly select the center focus point by pressing OK.

A couple of additional tips:

- When you use spot metering, the camera bases exposure on the selected focus point. The point you choose affects the way the camera calculates flash exposure as well. See Chapter 4 for details on spot metering; see Chapter 2 for help with flash photography.
- In any exposure mode except P, S, A, or M, the camera resets the AF-area mode to the default setting if you change exposure mode. So check this setting before

Selected autofocus points symbol

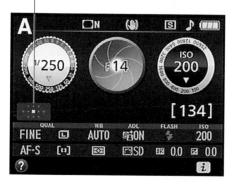

FIGURE 5-9: This symbol gives you information about which autofocus points are active.

Selected focus point

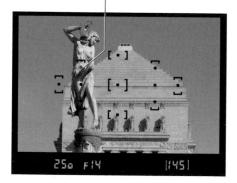

FIGURE 5-10: Use the Multi Selector to select the focus point that's over your subject.

every shoot if you aren't using the P, S, A, or M modes.

Choosing the right autofocus combo

You get the best autofocus results if you pair your chosen Focus mode with the most appropriate AF-area mode, because the two settings work in tandem. Here are the combinations I suggest:

- For still subjects: AF-S and Single Point. You select a focus point, and the camera locks focus on that point when you press the shutter button halfway. (It helps to remember the *S* factor: for still subjects, Single Point and AF-S.)
- For moving subjects: AF-C and Dynamic Area. You still begin by selecting a focus point, but the camera adjusts focus as needed if your subject moves within the frame after you press the shutter button halfway to establish focus. (Think *motion, dynamic, continuous.*) Remember to reframe as needed to keep your subject within the boundaries of the autofocus points, though.

The next two sections spell out the steps you use to set focus with both autofocus pairings.

Autofocusing with still subjects: AF-S and Single Point

For stationary subjects, the fastest, most precise autofocus option is to pair the AF-S (single-servo) Focus mode with the Single Point AF-area mode. The symbols you see in Figure 5-11 represent these settings in the Information display.

After selecting these options, follow these steps to focus:

 Use the Multi Selector to select a focus point.

> To see which point is selected, look through the viewfinder and press the shutter button halfway and then release it. The active point briefly turns red. Use the Multi Selector to cycle through the points until the one you want to use lights up. (It remains lit only for a second.)

Center point selected for setting autofocus distance

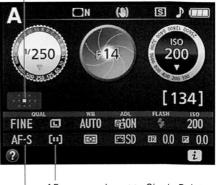

AF-area mode set to Single Point

Focus mode set to single-servo autofocus

FIGURE 5-11:

Select these autofocus settings for stationary subjects.

2. After making sure that the active focus point covers your subject, press the shutter button halfway to set focus.

When focus is achieved, the camera displays a green focus light in the viewfinder, as shown in Figure 5-12. Unless you're using the Quiet Shutter release mode, you also hear a beep. (You can disable the sound through the Beep option on the Setup menu.) In addition, the Shots Remaining value at the right end of the viewfinder changes to show you how many frames can fit in the memory buffer (24 in the figure). This number is important only if you set the Release mode to Continuous, as outlined in Chapter 2.

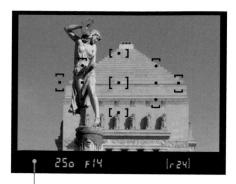

Focus achieved light

FIGURE 5-12: The green light indicates that the camera achieved focus.

Focus remains locked as long as you keep the shutter button pressed

halfway. If you're using autoexposure (any exposure mode but M), the initial exposure settings are also chosen at the moment you press the shutter button halfway, but they're adjusted as needed up to the time you take the shot. In M mode, the meter indicates the camera's take on your exposure settings but doesn't fool with those settings even if it thinks they're way off base.

3. Press the shutter button the rest of the way.

If needed, you can position your subject outside a focus point. Just compose the scene initially so that your subject is under a point, press the shutter button half-way to lock focus, and then reframe to your desired composition. Be sure that you keep the camera at the same distance from the subject when you recompose the shot, or else focus may be off. Also, if you're using autoexposure, you may want to lock focus and exposure together before you reframe, by pressing the AE-L/AF-L button. Otherwise, exposure is adjusted to match the new framing, which may not work well for your subject. See Chapter 4 for details about autoexposure lock.

Focusing on moving subjects: AF-C and Dynamic Area

To autofocus on a moving subject, select AF-C for the Focus mode and Dynamic Area for the AF-area mode. Figure 5-13 shows the symbols that represent these settings in the Information display; you can select both options via the control strip. (Press the *i* button to access the strip.) You also can set the AF-area mode through the Shooting menu.

The focusing process using this autofocus setup is the same as just outlined, with a couple exceptions:

- >> When you press the shutter button halfway, the camera sets the initial focusing distance based on your selected autofocus point. But if your subject moves from that point, the camera checks surrounding points for focus information.
- Focus is adjusted as needed until you take the picture. You see the green focus indicator light in the viewfinder, but it may flash on and off as focus is adjusted. The beep that you usually hear when using the AF-S Focus mode doesn't sound in AF-C mode, which is a Good Thing — otherwise,

Center point selected for setting initial focusing distance

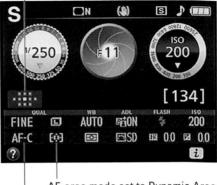

AF-area mode set to Dynamic Area

Focus mode set to continuous-servo autofocus

FIGURE 5-13:

For moving subjects, the AF-C and Dynamic Area settings work best for the Focus mode and AF-area mode options.

things could get pretty noisy because the beep would sound every time the camera adjusted focus.

>> Try to keep the subject under the selected focus point to increase the odds of good focus. But as long as the subject falls within one of the other focus points, focus should be adjusted accordingly. Note that you don't see the focus point actually move in the viewfinder, but the focus tweak happens just the same. You can feel and hear the focus motor doing its thing if you pay attention.

Getting comfortable with continuous autofocusing takes some time, so it's a good idea to practice before you need to photograph an important event. After you get the hang of the AF-C/Dynamic Area system, though, I think you'll really like it.

Understand, too, that you *can* pair continuous autofocusing (AF-C Focus mode) with Single Point AF-area mode. You may want to try this combo if you're tracking a single subject that's moving in a crowd — a runner in a marathon, for example. Restricting the camera to a single point ensures that it won't accidentally lock onto one of the surrounding runners when adjusting focus. However, you have to be careful to pan the camera so that your subject remains under the selected focus point because the camera will ignore all the other points in Single Point mode.

SHUTTER SPEED AND BLURRY PHOTOS

A poorly focused photo isn't always caused by the issues discussed in this chapter. Any movement of the camera or subject can also cause blur. Both of these problems are related to shutter speed, an exposure control that I cover in Chapter 4. Be sure to also visit Chapter 7, which provides some additional tips for capturing moving objects without blur.

Locking focus during continuous autofocusing

When you set your camera's Focus mode to AF-C, focusing is continually adjusted while you hold the shutter button halfway, so the focusing distance may change if the subject moves out of the active autofocus point or you reframe the shot before you take the picture. The same is true if you use AF-A mode and the camera senses movement in front of the lens, in which case it operates as I just described.

Should you want to interrupt continuous autofocusing and lock focus at a specific distance, press and hold the AE-L/AF-L button. Focus remains set as long as you hold down the button.

Keep in mind, though, that by default, pressing the AE-L/AF-L button also locks autoexposure. You can change this behavior, however, setting the button to lock just one or the other. Chapter 12 explains this option.

Focusing manually

Some subjects confuse even the most sophisticated autofocusing systems. Animals behind fences, reflective objects, water, and low-contrast subjects are just some autofocus troublemakers. Autofocus systems also struggle in dim lighting.

When you encounter situations that cause an autofocus hang-up, you can try adjusting the autofocus options discussed earlier in this chapter. But often, it's easier and faster to focus manually.

For the best results, follow these manual-focusing steps:

1. Set the Focus mode to MF.

Again, with an AF-P lens, you make this shift via the Focus mode setting (Information display control strip or Shooting menu).

With an AF-S lens, move the focus-method switch on the lens to the manual position. The setting is usually marked M or MF. With most AF-S lenses, moving the switch automatically changes the Focus mode setting to MF, but it never hurts to check.

2. Select a focus point.

Use the same technique as when selecting a point during autofocusing: Looking through the viewfinder, press the Multi Selector right, left, up, or down until the point you want to use flashes red. (You may need to give the shutter button a quick half press and release to wake up the camera first.)

Technically speaking, you don't *have* to choose a focus point for manual focusing — the camera focuses according to the position you set by turning the lens focusing ring. However, choosing a focus point is still a good idea, for two reasons: First, even though you're focusing manually, the camera provides some feedback to let you know whether focus is correct, and that feedback is based on the selected focus point. Second, if you use spot metering, an exposure option covered in Chapter 4, exposure is based on the selected point.

- **3.** Frame the shot so that your subject is under the selected focus point.
- Press and hold the shutter button halfway to initiate exposure metering.
- 5. Rotate the focusing ring on the lens to bring the subject into focus.

When the camera thinks focus is set on the object under the focus point, the green focus lamp in the lower-left corner of the viewfinder lights, just as it does during autofocusing.

6. Press the shutter button the rest of the way.

I know that when you first start working with an SLR-style camera, focusing manually is intimidating. But if you practice a little, you'll find that it's really no big deal and saves you the time and aggravation of trying to bend the autofocus system to your will when it has "issues."

In addition to the green focus lamp, your camera offers another manual focusing aid: You can swap out the viewfinder's exposure meter with a *rangefinder*, which uses a similar, meterlike display, as shown in Figure 5-14, to indicate whether focus is set on the object in the selected focus point. If bars appear to the left of the 0, as shown in the left example in Figure 5-14, focus is set in front of the subject; if the bars are to the right, as in the middle example, focus is slightly

behind the subject. The more bars you see, the greater the focusing error. As you twist the focusing ring, the rangefinder updates to help you get the focus on track. When you see a single bar on either side of the 0, you're good to go.

FIGURE 5-14: The rangefinder offers manualfocusing assistance.

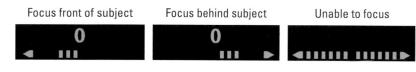

Before I tell you how to activate this feature, I want to point out the following details:

- >> You can use the rangefinder in any exposure mode except M. In M mode, the viewfinder always displays the exposure meter.
- The meter in the Information display performs its usual exposure function no matter what exposure mode you use; the rangefinder only affects the viewfinder meter.
- Your lens must offer a maximum aperture of f/5.6 or lower. (The AF-P 18–55mm kit lens qualifies.)
- With subjects that confuse the camera's autofocus system, the rangefinder may not work well either; it's based on the same system. If the system can't find the focusing target, you see the display labeled Unable to focus in Figure 5-14.
- >> The rangefinder is automatically replaced by the exposure meter if you switch back to autofocusing, but it reappears when you return to manual focus.

I leave the rangefinder off and rely on the focus indicator light and my eyes to verify focus. I shoot in A and S modes a lot, and I find it a pain to have to look at the Information display to see the exposure meter. But if you want to try the rangefinder, rotate the Mode dial to any setting but M, open the Setup menu, and set the Rangefinder option to On, as shown in Figure 5–15.

	SETUP MENU	
	Flicker reduction	AUTO
0	Buttons	
I	Rangefinder	ON
	Manual focus ring in AF mode	ON
	File number sequence	0FF
	Storage folder	205
	File naming	DSC
?	HDMI	

CORRECTING LENS DISTORTION

When you shoot with a wide-angle lens, vertical structures sometimes appear to bend outward from the center of the image. This is known as *barrel distortion*. On the flip side, shooting with a telephoto lens can cause vertical structures to bow inward, which is known as *pincushion distortion*.

The Retouch menu offers a post-capture Distortion Control filter you can apply to try to correct both problems. But the D3400 also has an Auto Distortion Control feature that attempts to correct the image as you're shooting. It works with only certain types of lenses — specifically, those that Nikon classifies as type G and E, excluding fisheye and certain other lenses. To activate the option, just set the Auto Distortion Control on the Shooting Menu to On, as shown here. By default, the option is set to Off.

One caveat: Some of the area you see in the viewfinder may not be visible in your photo because the anti-distortion manipulation requires some cropping of the scene. So frame your subject a little loosely when you enable Auto Distortion Control. Also note that the feature isn't available for movie recording.

	SHOOTING MENU	
	Noise reduction	ON
	Vignette control	
	Auto distortion control	ON
	Focus mode	
	AF-area mode	
	Built-in AF-assist illuminator	ON
	Metering	\bigotimes
?	Flash cntrl for built-in flash	TTL\$

Focusing During Live View and Movie Shooting

As with viewfinder photography, you can opt for autofocusing or manual focusing during Live View and movie shooting, assuming that your lens supports auto-focusing with the D3400. But focus techniques differ from those you use for view-finder photography.

The next several sections detail Live View and movie focusing. It's important to understand, however, that the camera typically takes longer to autofocus in Live View mode than it does during viewfinder photography. The difference is because of the type of autofocusing the camera must use when in Live View. For the fastest autofocusing response during still photography, take the camera out of Live View mode.

Unfortunately, Live View is the only game in town for movie recording; you can't use the viewfinder to frame movie shots. You also need to use Live View to autofocus in the Night Vision Effects mode.

Understanding Live View autofocusing

Whether you're shooting stills or movies, you control the camera's Live View focusing performance through the same two settings as for viewfinder photog-raphy: Focus mode and AF-area mode. Again, the settings are different from those available for viewfinder photography, though; the next two sections provide details.

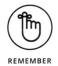

You can view the current settings at the top of the screen in the default Live View display mode, Show Photo Information, as shown in Figure 5-16, as well as in Show Movie Information mode. Press the Info button to change the display mode.

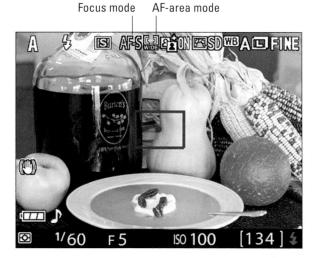

FIGURE 5-16: During Live View shooting, symbols representing the Focus mode and AF-area mode settings appear here.

Choosing a Focus mode

Through the Focus mode setting, you specify whether you want the autofocus system to lock focus at the time you press the shutter button halfway or continue to adjust focus until you take the picture or throughout movie recording. Or you can tell the camera that you prefer to focus manually. Here's how things work at each of the Focus mode settings:

- AF-S (single-servo autofocus): The camera locks focus when you press the shutter button halfway. This focus setting is one of the few that works the same during Live View shooting as it does during viewfinder photography. Generally speaking, AF-S works best for focusing on still subjects.
- AF-F (full-time servo AF): This option is available for all exposure modes except for the Toy Camera and Miniature Effects modes.

The main purpose of AF-F is to enable continuous focus adjustment throughout a movie recording. To use this option, keep your finger *off* the shutter button. Just switch the camera to the AF-F mode, wait for it to find its focus point, and then press the Movie-Record button to start recording. Focus is adjusted as needed if your subject moves through the frame or you pan the camera. If you decide to lock focus, press and hold the shutter button halfway down. As soon as you release the button, continuous autofocusing begins again.

Unfortunately, there's a downside that makes AF-F less than ideal. If you shoot a movie with sound recording enabled and use the internal microphone, the microphone may pick up the sound of the autofocus motor as it adjusts focus. So if pristine audio is your goal, use AF-S mode and lock focus before you begin recording, or abandon autofocus altogether and focus manually. You also can record sound using a separate audio-recording device and then marry the soundtrack to your video footage in a video-editing program. (The D3400 doesn't have a jack or other connection for attaching an external microphone.)

For still photography in AF-F mode, focus locks when you press the shutter button halfway, just as with AF-S mode. The only difference between the two modes is that AF-F mode finds a focusing target and keeps adjusting it until you press the shutter button halfway. You might find this option helpful when you're not sure where a moving subject will be when you want to snap the picture: As your subject moves or you pan the camera to keep the subject in the frame, autofocus is adjusted so that when the moment comes to take the shot, you just press the shutter button halfway, pause, and take the picture.

>> MF (manual focus): Select this option to focus manually.

To change the setting, press the *i* button to activate the control strip. Then highlight the Focus mode setting, as shown on the left in Figure 5-17, and press OK to display the screen where you can select the option you want to use, as shown on the right in the figure.

FIGURE 5-17: Press the *i* button to bring up the control strip and adjust the Focus mode setting.

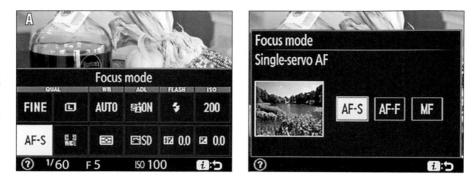

As an alternative, you can set the Focus mode via the Shooting menu, as shown on the left in Figure 5-18. Be sure to choose the Live View/Movie option, as shown on the second screen in the figure, to access the correct list of Focus mode settings.

FIGURE 5-18: You also can choose the Focus mode for Live View and Movie recording through the Shooting menu.

	SHOOTING MENU			Focus mode	
	Noise reduction	ON			
	Vignette control				
L,	Auto distortion control	ON		Viewfinder	AF-C
	Focus mode			viewinder	AF-C
	AF-area mode			Live view/movie	AF-S ►
	Built-in AF-assist illuminator	0 N			AL-2 N
	Metering	$\mathbf{\overline{O}}$			
?	Flash cntrl for built-in flash	TTL#	?		

Selecting the AF-area mode

The AF-area mode tells the camera what part of the frame contains your subject so that it can set the focusing distance correctly. For Live View photography and movie recording, the camera offers these settings:

Wide Area: In this mode, you use the Multi Selector to move a rectangular focusing frame around the screen to specify a focusing spot. (Details on using this option and others are provided in the upcoming section "Stepping through the autofocusing process.")

>> Normal Area: This mode works the same way as Wide Area autofocusing but uses a smaller focusing frame. The idea is to enable you to base focus on a very specific area. With such a small focusing frame, however, you can easily miss your focus target when handholding the camera. If you move the camera slightly as you're setting focus and the focusing frame shifts off your subject as a result, focus will be incorrect. For the best results, use a tripod in this mode.

Face Priority: Designed for portrait shooting, this mode attempts to focus on faces. Face Detection typically works only when your subjects are facing the camera, however. If the camera can't detect a face, you see a plain red focus frame, and things work as they do in Wide Area mode. In a group shot, the camera typically focuses on the closest face.

Subject Tracking: This mode tracks a subject as it moves through the frame and is designed for focusing on a moving subject. But subject tracking isn't always as successful as you might hope. For a subject that occupies only a small part of the frame — say, a butterfly flitting through a garden — autofocus may lose its way. Ditto for subjects moving at a fast pace, subjects getting larger or smaller in the frame (when moving toward you and then away from you, for example), or scenes in which not much contrast exists between the subject and the background. Oh, and scenes in which there's a great deal of contrast can create problems, too. My take on this feature is that when the conditions are right, it works well, but otherwise the Wide Area setting gives you a better chance of keeping a moving subject in focus.

You can't adjust this option in Auto mode or Auto Flash Off mode. In those two modes, the camera insists on using Face Priority mode. Nor do you have control in the Miniature Effects mode, which always uses Wide Area focusing. Subject Tracking mode isn't available for the Night Vision, Photo Illustration, Toy Camera, or Selective Color Effects modes.

As with the Focus mode setting, you can take two routes to adjusting the AF-area mode option:

Control strip: Press the *i* button to activate the strip and then highlight the AF-area mode symbol, as shown on the left in Figure 5-19. Press OK to display the selection screen, as shown on the right. Highlight your choice and press OK.

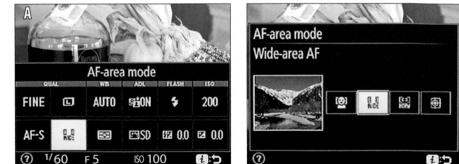

FIGURE 5-19: Access the AF-area mode via the control strip.

Shooting menu: Select AF-area mode from the Shooting menu, as shown in Figure 5-20, and press OK. On the next screen, select Live View/Movie, as shown on the right in Figure 5-20, and then press the Multi Selector right to display the settings selection screen. Make your choice and press OK.

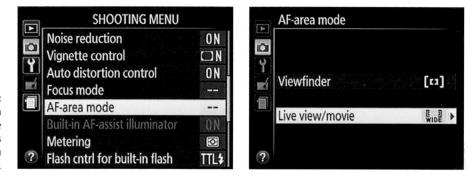

FIGURE 5-20: You also can change the setting via this Shooting menu option.

Choosing the right Live View and movie focusing pairs

To recap, the way the camera sets focus during Live View and movie shooting depends on your Focus mode and AF-area mode settings. Until you get fully acquainted with the various combinations of Focus mode and AF-area mode settings and can make your own decisions about which pairings you like best, I recommend the following settings (assuming, of course, that the exposure mode you're using permits them):

For moving subjects: Set the Focus mode to AF-F and the AF-area mode to Wide Area. You also can try the Subject Tracking AF-area mode, but see my comments in the preceding section regarding which subjects may not be well suited to that mode. Either way, remember that in AF-F mode, you don't press the shutter button halfway until you're ready to lock focus and take the picture — focusing begins immediately after you switch the autofocus mode to AF-F and continues *until* you press the shutter button halfway.

For movie recording, keep your finger off the shutter button if you want the camera to continuously adjust focus during the recording. Just remember that if you record sound, the camera's microphone may pick up the noise made by the autofocus motor.

For stationary subjects: Set the Focus mode to AF-S and the AF-area mode to Wide Area. Or, if you're shooting a portrait, give the Face Priority AF-area option a try.

Press the shutter button halfway to initiate focusing; after the camera finds the focusing point, focus is locked. For movie recording, you can release the shutter

button. For still photography, keep your finger on the button — otherwise, focus is reset when you press the button to take the picture.

>> For difficult-to-focus subjects: If the camera has trouble finding the right focusing point when you use autofocus, don't spend too much time fiddling with the different autofocus settings. Just set the camera to manual focusing and set focus yourself. Remember that every lens has a minimum focusing distance, so if you can't focus automatically *or* manually, you may simply be too close to your subject.

Stepping through the autofocusing process

Having laid out all the whys and wherefores of the Live View autofocusing options, I offer the following summary of the steps involved in choosing the autofocus settings and then actually setting focus:

1. Choose the Focus mode and AF-area mode.

i

You adjust both settings via the control strip that appears when you press the *i* button. Refer to Figures 5-17 and 5-19 if you need help locating the two options. You also can change the settings through the Shooting menu.

Either way, remember that the camera doesn't let you access all settings in certain exposure modes; see the preceding sections for details on which modes permit which settings.

If you set the Focus mode to AF-F, the autofocus system perks up and starts hunting for a focus point immediately.

2. Locate the focus frame in the Live View display.

The frame appearance depends on the AF-area mode:

- Wide Area and Normal Area: You see a red rectangular frame, as shown in Figure 5-21. (The figure shows the frame at the size it appears in Wide Area mode; it's smaller in Normal Area mode.)
- Face Priority: If the camera locates faces, you see a yellow focus frame around each one, as shown on the left in Figure 5-22. One frame sports corner brackets inside the frame — in the figure, it's the frame on the left. The brackets indicate the face that the camera will use to

Wide-area focusing frame

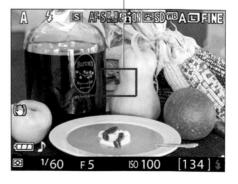

FIGURE 5-21:

The red box represents the focusing frame in Wide Area and Normal Area AF-area mode.

set focus — typically, the closest person. When your subjects are side-by-side, as here, it doesn't matter which framing box is selected as the focus point.

If you instead see a plain red frame, the camera can't detect a face and will set focus as it would if you were using Wide Area mode.

• *Subject Tracking:* A focusing frame like the one shown on the right in Figure 5-22 appears.

In AF-F mode, the frame turns green when the object under the frame is in focus. The frame blinks any time focus is being reset and turns red if the camera can't achieve focus.

Selected face

Subject-tracking focus frame

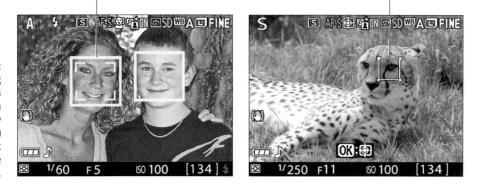

FIGURE 5-22: The focusing frame appears differently in Face Priority mode (left) and Subject Tracking mode (right).

3. Press the Multi Selector up, down, right, or left to position the focusing frame over your subject.

For example, I moved the frame over the soup garnish in the left example in Figure 5-23.

A couple of tips for positioning the frame:

- *In Face Priority mode,* use the Multi Selector to move the box with the double yellow border (which indicates the focusing point) from face to face in a group portrait.
- *In Wide Area and Normal Area modes,* press OK to quickly move the focus point to the center of the frame.
- 4. In Subject Tracking AF-area mode, press OK to initiate focus tracking.

If your subject moves, the focus frame moves with it. To stop tracking, press OK again. (You may need to take this step if your subject leaves the frame and press OK to stop tracking, reframe, and then press OK to start tracking again.)

5. In AF-S Focus mode, press the shutter button halfway to start autofocusing.

Focus achieved

FIGURE 5-23: The focus frame turns green when focus is achieved.

6. Wait for the focus frame to turn green. (Refer to the right screen in Figure 5-23.)

The appearance of the frame depends on the AF-area mode; the figure shows it as it looks in Wide Area mode.

What happens next depends on the Focus mode:

- AF-S: You hear a beep (assuming that you didn't disable it via the Beep option on the Setup menu). Focus is locked as long as you keep the shutter button pressed halfway.
- AF-F: Focus is adjusted if the subject moves. The focus frame turns back to red (or yellow or white) if focus is lost; when the frame turns green and stops blinking, focus has been achieved again. You can lock focus by pressing the shutter button halfway. In most cases, the camera resets focus on your subject when you press the button, even if the focus frame is already green. The focus-achieved beeper doesn't sound in this mode.

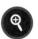

(Optional) Press the Zoom In button to magnify the display to doublecheck focus.

Each press gives you a closer look at the subject. A small thumbnail appears in the lower-right corner of the screen, with the yellow highlight box indicating the area that's being magnified, as shown in Figure 5-24. Press the Multi Selector to scroll the display if needed.

To reduce the magnification level, press the Zoom Out button. If you're not using Subject Tracking mode, you can also press OK to quickly return to normal magnification.

FIGURE 5-24: Press the Zoom In button to magnify the display and double-check focus.

Manual focusing during Live View and movie shooting

Manual focusing in Live View and Movie mode requires the same initial step as for viewfinder photography: Set the Focus mode to the MF option. (On an AF-S lens, you also need to move the switch on the lens to the M or MF position.) Then just rotate the lens focusing ring to focus. (Refer to Figure 5-1 for help locating the switch and focusing ring on the 18-55mm AF-P kit lens.)

Note a few quirks:

- >> Even with manual focusing, you still see the Live View focusing frame; its appearance depends on the current AF-area mode setting. In Face Priority mode, the frame automatically jumps into place over a face if it detects one. And if you press OK when Subject Tracking mode is enabled, the camera tries to track the subject under the frame until you press OK again. I find these two behaviors irritating, so I always set the AF-area mode to Wide Area or Normal Area for manual focusing.
- The focusing frame doesn't turn green to indicate successful focusing as it does with autofocusing. You have to know your subject appears in the monitor to judge focus.

However, you can press the Zoom In button to check focus in manual mode just as you can during autofocusing. Refer to Step 7 in the preceding section for details. Press the Zoom Out button to reduce the magnification level.

Manipulating Depth of Field

Getting familiar with the concept of depth of field is one of the biggest steps you can take to becoming a better photographer. I introduce you to depth of field in Chapter 4, but here's a quick recap:

- >> *Depth of field* refers to the distance over which objects in a photograph appear acceptably sharp.
- With a shallow depth of field, your subject is sharply focused but objects behind and in front of it appear blurry. How blurry those distant objects appear depends on three factors, which I discuss momentarily.
- With a large depth of field, the zone of sharp focus extends to include objects in front of and behind your subject.

Which arrangement works best depends on your creative vision and your subject. In portraits, for example, a classic technique is to use a short depth of field, as I did for the photo on the left in Figure 5–25. This approach increases emphasis

on the subject while diminishing the impact of the background. But for the photo shown on the right, I wanted to emphasize that the foreground figures were in St. Peter's Square, so I used a large depth of field, which kept the background buildings sharply focused and gave them equal weight in the scene.

Shallow depth of field

Large depth of field

FIGURE 5-25: A shallow depth of field blurs the background (left); a large depth of field keeps both foreground and background in focus (right).

Depth of field depends on the aperture setting, lens focal length, and distance from the subject, as follows:

REMEMBER

- Aperture setting (f-stop): The aperture is one of three main exposure settings, all explained fully in Chapter 4. Depth of field increases as you stop down the aperture (by choosing a higher f-stop number). For shallow depth of field, open the aperture (by choosing a lower f-stop number). Figure 5-26 offers an example; in the f/22 version on the left, focus is sharp all the way through the frame; in the f/2.8 version on the right, focus softens as the distance from the flag increases. I snapped both images at the same focal length and camera-to-subject distance, setting focus on the flag.
- >> Lens focal length: In lay terms, *focal length* determines what the lens "sees." As you increase focal length, measured in millimeters, the angle of view narrows, objects appear larger in the frame, and the important point for this discussion depth of field decreases. Additionally, the spatial relationship of objects changes as you adjust focal length. As an example, Figure 5-27 compares the same scene shot at a focal length of 127mm and 183mm. I used the same aperture and camera-to-subject distance for each shot, setting focus on the parrot.

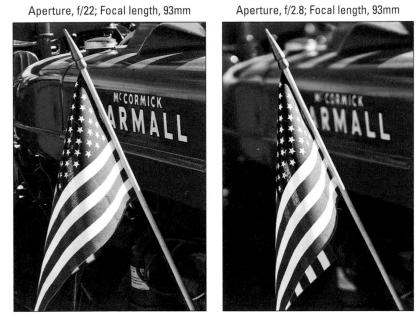

FIGURE 5-26: A lower f-stop number (wider aperture) decreases depth of field.

Whether you have any focal length flexibility depends on your lens: If you have a zoom lens, you can adjust the focal length by zooming in or out. If you have a prime lens — that is, not a zoom lens — the focal length is fixed, so scratch this means of manipulating depth of field. (For more details about focal length, flip to Chapter 1.)

Camera-to-subject distance: As you move the lens closer to your subject, depth of field decreases. This statement assumes that you don't zoom in or out to reframe the picture, thereby changing the focal length. If you do, depth of field is affected by both the camera position and focal length.

Together, the preceding three factors determine the maximum and minimum depth of field that you can achieve, as follows:

- To produce the shallowest depth of field: Open the aperture as wide as possible (the lowest f-stop number), zoom in to the maximum focal length of your lens, and get as close as possible to your subject.
- >> To produce maximum depth of field: Stop down the aperture to the highest possible f-stop number, zoom out to the shortest focal length (widest angle) your lens offers, and move farther from your subject.

Aperture, f/5.6; focal length, 127mm

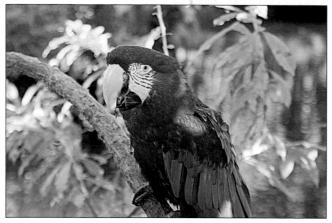

Aperture, f/5.6; focal length, 183mm

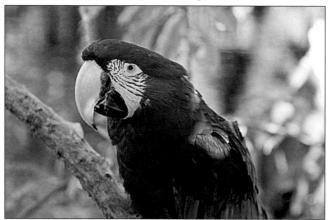

FIGURE 5-27: Zooming to a longer focal length also reduces depth of field.

A couple of final tips related to depth of field:

- Aperture-priority autoexposure mode (A) enables you to easily control depth of field while enjoying exposure assistance from the camera. In this mode, you rotate the Command dial to set the f-stop, and the camera selects the appropriate shutter speed to produce a good exposure. The range of available aperture settings depends on your lens.
- >> For greater background blurring, move the subject farther from the background. The extent to which background focus shifts as you adjust depth of field also is affected by the distance between the subject and the background. The portrait in Figure 5-25 offers an example: Notice that the wicker chair in which my model is sitting appears just slightly blurrier than she does, but the vines in the distance almost blur into a solid color.

IN THIS CHAPTER

- » Exploring white balance and its effect on color
- » Creating custom White Balance settings
- » Setting the Color Space (sRGB versus Adobe RGB)
- » Experimenting with Picture Controls

Chapter 6 Mastering Color Controls

ompared with understanding certain aspects of digital photography resolution, aperture, shutter speed, and so on — making sense of your camera's color options is easy-breezy. First, color problems aren't all that common, and when they are, they're usually simple to fix with a quick shift of your camera's White Balance setting. And getting a grip on color requires learning only a couple of new terms, an unusual state of affairs for an endeavor that often seems more like high-tech science than art.

This chapter explains the White Balance control along with other features that fine-tune the way your camera renders colors. See Chapter 11 for color adjust-ments you can make to existing pictures via the Retouch menu.

Understanding White Balance

Every light source emits a particular color cast. The old-fashioned fluorescent lights found in most public restrooms, for example, put out a bluish-greenish light, which is why we all look sickly when we view our reflections in the mirrors in those restrooms. And if you think that your beloved looks especially attractive by candlelight, you aren't imagining it: Candlelight casts a warm, yellow-red glow that is flattering to the skin.

Science-y types measure the color of light, officially known as *color temperature*, on the Kelvin scale, which is named after its creator. You can see the Kelvin scale in Figure 6–1.

When photographers talk about "warm light" and "cool light," though, they aren't referring to the position on the Kelvin scale — or at least not in the way most people think of temperatures, with a higher number meaning hotter. Instead, the terms describe the visual appearance of the light. Warm light, produced by candles and incandescent lights, falls in the red-yellow spectrum at the bottom of the Kelvin scale; cool light, in the blue spectrum, appears in the upper part of the Kelvin scale.

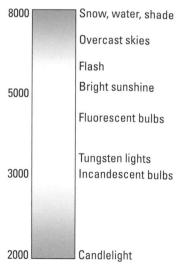

At any rate, most people don't notice these fluctuating colors of light because human eyes automatically compensate for them. Except in FIGURE 6-1: Each light source emits a specific color.

extreme lighting conditions, we perceive a white tablecloth as white no matter whether it's lit by candlelight, fluorescent light, or daylight. Similarly, a digital camera compensates for different colors of light through white balancing. Simply put, *white balancing* neutralizes light so that whites are always white, which in turn ensures that other colors are rendered accurately. If the camera senses warm light, it shifts colors slightly to the cool side of the color spectrum; in cool light, the camera shifts colors in the opposite direction.

Your camera's Auto White Balance setting tackles this process well in most situations, which means that you can usually ignore it and concentrate on other camera settings. But if the scene is lit by two or more light sources that cast different colors, the white balance sensor can get confused, producing an unwanted color cast like the one you see in the left image in Figure 6-2.

I shot this image in my home studio — which is a fancy name for "guest bedroom" — using tungsten photo lights, which produce light with a color temperature similar to incandescent bulbs. The problem is that windows in that room permit strong daylight to filter through. In Auto White Balance mode, the camera reacted to the daylight — which has a cooler color cast — and applied too much warming, giving my original image a yellow tint. No problem: I switched the White Balance mode from Auto to the Incandescent setting. The image on the right in Figure 6-2 shows the corrected colors. FIGURE 6-2: Multiple light sources resulted in a yellow color cast in Auto White Balance mode (left); switching to the Incandescent setting solved the problem (right).

Unfortunately, you can't control White Balance in the automatic exposure modes, so if you spy a color issue, you must switch to P, S, A, or M mode. The next section explains how to make a simple white balance correction; following that, you can explore advanced options.

Changing the White Balance setting

You can view the current White Balance setting in the Information and Live View displays, as shown in Figure 6–3. The figures show how things look when the Auto White Balance option is selected; settings other than Auto are represented by the icons you see in Table 6–1.

E AFS BEFON ESSOWE AND FINE ON (0) S 2 11 100 Amin [134] 150 200 FINE SHON AUTO, 3 AF-S [11] 8 ⊡SD EE 0.0 EE 0.0 i 6 1/160 F11 ISO 100 [134

FIGURE 6-3: A symbol representing the current White Balance setting appears in the displays.

White Balance setting

White Balance setting

Manual White Balance Settings

Symbol	Light Source
*	Incandescent
	Fluorescent
☀	Direct sunlight
4	Flash
ð	Cloudy
1 ///.	Shade
PRE	Preset

In Live View mode, colors in the preview are rendered according to the current White Balance setting. If you're unsure of which setting to use, just experiment: After you adjust the setting, the preview updates to show you the effect on photo colors.

You can adjust the White Balance setting in two ways:

Control strip: After highlighting the White Balance option, as shown on the left in Figure 6-4, press OK to access the available settings, as shown on the right. Highlight your choice and press OK.

Although the figures in this chapter show the control strip as it appears during viewfinder photography, things work the same way in Live View mode. In both cases, press the *i* button to access the control strip.

Shooting menu: You also can access the setting from the Shooting menu, as shown in Figure 6-5.

When you go the menu route, you can access these advanced features:

Fine-tune the settings. If you choose any setting but Fluorescent, pressing the Multi Selector right takes you to a screen where you can fine-tune the setting, a process I explain in the next section.

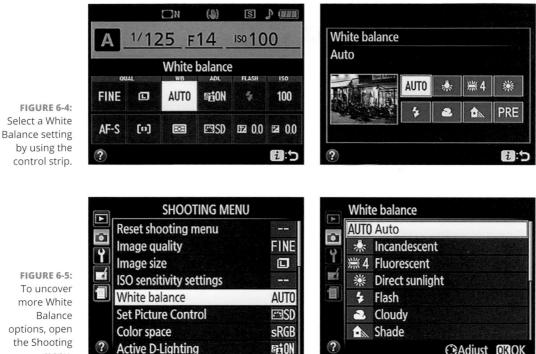

FIGURE 6-5: To uncover more White Balance options, open the Shooting menu.

- >> Select a specific type of fluorescent bulb. When you choose Fluorescent from the menu, as shown on the left in Figure 6-6, pressing the Multi Selector right displays the screen on the right, where you can select a specific type of bulb. Select the option that most closely matches your bulbs and then press OK. Or, to go to the fine-tuning screen, press the Multi Selector right.
- >> Create a custom white balance preset. If you scroll to the second screen of the initial White Balance menu, you find the PRE option (not shown in Figures 6-5 and 6-6). This option enables you to create a customized White Balance setting based on the actual lighting or an existing photo, as explained in the upcoming section "Creating white balance presets." This feature provides the fastest way to achieve accurate colors when the scene is lit by multiple light sources that have differing color temperatures.

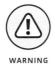

The selected White Balance setting remains in force until you change it. Get in the habit of checking the setting before every shoot to make sure that you don't need to modify it.

Adjust OBOK

FIGURE 6-6: If you adjust the White Balance setting from the Shooting menu, you can select a specific type of fluorescent bulb.

White balance		Fluorescent
AUTO Auto		🔚 🗯 1 Sodium-vapor lamps
🔹 🗼 Incandescent		■ ※2 Warm-white fluorescent
₩4 Fluorescent	•	工 ※ 3 White fluorescent
🖉 🛞 Direct sunlight		₩4 Cool-white fluorescent
📕 🐓 Flash		III ※ 5 Day white fluorescent
Cloudy		※6 Daylight fluorescent
▲ Shade		※7 High temp. mercury-vapor
?	OBOK	CAdjust OBOK

Fine-tuning White Balance settings

You can fine-tune any White Balance setting except a custom preset that you create by using the PRE option. Make the adjustment as follows:

1. Display the Shooting menu, highlight White Balance, and press OK.

You see the screen shown on the left in Figure 6-7.

2. Highlight the White Balance setting you want to adjust and press the Multi Selector right.

For any White Balance setting but Fluorescent, you see a screen offering the fine-tuning controls shown on the right in Figure 6-7.

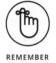

If you select Fluorescent, you first go to a screen where you select a specific type of bulb. After you highlight your choice, press the Multi Selector right to get to the fine-tuning screen.

Adjustment marker

White balance Incandescent A **AUTO** Auto G Ö Ö * Incandescent A-B 4 ※4 Fluorescent A2. 0 * **Direct sunlight** G-M A в 4 Flash M2. 0 Cloudy Shade Adjust M ? CAdjust OBOK OKIOK

FIGURE 6-7: Press the Multi Selector right to get to the fine-tuning screen.

3. Fine-tune the setting by using the Multi Selector to move the white balance shift marker in the color grid.

The grid is set up around two color pairs: Green and Magenta, represented by G and M; and Blue and Amber, represented by B and A. By pressing the Multi Selector, you can move the adjustment marker (refer to the little black box labeled in Figure 6-7) around the grid.

As you move the marker, the A–B and G–M boxes on the right side of the screen show you the current amount of color shift. A value of 0 indicates the default amount of color compensation applied by the selected White Balance setting. In Figure 6-7, the readout shows A2.0 for the A-B adjustment, indicating

that I moved the marker two levels toward amber. For the G-M adjustment, I move the marker two levels toward magenta, thus the M2.0 value in the display. The result was a slight warming of photo colors.

4. Press OK to complete the adjustment.

After you fine-tune a White Balance setting, an asterisk appears next to the icon representing the setting on the Shooting menu, as shown in Figure 6-8. You see an asterisk next to the White Balance setting in the Information and Live View displays as well.

SHOOTING MENU Reset shooting menu FINE Image quality Image size -ISO sensitivity settings White balance * Set Picture Control ras D Color space sRGB Active D-Lighting BHON

White Balance fine-tuning symbol

FIGURE 6-8: The asterisk indicates that you fine-tuned the White Balance setting.

Creating white balance presets

If none of the standard White Balance settings does the trick and you don't want to fool with fine-tuning them, take advantage of the PRE (Preset Manual) feature. This option enables you to base white balance on a direct measurement of the actual lighting conditions or to match white balance to an existing photo. The next two sections provide step-by-step instructions for creating both types of presets.

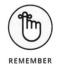

You can store only one preset at a time. For example, if you create a preset based on lighting conditions on Monday and then decide on Tuesday to create a different one based on a photo, the light-based preset goes kaput.

Setting white balance with direct measurement

To use this technique, you need a piece of card stock that's neutral gray or absolute white — not eggshell white, sand white, or any other close-but-not-perfect

159

CHAPTER 6 Mastering Color Controls

white. (You can buy reference cards made just for this purpose in many camera stores for less than \$20.)

Position the reference card so that it receives the same lighting you'll use for the photo. Then take these steps:

1. Set the camera to the P, S, A, or M exposure mode.

If the exposure meter reports that the image will be under- or overexposed at the current exposure settings, make the necessary adjustments now. (Chapter 4 tells you how.) Otherwise, the camera can't create your preset.

2. Frame your shot so that the reference card fills the viewfinder.

You must use the viewfinder to take the reference shot; you can't create a preset in Live View mode.

3. From the Shooting menu, select White Balance, press OK, and scroll to the second page of the menu to select PRE Preset Manual, as shown on the left in Figure 6-9.

	White balance	White balance
	PRE Preset manual	Preset manual
	2	
FIGURE 6-9: Select these		Measure
options to set white balance		Use photo
by measuring a white or gray card.	OBOK	

4. Press the Multi Selector right, select Measure (as shown on the right in Figure 6-9), and press OK.

The camera asks whether you want to overwrite existing data.

5. Select Yes and press OK.

You see a message telling you to take your picture. You have about 6 seconds to do so. (The letters *PRE* flash to let you know the camera is ready to record your white balance reference image.)

6. Take the reference shot.

Your camera may have a hard time autofocusing because the reference card doesn't contain any contrast. To solve the problem, use manual focusing.

If the camera is successful at recording the white balance data, the letters Gd flash in the viewfinder, and the message "Data Acquired" appears in the Information display. If the camera can't set the custom white balance, you instead see the message No Gd in the viewfinder, and a message in the Information display urges you to try again. Try adjusting the lighting before doing so.

You also can create a direct-measurement preset via the Information display control strip: After setting the White Balance option to PRE, press OK until the letters PRE start to flash. Then take your reference shot.

After you complete the process, the camera sets the White Balance option to PRE so that you can begin using your preset. Your custom setting is stored in the camera until you override the setting with a new preset. If you switch to a different White Balance option — say, Auto or Incandescent — and you want to return to your custom preset, just choose PRE as the White Balance setting.

Matching white balance to an existing photo

Suppose that you're the marketing manager for a small business, and one of your jobs is to shoot portraits of the company bigwigs for the annual report. You build a small studio just for that purpose, complete with a couple of photography lights and a nice, conservative beige backdrop. Of course, the bigwigs can't all show up to get their pictures taken in the same month, let alone on the same day. But you have to make sure that the colors in that beige backdrop remain consistent for each shot, no matter how much time passes between photo sessions. This scenario is one possible use for a feature that enables you to create a White Balance preset based on an existing photo.

Two words of caution:

- Basing white balance on an existing photo works only in strictly controlled lighting situations, where the color temperature of the lights is consistent from day to day.
- If you previously created a preset using the direct measurement option, you wipe out that preset when you base a preset on an existing photo.

With those caveats out of the way, follow these steps to create a preset based on a photo:

1. Copy the picture that you want to use as the reference photo to your camera memory card, if it isn't already stored there.

You can copy the picture to the card using a card reader and whatever method you usually use to transfer files from one drive to another. Assuming that

you're using the default folder names, copy the file to the 100D3400 folder. inside the main DCIM folder.

- 2. Open the Shooting menu, highlight White Balance, and press OK.
- 3. Select PRE Preset Manual, as shown on the left in Figure 6-10, and press the Multi Selector right.

The screen shown on the right in Figure 6-10 appears.

FIGURE 6-10: You can create a white balance preset based on a photo.

4. Highlight Use Photo and press the Multi Selector right.

You see the options shown in Figure 6-11. If you haven't yet used the photo option to store a preset, you see an empty white box in the middle of the screen, as shown in the figure. If you previously created a preset, the thumbnail for that reference image appears instead.

White balance Use photo iÔ1 4 1 This image Select image

Measure

Use photo

.

5. Select the photo you want to use.

If the photo is already displayed on the screen, skip to Step 6. Otherwise, highlight Select Image and press the Multi Selector right to access screens

FIGURE 6-11:

Highlight Select Image and press the Multi Selector right to choose the image that you want to use as the basis for your preset.

that let you scroll through your pictures. (If your memory card contains multiple storage folders, you first have to select the folder that contains the photo.) Highlight the photo you want to use as the basis for the preset and press OK to return to the screen shown in Figure 6-11. Your selected photo appears on the screen.

6. Highlight This Image and press OK to set the preset white balance based on the selected photo.

Choosing a Color Space

By default, your camera captures images using the *sRGB color space*, which refers to an industry-standard spectrum of colors. (The *s* is for *standard*, and the *RGB* is for *r*ed, *g*reen, *b*lue, which are the primary colors in the digital color world.) This color space was created to help ensure color consistency as an image moves from camera (or scanner) to monitor and printer; the idea was to create a spectrum of colors that all devices can reproduce.

Because sRGB excludes some colors that *can* be reproduced in print and onscreen, at least by some devices, your camera also enables you to shoot still photos in the Adobe RGB color space, which contains a larger spectrum of colors. Figure 6–12 offers an illustration that indicates the differences in the two color spaces; notice that neither can capture all the colors that the human eye can see.

Although using a larger color spectrum sounds like a no-brainer, choosing Adobe RGB isn't necessarily the right choice. Consider these factors when making your decision:

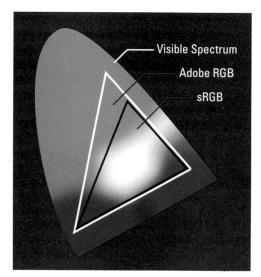

- Some colors in the Adobe RGB spectrum can't be reproduced in print; the printer substitutes the closest printable color, if necessary.
- If you print and share your photos without making any adjustments in your photo editor, sRGB is a better choice because most printers and web browsers are designed around that color space.
- Finally, to retain the original Adobe RGB colors when you work with your photos, your editing software must support that color space not all programs do. You also must be willing to study the topic of digital color a little because you need to use specific software and printing settings to avoid mucking up the color works.

To experiment with Adobe RGB, open the Shooting menu and change the Color Space option from sRGB to Adobe RGB, as shown in Figure 6-13. Note that movies are always recorded in sRGB even if you select Adobe RGB from the menu.

FIGURE 6-13: Select the color space through this Shooting menu option.

One final tip with regard to this option: The picture filename indicates which color space you used. Filenames of Adobe RGB images start with an underscore, as in _DSC0627.jpg. For pictures captured in sRGB, the underscore appears in the middle of the filename, as in DSC_0627.jpg.

Taking a Quick Look at Picture Controls

When you shoot movies or capture photos using the JPEG Image Quality settings (Fine, Normal, or Basic), colors are also affected by the Picture Control setting. This option also affects other picture characteristics that the camera tweaks when you shoot in the JPEG format, including contrast and sharpening.

Sharpening is a software process that boosts contrast to create the illusion of slightly sharper focus. I emphasize, "slightly sharper focus." Sharpening produces a subtle *tweak*; it's not a fix for poor focus.

In the P, S, A, and M exposure modes, you can choose from the following Picture Controls, represented on the menus and in the Information and Live View displays by the two-letter codes labeled in Figure 6-14. In other exposure modes, the camera selects the Picture Control setting.

- >> Standard (SD): The default setting, this option captures the image using characteristics that Nikon considers suitable for the majority of subjects.
- >> Neutral (NL): The camera doesn't enhance color, contrast, and sharpening as much as in the other modes. This setting is designed for people who want to precisely manipulate these picture characteristics in a photo editor. By not overworking colors, sharpening, and so on when producing your original file, the camera delivers an original that gives you more latitude in the digital darkroom.

Picture Control setting

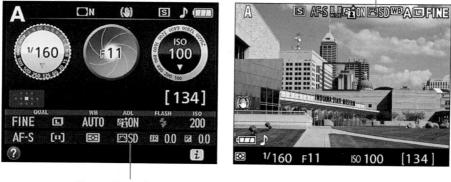

FIGURE 6-14: This twoletter code represents the Picture Control setting.

Picture Control setting

>> Vivid (VI): Color saturation, contrast, and sharpening are increased.

Monochrome (MC): This setting creates a black-and-white image or movie. However, for still photos, I prefer to shoot in color and then create a blackand-white copy in my photo software. Good photo programs have tools that let you choose how original tones are translated to the black-and-white palette, giving you more control over the black-and-white version. But even if you're not much of a black-and-white artist — or you simply need a monochrome image right away — I still recommend shooting the original in color. You can then create a black-and-white copy using the Monochrome filter on the Retouch menu, which I cover in Chapter 11. Remember, you can always go from color to black and white, but the reverse isn't possible.

The Monochrome Picture Control *is* a fun option to try for movie recording, producing an instant *film noir* look. Chapter 8 covers movie recording.

- Portrait (PT): Tweaks colors and sharpening in a way that's designed to produce nice skin texture and pleasing skin tones.
- >> Landscape (LS): Emphasizes blues and greens.
- Flat (FL): Flat images display even less contrast, sharpness, and saturation than Neutral and, according to Nikon, capture the widest tonal range possible with the D3400. Videographers who do a lot of post-processing to their footage may find this setting especially useful.

The extent to which Picture Controls affect an image depends on the subject, but Figure 6–15 gives you an idea of what to expect from the color options. As you can see, Standard, Vivid, and Landscape produce pretty similar results, as do Portrait and Neutral. As for Flat — well, to my eye, that rendition *needs* extensive editing to bring it to life.

FIGURE 6-15: Picture controls apply preset adjustments to color, sharpening, and contrast to images you shoot in the JPEG file format.

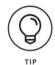

While you're new to the camera, I recommend sticking with the Standard setting. Again, this is the default for P, S, and A modes, which are the only ones that let you change the Picture Control. Standard captures most subjects well, and you have lots of other, more important settings to remember. Also keep in mind that if you shoot in the Raw format, you can choose a Picture Control during Raw processing if you tackle that task using the built-in Raw converter or Nikon Capture NX–D, both of which I cover in Chapter 10. The camera uses the currently selected setting just to create the image preview you see on the monitor.

(4)

If you do want to change the Picture Control setting, you can get the job done quickly via the control strip, as shown in Figure 6–16, or the Shooting menu, as shown in Figure 6–17.

S 🕽 📶

FIGURE 6-16: The fastest way to select a Picture Control is by using the control strip.

FIGURE 6-17: The Shooting menu provides access to settings that let you tweak the results of each Picture Control.

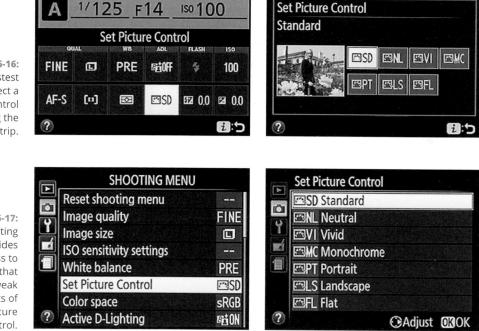

I should also alert you to a feature that may make Picture Controls a little more useful to some people: You can modify any Picture Control to more closely render a scene the way you envision it. For example, if you like the bold colors of Vivid mode but don't think that the effect goes far enough, you can adjust the setting to amp up colors even more.

To reserve page space in this book for functions that will be the most useful to the most readers, I opted not to provide full details about customizing Picture Controls. But the following steps provide a quick overview of the process so that if you encounter the menu screens that contain the related options, you'll have some idea of what you're seeing:

- 1. Set the Mode dial to P, S, A, or M.
- 2. Choose Set Picture Control from the Shooting Menu.

3. Highlight the Picture Control you want to modify.

For example, I highlighted the Vivid setting on the left in Figure 6-18.

FIGURE 6-18: After selecting a Picture Control, press right to display options for adjusting its effect on your pictures.

Set Picture Con	trol	Vivid	et on
SD Standard		Quick adjust	$0 \overline{-} \overset{0}{\longrightarrow} \overset{+}{\longrightarrow} $
Neutral		Sharpening	4.00 A.
VI Vivid		Clarity	+1. 00 ?
MC Monochr	ome	Contrast	0.00 4 - 0 +
Terrait		Brightness	0.00 - +
ELS Landscap	e	Saturation	+1. 00
ESFL Flat		Hue	0.00
?	CAdjust OBOK	? 😹 🔘:A•	TT BReset OKOK

4. Press the Multi Selector right.

You see the screen shown on the right in Figure 6-18, containing sliders that you use to modify the Picture Control. Which options you can adjust depend on the Picture Control.

5. Highlight a picture characteristic and then press the Multi Selector right or left to adjust the setting.

A few pointers:

- Pressing the Multi Selector adjusts the setting value in increments of 1. To make a smaller adjustment, rotate the Command dial, which nudges the value in increments of .25.
- The triangle under each adjustment scale indicates the current setting for the option. If you adjust the value, a second, yellow marker appears to represent the new setting. For example, on the right screen in Figure 6-18, take a look at the Saturation setting. The gray triangle under the zero indicates the default setting; the yellow triangle one notch to the right shows the new setting. A numerical value for the adjustment also appears to the left of the scale; in the figure, I raised the Saturation value +1.00.
- •
- The letter A at the left end of a slider bar indicates that you can enable an Auto adjustment instead of inputting a specific value. At the Auto setting, the camera tweaks the specified characteristic depending on the type of scene it thinks you're capturing. To try this feature, press the Zoom In button. The letter A then appears to the left of the adjustment scale instead of the numerical value. To go back to manual adjustment, press the Zoom In button again.

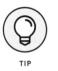

 Instead of varying individual characteristics of a Picture Control, you can choose the top option on the list, Quick Adjust. Through this setting, you can easily increase or decrease the overall effect of the Picture Control. A positive value produces a more exaggerated effect; set the slider to 0 to return to the default setting. Note that the Quick Adjust setting becomes disabled, as shown in the figure, as soon as you adjust any of the other slider values.

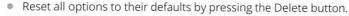

6. Press OK.

To remind you that you adjusted the Picture Control, an asterisk appears next to the Picture Control name on the menu and by the Picture Control symbol in the Information and Live View displays.

Again, these steps are intended only as a starting point for playing with Picture Controls. More details are found in the electronic version of the camera manual, which you can download from the Nikon support pages for your camera.

One more tip before I close out this chapter: At the bottom of many menu screens, Nikon adds small icons to remind you what controls you can use to adjust the current settings. For example, at the bottom of the left screen in Figure 6–18, notice the circular symbol next to the word Adjust. The symbol represents the Multi Selector; the right-pointing triangle indicates that pressing the Multi Selector right accesses the Picture Control Adjustment screen. On the right screen in the figure, the half-circle with the numbers 0.25 is a reminder to rotate the Command dial for a 0.25 increment of change; the magnifying glass symbol indicates that you press the Zoom In button to toggle between the Auto and manual adjustment options; and the trash can symbol tells you to press the Delete button to reset all values to their defaults.

Many screens also sport the question mark symbol at the left side of the screen; that's your cue to press the Zoom Out button to display a help screen with information about the current menu option. And the OK symbol is there to show that you must press the OK button to finalize your selection and exit to the previous menu screen.

IN THIS CHAPTER

- » Reviewing the best all-around picture-taking settings
- » Adjusting the camera for portrait photography
- » Discovering the keys to super action shots
- » Dialing in the right settings to capture landscapes and other scenic vistas
- » Capturing close-up views of your subject

Chapter **7** Putting It All Together

arlier chapters of this book break down each and every picture-taking feature on your camera, describing in detail how the various controls affect exposure, picture quality, focus, color, and the like. This chapter pulls together all that information to help you set up your camera for specific types of photography.

Keep in mind, though, that there are no hard-and-fast rules for the "right way" to shoot a portrait, a landscape, or whatever. So feel free to wander off on your own, tweaking this exposure setting or adjusting that focus control, to discover your own creative vision. Experimentation is part of the fun of photography, after all — and thanks to your camera monitor and the Delete button, it's an easy, completely free proposition.

Recapping Basic Picture Settings

Your subject, creative goals, and the lighting conditions determine which settings you should use for certain picture-taking options, such as aperture and shutter speed. I offer my take on those options throughout this chapter. But for many basic options, I recommend the same settings for almost every shooting scenario. Table 7-1 shows you those recommendations and also lists the chapter where you can find details about each setting.

TABLE 7-1	All-Purpose	Picture-Taking Settings
-----------	-------------	-------------------------

Option	Recommended Setting	See This Chapter
Active D-Lighting	Off	4
AF-area mode	Still subjects, Single Point; moving subjects, Dynamic Area	5
Exposure mode	P, S, A, or M	4
Focus mode	For autofocusing on still subjects, AF-S; moving subjects, AF-C	5
Image Quality	JPEG Fine or Raw (NEF)	2
Image Size	Large or medium	2
ISO Sensitivity	100	4
Metering	Matrix	4
Release mode	Action photos: Continuous; all others: Single Frame	2
White Balance	Auto	6

One key point: The instructions in this chapter assume that you set the exposure mode to P, S, A, or M. These modes, detailed in Chapter 4, are the only ones that give you access to the entire cadre of camera features. In most cases, I recommend using S (shutter-priority autoexposure) when controlling motion blur is important, and A (aperture-priority autoexposure) when you're primarily concerned with controlling depth of field (the distance over which focus remains sharp). These two modes let you concentrate on one side of the exposure equation and let the camera handle the other. Of course, if you're comfortable making both the aperture and shutter speed decisions, you may prefer to work in M (manual) exposure mode instead. P (programmed autoexposure) is my last choice because it makes choosing a specific aperture or shutter speed more cumbersome.

Additionally, this chapter discusses choices for viewfinder photography. Although most picture settings work the same way during Live View photography, the focusing process is different. For help with Live View focusing, visit Chapter 5.

Shooting Still Portraits

By *still portrait*, I mean that your subject isn't moving. For subjects who aren't keen on sitting still, skip to the next section and use the techniques given for action photography instead. Assuming that you do have a subject willing to pose, the classic portraiture approach is to keep the subject sharply focused while throwing the background into soft focus. This artistic choice emphasizes the subject and helps diminish the impact of any distracting background objects. The following steps show you how to achieve this look:

1. Set the Mode dial to A (aperture-priority autoexposure) and select a low f-stop value.

A low f-stop setting opens the aperture, which not only allows more light to enter the camera but also shortens depth of field, or the distance over which focus appears acceptably sharp. However, for a group portrait, don't go too low or else the depth of field may not be enough to keep everyone in the sharp-focus zone. Take test shots and inspect your results at different f-stops to find the right setting.

To adjust f-stop in A mode, rotate the Command dial. The camera then selects the shutter speed for you, but you need to make sure that the selected speed isn't so slow that movement of the subject or camera will blur the image. You can monitor the f-stop and shutter speed in the Information display and viewfinder, as shown in Figure 7-1.

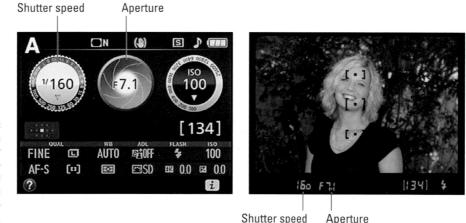

FIGURE 7-1: You can monitor aperture (f-stop) and shutter speed settings in the displays.

2. To further soften the background, zoom in, get closer, and put more distance between the subject and background.

Zooming in to a longer focal length also reduces depth of field, as does moving closer to your subject. And the greater the distance between the subject and background, the more the background blurs.

Avoid using a lens with extremely short or long focal lengths (wide angle and super-telephoto lenses), which can distort the face and other features. A lens with a focal length of 85mm to 120mm is ideal for a classic head-and-shoulders portrait.

3. Check composition.

Two pointers on this topic:

- *Consider the background*. Scan the entire frame, looking for background objects that may distract the eye from the subject. If necessary, reposition the subject against a more flattering backdrop.
- Frame the subject loosely to allow cropping to a variety of frame sizes. Your camera produces images that have an aspect ratio of 3:2. That means your portrait perfectly fits a 4 x 6 print size but will require cropping to print at any other proportion, such as 5 x 7 or 8 x 10.

4. For indoor portraits, shoot flash-free, if possible.

Shooting by available light rather than by flash produces softer illumination and avoids the problem of red-eye. To get enough light to go flash-free, turn on room lights or, during daylight, pose your subject next to a sunny window, as I did for the image in Figure 7-2.

In the A exposure mode, simply keeping the built-in flash unit closed disables the flash. If flash is unavoidable, see my flash tips at the end of this step list to get better results.

5. For outdoor portraits, use a flash if possible.

Even in daylight, a flash usually adds a beneficial pop of light to subjects' faces, as illustrated in Figure 7-3. A flash is especially important when the background is brighter than the subjects, as in this example.

FIGURE 7-2: For more pleasing indoor portraits, shoot by available light instead of using flash.

In the A exposure mode, press the Flash button on the side of the camera to raise the built-in flash. For daytime portraits, set the Flash mode to Fill Flash. (That's the regular, basic Flash mode.) For nighttime images, try red-eye reduction or slow-sync flash; again, see the flash tips at the end of these steps to use either mode most effectively.

REMEMBER

No flash

Fill flash

FIGURE 7-3: To properly illuminate the face in outdoor portraits, use flash.

The fastest shutter speed possible for flash photography on the D3400 is 1/200 second, so in bright light, you may need to stop down the aperture to avoid overexposing the photo, as I did for the bottom image in Figure 7-3. Doing so, of course, brings the background into sharper focus, so if that creates an issue, move the subject into a shaded area instead.

6. Press and hold the shutter button halfway to initiate exposure metering and autofocusing.

Or, if you're focusing manually, set focus by rotating the focusing ring on the lens.

7. Press the shutter button the rest of the way.

When flash is unavoidable, try these tricks for better results:

>> Indoors, turn on as many room lights as possible. With more ambient light, you reduce the flash power that's needed to expose the picture. Adding light also causes the pupils to constrict, further reducing the chances of red-eye.

As an added benefit, the smaller pupil allows more of the subject's iris to be visible in the portrait, so you see more eye color.

- >> Pay attention to white balance if your subject is lit by both flash and ambient light. If you set the White Balance setting to Auto, as I recommend in Table 7-1, enabling flash tells the camera to warm colors to compensate for the cool light of a flash. If your subject is also lit by other light sources, such as sunlight, the result may be colors that are slightly warmer or cooler (more blue) than neutral. A warming effect typically looks nice in portraits, giving the skin a subtle glow. If you aren't happy with the result, see Chapter 6 to find out how to fine-tune white balance.
- >> Try using a Flash mode that enables red-eye reduction or slow-sync flash. If you choose the first option, warn your subject to expect both a preliminary light from the AF-assist lamp, which constricts pupils, and the flash. And remember that slow-sync flash uses a slower-than-normal shutter speed, which produces softer lighting and brighter backgrounds than normal flash. (Chapter 2 explains the various Flash modes.)

Figure 7-4 offers an example of how using slow-sync flash can improve an indoor portrait. When I used regular flash, the shutter speed was 1/60 second. At that speed, the camera has little time to soak up any ambient light. As a result, the scene is lit primarily by the flash. That caused two problems: The strong flash created glare on the subject's skin, and the window frame is more prominent because of the contrast between it and the darker bushes outside the window. Although it was daylight when I took the picture, the skies were overcast, so at 1/60 second, the exterior appears dark.

In the slow-sync example, shot at 1/4 second, the exposure time was long enough to permit the ambient light to brighten the exteriors to the point that the window frame almost blends into the background. And because much less flash power was needed to expose the subject, the lighting is much more flattering. In this case, the bright background also helps to set the subject apart because of her dark hair and shirt. If the subject had been a pale blonde, this setup wouldn't have worked as well. Again, note the warming effect that can occur when you use Auto White Balance and shoot in a combination of flash and daylight and help eliminate shadows even more.

Using a slower-than-normal shutter speed increases the risk of blur due to camera shake, so use a tripod or otherwise steady the camera. Remind your subjects to stay absolutely still, too, because they'll appear blurry if they move during the exposure. I was fortunate to have both a tripod and a cooperative subject for my examples, but I probably wouldn't opt for slow-sync for portraits of young children or pets.

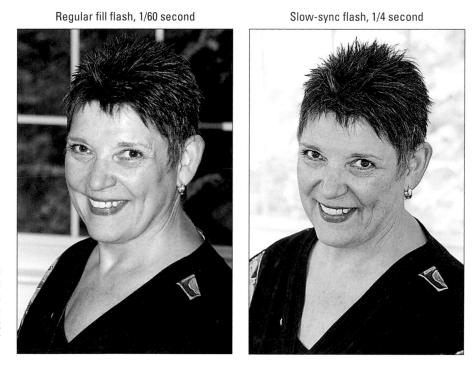

FIGURE 7-4: Slow-sync flash produces softer, more even lighting and brighter backgrounds.

>> For professional results, use an external flash with a rotating flash head.

Aim the flash head upward so that the flash light bounces off the ceiling and falls softly down onto the subject. External flashes can be pricey, but the results make the purchase worthwhile if you shoot lots of portraits. Compare the two portraits in Figure 7-5 for an illustration. In the first example, using the built-in flash resulted in strong shadowing behind the subject and harsh, concentrated light. To produce the better result on the right, I used a Nikon Speedlight external flash and bounced the light off the ceiling. I also moved the subject a few feet farther in front of the background to create more background blur.

Make sure that the surface you use to bounce the light is white; otherwise, the flash light will pick up the color of the surface and influence the color of your subject.

Invest in a flash diffuser to further soften the light. A diffuser is simply a piece of translucent plastic or fabric that you place over the flash to soften and spread the light — much like how sheer curtains diffuse window light. Diffusers come in lots of different designs, including models that fit over the built-in flash.

Bounce flash

FIGURE 7-5: To eliminate harsh lighting and strong shadows (left), use bounce flash and move the subject farther from the background (right).

Capturing Action

A fast shutter speed is the key to capturing a blur-free shot of a moving subject, whether it's a flower in the breeze, a spinning Ferris wheel, or, as in the case of Figure 7-6, a racing cyclist.

Along with the basic capture settings outlined earlier in Table 7-1, try these techniques to photograph a subject in motion:

- 1. Set the Mode dial to S (shutterpriority autoexposure).
- 2. Rotate the Command dial to select the shutter speed.

Refer to Figure 7-1 to locate shutter speed in the Information display and viewfinder. After you select the shutter speed, the camera selects an aperture (f-stop) to match.

FIGURE 7-6: Use a high shutter speed to freeze motion.

What shutter speed should you choose? It depends on the speed of your subject, so you need to experiment. But generally speaking, 1/320 second should be plenty for all but the fastest subjects (race cars, boats, and so on). For slow subjects, you can even go as low as 1/250 or 1/125 second. My subject in Figure 7-6 zipped along at a pretty fast pace, so I set the shutter speed to 1/640 second. Remember, though, that when you increase shutter speed, the camera opens the aperture to maintain the same exposure. At low f-stop numbers, depth of field becomes shorter, so you have to be more careful to keep your subject within the sharp-focus zone as you compose and focus the shot.

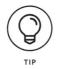

You also can take an entirely different approach to capturing action: Rather than choose a fast shutter speed, select a speed slow enough to blur the moving objects, which can create a heightened sense of motion and, in scenes that feature very colorful subjects, cool abstract images. I took this approach when shooting the carnival ride featured in Figure 7-7, for example. For the left image, I set the shutter speed to 1/30 second; for the right version, I slowed things down to 1/5 second. In both cases, I used a tripod, but because nearly everything in the frame was moving, the entirety of both photos is blurry — the 1/5 second version is simply more blurry because of the slower shutter.

1/30 second

1/5 second

FIGURE 7-7: Using a shutter speed slow enough to blur moving objects can be a fun creative choice, too.

3. In dim lighting, raise the ISO setting, if necessary, to allow a fast shutter speed.

Unless you're shooting in bright daylight, you may not be able to use a fast shutter speed at a low ISO, even if the camera opens the aperture as far as possible. Raising the ISO does increase the possibility of noise, so you have to decide whether a noisy shot is better than a blurry shot.

Why not add flash to brighten the scene? Well, adding flash is tricky for action shots, unfortunately. First, the flash needs time to recycle between shots, which slows the capture rate. Second, the built-in flash has limited range, so don't waste your time if your subject isn't close by. And third, remember that the fastest shutter speed you can use with flash is 1/200 second, which may not be high enough to capture a quickly moving subject without blur.

4. For rapid-fire shooting, set the Release mode to Continuous.

In this mode, the camera captures a continuous series of frames as long as you hold down the shutter button. On the D3400, you can capture as many as five images per second. Here again, though, you need to go flash-free; otherwise, you get one shot per press of the shutter button, just as in Single Frame release mode.

The fastest way to access the Release mode setting is to press the Release mode button on the back of the camera.

5. Select speed-oriented focusing options.

For fastest shooting, try manual focusing: It eliminates the time the camera needs to lock focus when you use autofocusing. However, manual focusing certainly adds to the challenge of keeping a fast-moving subject in focus. So I typically rely on autofocus, using the following two autofocus settings:

- Set the Focus mode to AF-C (continuous-servo autofocus).
- Set the AF-area mode to Dynamic Area.

At these settings, the camera sets focus initially on your selected focus point but looks to surrounding points for focus information if your subject moves away from the selected point. Focus is adjusted continuously until you take the shot. (Again, these instructions relate to viewfinder photography; for help with Live View focusing, see Chapter 5.)

6. Compose the subject to allow for movement across the frame.

Frame your shot a little wider than you normally might so that you lessen the risk that your subject will move out of the frame before you record the image. You can always crop to a tighter composition later. It's also a good idea to leave more room in front of the subject than behind it. This makes it obvious that your subject is going somewhere.

Action-shooting strategies also are helpful for shooting candid portraits of kids and pets. Even if your subjects aren't currently running, leaping, or otherwise cavorting, snapping a shot before they do move is often tough. So if an interaction catches your eye, set your camera into action mode and fire off a series of shots as fast as you can.

Capturing Scenic Vistas

Providing specific settings for landscape photography is tricky because there's no single best approach to capturing a beautiful stretch of countryside, a city skyline, or another vast subject. Most people prefer using a wide-angle lens, for example, to incorporate a large area of the landscape into the scene, but if you're far away from your subject, you may like the results you get from a telephoto or medium-angle lens. When shooting the scene in Figure 7-8, for example, I had to position myself across the street from the buildings, so I captured the shot using a focal length of 82mm. And consider depth of field: One person's idea of a super cityscape might be to keep all buildings in the scene sharply focused, but another photographer might prefer to keep a building in the foreground sharply focused but blur the background, thus drawing the eye to that foreground building.

FIGURE 7-8: Use a high f-stop value to keep the foreground and background sharply focused.

I can, however, offer a few tips to help you photograph a landscape the way *you* see it:

- Shoot in aperture-priority autoexposure mode (A) so that you can control depth of field. If you want extreme depth of field so that both near and distant objects are sharply focused, select a high f-stop value. I used an aperture of f/18 for the shot in Figure 7-8. For shallow depth of field, use a low f-stop value.
- If the exposure requires a slow shutter speed, use a tripod to avoid blurring. The downside to a high f-stop is that you may need a slower shutter speed to produce a good exposure. If the shutter speed drops below what you can comfortably handhold, use a tripod to avoid picture-blurring camera shake.

If you don't have a tripod handy and can't find any other way to stabilize the camera, try turning on the Optical VR feature, found on the Shooting menu. This option helps to compensate for slight camera movement (the VR stands for *vibration reduction*) when you use certain lenses, including the AF-P kit lens featured in this book. Some lenses, including Nikon's AF-S lenses, have an external switch for enabling and disabling a similar feature. (On Nikon lenses, the switch is marked VR.) See Chapter 1 for more information about this feature.

For dramatic waterfall shots, consider using a slow shutter to create that "misty" look. The slow shutter blurs the water, giving it a soft, romantic appearance, as shown in Figure 7-9. Again, use a tripod to ensure that the rest of the scene doesn't also blur due to camera shake. The shutter speed for the image in Figure 7-9 was 1/5 second.

In very bright light, you may overexpose the image at a very slow shutter, even if you stop the aperture all the way down and select the camera's lowest ISO setting. As a solution, consider investing in a *neutral density filter* for your lens. This type of filter works something like sunglasses for your camera: It simply reduces the amount of light that passes through the lens, without affecting image colors, so that you can use a slower shutter than would otherwise be possible.

At sunrise or sunset, base exposure on the sky. The foreground will be dark, but you can usually brighten it in a photo editor, if needed. If you base exposure on the foreground, on the other hand, the sky will become so bright that all the color will be washed out — a problem you usually can't fix after the fact. You can also invest in a graduated neutral-density

FIGURE 7-9: For misty waterfalls, use a slow shutter speed and a tripod.

filter, which is dark on top and clear on the bottom. You orient the filter so that the dark half falls over the sky and the clear side falls over the dimly lit portion of the scene. This setup enables you to better expose the foreground without blowing out the sky colors.

Also experiment with Active D-Lighting, which I feature in Chapter 4; it's designed to create images that contain a greater range of brightness values than is normally possible. If you already captured the image, see Chapter 11

to find out how to use the D-Lighting feature found on the Retouch menu. You may be able to brighten shadows using that tool.

For cool nighttime city pics, experiment with slow shutter speeds. Assuming that vehicles with their lights on are moving through the scene, the result is neon trails of light like those you see in the foreground of the image in Figure 7-10. Shutter speed for this image was about 10 seconds.

Rather than change the shutter speed manually between each shot, try *Bulb* mode. Available only in M (manual) exposure mode, this option records an image for as long as you hold down the shutter button. So just take a series of images, holding down the button for different lengths of time for each shot. In Bulb mode, you also can exceed the standard maximum exposure time of 30 seconds.

As is the case for other slow-shutter photos, using a tripod is a must for this type of shot; any camera shake will blur the stationary objects in the scene. And note that enabling Optical VR (vibration reduction) isn't sufficient for the very slow shutter speeds used to capture either my waterfall picture in Figure 7-9 or the city scene in Figure 7-10.

For the best lighting, shoot during the magic hours. That's the term photographers use for early morning and late afternoon, when the light cast by the sun is soft and golden, giving everything that beautiful, gently warmed look.

Can't wait for the perfect light? Tweak your camera's White Balance setting, using the instructions laid out in Chapter 6, to simulate the color of magic-hour light.

>> In tricky light, bracket exposures.

Bracketing simply means to take the same picture at several different exposure settings to increase the odds that at least one of them will capture the scene the way you envision. Bracketing is especially a

FIGURE 7-10: Using a slow shutter speed creates neon light trails in nighttlme city street scenes.

good idea in difficult lighting situations, such as sunrise and sunset.

In the M exposure mode, it's best to bracket exposures by changing the shutter speed between each shot rather than the f-stop. That way, depth of field — which is in part determined by the f-stop — remains consistent throughout all your shots.

In P, S, and A exposure modes, you can bracket exposures by using different Exposure Compensation settings for each shot. For example, take one image using no compensation, a second with Exposure Compensation set to +1.0, and a third at -1.0. To set the Exposure Compensation value, press and hold the Exposure Compensation button on top of the camera as you rotate the Command dial. Chapter 4 offers more details about this feature.

Capturing Dynamic Close-Ups

For great close-up shots, try these techniques:

- >> Check your lens manual to find out its minimum close-focusing distance. How "up close and personal" you can get to your subject depends on your lens.
- Take control over depth of field by setting the camera mode to A (aperture-priority autoexposure) mode. Whether you want a shallow,

medium, or extreme depth of field depends on the point of your photo. In classic nature photography, for example, the artistic tradition is a very shallow depth of field, as shown in Figure 7-11, and requires an open aperture (low f-stop value). If you want the viewer to be able to clearly see all details throughout the frame — for example, you're shooting a product shot for a sales catalog you need to go in the other direction, stopping down the aperture as far as possible.

Remember that depth of field decreases when you zoom in or move closer to your subject. If you need depth of field beyond what you can achieve with the aperture setting, you may need to back away, zoom out, or both. (You can always crop your image to show just the parts of the subject that you want to feature.)

FIGURE 7-11: Shallow depth of field is a classic technique for close-up floral images.

- When shooting flowers and other nature scenes outdoors, pay attention to shutter speed, too. Even a slight breeze may cause your subject to move, causing blurring at slow shutter speeds.
- >> Experiment with using flash for better outdoor lighting. Just as with portraits, a tiny bit of flash can sometimes improve close-ups when the sun is the primary light source. Again, though, keep in mind that the maximum shutter speed possible when you use the built-in flash is 1/200 second. So in very bright light, you may need to use a high f-stop setting to avoid overexposing the picture. You can also adjust the flash output via the Flash Compensation control. Chapter 2 offers details.
- >> When shooting indoors, avoid using the built-in flash as your primary light source when you are positioned very near the subject. At close range, the light from your flash may be too harsh even at a low Flash Compensation setting. If flash is inevitable, turn on as many room lights as possible to reduce the flash power that's needed. (If you have multiple light sources, though, you may need to tweak the White Balance setting.)

>> To get really close to your subject, invest in a macro lens or a set of

diopters. A true macro lens, which enables you to set focus really, really close to your subjects, is an expensive proposition; prices range from a few hundred to a couple thousand dollars. If you enjoy capturing the tiny details in life, though, it's worth the investment.

For a less expensive way to go, you can spend about \$40 for a set of diopters, which are like reading glasses that you screw onto your lens. Diopters come in several strengths -+1, +2, +4, and so on — with a higher number indicating a greater magnifying power. I took this approach to capture the extreme close-up in Figure 7-12, attaching a +2 diopter to my lens. The downside of using a diopter, sadly, is that it typically produces images that are very soft around the edges, a problem that doesn't occur with a good macro lens.

FIGURE 7-12: To extend your lens's close-focus capability, you can add magnifying diopters.

IN THIS CHAPTER

- » Recording your first movie using the default settings
- » Taking a still photo during recording
- » Understanding the frame rate, frame size, and movie quality options
- » Adjusting audio-recording options
- » Controlling exposure during movie recording
- » Playing and trimming movies

Chapter **8** Shooting, Viewing, and Trimming Movies

n addition to being a stellar still-photography camera, your D3400 enables you to record HD (high-definition) movies. This chapter tells you everything you need to know to take advantage of the movie-recording options.

Check that: This chapter tells you *almost* everything about movie recording. What's missing here is detailed information about focusing, which works the same way for movie shooting as it does when you use Live View to shoot a still photo. Rather than cover the subject twice, I detail your focusing options in Chapter 5 and provide just a basic recap in these pages.

Also visit the Chapter 1 section that introduces you to Live View basics, including precautions to take while Live View is engaged. (To answer your question: No, you can't use the viewfinder for movie recording; Live View is your only option.)

For even more insights into recording movies, hop online and check out Nikon's Image Chaser site (www.imagechaser.com). Click the Cinema link at the top of the home page to get to movie-recording tips and techniques.

Shooting Movies Using Default Settings

Video enthusiasts will appreciate the fact that the D3400 enables you to tweak a variety of movie-recording settings. But if you're not up to sorting through those options, just use the default settings. (You can restore the critical defaults by opening the Shooting menu and choosing Reset Shooting Menu.) At these settings, you get a full HD movie with sound enabled.

Movies are created in the MOV format, which means you can play them on your computer using most video-playback programs. You also can view movies in Nikon ViewNX-i, the free software Nikon makes available on the support pages of its website. To view your movies on an HDTV screen, see the end of Chapter 9 to find out how to connect your camera to your set.

The following steps show you how to record a movie using autofocusing. If you prefer manual focusing, bypass the autofocusing instructions. Again, you can find specifics on focusing during Live View in Chapter 5.

1. Set the Mode dial on top of the camera to Auto.

In this mode, the camera takes care of most movie settings for you, including ones that affect exposure and color.

2. Engage Live View by pressing the LV button on the back of the camera.

The viewfinder goes dark, and your subject appears on the monitor.

3. Press the Info button (top of the camera) until the display is set to Show Movie Indicators view, as shown in Figure 8-1.

Later sections decode all the symbols you see; for now, just pay attention to these bits of information:

- The boundaries of the movie frame are represented by shaded bars. At the default recording settings, you see bars around all four edges of the frame, as shown in the figure. Only the area inside the bars will be captured when you record the movie. All movies are captured at an aspect ratio of 16:9.
- At the default recording settings, your movie can be 20 minutes long. The available recording time appears in the area labeled in Figure 8-1. Keep in mind that the 20-minute recording time presumes that your memory card has enough space on it to hold the entire movie. The maximum file size for a movie is 4GB (gigabytes).

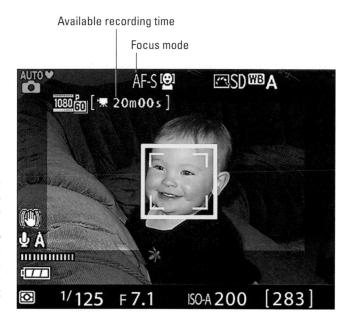

FIGURE 8-1: Press the Info button to cycle through the Live View display modes until you see these movierecording symbols.

> If the letters REC with a slash through them appear to the right of the recordingtime value, recording isn't possible. You see this symbol if no memory card is inserted or the card is full, for example.

4. To use autofocusing, set the Focus mode to AF-S or AF-F.

If you use an AF-S lens, you also need to set the switch on the exterior of the lens to the autofocus position, which is usually labeled A, AF, or AF/M (autofocus with manual override). With an AF-P lens like the one featured in this book, you set the lens to automatic focusing via the Focus mode option.

For autofocusing, you get two choices: AF-F and AF-S. Here's what you need to know to choose the best option for your movie:

 AF-F: This setting produces full-time, continuous autofocusing, with the camera adjusting focus as your subject moves or you pan the camera to follow the action. Focusing starts immediately after you set the Focus mode to AF-F. To lock focus at the current focusing distance, press the shutter button halfway. When you release the button, continuous autofocusing resumes.

Although AF-F autofocusing seems ideal for tracking moving subjects, the camera's built-in microphone sometimes picks up the sound of the focusing motor. The only way around this issue is to disable the camera's audio recording function and record the soundtrack using a separate microphone and audio recorder. Of course, you then have to marry the video footage and the audio in a video-editing program. Also, the scene may intermittently go in and out of focus while the camera adjusts focus to accommodate your subject's movement.

 AF-S: With this option, you can lock in the focus distance before you start recording, eliminating both of the issues associated with full-time autofocusing. With AF-S mode, you press the shutter button to autofocus, just as you do for still photography, but you can then lift your finger off the shutter button. Focus remains set at the current focusing distance throughout your recording unless you press the shutter button halfway again to reset focus. Choose this option if you expect your subject to remain the same distance from the camera throughout the movie — for example, if you're recording a piano performance. (Think AF-S, for stationary.)

.

You can see the current Focus mode setting at the top of the monitor, as shown in Figure 8-1. To change the setting, the fastest option is to use the control strip, as shown in Figure 8-2. **Remember:** Press the *i* button to bring up the control strip. You also can change the Focus mode via the Shooting menu. After selecting Focus mode from the menu, as shown on the left in Figure 8-3, select Live View/Movie, as shown on the right. On the next screen, you can select the Focus mode you want to use.

In either case, to disable autofocusing and use manual focusing, choose the MF Focus mode setting.

	Focus	mode	
QUAL	I WB	ж	
103060	AUTO	₽₽	2 0.0
AF-S	ଡ୍ରୋ		⊡SD

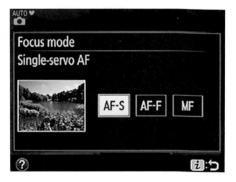

FIGURE 8-2: You can set the Focus mode via the control strip.

4	Focus mode	
â		
I H	Viewfinder	AF-A
	Live view/movie	AF-S ▶
?		

FIGURE 8-3: You also can change the setting via the Shooting menu.

REMEMBER

5. Compose your initial shot in the monitor.

Again, make sure that your subject is within the boundaries indicated by the shaded bars. Anything under those shaded borders won't be included in the movie scenes.

6. If necessary, move the Live View focusing frame over your subject.

By default, the camera uses the Face-Priority AF-area mode, which means that if your scene contains a face, the focusing system automatically focuses on that portion of the frame. In this scenario, you see a yellow focus frame over the face, as shown on the left in Figure 8-4. When the scene contains more than one face, you see multiple frames; the one with the interior corner markings indicates the face chosen as the focus point. You can use the Multi Selector to move the frame over a different face.

FIGURE 8-4: If the camera detects a face, you see the yellow focus frame shown on the left; otherwise, the focus frame is a red rectangle, as shown on the right.

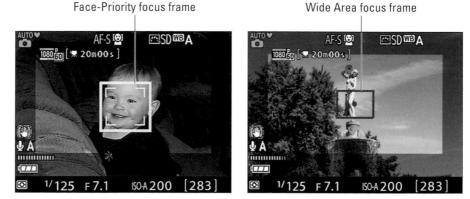

If the camera doesn't detect a face, it instead uses the Wide Area AF-area mode, and the focus frame appears as a red rectangle, as shown on the right side of Figure 8-4. Use the Multi Selector to move the frame over your subject.

7. Focus the shot.

Again, with AF-F focusing, you don't need to do anything; after setting the Focus mode to AF-F, just wait for the focusing frame to turn green, indicating that initial focus is set. If you use the AF-S mode, press the shutter button halfway until focus is achieved. The focusing frame turns green when that happens. You can then take your finger off the shutter button if you want.

0

To begin recording, press the red movie-record button on top of the camera.

As soon as you press the button, the original shaded borders disappear, and the area that was inside them is enlarged to give you a better view of what you're recording, as shown in Figure 8-5. The available recording area isn't

changed — the final result remains a 16:9 movie frame (the top and bottom boundaries of the frame are indicated by solid black bars). The camera is just showing you the scene as it will appear in the final movie, without the shaded bars to distract you.

Some shooting data also disappears, and a red Rec symbol appears in the area labeled in Figure 8-5. As recording progresses, the area labeled *Recording time remaining* in the figure shows you how many more minutes of video you can capture.

9. To stop recording, press the movie-record button again.

Be sure to wait for the memory-card access light to turn off before powering down the camera; while the light is on, data is still being written to the memory card. Look for the light on the back of the camera, just below the Delete (trash can) button. Recording time remaining

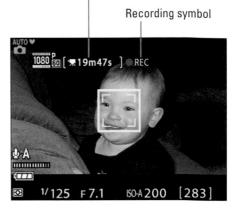

FIGURE 8-5:

The red Rec symbol appears while recording is in progress.

Two quick tips to add to these basics:

>> Declutter the display by pressing the Info button. The display changes to the Hide Indicators display mode, shown on the left in Figure 8-6. In this mode, white corner marks appear to indicate the 16:9 movie-framing area; I labeled one of the marks in the figure. Press Info again to display a grid over the scene, as shown on the right. When you start recording, the corner frame marks disappear, and your subject fills the available frame area, as when you record using the default display mode. The grid remains visible during recording.

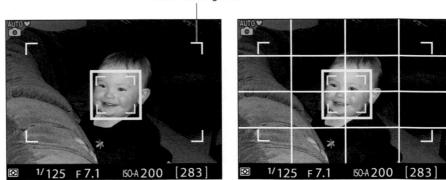

Movie framing mark

button to hide most of the onscreen data or display a grid.

FIGURE 8-6: Press the Info

Here's an important caveat, though: In these two display modes, you can't change movie settings via the control strip. Instead, pressing the *i* button brings up the control strip for still photography. To view the movie version of the control strip, you must use the Show Movie Indicators display (refer to Figure 8-1). Again, just press the Info button as needed to get back to that display.

>> You can stop recording and capture a still image in one fell swoop. Just press and hold the shutter button until you hear the shutter release. The number found within the brackets in the lower-right corner of the screen indicates how many still photos you can fit in the empty card space if you stop recording. As each second of recording ticks by and card space is depleted, the value that indicates the number of remaining still shots drops. For another option, you can save a single frame of your movie as a still photo. The last section of this chapter tells you how.

Adjusting Video Settings

If you're interested in taking more control over your recordings, start by exploring the Frame Size/Frame Rate and Movie Quality settings. Together, these settings determine the look of your video and its file size, which in turn determines the length of the movie you can record. (See the sidebar for the maximum length of the movie you can record when using each combination of the two settings.)

Using the Live View control strip, you can adjust both settings at once — more about that option later. But unless you're an experienced videographer, it's helpful to look at them separately first so that you understand what each option adds to the mix.

Start by scrolling to the second page of the Shooting menu, as shown on the left in Figure 8-7. Choose Movie Settings to display the screen shown on the right, where the Frame Size/Frame Rate and Movie Quality options head the list of the D3400 movie-recording settings.

The options you find for both settings are a little cryptic, to say the least. So the following list breaks things down for you:

>> Frame Size/Frame Rate: Choose

Frame Size/Frame Rate, as shown on the right in Figure 8-7, to display the screen shown in Figure 8-8. For now, concentrate on the numbers that follow the symbol to the left of each setting. The first pair of numbers indicates frame size, or movie *resolution* (number of pixels). In the world of HDTV, 1920 x 1080 pixels is considered *Full HD*, whereas 1280 x 720 is known as *Standard HD* and produces slightly lesser quality than Full HD (although I suspect few people can determine the differ-

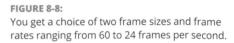

ence). Both options result in a frame with a 16:9 aspect ratio.

The second value represents the frame rate, measured in frames per second (fps). Available frame rates range from 60 to 24 frames per second, with each delivering a slightly different video quality, as follows:

- 24 fps is the standard for motion pictures. It gives your videos a softer, more movielike look.
- 25 fps gives your videos a slightly sharper, more "realistic" look. This frame rate is the standard for television broadcast in countries that follow the PAL video-signal standard, such as some European countries.
- *30 fps produces an even crisper picture than 25 fps.* This frame rate is the broadcast video standard for the United States and other countries that use the NTSC signal standard.
- 50 and 60 fps are often used for recording high-speed action and creating slow-motion footage. With more frames per second, fast movements are rendered more smoothly, especially if you slow down the movie playback for a slo-mo review of the action.

How about 50 versus 60? You're back to the PAL versus NTSC question: 50 fps is a PAL standard, and 60 is an NTSC standard.

The default setting is 1920 x 1080 at 60 fps. At this setting, as well as 1920 x 1080 at 50 fps, the camera records a smaller area at the center of the screen than is captured at other settings. Shaded bars around the edges of the monitor represent the boundaries of the recording area (refer to Figure 8-1). At any other setting, you don't see the shaded bars; instead, solid black bars appear to indicate the top and bottom boundaries of the 16:9 frame.

As for the letter *p* following the frames-per-second value, it indicates that footage is recorded using the *progressive* video format, which is the most current dSLR video-recording technology. The D3400 uses only this format; the older *interlaced (i)* format isn't provided.

Now back to the symbol at the left side of each option: It simply puts into graphic form the selected setting. However, only the horizontal frame size is presented (1080 or 720). So the graphic on line one of Figure 8-8 indicates that the Frame Size is set to 1920 x 1080 and the Frame Rate is set to 60p.

Movie Quality: This option determines how much compression is applied to the video file. The compression level affects the *bit rate*, or how much data is used to represent 1 second of video, measured in Mbps (megabits per second). You get two choices: High and Normal. The High setting results in a higher bit rate, which means better quality and larger files. Normal produces a lower bit rate and smaller files.

To adjust the Movie Quality setting, select Movie Settings from the Shooting menu, as shown on the left in Figure 8-9. On the next screen, select Movie Quality, as shown on the right side of Figure 8-9. Press the Multi Selector right to display a screen where you can select High or Normal as the setting you want to use.

SHOOTING ME	NU	Movie settings	
Optical VR	(@)ON		
Novie settings		P Frame size/frame rate	1080
		Movie quality	NORM
		Microphone	⊉ A
		Wind noise reduction	OFF
		Manual movie settings	0FF

FIGURE 8-9: To set the Movie Quality, follow this menu path.

If you take a magnifying glass to the Live View display, you also can view the current Frame Size/Frame Rate and Movie Quality settings near the upper-left corner of the screen, as shown in Figure 8-10. The Frame Size/Frame Rate symbols are the same ones you see on the menu selection screen; the Movie Quality is indicated by a star or lack thereof. If you see a star, as shown in the figure, the Movie Quality is set to High. No star means the option is set to Normal (which is the default).

After you're comfortable with both settings, you can save time by adjusting them as a combo pack via the control strip, shown in Figure 8-11. Just to add a little confusion to an already baffling situation, the option name on the control strip is Qual; it's highlighted in the left screen shown in the figure. Select the Qual option and press OK to get to the screen shown on the right in the figure. Here you see boxes representing each of the possible combinations of frame size, frame rate, and movie quality. As you scroll through the settings, a label at the top of the screen tells you what Frame Size/Frame Rate and Movie Quality the current option delivers. For example, the chosen setting in the figure results in a 1920 x 1080 Frame Frame Size/Frame Rate

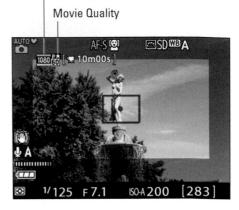

FIGURE 8-10:

In the default Movie display mode, the Frame Size/Frame Rate and Movie Quality settings appear here.

Size, 60 fps Frame Rate, and High Movie Quality.

S Hay	Mrs &	4	
N	lovie fram	e size/quality	/
108060	AUTO	& A	⊠ 0.0
AF-S	(@)	SQ0FF	⊡S0

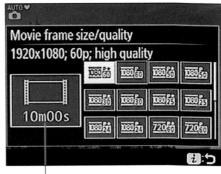

Maximum movie length

FIGURE 8-11: For fast access to video settings, press the *i* button to bring up the movierecording version of the control strip.

Note that as you cycle through the settings, the box on the left side of the screen tells you the maximum length of movie you can create at the current pairing of Frame Size/Frame Rate and Movie Quality. When you max things out for both options (top frame size, top frame rate, and high quality), the maximum recording time is 10 minutes, as shown on the right in Figure 8–11.

MAXIMUM MOVIE RECORDING TIMES

REMEMBER

The maximum recording time of a single video clip depends on the Frame Size/Frame Rate and Movie Quality options, as outlined here. Your memory card also must have enough free space to hold the entire movie; the maximum file size for a movie at any setting is 4GB. Recording stops automatically when you reach the maximum file size for recording time or run out of memory card space.

Frame Size	FPS	Quality	Maximum Movie Length
1920 x 1080	60, 50	High	10 minutes
		Normal	20 minutes
1920 x 1080	30, 25, 24	High	20 minutes
		Normal	29 minutes, 59 seconds
1280 x 720	60, 50	High	20 minutes
		Normal	29 minutes, 59 seconds

Controlling Audio

You can record sound using the camera's built-in microphone, labeled on the left in Figure 8-12, or disable the mic to record a silent movie. (Unfortunately, you can't attach an external microphone to the D3400.) During on-camera playback, sound comes from the speaker on top of the camera, labeled on the right in the figure.

If you use the built-in mic, you can adjust two audio settings, Microphone and Wind Noise Reduction, explained in the next two sections.

Choosing the Microphone setting (volume control)

The most critical audio-recording control is the Microphone setting, which affects sound volume. You must choose the setting *before* starting the recording; you can't change it while recording is in progress.

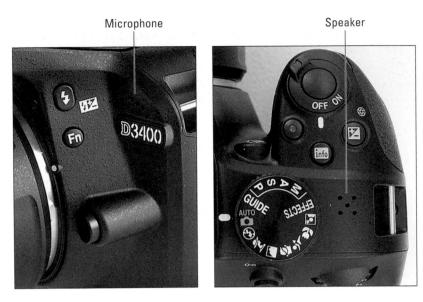

FIGURE 8-12: You can record audio with the internal microphone (left); the speaker for in-camera playback is on top of the camera (right).

You can choose from the following three settings:

- Auto Sensitivity: The camera automatically adjusts the volume according to the level of the ambient noise. This setting is the default.
- Manual Sensitivity: You specify the volume level, with settings ranging from 1 to 20.
- >> Microphone Off: Choose this setting to record video with no sound.

Symbols representing the current setting appear in the display, as shown in Figure 8–13. (If you don't see similar data on your screen, press the Info button to change the display style.) The microphone symbol indicates that audio recording is enabled; the letter *A* indicates the Auto Sensitivity option. If you set the camera to Manual Sensitivity, your selected volume level appears instead. Turn audio recording off, and you see a microphone with a slash through it.

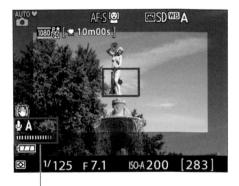

Microphone setting

FIGURE 8-13: These symbols indicate the current Microphone setting and volume level.

Beneath those symbols, you see a horizontal bar that indicates sound volume. Audio levels are measured in decibels (dB), and levels on the volume meter range from -40 (very, very soft) to 0 (as loud as can be measured digitally). Ideally, sound should peak consistently in the -12 range. The indicators on the meter turn yellow in this range, as shown in Figure 8-13. If the sound level is too high, the bar at the top of the meter turns red — a warning that audio may be distorted.

To adjust the Microphone setting, you can go two routes:

Shooting menu: Choose Movie Settings from the Shooting menu to display the screen shown on the left in Figure 8-14. Select Microphone to display the screen shown on the right, which lists the three settings plus a volume meter. After highlighting your choice, press OK.

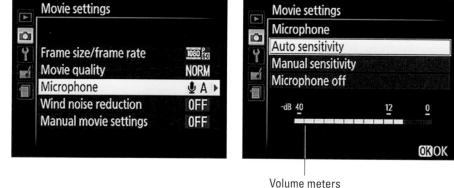

If you choose Manual Sensitivity, as shown on the left in Figure 8-15, you see a screen where you can set a specific volume level from 1 to 20. Press the Multi Selector up and down to change the setting. Again, the volume meter is there to guide you as you adjust the level. Don't forget to press OK to make your change official.

Ð

Control strip: Press the *i* button to display the control strip. Select the Microphone setting, as shown on the left in Figure 8-16, to display the second screen in the figure. Again, you see the volume meter plus symbols representing the Auto, Manual, and Off settings, as labeled in the figure. If you choose Manual, options appear to enable you to set the volume level. Press OK to lock in your choice. Then press the *i* button to exit the screen.

FIGURE 8-14: You can access the Microphone settings via the Movie Settings option on the Shooting menu.

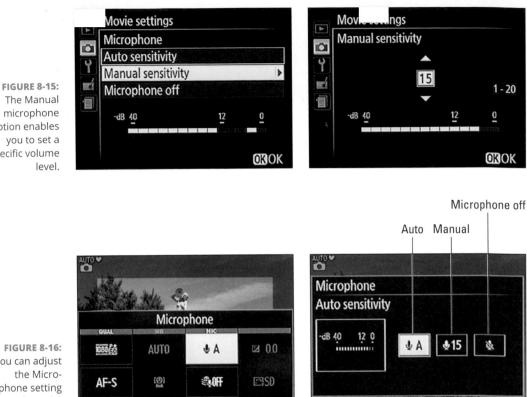

i

microphone option enables you to set a specific volume level.

FIGURE 8-16: You can adjust the Microphone setting from the control strip.

Reducing wind noise

ISO-A 200

1/125 F7.1

Ever seen a newscaster out in the field, carrying a microphone that looks like it's covered with a big piece of foam? That foam thing is a wind filter. It's designed to lessen the sounds that the wind makes when it hits the microphone.

DROK

You can enable a digital version of the same thing via the Wind Noise Reduction option. Essentially, the filter works by reducing the volume of noises that are similar to those made by wind. The problem is that some noises not made by wind can also be muffled when the filter is enabled. So when you're indoors or shooting on a still day, keep this option set to Off, as it is by default.

FIGURE 8-17: Access the Wind Noise Reduction setting via the Movie Settings option on the Shooting menu or via the control strip.

Movie settings		AUTO
Frame size/frame rate	1080 50	28
Movie quality	NORM	1 Q
Microphone	₽ A	DE
Wind noise reduction	€ON ►	
Manual movie settings	OFF	A
		(?)

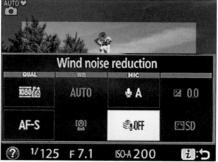

To turn Wind Noise Reduction on or off, visit the Shooting menu, open the Movie Settings screen, and choose Wind Noise Reduction, as shown on the left in figure 8–17. You also can turn the feature on an off via the control strip, as shown on the right.

When the feature is enabled, the symbol labeled in Figure 8–18 appears with the other microphone settings. The symbol disappears if you turn off Wind Noise Reduction.

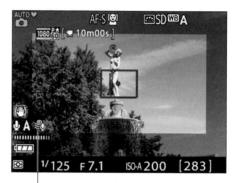

Wind Noise Reduction enabled

FIGURE 8-18: This symbol tells you that Wind Noise Reduction is turned on.

Exploring Other Recording Options

In addition to settings reviewed in the preceding sections, you can control a few other aspects of your cinematic effort. Figure 8–19 labels the symbols that represent these settings in the display. The figure also shows where to find the symbol representing the battery status; be sure the battery symbol is full, as in the figure, so that you don't run out of power during your recording. Near the lower-right corner of the display, the number labeled *Still photos remaining* indicates how many still photos you can fit in the currently available free space on the memory card.

Here's a brief explanation of the settings you can adjust:

Exposure mode: You can record movies in any exposure mode (Auto, Scene modes, Effects modes, P, M, and so on). As with still photography, your choice determines which camera settings you can access. (The Movie Settings menu options are available in all modes, however.)

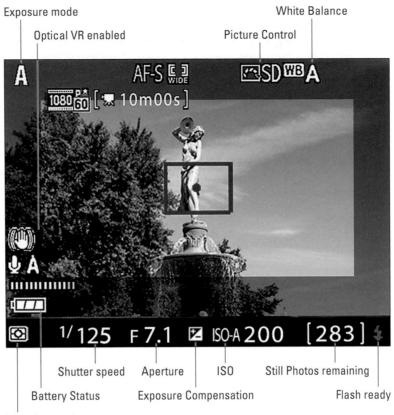

FIGURE 8-19: Here's your road map to other symbols shown on the monitor in the Show Movie Indicators display mode.

Metering mode

- Exposure settings: The aperture (f-stop), shutter speed, ISO, Metering mode, and Exposure Compensation settings, all labeled in Figure 8-19, determine movie exposure. In the P, S, A, and M modes, as well as in Night Vision Effects mode, you have some control over all these options except Metering mode; the camera always uses Matrix metering for movie recording. See the next section for details on adjusting exposure. For all other exposure modes, the camera handles exposure automatically.
- >> White Balance and Picture Control: The colors in your movie are rendered according to the current White Balance and Picture Control settings, both detailed in Chapter 6. However, you have control over these options only when the Mode dial is set to P, S, A, or M. The current settings appear in the areas labeled in Figure 8-19; you can adjust both options either via the Shooting menu or the control strip.

Want to record a black-and-white movie? Select Monochrome as the Picture Control. Instant *film noir.*

Flash: Flash comes into play only if you snap a still photo at the end of your recording. If the flash is enabled and ready to fire, the red flash symbol appears in the lower-right corner of the display. See Chapter 2 for details on using flash.

For a review of autofocusing at the default movie recording settings, see the first section of this chapter; for details on all Live View and movie focusing features, check out Chapter 5.

Manipulating Movie Exposure

Normally, the camera automatically adjusts exposure during movie recording. Exposure is calculated using Matrix (whole frame) metering, regardless of which Metering mode setting is selected. But in a few exposure modes, you can adjust exposure by changing the following settings:

- Shutter speed and ISO: The camera sets both these options by default. (Look for the current settings in the areas labeled in Figure 8-19.) But if you enable the Manual Movie Settings option on the Movie Settings menu, as shown in Figure 8-20, you can control both settings. This path is one for experienced videographers, however. If you fit that category, here are a few things you need to know:
 - *Exposure mode:* You must set the Mode dial to M (manual) exposure to take advantage of this option.
 - Shutter speed: You can select shutter speeds as high as 1/4000 second. The slowest shutter speed depends on your chosen frame rate. For 24p, 25p, and 30p, you can drop as low as 1/30 second; for 50p, 1/50 second; and for 60p, 1/60 second. To set the shutter speed in M mode, rotate the Command dial.

	SHOOTING MEN	U	Movie settings	
	Optical VR	(DON)		
Y	Novie settings		Frame size/frame rate	
			Movie quality Microphone	Norm ⊈ A
			Wind noise reduction	Step on
			Manual movie settings	ON 🕨
			?	

FIGURE 8-20: Enable this option to take control over movie exposure.

REMEMBER

If you choose a shutter speed outside the stated ranges, the camera chooses the closest in-range setting after you begin recording.

• ISO: You can set the ISO value as low as 100 or as high as 25600. Note that Auto ISO Sensitivity control doesn't work when the Manual Movie Settings option is enabled; the camera sticks with your selected setting regardless of whether you enable Auto ISO — and, more importantly, regardless of whether your selected setting produces an under- or overexposed movie.

To adjust ISO guickly, press the Fn button while rotating the Command dial. You can also select the ISO value via the ISO Sensitivity settings option on the Shooting menu or by using the Live View control strip.

Because the camera is set to Manual exposure mode, you also have to set the f-stop that delivers the exposure you want at your selected ISO and shutter speed. Read the next bullet point for details on that setting.

>> Aperture (f-stop): You can adjust the f-stop before (but not during) recording if you set the Mode dial to A (aperture-priority autoexposure) or M (manual exposure). The advantage of controlling aperture is that in addition to altering exposure, changing the f-stop affects depth of field. So if you want your subject to be sharp but the background to be blurry, for example, you can choose a low f-stop number, which creates that result. Chapter 4 explains the aperture setting completely, but keep in mind that you can manipulate depth of field in other ways. Chapter 5 explains the other factors that affect this characteristic of your photos and movies.

In A mode, change the aperture setting by rotating the Command dial. In M mode, press and hold the Exposure Compensation button while rotating the dial. In either case, remember that the live preview doesn't indicate the depth of field that your f-stop setting will produce — the camera can't provide this feedback because the aperture doesn't actually open to your selected setting until you start recording.

One guirk to note: If Manual Movie Settings is enabled, as explained in the preceding bullet point, and the Mode dial is set to M (manual exposure), you must exit Live View mode before you can change the aperture setting. Press the LV button to do so. Then adjust the aperture by pressing the Exposure Compensation button while rotating the Command dial. Press the LV button to return to Live View mode.

>> Exposure Compensation: Exposure Compensation, detailed in Chapter 4, enables you to override the camera's autoexposure decisions, asking for a brighter or darker picture. You can apply this adjustment for movies when you use the following exposure modes: P, S, A, or M; any Scene mode; or the Night Vision Effects mode. However, you're limited to an adjustment range of EV +3.0 to -3.0 rather than the usual five steps that are possible during normal photography. Note that the display shows the plus/minus symbol you see in Figure 8-19 only when Exposure Compensation is in force.

REMEMBER

In any exposure mode except M, you can apply Exposure Compensation easily by holding down the Exposure Compensation button while rotating the Command dial. (That button/dial combo adjusts the aperture when you use the M exposure mode.) Alternatively, press the *i* button to access the setting via the movie-recording version of the control strip. The setting is the top-right option on the control strip.

Just to head off any possible confusion: For viewfinder photography, Exposure Compensation isn't needed in M exposure mode; if you want a brighter or darker exposure, you just change the aperture, shutter speed, or ISO Sensitivity settings. But because the camera doesn't give you control over shutter speed or ISO during movie recording — *unless you enable Manual Movie Settings* — you need some way to tell the camera that you want a brighter or darker picture in M mode, and Exposure Compensation is it.

Autoexposure lock: In any exposure mode except Auto or Auto Flash Off, you can lock exposure at the current settings by pressing and holding the AE-L/AF-L button. Chapter 4 also tells you more about autoexposure lock.

Screening Your Movies

To play your movie, set the camera to playback mode by pressing the Playback button. In single-image playback mode, you can spot a movie file by looking for the little movie camera icon in the upper-left corner of the screen, as shown in Figure 8–21. The default display mode also shows other movie-related data, including the movie length, Frame Size, Frame Rate, and Movie Quality setting. (*Remember:* A star next to the Frame Rate value means that you set the Movie Quality option to High.) The pair of numbers in the upper-right corner tells you the number of the current file and the total number of files on the card. The actual filename appears at the bottom of the screen.

In the thumbnail and Calendar playback modes, both described in Chapter 9, you see little dots along the edges of image thumbnails to represent movie files. After you locate the movie you want to play, press OK to shift to single-image view.

To begin playback, press OK (the OK Play label near the bottom of the screen reminds you to use the OK button). During playback, you see the data labeled in Figure 8–22. The progress bar and Elapsed Time value show you how much of the movie has played so far; you can also see the total movie length.

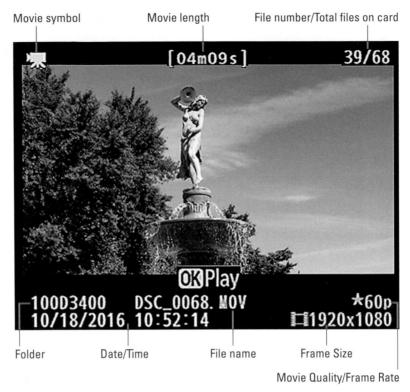

FIGURE 8-21: When you use the default playback display mode, you see this movie data on the screen.

You can control playback as follows:

- **Stop playback:** Press the Multi Selector up or press the Playback button to stop the movie and return to the initial playback screen.
- >> Pause/resume playback: Press the Multi Selector down to pause playback and press OK to resume playback. (That white circle labeled *Playback control symbols* in the figure is designed to remind you of the Multi Selector's movie-playback role.)
- >> Fast-forward/rewind: Press the Multi Selector right or left to fast-forward or rewind the movie, respectively. Press again to double the fast-forward or rewind speed; keep pressing to increase the speed. Hold down the button to fast-forward or rewind all the way to the end or beginning of the movie.
- Forward/rewind 10 seconds: Rotate the Command dial to the right to jump 10 seconds forward through the movie; rotate to the left to jump back 10 seconds. The camera pauses playback after every jump; press OK to resume playback.
- >> Play in slow motion: Start playback and then press the Multi Selector down twice. Sound is disabled. Press OK to resume normal playback.

Elapsed time/Total length

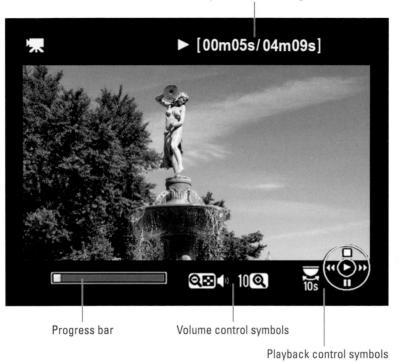

FIGURE 8-22: The icons at the bottom of the screen remind you which buttons to use to control playback.

> Advance frame by frame: First press the Multi Selector down to pause playback. Then press the Multi Selector right to advance one frame; press left to go back one frame.

Adjust playback volume: See the markings labeled Volume control symbols in Figure 8-22? They remind you that you can press the Zoom In button to increase volume and press the Zoom Out button to lower it. The number value tells you the current volume level (10, in the figure).

Trimming Movies

You can do some limited movie editing in camera. I emphasize: *limited* editing. You can trim frames from the start of a movie and clip off frames from the end, and that's it. To eliminate frames from the start of a movie, take these steps:

- **1.** After putting the camera in playback mode, display your movie in single-image view.
- 2. Press OK to begin playback.
- **3.** When you reach the first frame you want to keep, pause the movie by pressing the Multi Selector down.

The onscreen display updates to show the controls that appear on the left in Figure 8-23.

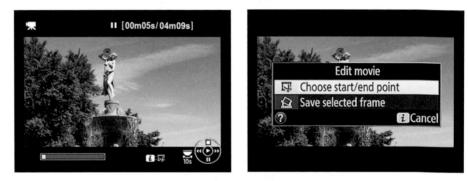

FIGURE 8-23: With the movie paused, press the *i* button to access the movie-editing screens.

4. Press the *i* button at the bottom of the screen.

You see the menu options shown on the right in Figure 8-23.

5. Select Choose Start/End Point.

You see the options shown in Figure 8-24.

6. Select Start Point.

You return to the playback screen, which now sports a couple additional symbols. First, you see two markers on the progress bar at the bottom of the screen. The left marker indicates the start point; the right marker, the end point. You also see an AE-L/AF-L symbol. (More about both these controls later.)

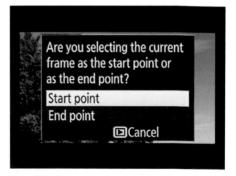

FIGURE 8-24:

To trim frames from the beginning of a movie, select the Start Point option.

7. Press the Multi Selector up to lop off all frames that came before the current frame.

Now you see the options shown in Figure 8-25. If you want to preview the movie, select Preview and press OK; after the preview plays, you're back at the menu screen.

8. To preserve your original movie and save the trimmed one as a new file, choose Save as New File and press OK.

> Alternatively, you can opt to overwrite the existing file, but you can't get the original file back if you do.

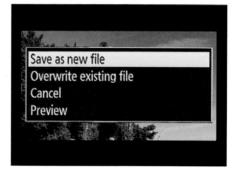

FIGURE 8-25:

When you're happy with your edited movie, choose Save as New File to avoid overwriting the original movie file.

A message appears, telling you that the trimmed movie is being saved. During playback, edited files are indicated by a little scissors icon that appears in the upper-left corner of the screen, as shown in Figure 8-26.

To instead trim footage from the end of a film, follow the same steps but this time pause playback on the last frame you want to keep in Step 3. Then, in Step 6, select Choose End Point instead of Choose Start Point.

You can trim an already trimmed movie, by the way. So you can go through the steps once to set a new start point and a second time to set a new end point. Or, if you prefer, you can trim files from both the beginning and end of a movie in one pass. After you finish Step 6, press the AE/L-AF-L button. The marker at the right end of the progress bar turns yellow, indicatTrimmed movie symbol

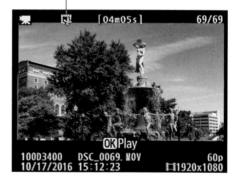

FIGURE 8-26: The scissors symbol tells you that you're looking at a trimmed movie.

ing that you can now rewind the movie to the frame that you want to use as the end of the video. You can keep pressing the AE-L/AF-L control to toggle between the start/end point controls on the progress bar. To finalize the edit, press the Multi Selector up.

Saving a Movie Frame as a Still Image

You can save a frame of the movie as a still photo. Here's how:

- **1.** Begin playing your movie.
- 2. When you reach the frame you want to capture, press the Multi Selector down to pause playback.

- **3.** Press the *i* button to bring up the Edit Movie screen, shown in Figure 8-27.
- 4. Choose Save Selected Frame.

The frame appears on the monitor.

- 5. Press the Multi Selector up.
- **6.** On the confirmation screen that appears, select Yes.

Your frame is saved as a JPEG photo.

FIGURE 8-27: This option lets you save a single frame as a JPEG image.

Remember a few things about pictures you create this way:

- >> When you view the image, it's marked with a little scissors icon in the upperleft corner. (It looks just like the one labeled in Figure 8-26.)
- The resolution of the picture depends on the resolution of the movie: For example, if the movie resolution is 1920 x 1080, your picture resolution is 1920 x 1080.
- You can't apply editing features from the Retouch menu to the file, and neither can you view all the shooting data that's normally associated with a JPEG picture.

After the Shot

IN THIS PART . . .

Get the details on picture playback, including how to customize playback screens.

Delete files you don't want, assign ratings to pictures and movies, and protect your best work from being accidentally deleted.

Transfer files from the camera to the computer.

Convert Raw images using the built-in conversion tool or the one available in Nikon Capture NX-D.

Prepare photos for online sharing.

IN THIS CHAPTER

- » Exploring picture playback functions
- » Magnifying photos to check small details
- » Taking advantage of Calendar view
- » Deciphering the picture information displays
- » Creating a digital slide show
- » Viewing your photos and movies on an HDTV screen

Chapter **9** Playback Mode: Viewing Your Photos

ithout question, my favorite thing about digital photography is being able to view my pictures the instant after I shoot them. No more guessing whether I captured the image or need to try again, as in the film days; no more wasting money on developing pictures that stink.

Seeing your pictures is just the start of the things you can do when you switch your camera to playback mode, though. You also can review settings you used to take the picture, display graphics that alert you to exposure problems, and magnify a photo to check details. This chapter introduces you to these playback features and more.

Picture Playback 101

Unless the D3400 is your first digital camera, you're probably familiar with the basics of picture playback, which are pretty much the same on every digital camera. But just in case, here's a quick refresher:

1. Press the Playback button to put the camera in playback mode.

Figure 9-1 shows you where to find the button. By default, you see a single photo along with some picture information, as shown in the figure.

If you see multiple thumbnails after you press the Playback button, press the OK button to switch to single-photo view. If you instead see a calendar display, press OK twice. (Upcoming sections explain how to use these alternative displays.)

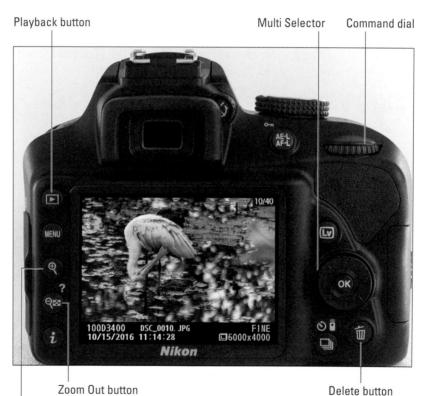

FIGURE 9-1: These buttons play the largest roles in picture playback.

- **2.** To scroll through your pictures, press the Multi Selector right or left or rotate the Command dial, both labeled in Figure 9-1.

Zoom In button

You can magnify the current image by pressing the Zoom In button, labeled in the figure. While the image is magnified, press the Multi Selector to scroll the display. Press the Zoom Out button to reduce picture magnification.

This trick works only for photographs. During movie playback, pressing the Zoom In and Zoom Out buttons increases and decreases audio volume, respectively. To start a movie, press OK; to pause playback, press the Multi Selector down. Press OK again to restart the movie.

3. To erase an embarrassing photo or movie before anyone can see it, press the Delete button.

A confirmation screen appears; press Delete again to give the go-ahead to erase the photo. (Chapter 10 offers additional ways to erase.)

4. To return to picture-taking mode, press the Playback button again or press the shutter button halfway and then release it.

Of course, just as with every other aspect of using the D3400, Nikon provides you with a variety of options for customizing playback. Chapter 8 covers movie-specific techniques, such as how to fast forward, rewind, and trim movies. The rest of this chapter explains playback features that relate only to still images or work for both stills and movies.

Choosing Which Images to View

Your camera organizes pictures into folders that are assigned generic names: 100D3400, 101D3400, and so on. You can see the name of the current folder by looking at the Storage Folder option found on the third page of the Setup menu. (The default folder name appears on this menu as simply 100.) You also can create custom folders by using the process outlined in Chapter 12. Which folders' photos appear during playback depends on the Playback Folder option on the Playback menu, shown in Figure 9–2.

You can choose from the following options, shown on the right in the figure:

- >> D3400: All pictures taken with the D3400 are viewable, regardless of which folder they call home.
- All: The difference between this setting and the D3400 setting is that if your card contains pictures shot with a different camera, they're also displayed. The only requirement is that the files be in an image format that the camera recognizes. For example, you may not be able to view Raw files shot with another brand of camera. This setting is the default.

FIGURE 9-2: If your memory card contains multiple image folders, specify which folder you want to view.

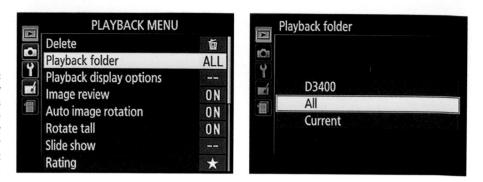

Current: The camera displays images contained in the folder selected as the Storage Folder option on the Setup menu — in other words, the folder in which new photos are currently being stored.

Adjusting Playback Timing

You can specify when and for how long each photo is displayed, too. Here's a look at your options:

- >> Adjust the timing of automatic shutoff. When the camera is in playback mode, the monitor is set by default to turn off automatically after 5 minutes elapse without any activity. You can adjust this shutoff timing by opening the Setup menu and selecting Auto Off Timers, which brings up the screen shown on the left in Figure 9-3. Ignore the first three options for now; they control the shutoff timing for a variety of camera operations in addition to playback shutoff. Instead, choose Custom, as shown in the figure, and then select Playback/Menus, as shown on the right. You then can choose playback shutoff limits ranging from 8 seconds to 10 minutes. Remember that the monitor is a big battery drain, so keep the display time as short as you find practical. Just note that as the setting name implies, this option also controls the length of time camera menus are displayed before automatic shutdown occurs. For more details on the Auto Off Timers feature, check out Chapter 12.
- >> **Turn Image Review on or off.** This feature, found on the Playback menu and turned on by default, enables you to get a quick look at a photo without having to shift out of shooting mode and into playback mode. As soon as the camera finishes recording the shot to the memory card, the photo appears for 4 seconds on the monitor.

FIGURE 9-3: You can control how long pictures are displayed before automatic monitor shutdown occurs.

Auto off timers		Auto off timers	
SHORT Short		Playback/menus	5m 🕨
NORM Normal		Image review	4s
LONG Long		Live view	10m
🕑 🖉 Custom	•	Standby timer	8s
			OK Done

During the Image Review display, the monitor shows a bit of shooting data, including the exposure mode, number of shots remaining, the battery status symbol, and the Image Size and Quality of the photo. In the upper-right corner of the screen, you also see a pair of numbers indicating how many files are on the memory card and the number of the frame you just captured — for example, 4/15 means that you're looking at the fourth of 15 files on the card.

You can change the length of the Image Review display through the same Setup menu option that controls regular playback shutoff (Auto Off Timers). After choosing Custom, as shown on the left in Figure 9-3, choose Image Review and select a display time. Choices range from 4 seconds to 10 minutes.

To disable Image Review altogether, open the Playback menu and set that option to Off, as shown in Figure 9-4. You can still view your pictures at any time by pressing the Playback button.

Innel	PLAYBACK MENU	
	Delete	ŭ
D S	Playback folder	D3400
Ŷ	Playback display options	
	Image review	OFF
	Auto image rotation	ON
	Rotate tall	ON
	Slide show	
?	Rating	*

FIGURE 9-4: To save battery power, you may want to disable Image Review.

Enabling Automatic Picture Rotation

When you take a picture, the camera records the image *orientation* — whether you held the camera normally, creating a horizontally oriented image, or turned the camera on its side to shoot a vertically oriented photo. During playback, the camera reads the orientation data and rotates vertical images so that they appear in the upright position, as shown on the left in Figure 9–5. The picture is also automatically rotated when you view it in any photo programs that can read the data.

FIGURE 9-5: You can display vertically oriented pictures in their upright position (left) or sideways (right).

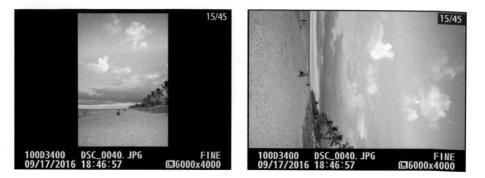

If you prefer, you can disable rotation, in which case vertically oriented pictures appear sideways, as shown on the right in Figure 9-5. To control this playback function, open the Playback menu and use the following two menu options, high-lighted in Figure 9-6:

FIGURE 9-6: These two Playback menu options affect whether pictures are tagged with orientation data and whether the camera rotates tagged pictures during playback.

	PLAYBACK MENU		PLAYBACK MENU		
	Delete	面	Delete		
	Playback folder	ALL	Playback folder	ALL	
	Playback display options		Playback display opt		
	Image review	ON	Image review	ON	
	Auto image rotation	ON	Auto image rotation		
	Rotate tall	ON	Rotate tall	ON	
	Slide show		Slide show	- 2012	
?	Rating	*	Rating	*	

- Auto Image Rotation: This option determines whether orientation data is included in the picture file. Select Off to leave out the data. Pictures then aren't rotated during on-camera playback or in your photo software.
- Rotate Tall: This option controls whether the camera pays attention to the orientation data during playback. Choose Off if you don't want the camera to rotate pictures that are tagged with orientation data. (Pictures not tagged with the data don't rotate even if you set Rotate Tall to On.)

Regardless of the settings you choose, no rotation occurs during the instantreview picture display. Nor are movies rotated. Also be aware that shooting with the lens pointing directly up or down sometimes confuses the camera, causing it to record the wrong orientation data.

Shifting from Single-Image to Thumbnails Display

Instead of displaying each photo or movie one at a time, you can display 4 or 9 thumbnails, as shown in Figure 9-7, or even a whopping 72 thumbnails.

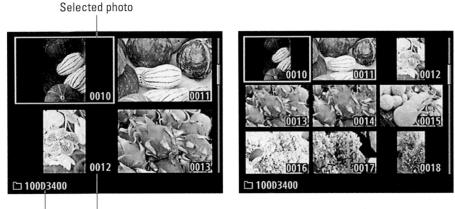

FIGURE 9-7: You can view multiple image thumbnails at the same time.

Folder number Frame number

Here's how this display option works:

>> Display thumbnails. Press the Zoom Out button to cycle from single-picture view to 4-thumbnail view, press again to shift to 9-picture view, and press once more to bring up the itty-bitty thumbnails featured in 72-image view. One more press takes you to Calendar view, a nifty feature explained in the next section.

- >> Display fewer thumbnails. Pressing the Zoom In button takes you from Calendar view back to the standard thumbnails display or, if you're already in that display, reduces the number of thumbnails so you can see each one at a larger size. Again, your first press takes you from 72 thumbnails to 9, your second press to 4 thumbnails, and your third press returns you to single-image view.
- Select an image. To perform certain playback functions, such as deleting a photo, you first need to select an image. A yellow box surrounds the selected image, as shown in Figure 9-7. To select a different image, use the Multi Selector or Command dial to move the box over the image.
- Toggle between thumbnails display and full-frame view. Don't waste time pressing the Zoom In button repeatedly to return to the full-frame view: Instead, just press OK. The selected frame takes over the screen. Press OK again to go back to thumbnails display *unless* the currently displayed file is a

movie, in which case pressing OK starts movie playback. In that scenario, press the Zoom Out button to go back to thumbnails view.

Scroll the display. Press the Multi Selector up and down to scroll to the next or previous screen of thumbnails.

The four- and nine-thumbnail displays include the name of the folder that holds the images as well as the frame number of each file, as shown in Figure 9-7. The frame number isn't the same thing as the filename; it just tells you which file you're viewing in a series of files. In Figure 9-7, for example, the *Frame number* label points to the twelfth file on the card (or in the current folder). In 72-thumbnail view, the folder number and frame number of the currently selected image both appear at the bottom of the screen.

Displaying Photos in Calendar View

Calendar display mode, shown in Figure 9–8, makes it easy to locate pictures according to the date you shot them. Try it out:

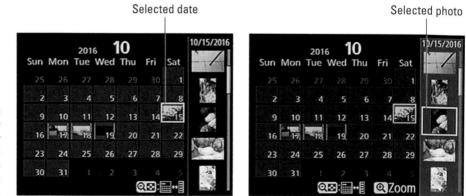

FIGURE 9-8: Calendar view makes it easy to view all photos shot on a particular day.

1. Press the Zoom Out button as needed to cycle from single-image view to thumbnails view to Calendar view.

If you're currently viewing images in full-frame view, for example, you need to press the button four times to get to Calendar view.

2. Using the Multi Selector, move the yellow highlight box over a date that contains an image.

In the left example in Figure 9-8, October 15 is selected. (The number of the month appears at the top of the screen, to the right of the year.) The right

side of the screen displays thumbnails of the first few pictures taken on the selected date. However, you can't scroll the thumbnail display to see all pictures shot on the date or select a specific image until you take the next step.

3. To activate the thumbnail strip so that you can view and select any photo taken on the selected date, press the Zoom Out button again.

After you press the button, the vertical thumbnail strip becomes active, as shown on the right in Figure 9-8, and you can scroll through the thumbnails by pressing the Multi Selector up and down. The thumbnail surrounded by the yellow box is the currently selected; the box moves from one frame to the next as you scroll the display.

 To temporarily get a larger view of the selected image, as shown in Figure 9-9, hold down the Zoom In button.

When you release the button, the large preview disappears, and the calendar comes back into view. The thumbnail strip is still the active part of the display, so you can scroll to and magnify another image if necessary.

5. To jump back to the calendar side of the display so that you can select a different date, press the Zoom Out button.

FIGURE 9-9: After highlighting a thumbnail, press the Zoom In button to temporarily view it at a larger size.

You can just keep pressing the button to jump between the calendar side of the display and the thumbnail strip as much as you want.

Notice the symbols at the bottom of the display, which represent the Zoom In and Zoom Out buttons. (Refer to Figure 9-8.) They're your reminder of the function these buttons play in Calendar view.

6. To exit Calendar view and return to single-image view, highlight the image you want to view in the thumbnails strip. Then press OK.

Magnifying Photos During Playback

After displaying a photo in single-frame view, as shown on the left in Figure 9-10, you can magnify it, as shown on the right. You can zoom in on still photos only, however; this feature isn't available for movies.

FIGURE 9-10: Use the Multi Selector to move the yellow box over the area you want to inspect.

Magnified area

To shift from Thumbnails view to single-image view, select the photo and then press OK. If the display is in Calendar view, press OK twice.

After the photo is onscreen all by its lonesome, try these magnification features:

Magnify the image. Press the Zoom In button. You can magnify the image to a maximum of 19 to 38 times its original display size, depending on the resolution (pixel count) of the photo. Just keep pressing the button until you reach the magnification you want. (Notice the plus-sign magnifying glass symbol on the button, indicating zoom in.)

- Reduce magnification. Press the Zoom Out button the one that sports the minus-sign magnifying glass. (That gridlike thing next to the magnifying glass reminds you that the button also comes into play when you want to go from full-frame view to Thumbnails view.)
- >> View another part of the magnified picture. When an image is magnified, a thumbnail showing the entire image appears in the lower-right corner of the screen, as shown in Figure 9-10. The yellow outline in this picture-in-picture image indicates the area that's currently consuming the rest of the monitor space. (The white bar below the box indicates the zoom level; the bar turns green when you reach maximum magnification.) Use the Multi Selector to scroll the yellow box and display a different portion of the image. After a few seconds, the navigation thumbnail disappears; press the Multi Selector in any direction to redisplay it.

>> Inspect faces. When you magnify portraits, the picture-in-picture thumbnail displays a white border around each face. If you press the *i* button, a minimenu appears, offering two options, Face Zoom and Trim. Select Face Zoom, and you can then press the Multi Selector right or left to jump from face to face for a closer look. Press the *i* button again to exit Face Zoom mode.

When it works correctly, though, this is a nice tool for checking for closed eyes, red-eye, and, of course, spinach in the teeth. Unfortunately, the camera sometimes fails to detect faces, especially if the subject isn't looking directly at

the camera. And when the photo contains only a few faces, you may find it easier to simply move the magnification box around the screen yourself, without bothering with Face Zoom.

>> View more images at the same magnification. While the display is zoomed, you can rotate the Command dial to display the same area of the next photo at the same magnification.

>> Crop the picture to the magnified view. When a picture is magnified, you can quickly create a second image that contains just the area currently visible on the monitor. In other words, you can do instant in-camera cropping. Your original is left intact; the camera makes a copy of the photo and crops the copy. To perform this trick, press the *i* button to display the aforementioned mini-menu, but this time choose Trim. On the next screen, choose Done to create the cropped copy. For other cropping options, check out the Trim function on the Retouch menu, which I detail in Chapter 11.

Return to full-frame view. You don't need to keep pressing the Zoom Out button until the entire photo is displayed. Instead, just press OK.

Viewing Picture Data

In single-image picture view, you can choose from a variety of display modes, all shown in Figure 9-11. Each mode presents different shooting data along with the image or movie file.

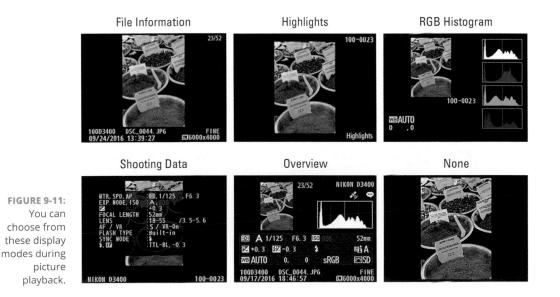

During playback, you shift from one display to the next by pressing the Multi Selector up and down. However, the File Information mode is the only one available by default; to use the others, you must enable them via the Playback Display Options setting on the Playback menu, as shown in Figure 9-12.

FIGURE 9-12: Enable the display options you want to use via this Playback menu screen.

PLAYBACK MENU		Playback display options		
Delete	茴			
Playback folder	D3400			None (image only)
Playback display options		I		Highlights
Image review	ON		\mathbf{Y}	RGB histogram
Auto image rotation	ON		Y	Shooting data
Rotate tall	ON		V	Overview
Slide show				
Rating	*	?		Select OROK

A check mark in the box next to an option means that the feature is turned on. To toggle the check mark on and off, highlight the option and then press the Multi Selector right. After turning on the options you want to use, press OK.

The next sections explain what details you can glean from the data that appears in the various display modes, with the exception, of course, of the None mode.

Note: Information and figures in these sections relate to still photography. For help with understanding data that appears during movie playback, see the playback section of Chapter 8. Although you can view the first frame of your movie in any of the photo display modes, after you start playback, the movie takes over the whole screen and playback data appears as described in that part of Chapter 8.

File Information mode

In File Information mode, the monitor displays the data shown in Figure 9-13. Here's the key to what information appears, starting at the top of the screen and working down:

Frame Number/Number Frames: The first value here indicates the frame number of the currently displayed photo; the second tells you the total number of frames on the memory card. (Movies are included in the frame count, with each clip counted as a single frame.)

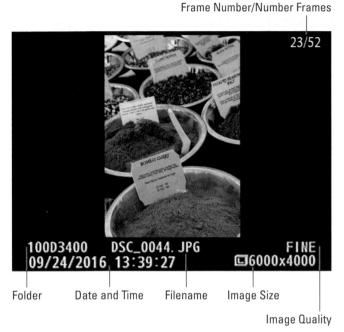

FIGURE 9-13: In File Information mode, you can view these bits of data.

> Folder: Folders are named automatically by the camera unless you create custom folders, an advanced trick you can explore in Chapter 12. The first camera-created folder is named 100D3400. Each folder can contain up to 9,999 images; when you exceed that limit, the camera creates a new folder and assigns the next folder number.

By the way, the highest folder number possible is 999. If folder 999 happens to contain 999 files or a picture with the file number 9999, the camera becomes terribly flustered, so much so that it won't take another picture until you get rid of some files in folder 999 or choose a folder that has a lower number. (You're always free to empty a folder and reuse that folder's number.)

>> Filename: The camera also automatically names your files. Filenames end with a 3-letter code that represents the file format, which is either JPG (for JPEG) or NEF (for Raw) for still photos. Chapter 2 discusses these formats. If you record a movie, the file extension is MOV; if you create a dust-off reference image file, an advanced feature designed for use with Nikon Capture NX-D, the camera instead uses the extension NDF. (You can read more about this Nikon software in Chapter 10.)

The first four characters of filenames also can vary as follows:

• *DSC_:* You captured the photo in the default Color Space, sRGB. This setting is the best choice for most people, for reasons you can explore in Chapter 6.

• *_DSC:* If you change the Color Space setting to Adobe RGB, the underscore character comes first. (You can't use this color space when recording movies, by the way.)

Each image is also assigned a 4-digit file number, starting with 0001. When you reach image 9999, the file numbering restarts at 0001, and the new images go into a new folder to prevent any possibility of overwriting the existing image files.

- >> Date and Time: Just below the folder and filename info, you see the date and time that you took the picture. Of course, the accuracy of this data depends on whether you set the camera's date and time correctly, which you do via the Setup menu.
- Image Quality: Here you can see which Image Quality setting you used when taking the picture. Again, Chapter 2 has details, but the short story is this: Fine, Normal, and Basic are the three JPEG options, with Fine representing the highest JPEG quality. Raw refers to the Nikon Camera Raw format, NEF.
- Image Size: This value tells you the Image Size setting, which determines image resolution, or pixel count. See Chapter 2 to find out about resolution. In the figure, the L represents the Large setting, which produces a resolution of 6000 x 4000 pixels.

In addition, you may see the following symbols, labeled in Figure 9-14:

- >> Protected symbol: The key indicates that you used the fileprotection feature to prevent the image or movie from being erased when you use the camera's Delete function. See the next chapter to find out more. (*Note:* Formatting your memory card, a topic discussed in Chapter 1, *does* erase even protected pictures.) This area appears empty if you didn't apply protection.
- Retouch symbol: This icon appears on images that you created by applying one of the Retouch menu features to a picture. (The camera preserves the original and applies your alterations to a copy of the file.) Chapter 11 explains this feature and other Retouch menu options. See

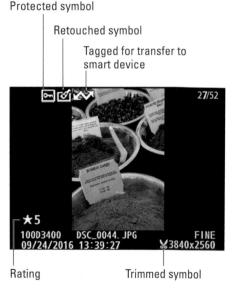

FIGURE 9-14:

These symbols indicate the protect, retouch, and send-to-smart device features.

Chapter 8 for help with the movie-editing function found on the menu; for edited movies, you see a little scissors icon instead of the Retouch symbol shown in the figure.

Speaking of a scissors symbol, notice the one in the lower-right corner of Figure 9-14. When you see the symbol here, it means that you're viewing a photo that you created by using the Trim feature on the Retouch menu to crop an original image. The numbers after the scissors show the pixel count of the cropped photo.

- Send to Smart Device symbol: This symbol appears if you tagged the photo for later transfer to a smartphone or tablet using the camera's Bluetooth wireless connection feature. See the appendix for help using this feature and Nikon SnapBridge, the app you need to install on your device.
- Rating: Chapter 10 shows how to assign ratings to your photos, a great tool for helping you easily find your best images. If you rate a picture, the number of stars you gave it (1 to 5) appears here. You also have the option to assign a special rating to photos you plan to delete; a trash can symbol marks those files.

Highlights ("blinkies") display mode

One of the most difficult problems to correct in a photo-editing program is known as *blown highlights* in some circles and *clipped highlights* in others. In plain English, both terms mean that *highlights* — the brightest areas of the image — are so overexposed that areas that should include a variety of light shades are instead totally white. For example, in a cloud image, pixels that should be light to very light gray become white due to overexposure, resulting in a loss of detail in those clouds.

Highlights display mode alerts you to clipped highlights by blinking the affected pixels on and off. Highlights mode is disabled by default; follow the instructions in the "Viewing Picture Data" section, earlier in this chapter, to enable it.

Figure 9-15 displays an image that contains some blown highlights to show you how things look in Highlights display mode. I captured the screen at the moment the highlight blinkies blinked "off" — the black areas in the figure indicate the blown highlights. (I labeled two in the figure.) But as

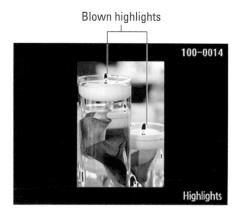

FIGURE 9-15: In Highlights mode, blinking areas indicate blown highlights.

this image proves, just because you see the flashing alerts doesn't mean that you should adjust exposure — the decision depends on where the alerts occur and how the rest of the image is exposed. In my candle photo, for example, there are indeed small white areas in the flames and the glass vase, yet exposure in the majority of the photo is fine. If I reduced exposure to darken those spots, some areas of the flowers would be underexposed. In other words, sometimes you simply can't avoid a few clipped highlights when the scene includes a broad range of brightness values.

Highlights display mode also presents the same symbols shown in Figure 9-14 if you used the related features. In the upper-right corner, you see the folder number and the frame number — 100 and 0014, respectively, in Figure 9-15. Highlights also appears in the lower-right corner to let you know the current display mode.

RGB Histogram mode

From Highlights mode, press the Multi Selector down to get to RGB Histogram mode, which displays your image as shown in Figure 9–16. (*Remember:* You can access this mode only if you enable it via the Playback Display Options setting on the Playback menu.)

The data underneath the thumbnail shows the White Balance settings used for the shot. (White balance is a color feature you can explore in Chapter 6.) The first value tells you the setting (Auto, in the figure), and the two number values tell you whether you finetuned that setting along the amber to blue axis (first value) or green to magenta axis (second value). Zeros, as

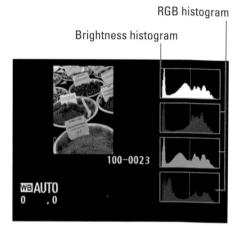

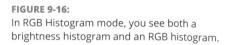

in the figure, indicate no fine-tuning. You also see symbols representing the protect, retouched, rating, and send-to-smart-device tag if you used those features.

In addition, you get four charts, called *histograms*. You actually get two types of histograms, as labeled in the figure: The top one is a Brightness histogram and reflects the composite, three-channel image data. The three others represent the data for the single red, green, and blue channels. This trio is sometimes called an *RGB histogram*, thus the display mode name.

The next two sections explain what you can discern from the histograms. But first, here's a cool trick to remember: If you press the Zoom In button, you can zoom the thumbnail to a magnified view. The histograms then update to reflect only the magnified area of the photo. Use the Multi Selector to scroll the display to see other areas of the picture. To return to the regular view and once again see the whole-image histogram, press OK.

Reading a Brightness histogram

You can get an idea of image exposure by viewing your photo on the monitor and by looking at the blinkies in Highlights mode, but the Brightness histogram provides a way to gauge exposure that's a little more detailed.

A Brightness histogram indicates the distribution of shadows, highlights, and *midtones* (areas of medium brightness) in your image. Figure 9–17 shows you the histogram for the image featured in Figure 9–16, for example.

The horizontal axis of the histogram represents the possible picture brightness values — the maximum *tonal range* in photography-speak — from the darkest shadows on the left to the brightest highlights on the right. And the vertical axis shows you how many pixels fall at a particular brightness value. A spike indicates a

heavy concentration of pixels at that brightness value.

Keep in mind that there is no "perfect" histogram that you should try to achieve. Instead, interpret the histogram with respect to the distribution of shadows, highlights, and midtones that comprise your subject. You wouldn't expect to see lots of shadows, for example, in a photo of a polar bear walking on a snowy landscape. Pay attention, however, if you see a high concentration of pixels at the far right or left end of the histogram, which can indicate a seriously overexposed or underexposed image, respectively.

When shooting subjects that contain a significant amount of white, I usually underexpose the photo just a hair. That way, I make sure that I don't blow out highlights. In such cases, the histogram may show no or few pixels at the right end of the scale, as in Figure 9-17. For the spice image, increasing exposure enough to get some pixels at the right end of the histogram would have blown out the highlights in the rims of the spice bowls. So again, read the histogram with an eye toward getting the exposure of the main subject correct.

To find out how to resolve exposure problems, visit Chapter 4.

Understanding RGB histograms

In RGB Histogram display mode, you see the Brightness histogram, covered in the preceding section, and an RGB histogram. Figure 9-18 shows the RGB histogram for the spice image.

TECHNICAL STUFF

Digital images are known as RGB images because they're created from three primary colors of light: red, green, and blue. In an image file, the brightness data for each color is stored separately in a digital container called a *color channel*. Whereas the Brightness histogram reflects the brightness of all three color channels rolled into one, RGB histograms let you view the values for each channel.

When you look at the brightness data for a single channel, though, you glean information about color saturation rather than image brightness. (*Saturation* refers to the purity of a color; a fully saturated color contains no black or white.) I don't have space in this book to provide a full lesson in RGB color theory, but the short story is

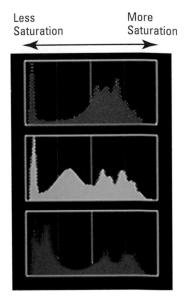

FIGURE 9-18: The RGB histogram can indicate problems with color saturation.

that when you mix red, green, and blue light, and each component is at maximum brightness, you create white. Zero brightness in all three channels creates black. If you have maximum red and no blue or green, though, you have fully saturated red. If you mix two channels at maximum brightness, you also create full saturation. For example, maximum red and blue produce fully saturated magenta. And, wherever colors are fully saturated, you can lose picture detail. For example, a rose petal that should have a range of tones from medium to dark red may instead be a flat blob of pure red.

The upshot is that if all the pixels for one or two channels are slammed to the right end of the histogram, you may be losing picture detail because of overly saturated colors. If all three channels show a heavy pixel population at the right end of the histogram, you may have blown highlights — again, because the maximum levels of red, green, and blue create white. Either way, you may want to adjust the exposure settings and try again.

A savvy RGB histogram reader can also spot color balance issues by looking at the pixel values. But frankly, color balance problems are fairly easy to notice just by looking at the image on the camera monitor. See Chapter 6 to find out how to correct any color problems that you spot during picture playback.

Shooting Data mode

Before you can access Shooting Data mode, you must enable it via the Playback Display Options setting on the Playback menu. See the earlier section, "Viewing Picture Data," for details.

In Shooting Data mode, you can view multiple screens of information, which you scroll through by pressing the Multi Selector up and down. Figure 9–19 shows just the first screen of data.

Most of the data you see won't make sense until you explore Chapters 4 through 6, which explain the exposure, color, and focusing settings available on your camera. But I want to call your attention to a few facts now:

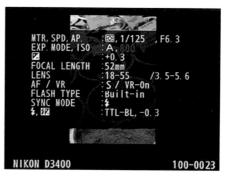

- The upper-left corner of the monitor shows the Protected, Retouch, and Send to Smart Device icons, if you used these features. (Refer to Figure 9-14 to see each of these icons.) If you use the Rating feature, the rating you assigned appears in the lower-left corner of the screen.
- The current folder and frame number appear in the lower-right corner of the display.
- The Comment item, which is the final item on the third Shooting Data screen, contains a value if you use the Image Comment feature on the Setup menu. I cover this option in Chapter 12.
- If the ISO value on Shooting Data Page 1 appears in red, as in Figure 9-19, the camera overrode the ISO Sensitivity setting that you selected in order to produce a good exposure. This shift occurs only if you enable automatic ISO adjustment in the P, S, A, and M exposure modes; see Chapter 4 for details.
- The fourth screen appears only if you include copyright data with your picture, a feature you can explore in Chapter 12.
- >> By using the Nikon SnapBridge app and a compatible smartphone or tablet, as detailed in the appendix of this book, you can tag pictures with location data. The data is acquired from your smart device. If you take advantage of this option, the information appears on a separate Shooting Data display screen. (Technically, Nikon calls this screen Location Data mode, but for all practical purposes, it's part of the Shooting Data display mode. It's enabled automatically when you turn on the Shooting Data mode.)

Overview mode

In Overview mode, the playback screen contains a small image thumbnail along with scads of shooting data although not quite as much as Shooting Data mode — plus a Brightness histogram. Figure 9-20 offers a look. You enable and disable this display mode via the Playback Display Options setting on the Playback menu.

The earlier section "Reading a Brightness histogram" tells you what to make of that part of the screen. The Frame Number/Total Frames data appears at the upper-right corner of the image thumbnail. For details on that data, see the earlier section "File Information mode." As with the other display modes, symbols representing the pro-

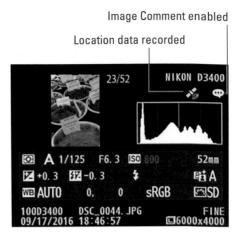

FIGURE 9-20:

In Overview mode, you can view your picture along with the major camera settings you used to take the picture.

tect, retouch, rating, and send-to-smart-device features show up only if you used those features when working with the picture or movie file.

To sort out the maze of other information, the following list breaks things down into the five rows that appear under the thumbnail and histogram. In the accompanying figures as well as in Figure 9-20, I include all possible data for the purpose of illustration; if any items don't appear on your screen, it simply means that the relevant feature wasn't enabled when you captured the shot:

>> Row 1: This row shows the exposure-related settings labeled in Figure 9-21, along with the focal length of the lens you used to take the shot. As in Shooting Data mode, the ISO value appears red, as in the figure, if you had auto ISO override enabled in the P, S, A, or M exposure modes and the camera adjusted the ISO for you. Chapter 4 details the exposure settings; Chapter 1 introduces you to focal length.

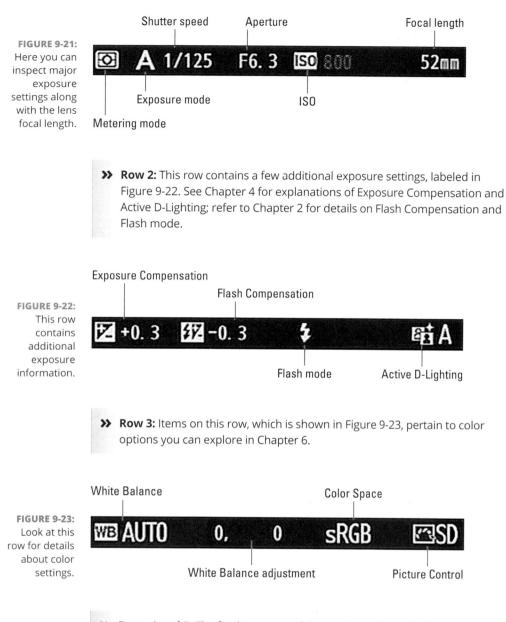

Rows 4 and 5: The final two rows of data (refer to Figure 9-20) show the same information you get in File Information mode, explained earlier in this chapter.

Creating a Digital Slide Show

Many photo-editing programs offer a tool for creating digital slide shows that can be viewed on a computer or, if copied to a DVD, on a DVD player. You can even add music, captions, graphics, special effects, and the like to jazz up your presentations. But if you want to create a simple show — that is, one that just displays the photos and movies on the camera memory card one by one — you can create and run the show directly on your camera by using the Slide Show function on the Playback menu. And by connecting your camera to a television, as outlined in the next section, you can present your show to a whole roomful of people.

One important point to note: The files the camera can access depend on the setting of the Playback Folder option on the Playback menu. If your memory card contains multiple folders, see "Choosing Which Images to View," earlier in this chapter, for help with selecting the playback folder.

With that detail out of the way, follow these steps to present a slide show:

1. Display the Playback menu and highlight Slide Show, as shown on the left in Figure 9-24.

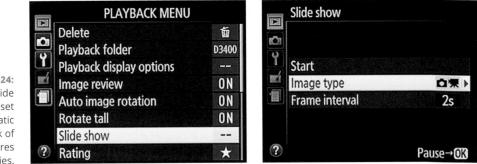

- Press OK to display the Slide Show setup screen (shown on the right side of Figure 9-24).
- 3. Highlight Image Type and press the Multi Selector right.

You see the screen shown on the left in Figure 9-25.

4. Select the type of files you want to include in the show.

You have four options: Display photographs and movies, photos only, movies only, or files that you assigned a specific rating. (Chapter 10 shows how to rate photos.)

FIGURE 9-24: Choose Slide Show to set up automatic playback of your pictures and movies. FIGURE 9-25: Choose the By Rating option to include only your pictures rated with five stars in the show.

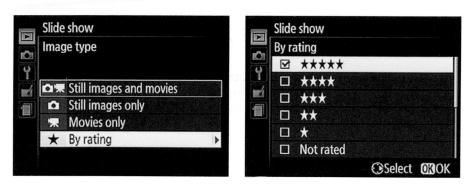

If you select By Rating, press the Multi Selector right to display the screen shown on the right in Figure 9-25. Here, you can specify the rating a picture or movie must have to make it into the show. For example, in the figure, I selected only the 5-star option. (I see no point in showing people that I sometimes take less-than-stellar photos.) Highlight a rating and press the Multi Selector right to put a check in the box and include photos to which you assigned that rating. Press OK to return to the Image Type screen.

After setting the Image Type, press OK to return to the Slide Show setup screen (the screen on the right in Figure 9-24).

5. Highlight Frame Interval and press the Multi Selector right.

On the screen that appears, you can specify how long you want each image to be displayed.

6. Select the frame interval you want to use and press OK.

You return to the Slide Show setup screen.

7. To start the show, highlight Start and press OK.

When the show ends, you see a screen offering three options: Restart the show, adjust the frame interval, or exit to the Playback menu. Highlight your choice and press OK. During the show, you can control playback as follows:

- Pause the show. Press OK. Again, you see three options onscreen. To restart playback, select Restart and press OK. You also can adjust the frame interval or exit to the Playback menu.
- >> Exit the show. You have three options:
 - To return to regular playback, press the Playback button.
 - To return to the Playback menu, press the Menu button.
 - *To return to picture-taking mode,* press the shutter button halfway and release it.

- Skip to the next/previous image manually. Press the Multi Selector right or left.
- Change the information displayed with the image. Press the Multi Selector up or down to cycle through the display modes. See the earlier section "Viewing Picture Data" for help understanding the various modes.

Adjust movie volume. Press the Zoom In button to increase the volume; press the Zoom Out button to decrease it.

Viewing Your Photos on a Television

Your camera is equipped with a feature that allows you to connect your camera to a high-definition television so that you can view your pictures and movies on the HDTV screen. However, you need to purchase a Type C mini-pin HD cable to connect the two devices. Prices start at about \$20. Nikon doesn't make its own cable, so just look for a quality third-party version.

By default, the camera decides the proper video resolution to send to the TV after you connect the two devices. But you have the option of setting a specific resolution as well. To do so, select HDMI from the Setup menu, press OK, and then choose Output Resolution, as shown in Figure 9–26. Press the Multi Selector right to access the available settings.

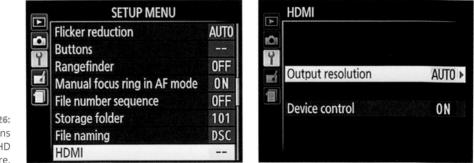

FIGURE 9-26: Select options for HD playback here.

If your television is compatible with HDMI CEC, your D3400 enables you to use the buttons on the TV's remote control to perform the functions of the OK button and Multi Selector during full-frame picture playback and slide shows. To make this feature work, you must enable it via the Setup menu. Again, start with the HDMI option, but this time, select Device Control and set the option to On.

After you select the necessary Setup menu options, grab your video cable, turn off the camera, and open the lower rubber door on the left side of the camera. Plug the end of the cable that has the smaller connector into the port labeled *HDMI out* in Figure 9–27. The other end of the cable goes into the HDMI-in port on your TV. Check your TV instruction manual if you need help finding the proper port and selecting the necessary settings to enable playback from an auxiliary input device. Then just turn on your camera to send the signal to the TV.

If your TV or its remote control doesn't offer HDMI CEC capability, just control playback by using the buttons on the camera, as you would if you were viewing pictures on the camera monitor. You can also run a slide show by following the steps outlined in the preceding section.

FIGURE 9-27: The HDMI-out port is under the door on the side of the camera.

IN THIS CHAPTER

- » Rating photos and movies
- » Deleting unwanted files
- » Protecting files from accidental erasure
- » Downloading files to your computer
- » Processing Raw files
- » Shrinking files for online use

Chapter **10** Working with Picture and Movie Files

very creative pursuit involves its share of cleanup and organizational tasks. Painters have to wash brushes, embroiderers have to separate strands of floss, and woodcrafters have to haul out the wet/dry vac to suck up sawdust. Digital photography is no different: At some point, you have to stop shooting so that you can download and process your files.

This chapter explains these after-the-shot tasks. First up is a review of several in-camera file-management operations: rating files, deleting unwanted files, and protecting your best work from accidental erasure.

Following that, you can get help with transferring files to your computer, processing files that you shot in the Raw (NEF) format, and creating low-resolution copies of photos for online sharing. Along the way, I introduce you to Nikon ViewNX-i and Capture NX-D, two free computer programs that you can use to handle some of these tasks.

Note: If you own a smartphone, tablet, or other smart device that can run Nikon's SnapBridge app, check out the appendix. It offers information about connecting

your camera to the smart device so that you can transfer photos wirelessly to the device and, from there, upload images to your favorite social media site or Nikon Image Space, a free online photo-storage and sharing site.

Rating Photos and Movies

Using your camera's Rating feature, you can assign a rating to a picture or movie file: five stars for your best shots, one star for those you wish you could reshoot, and so on. You can even assign a "trash this" rating to flag files that you think you want to delete.

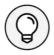

Rating pictures has several benefits. First, when you create a slide show, as outlined in Chapter 9, you can tell the camera to display only photos or movies that have a certain rating. Second, assigning the Delete tag makes it easy to spot the rotten apples amid all your great work when you take the step of erasing files. (Merely assigning the Delete tag doesn't actually erase the file.) Finally, some photo programs can read the rating and then sort files according to rating. That feature makes it easier to cull your photo and movie collection and gather your best work for printing and sharing.

Before showing you how to rate files, I need to share one rule of the road: If you protect a file by using the feature described in the later section "Protecting Photos and Movies," you can't assign a rating to it. To remove protection, display the file and press the AE-L/AF-L button.

Assuming that the file isn't protected, you can assign a rating in two ways:

>> Choose Rating from the Playback menu. After selecting the Rating option, as shown on the left in Figure 10-1, press OK to display image thumbnails, as shown on the right. Press the Multi Selector right or left or use the Command dial to move the yellow selection box over an image you want to rate.

To assign the rating, press and hold the Zoom Out button as you press the Multi Selector up or down. You can choose a rating from one star to five stars or, to mark a file as a dud, select the symbol that looks like a trash can. When you release the button, a symbol representing the rating appears with the thumbnail, as labeled in the figure.

For a closer view of a selected photo, press the Zoom In button. Release the button to return to thumbnails view.

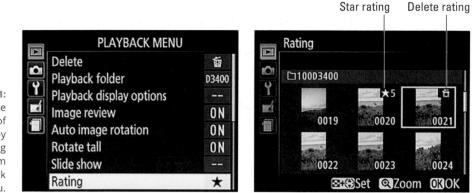

FIGURE 10-1: You can rate a batch of photos by choosing Rating from the Playback menu.

> To rate another photo, move the selection box over it and repeat the process. After rating your photos, press OK to exit to the Playback menu.

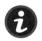

➤ Assign a rating without leaving playback mode. Instead of using the Playback menu, you can set the camera to playback mode, display the photo or movie you want to rate, and press the *i* button. The screen displays a mini-menu atop your photo, as shown on the left in Figure 10-2. Select Rating and press the Multi Selector right (note the right-pointing arrow, which is your cue to press the right Multi Selector to move to the next screen.) The mini-menu disappears and the rating strip highlighted on the right side of the figure appears. Press the Multi Selector right or left to choose a star rating from 1 to 5. Select the far left dot, labeled *Delete rating* in the figure, to tag a picture for erasure. You *do not* have to simultaneously press the Zoom Out button to set the rating in this case, but you do need to press OK to complete the job.

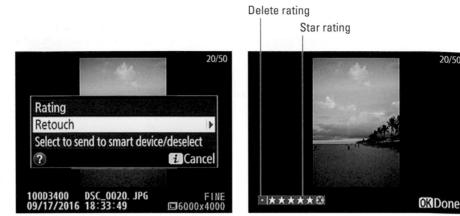

FIGURE 10-2: During playback, press the *i* button, select Rating, and then press the Multi Selector right or left to set the rating.

> In playback mode, the rating appears with the image. Figure 10-3 shows you where to find the rating in the default display mode (File Information mode). For more about display modes, see Chapter 9.

Deleting Files

You have three options for erasing files from a memory card when it's in your camera. The next few sections give you the lowdown.

FIGURE 10-3: The rating appears here in File Information playback mode.

One note before you begin: None of the

Delete features erase files that you protect via the option that I outline in the upcoming section "Protecting Photos and Movies." To remove file protection, display the file in playback mode and press the AE-L/AF-L button.

Deleting files one at a time

During playback, you can use the Delete button to erase photos and movie files. But the process varies depending on the current playback mode:

- >> In single-image view, press the Delete button.
- In thumbnails view, use the Multi Selector or Command dial to highlight the picture you want to erase, and then press Delete.

In Calendar view, highlight the date that contains the file. Then press the Zoom Out button to jump to the thumbnail list, use the Multi Selector to highlight the file's thumbnail, and press Delete.

You then see a message asking whether you really want to erase the picture. If you do, press Delete again. To cancel the process, press the Playback button.

By default, the camera displays your photo briefly after the shot is recorded. (You enable or disable this feature via the Image Review option on the Playback menu.) During the instant review period, you can press the Delete button to trash the file immediately. But you have to be quick or else the camera returns to shooting mode.

Deleting all files

Open the Playback menu, select Delete, as shown on the left in Figure 10–4, and press OK to display the second screen in the figure. Then highlight All and press OK. The camera asks you to verify that you want to delete all your pictures and movies; select Yes and press OK.

If your memory card contains multiple folders, these steps delete only pictures in the folder that is currently selected via the Playback Folder option on the Playback menu. For information, see the Chapter 9 section related to choosing which images to view. (Set the Playback Folder to All if you truly want to dump photos from all folders.)

FIGURE 10-4: To delete all files (except those you protected), use this Playback menu option.

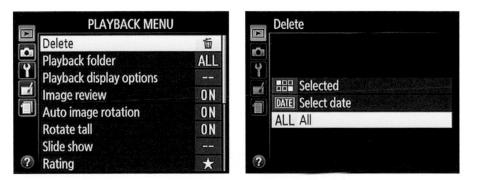

Deleting a batch of selected files

When you want to get rid of more than a few files — but not erase all pictures and movies on the card — don't waste time erasing each file, one at a time. Instead,

you can tag multiple files for deletion and then take them all out to the trash at one time.

To start, display the Playback menu, highlight Delete, and then press OK. You see the screen shown on the left in Figure 10–5, which offers two options for selecting files to erase:

Selected: Use this option if the files you want to delete weren't all taken on the same day. Highlight Selected, as shown on the left in Figure 10-5, and press the Multi Selector right to display thumbnails, as shown on the right.

Use the Multi Selector to place the yellow highlight box over the first file you want to delete and then press the Zoom Out button. A trash can appears in the upper-right corner of the thumbnail, as shown in the figure. If you change your mind, press the Zoom Out button again to remove the Delete tag. To undo deletion for all selected files, press the Playback button.

For a closer look at the selected image, press and hold the Zoom In button. When you release the button, the display returns to normal thumbnails view.

Images that you tag with the Delete rating, as explained in the first section of this chapter, are *not* officially marked for the trash heap. When you view your files, you see the Delete Rating symbol, labeled on the right in Figure 10-5; when you select the photo via the Delete menu, you see the symbol marked Delete File in the figure. That's the symbol that triggers the camera to dump the file.

Delete file symbol

Delete rating symbol Delete Delete Selected 1Ö1 Ö C1100D3400 4 4 BBB Selected . IIIC) DATE Select date 0019 0020 0021 ALL AII 0022 0023 0024 ? Q⊡Set QZoom OKOK

FIGURE 10-5: This Delete menu option offers a quick way to delete a batch of photos. Select Date: Use this option to quickly delete any record of that day you'd rather not remember. After choosing Select Date, as shown on the left in Figure 10-6, press the Multi Selector right to display a list of dates, as shown on the right. Highlight a date and press the Multi Selector right. A check mark appears in the box next to the date, tagging for deletion all images taken on that day. To remove the check mark, press the Multi Selector right again.

Dele	ete	5	Selec	ct date	
				09/12/2016	
Y				09/16/2016	
	Selected			09/17/2016	174
DATE] Select date	•		09/21/2016	<u>. Si a</u>
ALL	All			09/22/2016	1.000
				09/24/2016	
?				Q ⊡Confirm	Select OROK

FIGURE 10-6: With the Select Date option, you can quickly erase all photos taken on a specific date.

Can't remember what photos are associated with the selected date? Try these tricks:

• To display thumbnails of all images taken on the selected date, press the Zoom Out button. (Again, notice the symbol that appears next to the word Confirm at the bottom of the screen; the symbol looks similar to the one on the Zoom Out button. If the available screen area permits, you see both the magnifying glass symbol and the grid, as on the button; other times, you see one or the other, as in the right screen in Figure 10-1.)

- To temporarily view the selected thumbnail at full-size view, press the Zoom In button.
- To return to the date list, press the Zoom Out button again.

After tagging files for deletion or specifying a date to delete, press OK. You see a confirmation screen; select Yes and press OK.

You have one alternative way to quickly erase all files shot on a specific date: In the Calendar display mode, highlight the date and then press the Delete button. You see the standard confirmation screen; press Delete again to wrap up. Visit Chapter 9 for the scoop on Calendar display mode.

Protecting Photos and Movies

You can protect files from accidental erasure by giving them *protected* status. After you take this step, the camera doesn't allow you to delete the file, whether you press the Delete button or use the Delete option on the Playback menu.

I also use the Protect feature when I want to keep a handful of pictures on the card but delete the rest. Rather than use the options I describe in the preceding section to select all the pictures I want to trash, I protect the handful I want to preserve. Then I set the Delete menu option to All and dump the rest. The protected pictures remain intact.

Formatting your memory card *does* erase even protected pictures. In addition, when you protect a picture, it may show up as a read-only file when you transfer it to your computer, depending on whether the software you use can read the protection tag. Files that have the read-only status can't be altered until you unlock them. You can do this in Nikon ViewNX-i. After selecting the image, open the File menu, choose Protect Files, and then select Unprotect.

Remember, too, that locking the file prevents you from assigning a rating to it — so rate photos before giving them protected status. (Refer to the first section of this chapter for information about the Rating feature.) Nor can you use tools on the Retouch menu to edit the file.

To protect a file, take these steps:

1. Display or select the file you want to protect.

- In single-image view, just display the photo or movie.
- *In 4/9/72 Thumbnail mode,* use the Multi Selector or Command dial to place the yellow selection box over the file's thumbnail.

• *In Calendar view,* highlight the file thumbnail in the strip of thumbnails that appears on the right side of the screen. (Press the Zoom Out button to jump between the calendar dates and the thumbnails.)

AEL 2

Press the AE-L/AF-L button, shown in Figure 10-7.

See the key symbol above the button? That's your reminder that you use the button to lock a picture. A key symbol also appears with locked photos during playback, as shown in the figure.

To remove protection, display or select the file and then press the AE-L/AF-L button again.

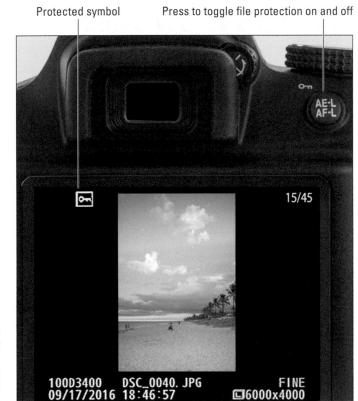

FIGURE 10-7: Press the AE-L/ AF-L button to give an image protected status.

Taking a Look at Nikon's Photo Software

To move pictures and movies to your computer, you need some type of software to download, view, and manage the files. If you don't have a favorite photo program for handling these tasks, Nikon offers the following free solutions:

Nikon ViewNX-i: Shown in Figure 10-8, this program offers basic photo organizing and editing tools. In addition, a tool built into the program, Nikon Transfer, simplifies the job of sending pictures from a memory card or your camera to your computer. I explain the process in the next section.

Your program may not initially look like the one in the figure because I customized the screen layout to suit my needs. You can do the same via the options on the View and Window menus after opening the program.

FIGURE 10-8: You can see the selected focus point and other camera settings when you view photos in Nikon ViewNX-i.

Two features I especially like about ViewNX-i:

 Viewing picture settings (metadata): You can display a panel that shows the settings you used when shooting the picture, as shown in Figure 10-8. The settings are stored as metadata (extra data) in each picture's file. Although other photo programs can display some metadata, they often can't show all the detailed information that you can see in ViewNX-i.

Don't see the panel? Open the Window menu at the top of the program window and choose Adjustments/Metadata. You may then need to click the triangle labeled *Click to hide/view metadata* to expand the panel. Drag the scroll bar on the right side of the panel to view any hidden information.

Displaying focus points: Click the Focus Point button, also labeled in Figure 10-8, to display one or more red rectangles on the photo, as shown in the figure. The rectangles indicate which focus point (or points) the camera used to establish focus, which can be helpful for troubleshooting focus problems. If the focus point is over your subject but the subject is blurry, the cause is likely not due to focusing at all, but to subject or camera movement during a too-long exposure (slow shutter speed). You don't see the focus point if you used manual focusing, and it also may not appear if you used continuous autofocusing. The program also contains some limited photo-editing tools; access them by clicking the Edit tab near the top-left corner of the program window. For more sophisticated editing tools, use Nikon Capture NX-D, described next. You can send the current photo directly to that program from ViewNX-i by clicking the capture NX-D icon near the top-right corner of the program window or by choosing File ⇔ Open with Capture NX-D.

Nikon Capture NX-D: This program replaces Capture NX 2, which was aimed at photographers who wanted serious photo-editing tools — and who didn't mind paying about \$200 for them. Actually, "replace" is too strong a word; NX-D is a completely different animal than its predecessor. The most important change is that NX-D does not offer the so-called "u-point technology" found in Capture NX, which provided a way to limit the effects of retouching tools to certain parts of the photo. In NX-D, all changes affect the entire image. However, like Capture NX 2, NX-D offers a good Raw processing tool, which I show you how to use later in this chapter. Best of all, NX-D is free.

You can download both programs from the Nikon website (in the United States, www.nikonusa.com). Head for the Support section of the website, where you'll find a link to camera software. Be sure to download the latest versions. At the time I write this chapter, ViewNX-i is Version 1.2.3; NX-D is Version 1.4.2. Older versions of the software lack support for D3400 files. Also make sure that your computer meets the software operating-system requirements. (The program is available for both Windows-based and Mac computers.)

 \bigcirc

TIP

GETTING HELP WITH THE NIKON SOFTWARE

For years, you could access a built-in users manual via the Help menu found in Nikon's photo programs. But things work differently now: You can go online and download a copy of the user manual or simply check the online help pages for answers. (I suggest downloading a copy of the manual so that you don't need an active Internet connection to get help.)

To take advantage of these options the first time, you do need to be online, however. When your Internet browser is up and running, launch the Nikon program whose Help system you want to access. In that program, open the Help menu (top of the program window) and then choose the Help item from menu. Your browser then displays a window that offers two options: Click Go to Help Site to jump to the program's pages at the Nikon website or click Get PDF Manual to download the instruction manual. The manual is provided in the PDF format (Portable Document Format), so you can read it in Adobe Acrobat (available free from the Adobe website, www.adobe.com) or any program that can display PDF documents.

Downloading Pictures to the Computer

All your files are stored on the SD (Secure Digital) memory card installed in your camera. You can move those files from the card to your computer in two ways:

- >> Use a memory card reader. A card reader, if you're unfamiliar, is just a small device that attaches to your computer (or, in some cases, is built into the computer). When you put a camera memory card into the reader, your computer recognizes the card as just another drive on the system, and you can then access the files on the card.
- >> Connect the camera to the computer via a USB cable. This option requires purchase of a specific Nikon cable, part UC-E21. You may be able to order it from Nikon directly (about \$12) or from an online camera superstore. Local camera stores don't usually carry the cable because it's not a commonly requested item.

I recommend going the card reader route for a couple of reasons. First, if you connect the camera directly to the computer, the camera must be turned on during the entire transfer, wasting battery power.

Additionally, unlike the cable, which is specific to this camera (and a handful of Nikon point-and-shoot cameras) a card reader can do universal duty, handling cards from any devices that use SD cards for storage. For example, I have a tablet that stores data on a mini-SD card, which is a tiny version of a standard SD card. The mini cards usually come with an adapter that enables them to be read as a regular SD card, so I can use my card reader to transfer files from my tablet as well as my camera.

Before you buy a card reader, though, make sure one isn't built into your computer. Some printers also have built-in card readers, and you can take that pathway to get files to the computer.

If you do need a card reader, look for an external version (versus one you have to install on a bay in the computer) so that you can use it with any computer. You can buy a good reader for under \$30; higher priced models typically have slots for multiple types of memory cards rather than just SD slots. Be sure that the reader meets two specifications: First, it uses the type of connection compatible with your computer (USB connection is the most common). Second, check that the reader accepts the type of card your camera uses (SD) as well as the capacity of the cards you use. Currently, the highest capacity SD cards are labeled SDXC (Secure Digital Expanded Capacity). Some older card readers still being sold can't read the high-capacity cards. Also, the faster the transfer speed of the card reader, the faster your image files can be shipped to the computer. For USB connections, a USB 3 reader or higher moves files more quickly than a USB 2 reader. If your computer only has USB 2 ports, don't worry; you won't enjoy the fastest speeds, but the reader will still work if it's backward-compatible with USB 2.

What about wireless transfer, you ask? Well, there is one way to do it: You can buy Eye-Fi memory cards, which have wireless connectivity built in. You can find out more about these cards and how to set them up to connect with your computer at the manufacturer's website, www.eye.fi. Also check the Eye-Fi details provided in the D3400 manual; look for the section related to the Eye-Fi Upload option on the Setup menu. (The menu item appears only when an Eye-Fi card is installed.) I don't cover these cards in this book.

As for the Bluetooth wireless communication feature found on the D3400, you can't use it to move files to your computer. But it does enable you to connect wire-lessly to Android- and iOS-based phones, tablets, and other smart devices. You can then send copies of your photos to the device so that you can display them or use the device's Wi-Fi or cellular Internet connection to upload the pictures online. However, your device needs to run a fairly recent version of the Android or iOS operating system. Otherwise, you can't install Nikon SnapBridge, the app that facilitates the Bluetooth transfer. Again, check the appendix for a primer on SnapBridge and the Bluetooth features.

All that said, the next section tells you how to connect your camera and computer via USB. Following that, you can read about the steps in making the actual file transfer whether you go the USB route or use a card reader.

Connecting via USB

If you decide to invest in the USB cable needed to download pictures directly from your camera to your computer, take these steps to connect the two devices:

1. Check the level of the camera battery.

If the battery is low, charge it before continuing. Running out of battery power during downloading can cause problems, including lost picture data. Alternatively, if you purchased the AC adapter, use it to power the camera during downloading.

2. Turn on the computer and give it time to finish its normal start-up routine.

- 3. Turn off the camera.
- 4. Insert the smaller of the two plugs on the USB cable into the USB port on the side of the camera.

Look under the lower rubber door on the left side of the camera for this port, labeled in Figure 10-9.

- 5. Plug the other end of the cable into a USB port on the computer.
- 6. Turn on the camera.

What happens now depends on the photo software you have installed on your computer. The next section explains the possibilities and how to proceed with the transfer process.

7. When the download is complete, turn off the camera and then disconnect it from the computer.

USB port

FIGURE 10-9: The port for connecting the USB cable is hidden under the rubber door on the left side of the camera.

Starting the file-transfer process

After you connect the camera to the computer or insert a memory card into a card reader, what happens next depends on the software installed on your computer. Here are the most common possibilities and how to move forward:

- >> On a computer running Windows, you see a message asking what software you want to use to download your pictures (or movies). If you don't have a favorite program to use for this task, I suggest you select Nikon ViewNX-i. The program should appear as an option after you install it onto your computer. I give step-by-step instructions for downloading and using this program in the next section.
- >> An installed photo program automatically displays a photo-download wizard. For example, on a Mac computer, you may see the downloader associated with Photos (or iPhoto, on systems running some older versions of the Mac OS). Or the downloader associated with some other photo program, such as Adobe Lightroom, may leap to the forefront. Usually, the downloader that appears is associated with the software that you most recently installed.

If you don't want a program's downloader to launch whenever you insert a memory card or connect your camera, you can turn off that feature. Check the software manual to find out how to disable the auto launch.

>> Nothing happens. Don't panic; assuming that your card reader or camera is properly connected, all is probably well. Someone simply may have disabled all the automatic downloaders on your system. Just launch your photo software and then transfer your pictures using whatever command starts that process.

The next section provides details on using Nikon ViewNX-i to download files. If you use another program, the concepts are the same, but check the program manual for specifics.

Downloading using Nikon Transfer 2

Nikon Transfer is a tool built into Nikon ViewNX-i. Follow these steps to use it to preview and download images and movies from your memory card:

1. Launch Nikon Transfer 2 if it isn't already open.

Depending on how you installed ViewNX-i, the Nikon Transfer 2 window, shown in Figure 10-10, may appear automatically. If not, start ViewNX-i, open the File menu, and choose Launch Transfer. You also can just click the Transfer button at the top of the ViewNX-i window. (Note that although my figures show the Windows version of the program, these steps work for the Mac version as well.)

2. Display the Source tab to view thumbnails of your pictures, as shown in the figure.

Don't see any tabs? Click the Options triangle (refer to Figure 10-10) to display them. Then click the Source tab. The icon representing your camera or memory card should be selected, as shown in the figure. (My card reader shows up as Removable Disk I, but the letter of the disk varies depending on what other drives you have installed and how many slots your memory card offers.) If your camera or card isn't selected, click the icon.

Thumbnails of your files appear in the bottom half of the dialog box. If you don't see the thumbnails, click the Thumbnails triangle (refer to Figure 10-10) to open the thumbnails area.

3. Select the files that you want to download.

Click a thumbnail to highlight it and then click the box near its lower-right corner to select that file for downloading.

These tricks to speed up the process:

- *Select protected files only.* If you used the in-camera function to protect pictures, you can select just those images by clicking the Select Protected icon (refer to Figure 10-10).
- Select all files. Click the Select All icon, also labeled in the figure.

Click to hide/display thumbnails

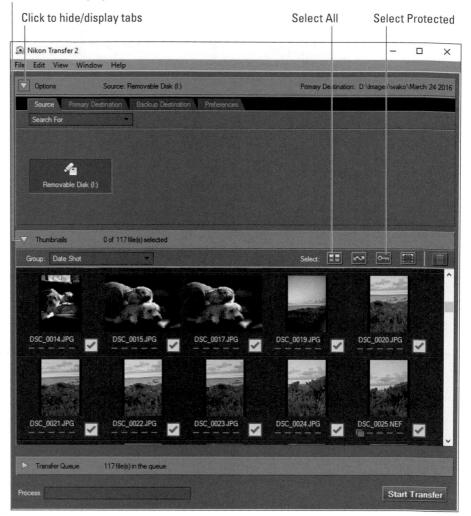

FIGURE 10-10: Select the check boxes of the images that you want to download.

4. Click the Primary Destination tab to display options for handling the file transfer, as shown in Figure 10-11.

You still see the entire Nikon Transfer window; I just cropped the figure to show only the options on the tab at the top of the window.

The most important setting on this tab is Primary Destination Folder, which determines where the program puts your transferred files. (Look for the option on the left side of the tab.) Open the drop-down list and choose the folder on your computer's hard drive (or external drive) where you want to put the pictures.

🗟 Nikon Transfer 2		-		×
ile Edit View Window Help				
Options Source: Removable [Disk (I:) Primary D	estination: C:\Users\Julie King\Picture	s\Nikon Tr	ansfer 2
Source Primary Destination Backup D	Destination Preferences			
Primary destination folder:	O Create subfolder for each transfer	Rename files during transf	er	
C:\\Pictures\Nikon Transfer 2	10_22_2016 Edit	<organal name="">_001.JPG</organal>	Edit	
	Use subfolder with same name if it exi	sts		
	Choose subfolder under Primary Destina folder	tion		
	Don't use subfolder			
	Copy folder names from camera			

Other options on this tab enable you to specify how pictures should be organized inside the primary destination folder and whether to rename files during the transfer. For example, I used the settings in the middle of the dialog box to tell the program to create a new subfolder for each transfer. Then I clicked the Edit button to choose settings that specify that the subfolders should be labeled with the date on which the pictures were taken and also to copy the main folder name from the camera.

5. To send copies of your pictures to a backup drive as well as to your main storage location, click the Backup Destination tab to display the options shown in Figure 10-12.

This feature is a big timesaver, enabling you to download photos to your primary drive and to a backup drive at the same time. After selecting the Backup Files box, as shown in the figure, use the other panel options to specify where you want the backup files to go.

FIGURE 10-11: Specify the folder where you want

FIGURE 10-12: Use the options on this tab to automatically send duplicates of your pictures to a backup drive at the same time they're being sent to your main storage drive.

Options Source	e: Removable Disk (l.)	Primary Destination: C:\Users\Julie King\Pictures\Nikon Tr	ansfe
Source Primary Destination	Backup Destination Prefe	rences	
Backup files			
Backup destination folder.	001		
H:\2016 Images	🖌 🖾 Lise subfold		
Use same settings as Primary De	stination		

6. Click the Preferences tab to display the options shown in Figure 10-13.

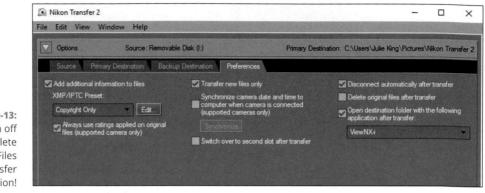

Three settings here are critical:

- Transfer New Files Only: This option, when selected, ensures that you don't waste time downloading images that you've already transferred.
- Delete Original Files after Transfer: **Turn off this option.** Otherwise, your pictures are erased from your memory card when the transfer is complete. Always make sure the pictures made it to the computer before you delete them from your memory card.
 - Open Destination Folder with the Following Application after Transfer: You can
 tell the program to immediately open your photo program after the
 transfer is complete. Choose ViewNX-i to view and organize your photos
 using that program. To choose another program, open the drop-down list,
 choose Browse, and select the program from the dialog box that appears.
 Click OK after doing so.

Your choices remain in force for any subsequent download sessions, so you don't have to revisit this tab unless you want the program to behave differently.

7. Click the Start Transfer button, found at the bottom of the Nikon Transfer 2 window (refer to Figure 10-10).

After you click the button, the Process bar in the lower-left corner of the program window indicates how the transfer is progressing. What happens when the transfer completes depends on the choices you made in Step 6; if you selected Nikon ViewNX-i as the photo program, it opens and displays the folder that contains your just-downloaded images.

FIGURE 10-13: Turn off the Delete Original Files after Transfer option!

DRAG-AND-DROP FILE TRANSFER

As an alternative to using a photo program to download files, you can use Windows Explorer or the Mac Finder to drag and drop files from your memory card to your computer, just as you can copy any file from a CD, DVD, or flash drive onto your computer. If you connect the camera's SD card through a card reader, the computer sees the card as just another drive on the system. Windows Explorer also shows the camera as a storage device when you cable the camera directly to the computer. (With some versions of the Mac OS, including the most recent ones, the Finder doesn't recognize cameras in this way.)

The downside to this method is that you may not be able to preview thumbnails of your photos. Instead, you may see only filenames in the Windows Explorer or Finder windows. So if time permits, I transfer using a photo program that lets me see my images and decide which ones I want to bother downloading. But I use the drag-and-drop method if I'm in a hurry to unload a memory card so that I can use it on my next shoot. The process is marginally faster because the photo program doesn't have to create thumbnails of each image, and I don't get distracted looking at each photo as it appears. When I return to the computer later, I can use my photo software to view and organize the files I downloaded.

Do be careful to copy, and not move, the image files when you drag and drop; that way, the images remain on the memory card as a backup if something goes awry during the transfer process.

Processing Raw (NEF) Files

Chapter 2 introduces you to the Raw file format. The advantage of capturing Raw files — NEF files on Nikon cameras — is that you make the decisions about how to translate the original picture data into an actual photograph. You take this step by using a software tool known as a *Raw converter*. To process your NEF files, Nikon offers the following free options:

- >> Use the in-camera processing feature. You can specify only limited image attributes when you go this route, and you can save the processed files only in the JPEG format, but still, having this option is a nice feature.
- Process and convert in Capture NX-D. For more control over how your raw data is translated into an image, use this option. Not only do you get access to tools not found on the camera, but you also can save the adjusted files in either the JPEG or TIFF format. You also have the advantage of evaluating your photos on a larger screen than the one on your camera.

TIFF stands for Tagged Image File Format and has long been the standard format for images destined for professional publication. I recommend saving your converted Raw files in this format because it does a better job than JPEG of holding onto your original image data. As explained in Chapter 2, JPEG compresses the file, meaning that it does away with what it considers "unnecessary" data.

Of course, you can use any third-party Raw-processing tool you prefer, such as the one provided with Adobe Photoshop and Adobe Lightroom. Just don't pay for a third-party tool until you've tried Capture NX-D — the fact that it's free doesn't mean that it isn't a good program. Also understand that third-party programs usually don't support new cameras right away, so check the program information to make sure that it can open Raw files from the D3400. You may need to download a software update to make that happen.

Processing Raw images in the camera

By using the NEF (RAW) Processing option on the Retouch menu, you can create a JPEG version of a Raw file right in the camera. Follow these steps:

Press the Playback button to switch to playback mode.

Display the picture in the full-frame view.

If necessary, you can shift from thumbnails view to single-image view by pressing OK. Press OK twice if you're in Calendar view. (Chapter 9 has details on these playback modes.)

3. Press the *i* button.

You see the screen shown on the left in Figure 10-14.

FIGURE 10-14: Select Retouch (left screen) and then scroll to the NEF (RAW) Processing option (right screen).

· du	20/50	RETOUCH M	ENU
		NEF (RAW) proce	ssing
Rating		🖌 Trim	
		Resize	
etouch		E D-Lighting	
elect to send to smart devic		CӁ、Quick retouch	
	2 Cancer	Red-eye correctio	n
		7 Straighten	
D3400 DSC_0020. JPG 17/2016 18:33:49	F1NE	?	<i>i</i> Cancel

- **4.** Highlight Retouch and press the Multi Selector right to display the Retouch menu.
- 5. Scroll to the NEF (RAW) Processing option (shown on the right side of Figure 10-14).
- 6. Press OK to display your processing options.

You see a screen similar to the one in Figure 10-15, which is where you specify which settings you want the camera to use when creating the JPEG version of the Raw image. If you press the Multi Selector down, you scroll to the second page of options, shown in Figure 10-16.

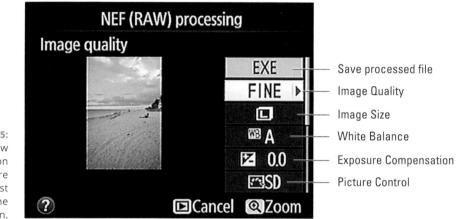

FIGURE 10-15: These Raw conversion options are on the first page of the menu screen.

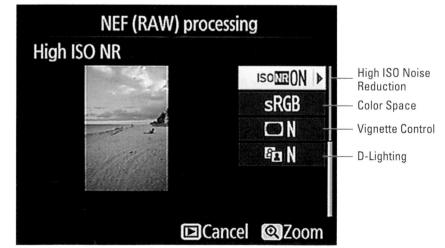

FIGURE 10-16: Press the Multi Selector down to scroll to the second page of conversion settings. screen shown on the right in the figure. Choose Resize and then press the Multi Selector right to display the screen shown in Figure 10-19.

FIGURE 10-18: Use the Resize option to create a low-resolution version of a picture.

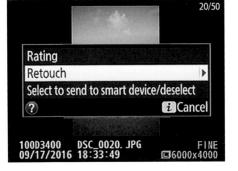

Electronic contraction of the second contrac	RETOUCH MEN NEF (RAW) processin Trim	
	Resize	Þ
82	D-Lighting	
1	Quick retouch	
\bigcirc	Red-eye correction	
7	Straighten	
?		<i>i</i> Cancel

The first value shows the pixel dimensions of the small copy; the second, the total number of pixels, measured in megapixels. Highlight a size and press the Multi Selector right. On the next screen, highlight Yes and press OK.

Resize a batch of photos. Display the Retouch menu and choose Resize, as shown on the left in Figure 10-20. Press OK to display the screen shown on the right in the figure. First, select Choose Size to set

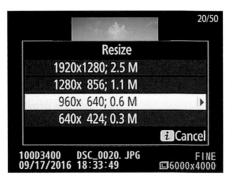

FIGURE 10-19:

Select one of these options to set the size for your low-res copy.

the pixel count of the small images. Then choose Select Image to display thumbnails of your photos, as shown in Figure 10-21.

FIGURE 10-20: To resize a batch of photos, it's quicker to do the job via the Retouch menu.

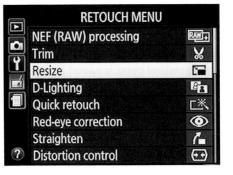

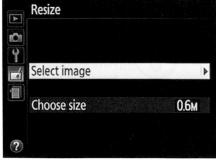

Use the Multi Selector to move the yellow selection box over an image you want to resize, and then press the Zoom Out button to tag it with a resize icon (labeled in the figure). Highlight the next photo, rinse, and repeat. After tagging all the photos, press OK to display the go-ahead screen; highlight Yes and press OK.

In both cases, the camera duplicates the selected images and *downsamples* (eliminates pixels from) the copies to achieve the size you specified. The small copies are saved in the JPEG file format, using the same Image Quality Resize symbol

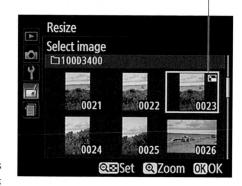

setting (Fine, Normal, or Basic) as the original. Raw originals are saved as JPEG Fine images. Either way, your original picture files remain untouched.

During playback, small-size copies are marked with the same Resize symbol you see in Figure 10-21. In some playback display modes, you also can view the pixel dimensions of the resized image. See Chapter 9 for help enabling and using the different display modes.

The Part of Tens

IN THIS PART . . .

Find out how to use the Retouch menu editing tools.

Repair red-eye, fix lens distortion, straighten tilting horizon lines, and crop to a better composition.

Correct minor exposure and color problems.

Create special effects by using the Effects exposure mode or by applying Retouch menu effects tools.

Add text comments and copyright notices to camera *metadata* (hidden file data).

Customize the Information display, AE-L/AF-L button, Function button, and other camera features.

IN THIS CHAPTER

- » Applying Retouch menu filters
- » Removing red-eye
- » Correcting crooked horizon lines, lens distortion, and perspective
- » Tweaking exposure, contrast, and color
- » Cropping away excess background
- » Creating a black-and-white version of a photo
- » Having fun with special effects

Chapter **11** Ten Fun (And Practical) Ways to Manipulate Your Photos

very photographer produces a clunker now and then. When it happens to you, don't be too quick to press the Delete button, because many common problems are surprisingly easy to fix. In fact, you often can repair your photos right in the camera, thanks to tools found on the Retouch menu.

This chapter starts with the basics of navlgating the Retouch menu and then provides specific instructions for using its photo-repair tools. Following that, I clue you in on a few special-effects tricks, including shooting in Effects mode. For information about the Resize and NEF (RAW) Processing options on the Retouch menu, see Chapter 10.

Applying the Retouch Menu Filters

With one exception, Retouch menu filters are designed for use on still photos and can't be applied to movies. I explain the single movie-related item on the menu. Edit Movies, in Chapter 8.

For all other photos, you can apply most Retouch menu features in two ways:

>> Go the regular menu route. Press the Menu button and then press the Multi Selector right to access the strip of menu icons on the left side of the screen. Select the Retouch menu icon, labeled on the left in Figure 11-1, and then press the Multi Selector right to access the menu options. Select a retouching tool and press OK to display thumbnails of your photos, as shown on the right in the figure. Use the Multi Selector to move the yellow selection box over the photo you want to adjust. Then press OK to access settings related to the retouching tool.

If a photo can't be altered, an X appears over the thumbnail (see the thumbnail labeled Not available for editing in Figure 11-1). Normally, you get the no-go signal because you already applied a certain Retouch menu option to a picture. For example, you can't edit a photo after you crop it using the Trim tool.

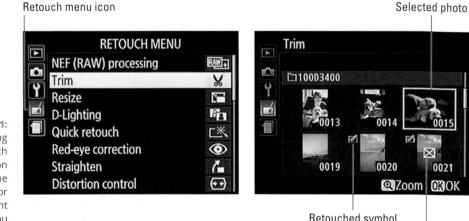

FIGURE 11-1: After selecting a Retouch menu option (left), use the Multi Selector to highlight the photo you want to edit (right).

Retouched symbol

Not available for editing

>> Use the Playback mode i button menu. In single-image view (one photo displayed at a time), scroll to the photo you want to edit. In thumbnails or Calendar view, use the Multi Selector to move the yellow selection box over the photo. Then press the *i* button. A mini-menu offering options available

during picture playback appears, as shown on the left in Figure 11-2. Highlight Retouch and press the Multi Selector right to display Retouch menu options superimposed over your photo, as shown on the right. Select a tool and press OK to display options related to that tool.

I prefer the second method, so that's how I approach things in this chapter, but it's entirely a personal choice. However, you can't use the *i* button method to access the Image Overlay menu item. That feature, which combines two Raw (NEF) photos to create a third, blended image, is available only when you display the Retouch menu by pressing the Menu button. (The last section in this chapter explains the Image Overlay feature.)

FIGURE 11-2: In Playback mode, you can press the *i* button to access the Retouch menu.

A few other facts to note:

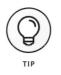

- >> Your originals remain intact. When you apply a Retouch menu tool, the camera creates a copy of your original photo and makes the changes to the copy. A retouch symbol appears near the image thumbnail to tell you that you're looking at an altered photo. (Refer to the right screen in Figure 11-1.)
- All Retouch menu tools work with either JPEG or Raw (NEF) originals except Image Overlay and NEF (Raw) Processing. Those two tools work only with Raw files. See the Chapter 2 discussion about the Image Quality setting for an explanation of JPEG and Raw (NEF). Chapter 10 shows you how to use the NEF (Raw) Processing tool. If you snapped the photo using the Raw+JPEG Image Quality setting, the camera uses the JPEG file as the basis for the retouched copy for all tools except Image Overlay and NEF (Raw) Processing.
- >> Retouched copies for all alterations except Image Overlay are saved in the JPEG file format. The retouched copy uses the same JPEG quality setting as the original (Fine, Normal, or Basic). Retouched copies of Raw originals are saved in the JPEG Fine format. For Image Overlay, the retouched image is stored using the current Image Quality and Image Size settings. (Chapter 2 discusses the Image Size setting also.)

- You can apply each correction to a picture only once. The exception, again, is Image Overlay. If you save the composite in the Raw format, you can combine the composite with a third Raw image. In fact, you can keep combining photos until your memory card is full if the urge hits you.
- The camera automatically assigns the next available file number to the retouched image. Make note of the filename of the retouched version so that you can easily track it down later.
- >> When applying certain filters, you can press the Zoom In button to see a magnified view of the adjusted photo. If so, you see the word *Zoom* along with a symbol that looks like the button at the bottom of the screen. Release the button to exit the magnified display.
- >> You can compare the original and the retouched version by using the Side-by-Side Comparison menu option. This menu option appears only when the camera is in playback mode. Start by displaying or selecting either the original or the retouched version. Then press the *i* button, choose Retouch, select Side-by-Side Comparison, and press OK. You see the original image on one side and the retouched version on the other, as shown in Figure 11-3. At the top of the screen, a label indicates the Retouch tool that you applied to the photo - Trim, in the figure.

These tricks work in Side-by-Side Comparison display:

- If you applied more than one Retouch tool to the picture, press the Multi Selector right and left to display thumbnails that show how each tool affected the picture.
- If you create multiple retouched versions of the same original for example, you create a monochrome version, save it, and then crop the original image and save that — use a different technique to compare the versions. First, press the Multi Selector right or left to surround the After image with the yellow selection box. Then press the Multi Selector up and down to scroll through the retouched versions.

To exit Side-by-Side Comparison view and return to picture playback, press the Playback button. The monitor automatically displays the picture you were viewing before you selected the Side-by-Side Comparison option. To instead see the companion image, move the yellow selection box over its thumbnail in the Side-by-Side Comparison display. Then press OK instead of the Playback button.

Removing Red-Eye

For portraits marred by red-eye, give the Red-Eye Correction filter a whirl, as shown in Figure 11-4. If the camera detects red-eye, it applies the filter and displays the results on the screen.

FIGURE 11-4: The Retouch menu offers an automated red-eye remover.

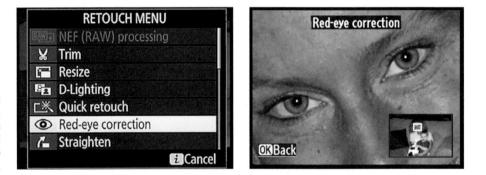

Press the Zoom In button to magnify the display, as shown in the figure, so that you can closely inspect the repair. (Use the Multi Selector to scroll the display as needed while zoomed.) Press OK twice if you're cool with the job the camera performed: The first press returns the display to normal magnification; the second makes the change official. To instead cancel the repair, press the Playback button.

Note that the filter can correct only red-eye; it can't fix animal eyes that a flash has turned white, yellow, or green. If the camera can't detect red-eye or you didn't use flash to take the picture, the Red-Eye Correction menu option is dimmed and unavailable.

Straightening Tilting Horizon Lines

I have a knack for shooting with the camera misaligned with respect to the horizon, which means that photos like the one on the left in Figure 11-5 often wind up crooked. Luckily for me, the Retouch menu offers a Straighten tool that can rotate tilting horizons back to the proper angle, as shown on the right. After you choose the Straighten filter from the Retouch menu, as shown on the left in Figure 11–6, you see a screen similar to the one on the right, with a grid superimposed on your photo to serve as an alignment aid. Press the Multi Selector right to rotate the picture clockwise; press left to rotate counterclockwise. Each press spins the picture by about 0.25 degrees. You can achieve a maximum rotation of 5 degrees. Press OK to create the straightened copy.

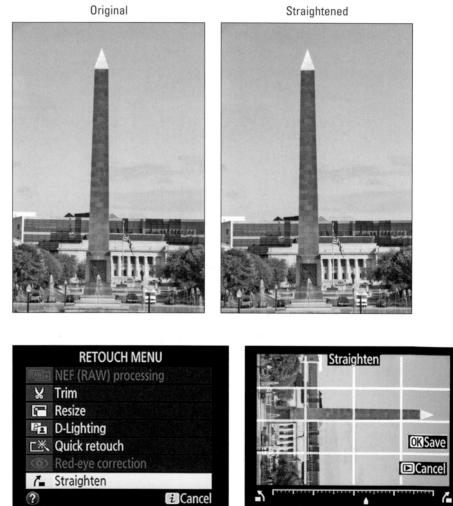

FIGURE 11-5: You can level crooked photos with the Straighten tool

FIGURE 11-6: Press the Multi Selector right or left to rotate the image in increments of 0.25 degrees.

To achieve this rotation magic, the camera must crop your image and enlarge the remaining area — that's why the After photo in Figure 11-5 contains slightly less subject matter than the original. (The same cropping occurs if you make this kind of change in a photo editor.) The camera updates the display as you rotate the photo so that you can get an idea of how much of the original scene may be lost.

Removing (Or Creating) Lens Distortion

Certain lenses can produce a type of distortion that causes straight lines to appear curved. Wide-angle lenses, for example, often create *barrel distortion*, in which objects at the center of a picture appear to be magnified and pushed outward — as if you wrapped the photo around the outside of a barrel. The effect is easy to spot in a rectangular subject like the oil painting in Figure 11-7. Notice that in the original image, on the left, the edges of the painting bow slightly outward. *Pincushion distortion* affects the photo in the opposite way, making center objects appear smaller and farther away.

Slight barrel distortion

After Distortion Correction filter

FIGURE 11-7: Barrel distortion makes straight lines appear to bow outward.

If you notice either type of distortion, try enabling the Auto Distortion Control option on the Shooting menu. This feature attempts to correct distortion as you take the picture. Or you may prefer to wait until after reviewing your photos and then use the Distortion Control tool on the Retouch menu to try to fix things, as I did for the image on the right in Figure 11–7. Less helpful, in my opinion, is a related Retouch menu filter, Fisheye, that creates distortion to replicate the look of a photo taken with a fisheye lens.

With either filter, you lose part of the original image area as a result of the distortion correction, just as you do with the Straighten tool. So if you're shooting a photo that you think may benefit from these filters, frame your subject a little loosely.

Here's how the Retouch menu filters work:

Distortion Control: After selecting the filter, as shown on the left in Figure 11-8, press the Multi Selector right to see the screen on the right in the figure. An Auto option is available for some lenses, as long as you didn't apply the Auto Distortion Control feature when taking the picture. As its name implies, the Auto option attempts to automatically apply the correct degree of correction.

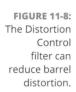

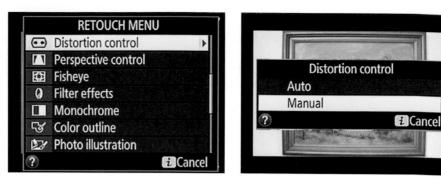

If the Auto option is dimmed or you prefer to do the correction on your own, choose Manual and press OK to display the screen shown in Figure 11-9. The scale represents the degree and direction of shift that you're applying. Press the Multi Selector right to reduce barrel distortion; press left to reduce pincushioning. Press OK to make your corrected copy of the photo.

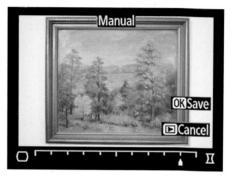

Fisheye: Select the filter and press OK to display a screen similar to the one in Figure 11-9, but with the word FIGURE 11-9: Press the Multi Selector right or left to adjust the correction.

Fisheye at the top. Press the Multi Selector right or left to set the distortion amount and then press OK.

Correcting Perspective

When you photograph a tall building and tilt the camera upward to fit it all into the frame, an effect that's referred to as *convergence*, or *keystoning*, occurs. This effect causes vertical structures to tilt toward the center of the frame. Buildings sometimes even appear to be falling away from you, as shown in the left image in Figure 11–10. (If the lens is tilting down, vertical structures instead lean outward, and the building appears to be falling toward you.) Using the Retouch menu's Perspective Control feature, you can right those tilting vertical elements, as I did to produce the second image in Figure 11–10. Original

After perspective correction

FIGURE 11-10: The original photo exhibited convergence (left); applying the Perspective Control filter corrected the problem (right).

Note, though, that as with the Straighten, Distortion Correction, and Fisheye tools, the Perspective tool results in some loss of area around the perimeter of your photo. So again, when shooting this type of subject, frame loosely — that way, you ensure that you don't sacrifice an important part of the scene due to the correction.

After you select the filter, you see a grid and horizontal and vertical scale, as shown in Figure 11–11. Press the Multi Selector left and right to move the out-of-whack object horizontally;

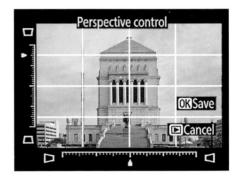

FIGURE 11-11: Again, use the Multi Selector to manipulate the image.

press up and down to rotate the object toward or away from you. When you're happy with the results, press OK.

Adjusting Exposure and Color

The following Retouch filters enable you to tweak exposure and color:

D-Lighting: Chapter 4 explains Active D-Lighting, which brightens too-dark shadows in a way that leaves highlight details intact. You can apply a similar adjustment to an existing photo by choosing the D-Lighting filter from the Retouch menu. I used the filter on the photo in Figure 11-12, where strong backlighting left the balloon underexposed in the original image. When you choose this filter, you see before-and-after views of the image, as shown in Figure 11-13. Press the Multi Selector left or right to adjust the Effect option, which sets the strength of the adjustment.

Also note the Portrait option, which is underneath the Effect option and dimmed in the figure. If the camera recognizes faces in the photo, you can select this option to limit the exposure adjustment to areas around the face (or faces). However, only three faces (maximum) are considered for this special exposure change. Also, you must have captured the photo with the Auto Image Rotation option on the Playback menu enabled. To see how things look with the portrait feature, highlight the option and press the Multi Selector right to put a check mark in the option box. Don't like the results? Press left to remove the check mark and turn off the portrait adjustment.

Original

D-Lighting, High

FIGURE 11-12: An underexposed, backlit subject (left) gets help from the D-Lighting filter (right).

You can't apply D-Lighting to a picture taken using the Monochrome Picture Control, introduced in Chapter 6. Nor does D-Lighting work on pictures to which you've applied the Quick Retouch filter, covered next, or the Monochrome filter, detailed a little later in this list.

Quick Retouch: This filter increases contrast and color saturation and, if your subject is backlit, also applies a D-Lighting adjustment to restore

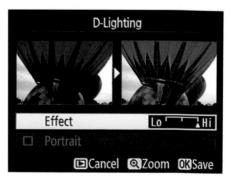

FIGURE 11-13:

Press the Multi Selector right or left to vary the strength of the correction.

some shadow detail that otherwise might be lost. As with D-Lighting, you can choose from three levels of Quick Retouch correction. And the same restrictions apply: You can't apply the filter to monochrome images or on pictures that you adjusted via D-Lighting.

- Filter Effects: Choose this option to access two warming filters, which enhance the warm (red and yellow) tones in the scene. You can choose from these options:
 - Skylight filter: Reduces the amount of blue to create a subtle warming effect
 - *Warm filter:* Produces a warming effect that's just a bit stronger than the Skylight filter

Both tools produce minimal color shift, and neither enables you to adjust the strength of the effect. And to answer your question, no, you can't apply the filter several times in a row to produce a stronger effect.

The other two filters on the Filter Effects, Cross Screen and Soft, are specialeffects filters. I describe both later in this chapter, in the section "Applying Effects to Existing Photos."

>> Monochrome: With the Monochrome Picture Control feature, covered in Chapter 6, you can shoot black-and-white photos. As an alternative, you can create a black-and-white copy of an existing color photo by applying the Monochrome option on the Retouch menu. You can also create sepia and *cyanotype* (blue and white) images via the Monochrome option. Figure 11-14 shows examples of each.

You can't apply certain Retouch menu options to your photo after you do the conversion; the D-Lighting, Quick Retouch, and Soft filters are among those that don't work on a monochrome copy. (Obviously, filters related to color adjustment also are no longer available.) So use those filters before heading to the Monochrome option.

After selecting Monochrome from the Retouch menu, select the type of image you want to create (black-and-white, sepia, or cyanotype) and press OK. For the Sepia and Cyanotype options, you then see a screen that asks you to set the intensity of the tint; press the Multi Selector up and down to do so and then give the OK button one final push.

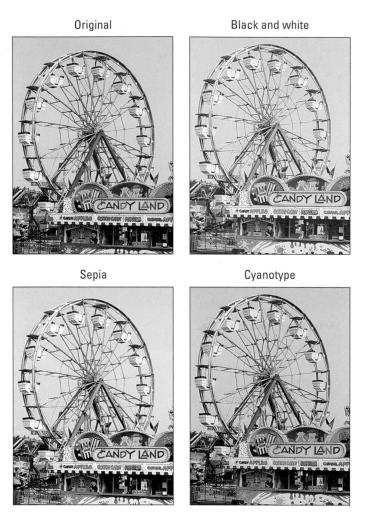

FIGURE 11-14: You can create three monochrome effects through the Monochrome tool on the Retouch menu.

Cropping Your Photo

To *crop* a photo means to trim away some of its perimeter. Cropping out excess background can often improve an image, as illustrated by Figure 11-15. When shooting this scene, I couldn't get close enough to fill the frame with the ducks. So I cropped the original image, shown on the left, to achieve the composition you see on the right. Because I captured the photo using a high-resolution (Image Size) setting, I had plenty of pixels to allow enlarging the cropped photo. (Chapter 2 explains this issue.)

With the Trim function on the Retouch menu, you can crop a photo right in the camera. However, always make this your *last* editing step because after you crop, you can't apply any other fixes from the Retouch menu.

FIGURE 11-15: Cropping creates a better composition and eliminates background clutter.

To get the cropping job done, take these steps:

Display your photo in single-image view, press the *i* button, select Retouch, and press the Multi Selector right.

The Retouch menu appears.

2. Select Trim and press OK.

You see the screen shown in Figure 11-16. The yellow box indicates the cropping frame. Anything outside the box won't appear in the cropped photo.

3. Rotate the Command dial to change the crop aspect ratio.

You can crop to one of five aspect ratios: 3:2, 4:3, 5:4, 1:1, and 16:9. The selected aspect ratio appears in the upper-right corner of the screen.

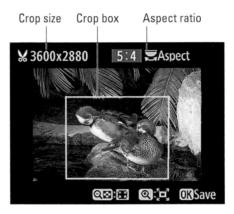

FIGURE 11-16: The yellow box indicates the cropping frame.

4. Adjust the cropping frame size and placement as needed.

For each aspect ratio, you can choose from a variety of crop sizes, which depend on the size of the original. The sizes are stated in pixel terms, such as 3600×2880 . If you're cropping in advance of printing the image, remember to aim for at least 200 pixels per linear inch of the print — 800×1200 pixels for a 4×6 print, for example. The current crop size appears in the upper-left corner of the screen.

You can adjust the size and placement of the cropping frame like so:

• *Reduce the size of the cropping frame.* Press and release the Zoom Out button. Each press of the button further reduces the crop size.

- Enlarge the cropping frame. Press the Zoom In button.
- *Reposition the cropping frame.* Press the Multi Selector up, down, right, or left to shift the frame position.

5. Press OK to create the cropped copy.

When you view the cropped image in Playback mode, a scissors symbol appears next to the Image Size readout (lower-right corner of the frame) to tell you that you're looking at a trimmed photo.

Applying Effects to Existing Photos

To alter reality beyond what you can achieve with the tools mentioned earlier in this chapter, experiment with these Retouch menu filters:

Cross Screen: This filter adds a starburst effect to the brightest part of the image, as shown in Figure 11-17. To try it, select Filter Effects from the Retouch menu and then select Cross Screen. Using the options that appear along the right side of the screen, you can adjust the number of points on the star, the intensity of the effect, the length of the star's rays, and the angle of the effect. Use the Multi Selector to highlight an option, and then press right to display the available settings. Highlight your choice and press OK. To update the preview after changing a setting, highlight Confirm and press OK. When you're happy with the effect, choose Save and press OK.

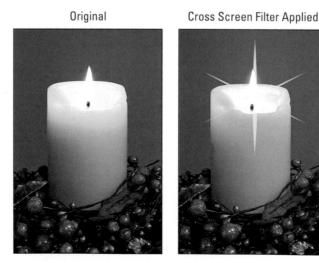

FIGURE 11-17: The Cross Screen filter adds a starburst effect to the brightest parts of the photo.

- Soft: Also on the Filter Effects menu, the Soft filter blurs your photo to give it a dreamy, watercolor-like look. You can choose from three levels of blur: Low, Normal, and High.
- Color Outline: Select this option from the Retouch menu to turn your photo into a black-and-white line drawing.
- Photo Illustration: This effect produces a cross between a photo and a bold, color drawing. Use the filter's Outlines option to adjust the look of the effect.
- Color Sketch: This filter creates an image similar to a drawing done in colored pencils; Figure 11-18 shows you an original (left) and its altered cousin (right). You can modify the effect through two options: Vividness, which affects the boldness of the colors; and Outlines, which determines the thickness of outlines.

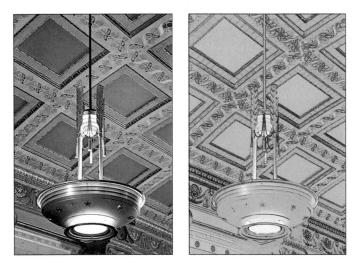

FIGURE 11-18: Color Sketch produces the effect you see on the right.

> Miniature Effect: Have you ever seen an architect's small-scale models of planned developments? The Miniature Effect filter attempts to create a photographic equivalent by applying a strong blur to all but one portion of an image, as shown in Figure 11-19. The left photo is the original; the right shows the result of applying the filter. For this example, I set the focus point on the part of the street occupied by the cars.

The Miniature Effect filter works best if you shoot your subject from a high angle — otherwise, you don't get the miniaturization result.

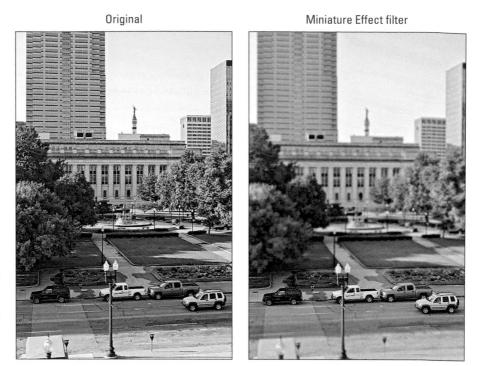

FIGURE 11-19: The Miniature Effect filter throws all but a small portion of a scene into very soft focus.

After choosing the filter from the Retouch menu, you see a yellow box over the photo, as shown in Figure 11-20. (Vertically oriented originals like my example image are automatically rotated to give you a larger view of the image.)

The yellow box represents the area that will remain in focus. Adjust its size and position as follows:

- *Rotate the box 90 degrees:* Press the Zoom Out button.
- Position and resize the box: When the box is oriented as shown in Figure 11-20, press the Multi Selector up/down to resize the box; press right/left to move it. If the box is oriented horizontally, use the opposite maneuvers. (The double-arrow symbol in the upper-right corner of the screen indicates which way to press the Multi Selector to resize the frame.)
- *Preview the effect:* Press the Zoom In button.

FIGURE 11-20:

Use the Multi Selector to position the yellow rectangle over the area you want to keep in sharp focus.

When you get a result you like, press OK to save a copy of the original with the effect applied.

Selective Color: This effect *desaturates* (removes color from) parts of a photo while leaving specific colors intact. For example, in Figure 11-21, I desaturated everything but the yellows and peaches in the rose.

FIGURE 11-21: I used the Selective Color filter to desaturate everything but the rose petals.

After choosing Selective Color, you can specify up to three colors to retain and also limit how much a color can vary from the selected one and still be retained. Make your wishes known as described in this list of (loosely ordered) actions:

- Select the first color to be retained. Using the Multi Selector, move the yellow box (labeled Color selection box on the left screen in Figure 11-22) over the color. Then press the AE-L/AF-L button to tag that color, which appears in the first color swatch at the top of the screen, as shown on the left in Figure 11-22.
- Set the range of the selected color. Rotate the Command dial to display a preview of the desaturated image and highlight the number box to the right of the color swatch, as shown on the right in the figure. Then press the Multi Selector up or down to choose a value from 1 to 7. The higher the number, the more a pixel can vary in color from the selected hue and still be retained. The display updates to show you the impact of the setting.
- *Choose one or two additional colors.* Rotate the Command dial to highlight the second color swatch and then repeat the selection process. To choose a third color, head around the track one more time.

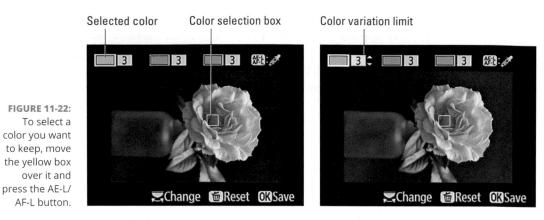

- Fine-tune your settings. You can keep rotating the Command dial to cycle through the color swatch and range boxes, adjusting each as necessary.
 - Reset a color swatch box. To empty a selected swatch box, press the Delete button. You can then move the yellow highlight box over a new color and press the AE-L/AF-L button to select that color. To reset all the swatch boxes, hold down the Delete button.
 - Save a copy of the image with the effect applied. Press OK.
- >> Painting: Try this filter for a bold, almost surreal, adaptation of your photo.

Shooting in Effects Mode

When you set the Mode dial to Effects, as shown in Figure 11–23, you can apply special effects as the camera writes the picture to the memory card.

For still photos, I prefer to capture my originals sans effect and then work from the Retouch menu to alter them. That way, I wind up with one normal image and one with the effect applied, just in case I decide that I prefer the unaltered photo to the effects version.

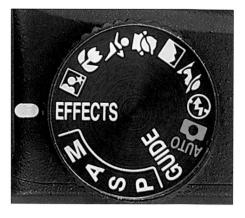

FIGURE 11-23: Effects mode lets you apply special effects to movies and still photos.

Shooting in Effects mode also brings up another problem: To create the effects, the camera puts most picture-taking controls, such as White Balance and Metering mode, off limits. Additionally, you can capture the image only in the JPEG format for all Effects modes except Silhouette, High Key, and Low Key. The Raw and Raw+JPEG Image Quality settings are disabled for all other effects. If you select Raw or Raw+JPEG before choosing an Effects mode that doesn't support Raw, the Image Quality setting is automatically changed to Fine.

However, Effects mode does offer some artistic filters not available on the Retouch menu. In addition, it enables you to add most effects to movies, which isn't possible on the Retouch menu. So even though I suspect that you won't find a use for the Effects mode very often, I'd be remiss if I didn't spend a little time discussing it.

As soon as you set the Mode dial to Effects, an icon representing the selected effect appears in the upper-left corner of the Information display, as shown on the left in Figure 11-24. Rotate the Command dial to cycle through the available effects, as shown on the right.

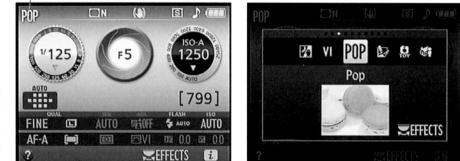

Current Effects mode

FIGURE 11-24: Rotate the Command dial to cycle through the effects.

Although the camera displays a thumbnail to indicate the result of each effect, you don't have to rely on that artwork: Instead, set the camera to Live View mode. The monitor then shows a live preview of each effect as you select it. You also need to use Live View mode to access the options that are available for some effects.

To shift to Live View mode, press the Live View (LV) button on the back of the camera. Rotate the Command dial to scroll through the various effects, just as you do when not in Live View mode.

After selecting an effect, you can exit Live View to take the picture using the viewfinder if you prefer. Or, to record a movie, remain in Live View mode and just press the red Movie-Record button to start and stop recording. Effects mode offers the following choices:

Night Vision: Use this setting in low-light situations to produce a grainy, black-and-white image that resembles what you see with night-vision goggles. Figure 11-25 has an example. To achieve the grainy effect, the camera uses a high ISO Sensitivity setting that high ISO produces noise, which results in the grainy look. How high the ISO climbs and, thus, how much noise becomes visible, depends on the ambient light.

A few critical points about Night Vision mode:

- Autofocusing is available only in Live View mode. For viewfinder photography, you must focus manually.
- *Flash is disabled, as is the AF-assist lamp.* The whole idea is to create a picture taken in little light, after all.

FIGURE 11-25: The Night Vision effect creates an exceptionally noisy black-andwhite image.

- Use a tripod to avoid blur. A slow shutter speed is needed to capture the image in dark conditions, and you must be careful to avoid camera movement during the exposure. If your subject is moving, it can appear blurry even if the camera is on a tripod.
- Super Vivid: Hey, will you look at that: a setting whose name tells you just what that setting will do. Super Vivid amps up color saturation and contrast for, er, super vivid pictures.
- >> Pop: If Super Vivid is too much excitement for you, try this setting, which increases only color saturation, making colors "pop."
- >> Photo Illustration: This setting creates a look similar to the one produced by the Photo Illustration option on the Retouch menu. Objects are rendered as simple shapes with strong outlines and a limited color palette. (In techie terms, pixels are run through a *posterization* filter, which reduces a range of colors to a single hue.) In Live View mode, you can adjust the effect by pressing OK and then pressing the Multi Selector right or left to change the size of the object outlines. Press OK again after you set this value. The camera will use the same value the next time you shoot using the Photo Illustration effect.

In this mode, you must focus manually when shooting movies. Additionally, movies that you record in Photo Illustration mode not only have the color posterization applied, but the frames are created in a way that causes the movie to look more like a slide show than a video.

For still photography, the maximum number of frames per second you can capture in the Continuous Release mode is reduced.

Toy Camera Effect: This mode creates a photo or movie that looks like it was shot by a toy camera — specifically, the type of toy camera that produces images that have a vignette effect (corners of the scene appear darker than the rest of the image).

In Live View mode, you can adjust the effect by pressing OK to access two options: Vividness, which affects color intensity; and Vignetting, which controls the amount of vignetting. After dialing in the settings you want to use, press OK to exit the setup screen.

Miniature Effect: This one is also a duplicate of an option on the Retouch menu; Figure 11-19 shows an example of the result. Again, the filter works by blurring all but a small portion of the scene.

To specify which area you want to keep in focus, first set the camera to Live View mode. In the center of the screen, you see a red focus frame; use the Multi Selector to center the frame over the area that you want to keep in focus and then press OK. Now you see horizontal markings that indicate the width of the sharp-focus region. Press the Multi Selector up or down to adjust the width of the in-focus region; press right or left to change the orientation of the box. When you achieve the look you want, press OK again.

A few other limitations also apply: Flash is disabled, as is the AF-assist lamp. If you use the Continuous Release mode, the frames per second rate is reduced. When autofocusing, you can't use any AF-area mode except Single Point (for viewfinder photography) or Wide Area mode (for Live View photography). Chapter 5 discusses these autofocus options.

For movies, sound recording is disabled, autofocus is disabled during recording, and movies play back at high speed. (The high-speed playback means that a movie that contains about 45 minutes of footage is compressed into a 3-minute clip, for example.)

Selective Color: Use this effect to create an image in which all but one to three colors are desaturated, just as when you use the Selective Color option on the Retouch menu. Figure 11-21 has an example.

To choose the colors you want to retain and specify the range of similar colors that are included, switch to Live View and then press OK. At the top of the screen, you see three color-swatch boxes and a value next to each box. In the middle of the screen, you see a small white box, which is the color selector box. Set up the effect as follows:

• *Choose a color to retain:* Frame the image so that the white selection box is over the color you want to preserve. Then press the Multi Selector up.

- Set the color range: After setting the color, press the Multi Selector up or down to adjust the color range value. A higher value retains a broader spectrum of similar shades than the one you chose.
- Choose additional color to retain: Rotate the Command dial to select the second color swatch box and repeat the process of choosing a color and setting its range value.
- Í
- *Deselect a color:* Change your mind about retaining one of your chosen colors? Rotate the Command dial to highlight its color swatch and then press the Delete button. Or hold down the button for a few seconds to delete all your selected colors.

After setting your color preferences, press OK to lock in your decisions and hide the options. The camera will use those settings any time you choose the Selective Color effect until you specify new settings. You can stay in Live View mode to shoot your photo or movie or exit Live View mode to take a picture using the viewfinder.

Note that flash is disabled in this mode. Even if the built-in flash is raised, it won't fire.

- Silhouette: Choosing this setting ensures that backlit subjects will be captured as dark silhouettes against a bright background, as shown in Figure 11-26. To help ensure that the subject is dark, flash is disabled.
- High Key: A high key photo is dominated by white or very light areas, such as a white china cup resting on a white doily in front of a sunny window. This setting is designed to produce a good exposure for this type of scene, which the camera otherwise tends to underexpose in response to all the high brightness values. Flash is disabled.

How does the name relate to the characteristics of the picture? Well, photographers refer to the dominant tones — or brightness values — as the *key tones*. In most photos, the *midtones*, or areas of medium brightness, are the key tones. In a high key image, the majority of tones are at the bird and of the bright

FIGURE 11-26: The Silhouette effect purposely underexposes backlit subjects.

majority of tones are at the high end of the brightness scale.

Low Key: The opposite of a high key photo, a low key photo is dominated by shadows. Use this mode to prevent the camera from brightening the scene too much and thereby losing the dark and dramatic nature of the image. Flash is disabled.

For Effects modes that allow flash, you can select from a few different flash modes, such as Auto flash, Flash Off, and Red-Eye Reduction flash. Which flash modes are available varies depending on the Effects mode.

To change the Flash mode, hold down the Flash button while rotating the Command dial. See Chapter 2 for more details on using flash.

Combining Two Photos with Image Overlay

The Image Overlay option on the Retouch menu enables you to merge two photographs into one. I used this option to combine a photo of a werewolf friend, shown on the left in Figure 11-27, with a nighttime garden scene, shown in the middle. The result is the ghostly image shown on the right. Oooh, scary!

FIGURE 11-27: Image Overlay merges two RAW (NEF) photos into one.

On the surface, this option sounds kind of cool. The problem is that you can't control the opacity or positioning of the individual images in the combined photo. For example, my overlay picture would have been more successful if I could move the werewolf to the left in the combined image so that he and the lantern aren't blended. And I'd also prefer to keep the background of the second image at full opacity in the overlay image rather than getting a 50:50 mix of that background and the one in the first image, which only creates a fuzzy-looking background in this particular example.

However, there is one effect that you can create successfully with Image Overlay: a "two views" composite like the onc in Figure 11–28. But for this trick to work, the background in both images must be the same solid color (black seems to be best), and you must compose your photos so that the subjects don't overlap in the combined photo, as shown here. Otherwise you get the ghostly effect that you see in Figure 11–27. FIGURE 11-28: If you want each subject to appear solid, use a black background and position the subjects so that they don't overlap.

REMEMBER

Additionally, the Image Overlay feature works only with pictures that you shoot in the Camera Raw (NEF) format. For details on Raw, see Chapter 2. Finally, in order to access Image Overlay, you must press the Menu button and navigate to the Retouch menu from there. Image Overlay is not available if you display the Retouch menu by pressing the *i* button during picture playback.

To be honest, I don't recommend using Image Overlay or Multiple Exposure for serious photo compositing. Instead, do this kind of work in your photo-editing software, where you have more control over the blend. So in the interest of reserving space in this book for features that I think you will find much more useful, I leave you to explore this feature on your own. The electronic version of the camera manual, available for download from the Nikon support pages for the D3400, explains the steps involved in using it.

- » Tagging files with image comments
- » Adding copyright data to files
- » Creating custom storage folders
- » Altering the camera's automatic shutdown timing
- » Customizing the Information display
- » Changing the function of some buttons

Chapter **12** Ten Special-Purpose Features to Explore on a Rainy Day

onsider this chapter the literary equivalent of the end of a late-night infomercial — the part where the host exclaims, "But wait! There's more!" The features covered in these pages aren't the sort that drive people to choose one camera over another, and they may come in handy only on certain occasions. Still, they're included at no extra charge, so check 'em out when you have a few spare moments.

Adding Hidden Image Comments

Through the Image Comment feature on the Setup menu, you can add hidden text comments to your picture files. Suppose, for example, that you're traveling on vacation and visiting a different destination every day. You can annotate all the pictures you take on a particular outing with the name of the location or attraction.

The text doesn't appear on the photo itself; instead, it's stored with other *metadata* (extra data, such as shutter speed, date and time, and so on). You can view the comment during playback in the Shooting Data display mode (see Chapter 9) or along with other metadata in Nikon ViewNX-i and Capture NX-D (see Chapter 10). Some third-party photo programs and apps also may be able to display the comments.

Enable the feature via the Image Comment option on the Setup menu, as shown on the left in Figure 12–1. Press OK, highlight Input Comment, as shown on the right in the figure, and press the Multi Selector right to display the keyboard screen shown on the left in Figure 12–2.

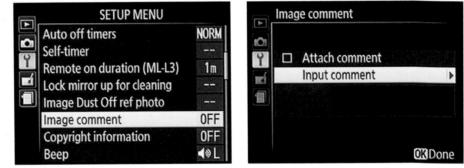

FIGURE 12-1: You can tag pictures with text comments through this feature.

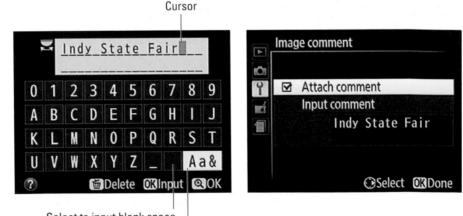

FIGURE 12-2: Use the Multi Selector to highlight a letter and press OK to enter it.

Select to input blank space

Use these text-entry techniques to create your comment:

Enter a character: Use the Multi Selector to highlight the character and then press OK. Your comment can be up to 36 characters long.

To switch from capital letters to lowercase letters, highlight the box in the lower-right corner of the keyboard — the one labeled Aa& and spotlighted in Figure 12-2 — and press OK. Press OK again to cycle to a screen of special symbols. Press OK one more time to return to the initial set of capital letters.

To enter a space, bring up either of the alphabetical screens, highlight the empty box to the left of that Aa& box, and press OK.

>> Move the text cursor: Rotate the Command dial.

>> Delete a letter: Move the cursor under the letter and press the Delete button.

After entering your comment, press the Zoom In button to display the screen shown on the right in Figure 12–2. You should see your text comment underneath the Input Comment line. Highlight Attach Comment and press the Multi Selector right to put a check mark in the box, as shown in the figure, and then press OK. The Image Comment item on the Setup menu should now read On.

To disable the feature, revisit the Setup menu, select Image Comment, highlight Attach Comment, and press the Multi Selector right to toggle the check mark off. Press OK to make your decision official.

Adding a Copyright Notice

Just as you can add miscellaneous comments via the Image Comment feature, you can embed copyright information within your image and movie files. Again, the copyright information is stored as metadata and can be viewed on the camera in some playback modes and also when looking at the photo or movie in some photo programs and apps.

Including a copyright notice is a reasonable first step to prevent people from using your pictures without permission. Anyone who views your picture in a program that can display metadata can see your copyright notice. Obviously, that won't be enough to completely prevent unauthorized use of your images. And technically speaking, you hold the copyright to your photo whether or not you mark it with your name. But if you ever come to the point of pressing legal action, you can show that you did your due diligence in letting people know that you hold the copyright. To add a copyright notice, choose Copyright Information from the Setup menu, as shown on the left in Figure 12-3. You see the screen shown on the right in the figure.

FIGURE 12-3: You also can tag files with copyright information.

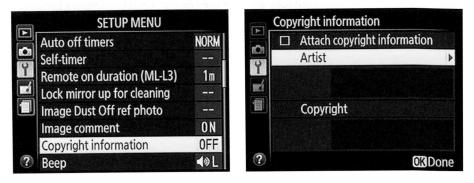

Select Artist to display the same keyboard screen provided for adding image comments. Use the techniques outlined in the preceding section to enter your name. Then return to the first Copyright Information screen (right screen in

Figure 12–3) and select Copyright to display a keyboard where you can add that information. The Artist field can hold 36 characters; the Copyright field, 54 characters.

After you enter your data, it appears on the Copyright Information screen, as shown in Figure 12–4. If everything looks good, select Attach Copyright Information to turn on the check mark in the accompanying box. Then press OK. To disable the copyright embedding, turn the Attach Copyright Information option off.

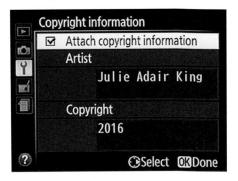

FIGURE 12-4:

After entering your copyright data, select Attach Copyright and press the Multi Selector right to put a check mark in the box.

Creating Custom Image Folders

By default, your camera stores all images in one folder, which it names 100D3400. Folders have a storage limit of 999 images; when you exceed that number, the camera creates a new folder, assigning a name that indicates the folder number — 101D3400, 102D3400, and so on. You're also given a new folder if a file in the current folder is numbered 9999. If you choose, you can create your own folder-numbering scheme. For example, perhaps you sometimes use your camera for business and sometimes for personal use. To keep your images separate, you can set up one folder numbered 200D3400 for work images and use the regular 100D3400 folder for personal photos.

To create a new storage folder, follow these steps:

1. Display the Setup menu and select Storage Folder, as shown on the left in Figure 12-5.

The number you see along with the Storage Folder option reflects the first three numbers of the folder name (100, in the figure). During playback, you see the entire folder name (100D3400, for example) in playback modes that show the folder name.

FIGURE 12-5: Use this Setup menu option to create customnumbered folders and specify the folder you want to use to hold the next shots you take.

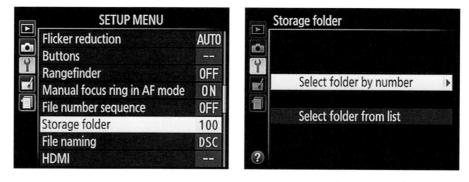

2. Choose Select Folder by Number, as shown on the right in Figure 12-5.

You see the screen shown in Figure 12-6, with the current folder number shown in the middle of the screen.

A folder icon next to the folder number indicates that the folder already exists. A half-full icon like the one in Figure 12-6 shows that the folder contains images. A full icon means that the folder is stuffed to its capacity (999 images) or contains a picture with the file number 9999. Either way, that full icon means that you can't put any more pictures in the folder.

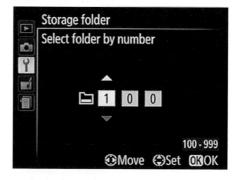

FIGURE 12-6:

Press the Multi Selector right or left to highlight a number box; then press up/down to change the number.

3. Assign the new folder a new number.

Press the Multi Selector right or left to select a number box; then press up/ down to change the number. When you create a new folder, the little folder icon disappears because the folder doesn't yet contain any photos.

4. Press the OK button.

The camera creates your new folder and automatically selects it as the current storage folder.

Each time you shoot, make sure to verify that the folder you want to use is shown for the Storage Folder option. If not, select that option and then choose Select Folder by Number to enter the folder number (if you know it) or choose Select Folder from List to pick from a list of all available folders.

Turning Off the AF-Assist Illuminator

In dim lighting, the camera may emit a beam of light from the AF-assist light on the front of the camera. If that light could be distracting to your subject or others in the room, you can disable it via the Shooting menu, as shown in Figure 12–7. You may need to focus manually, though, because without the light to help it find its target, the autofocus system may have trouble.

Adjusting Automatic Shutdown Timing

	SHOOTING MENU	
	Noise reduction	ON
	Vignette control	
Ŷ	Auto distortion control	OFF
	Focus mode	
	AF-area mode	
	Built-in AF-assist illuminator	0FF r
	Metering	$\overline{\mathbf{O}}$
?	Flash cntrl for built-in flash	TTL\$

FIGURE 12-7: Turn this option off to disable the AF-assist lamp.

When the camera is in shooting mode, its *standby timer* feature saves battery power by putting the Information display and viewfinder display to sleep after a period of inactivity. Similarly, the camera limits the Image Review period (the length of time your picture appears immediately after you press the shutter button), the length of time the Live View display remains inactive, how long a picture appears in playback mode, and how long menus remain onscreen.

You can control the auto-shutdown timing through the Auto Off Timers option, found on the Setup menu and shown on the left in Figure 12-8.

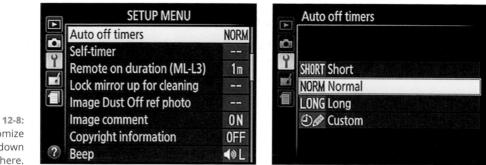

FIGURE 12-8: Customize auto shutdown timing here.

You get four choices, as shown on the right in the figure. The first three rows in Table 12–1 show the shutdown times that result when you select Short, Normal, or Long. (Normal is the default.) Select Custom to adjust the shutoff times for the various features separately; the range of delay times for each feature appears in the last row of the table.

TABLE 12-1 Auto Off Timers Options

Option Name	Standby Timer	Live View	Image Review	Playback/Menus
Short	4 seconds	5 minutes	4 seconds	20 seconds
Normal	8 seconds	10 minutes	4 seconds	5 minutes
Long	1 minute	20 minutes	20 seconds	10 minutes
Custom	4 seconds to 30 minutes	5 minutes to 30 minutes	4 seconds to 10 minutes	8 seconds to 10 minutes

To disable Image Review altogether, head for the Playback menu and set the Image Review item to Off.

Changing the Look of the Information Display

By default, the Information display appears as shown on the left in Figure 12-9 in the P, S, A, and M exposure modes. Other exposure modes use the same design but use a light gray background instead of the darker version used in the P, S, A, and M modes.

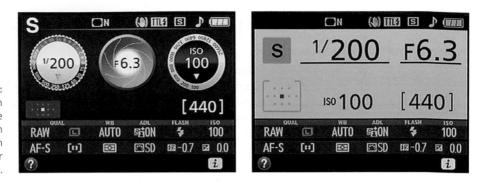

FIGURE 12-9: You can alter the Information display design and color scheme.

> I haven't a clue as to why Nikon opted to use different backgrounds for the default displays. But in both cases, one helpful aspect of this display is the graphic that shows the aperture setting, or f-stop — the middle circle, set to f/6.3 in the figure. As you change the f-stop, which widens or narrows the aperture to allow more or less light into the camera, the graphic updates to give you a visual reminder of what's happening. (Chapter 4 explains apertures, f-stops, and other exposure-related terms.)

> For obvious reasons, this default design is called Graphic display mode. If you prefer, you can switch to the simpler design - Classic mode - shown on the right in the figure. The benefit to this display is that the critical exposure settings (f-stop, shutter speed, and ISO) appear at a larger size, which is always a plus for those of us in the "where *did* I leave my reading glasses?" age category.

> With either design, you also can set the background color to teal, as shown on the right in the figure, or to dark or light gray. To make the change, select Info Display Format from the Setup menu, as shown in Figure 12-10. You then see the screen shown on the right in the figure. Choose the option that includes the exposure modes you want to affect and then select a design from the next screen.

006

....

FIGURE 12-10: Modify the look of the Information display through this Setup menu option.

SETUP MENU		Info display format
Reset setup options Format memory card Date stamp Time zone and date Language Monitor brightness	 0FF 0	AUTO/SCENE/EFFECTS P/S/A/M
Info display format Auto info display		

Keeping the Information Display Hidden

Just below the Info Display Format option on the Setup menu (refer to Figure 12-10), the Auto Info Display option offers another way to customize the Information display. When this option is On, as it is by default, the Information display appears when you press the shutter button halfway and release it. If you disable the Image Review feature (via the Playback menu), the Information display also appears after you take a picture.

Turn off the Auto Info Display option, and the Information screen appears briefly when you first turn on the camera, but after that, you must press the Info button to display it. Instructions in this book assume that you keep the option set to On. But because the monitor is one of the biggest drains of battery power, you may want to change it to Off if the battery is running low.

Changing the Function Button's Function

Tucked away on the left-front side of the camera, just under the Flash button, the Function (Fn) button is set by default to provide quick access to the ISO Sensitivity setting. By holding down the button and rotating the Command dial, you can adjust the setting without going through the Shooting menu or Information or Live View control strips. But if you don't adjust the ISO setting often, you may want to assign one of three other possible functions to the button.

Establish the button's behavior via the Buttons option on the Setup menu, shown on the left in Figure 12-11. After selecting Buttons, press OK to display the screen on the right in the figure and choose Assign Fn Button. Press the Multi Selector right to display a list of button functions, as shown in Figure 12-12.

FIGURE 12-11:
You can assign
any number
of jobs to
the Function
button.

	SETUP MENU			Buttons	
	Flicker reduction	AUTO			
•	Buttons				
T	Rangefinder	0FF	T	Assign Fn button	ISO ▶
-	Manual focus ring in AF mode	ON		Assign AE-L/AF-L button	
	File number sequence	0FF		Shutter-release button AE-L	OFF
	Storage folder	100		AF activation	ON
	File naming	DSC			
?	HDMI		1.1		

Here's what the Function button does at each setting:

- >> Image Quality/Size: Pressing the Fn button while rotating the Command dial cycles through all the possible combinations of the Image Quality and Image Size settings. Chapter 2 explains these two settings.
- ISO Sensitivity: Choose this option to return to the default setting. Again, when this option is selected, pressing the Fn button while turning the Command dial changes the ISO setting. See Chapter 4 for details about ISO.

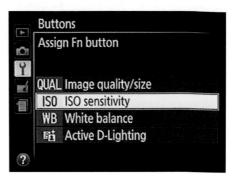

FIGURE 12-12:

The default option enables you to use the Function button to access the ISO Sensitivity option quickly.

- White Balance: Pressing the Fn button while turning the Command dial changes the White Balance setting, but only in P, S, A, and M exposure modes. Chapter 6 details white balance.
- Active-D Lighting: Pressing the Fn button while turning the Command dial toggles Active D-Lighting on and off. Like the White Balance option, this one is adjustable only in the P, S, A, and M exposure modes. Read about Active D-Lighting in Chapter 4.

After selecting the button function you want to assign, press OK.

Customizing the AE-L/AF-L Button

Set to the right of the viewfinder, the AE-L/AF-L button enables you to lock focus and exposure when you shoot in autoexposure and autofocus modes, as explored in Chapters 4 and 5.

By default, the button is set to lock autofocus and autoexposure together and to keep them locked as long as you keep your finger on the button. But you can also set things up so that the button locks exposure only or focus only.

Change the AE-L/AF-L button behavior by choosing Buttons from the Setup menu (refer to the left screen in Figure 12-11), and then selecting Assign AE-L/AF-L Button, as shown on the left in Figure 12-13. Press OK to display the available set-tings, shown on the right.

Buttons			► 10	Butte Assig	ons In AE-L/AF-L button
Assign Fn button	ISO		Y	Ê	AE/AF lock
Assign AE-L/AF-L button	â	•		Â	AE lock only
Shutter-release button AE-L	OFF			A O	AE lock (Hold)
AF activation	ON			AF	AF lock only
				AF-ON	AF-ON
			?	11000000000000000000000000000000000000	

The options produce these results:

- AE/AF Lock: This is the default setting. Focus and exposure remain locked as long as you press the button.
- AE Lock Only: Autoexposure is locked as long as you press the button; autofocus isn't affected. (You lock focus by pressing the shutter button halfway.)
- AE Lock (Hold): A single press of the button locks exposure only. Exposure lock remains in force until you press the button again or the Standby Timer delay time expires. (See the earlier section "Adjusting Automatic Shutdown Timing" for details on the Standby Timer option.)
- AF Lock Only: Focus remains locked as long as you press the button. Exposure isn't affected.
- AF-ON: Pressing the button activates the camera's autofocus mechanism. Whether focus is locked or continuously adjusted depends on the Focus mode setting, which I cover in Chapter 5. If you use the AE-L/AF-L button to set focus, pressing the shutter button activates exposure metering only.

The information that I give in this book with regard to using autofocus and autoexposure assumes that you stick with the default setting. So if you change the button's function, remember to amend my instructions accordingly.

Using the Shutter Button to Lock Exposure and Focus (or Not)

You also can customize the behavior of the shutter button as far as the button's impact on the autofocus and autoexposure systems. Again, start by opening the Setup menu and choosing the Buttons option. On the next screen, shown in

Figure 12–14, the last two settings relate to the shutter button. Here's what you need to know about each setting:

>> Shutter-release Button AE-L: This

option determines whether pressing the shutter button halfway locks focus only or locks both focus and exposure. (AE-L stands for *autoexposure lock*.) At the default setting, Off, you lock focus only when you press the shutter button halfway. Exposure is adjusted continually up to the time you take the shot. If you change setting to On, your half-

FIGURE 12-14:

The final two settings on the Buttons option list affect the shutter button's role in setting focus and exposure.

press of the shutter button locks both focus and exposure.

AF Activation: At the default setting, On, pressing the shutter button halfway initiates autofocusing. If you change the setting to Off, pressing the shutter button halfway fires up the autoexposure system only.

As with the AE-L/AF-L button adjustment described in the preceding section, I recommend that you leave both options set to their defaults while you're working with this book. Otherwise, your camera won't behave as described here (or in the camera manual, for that matter).

Appendix

Intro to Nikon SnapBridge

our D3400 enables you to use *Bluetooth*, a wireless connection technology, to connect your camera to a smartphone, tablet, or other "smart" device. To enjoy this function, you must install the Nikon SnapBridge app on your smart device.

The app is free, but is available only for devices that run Android or Apple iOS. (Visit Google Play for Android apps; go the App Store for iOS apps.) The app also requires a fairly recent version of these operating systems. Specifically, you need

- >> Android: Android OS 5.0 or higher
- >> Apple: iOS 8.4 or later

Your smart device also must offer Bluetooth low-energy (BLE), a special Bluetooth feature that minimizes the battery power required to handle wireless data transmission. (Look for Bluetooth version 4.0 or later.)

You typically can find the version of Bluetooth and the operating system your device runs by digging through the options that appear when you tap the Settings icon on the device.

I can't provide detailed instructions for installing and using SnapBridge because things vary depending on your device and its operating system. In addition, when Nikon issues updates to the app — which it is likely to do as it introduces new cameras that offer SnapBridge support — some aspects of the app itself may change. As I write this, the most current versions of the SnapBridge app are 1.0.2.3002 for Android and Version 1.0.2.3003 for iOS.

That said, this appendix provides you with some general guidance, starting with an overview of what SnapBridge brings to the photography table.

What Can I Do with SnapBridge?

Visit the Nikon website devoted to SnapBridge (snapbridge.nikon.com), and you find a splashy home page touting the benefits of the app. What's not immediately clear is that which SnapBridge features you can enjoy depends on your camera. For example, with some cameras, you can use SnapBridge to trigger the camera's shutter button, giving you an alternative to buying a wireless remote control. Sadly, this very useful function does not work with the D3400.

So what SnapBridge functions does the D3400 support? Here's the rundown:

>> Transfer photos from your camera to your smart device. After transferring photos, you can view them on the device or use the device's Wi-Fi or cellular Internet connection to upload them to Facebook and other favorite social media sites. You can also email your photos through your device's email program.

On this point, I must emphasize the word "*photos*." You can't use SnapBridge and the Bluetooth functionality to transfer movies that you record with the D3400. Additionally, you can't transfer pictures captured in the Raw format; the app works with JPEG pictures only.

>> Transfer either full-resolution or reduced-resolution versions of your photos. The low-resolution versions, which are 2MP (megapixel) files, take up less storage space on your device and are sized appropriately for online use. But if your device can accept removable storage cards or has oodles of built-in storage space, you can gain extra security by backing up original-resolution versions to the device.

In either case, the camera sends copies of your images; your originals remain on the camera memory card.

- REMEMBER
- Ship transferred photos to Nikon Image Space. Your D3400 purchase entitles you to a free account at Nikon Image Space, an online photo storage and sharing site. After registering for an account at the site (www. Nikonimagespace.com), you can use SnapBridge to upload transferred photos to your Image Space gallery.
- Tag photos with location data. You can embed the GPS (global positioning satellite) data provided by the device into the hidden photo data (metadata) stored in your picture files. You can view the data in some camera playback modes (see Chapter 9) and in photo programs and apps that can read the data.
- Automatically synchronize the camera's date and time with that provided by the smart device. This saves you the trouble of having to check the Date and Time option on the camera's Setup menu. Of course, the synchronization happens only when the device is connected to your camera.

You don't need to rely on SnapBridge to embed such data in your photo files; you also can use options on the camera's Setup menu to tag files with comments and copyright notices. See Chapter 12 to find out how.

Getting Familiar with the SnapBridge App

The first time you open SnapBridge, you may be presented with some preliminary screens introducing you to the app features and asking your permission for the app to access your device's photo gallery and location services data. Eventually, though, you should get to a screen that looks something like what you see in Figures A-1 and A-2, which show the iOS and Android versions of the app, respectively.

As you do with most apps, you access features by tapping various onscreen symbols or options. I labeled the three most critical icons in the figures, which you tap to access the following functions:

- Connect: Tap this icon to access the screen shown in Figures A-1 and A-2. The most critical setting here is the Auto Download option. Tap that option to display a screen where you can specify the following transfer options:
 - Auto download enable/disable: Turn the option on if you want photos to be transferred automatically whenever you connect the camera to your device.
 Which photos are sent depends on a menu option you choose on the camera, as outlined in the next section.

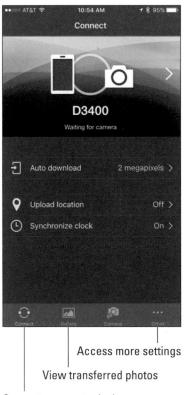

Connect camera to device

FIGURE A-1:

Here's a look at the iOS version of the SnapBridge app.

Connect camera to device

	Gallery (view transferred photos)	
	Other (access more settir	igs)
* Cor	* \$ 92%∎ nn≱ct ⊖ // // // // // // // // // // // // //	:33 PN
		⇔
	D3400 Waiting for camera	
Ð	Auto download 2 mgap kels	
•	Upload location Off	
٩	Synchronize clock on	

FIGURE A-2: And this is the Anrdoid version.

- Download size: You can specify whether you want to transfer photos from the camera at their original size or a more online-friendly, 2MP (megapixel) copy.
- *Nikon Image Space:* You also can enable or disable automatic upload to your Nikon Image Space account on this screen.
- Gallery: Tap the Gallery icon to view thumbnails of images that you've transferred to your device.
- Other: Tap this icon to display the screen shown on the left in Figure A-3. The two most useful features accessed via this screen are the following:
 - *Add credits:* Choose this option to access the features that enable you to embed copyright data and other information into your picture files.

FIGURE A-3: Tap the Other icon to display the options shown on the left; tap Info/Settings to uncover some buried but important app features, shown on the right.

	22 PM	1 ∦ 92% ■	•••••• AT&T 穼	12:58 PM	1 🕴 73% 🎫 🗈
0	ther		〈 Other	Info/settings	
—			INFO		
Add credits		Off >	App version		1.0.2.3003
Credits can automatically pictures.	be added to down	nloaded	About (view	EULA)	· · · ·
			Instructions		>
Nikon ID sign u	p/edit profile	```	Support		>
Notices from N	ikon	>			
APP Nikon App		>	OPTIONS Connected c	amera	>
Tutorial		>	Auto downlo	ad	>
(i) Info/settings		>	Upload locat	ion	>
			Synchronize	clock	>
•	ক্র				

 Info/settings: Tap this option to display the screen shown on the right in Figure A-3. From this screen, tap Instructions to launch the web browser on your device and access the SnapBridge Help site, as shown in Figure A-4.

What about that Camera icon found between the Other and Gallery icons? Sorry, that one accesses the features that enable you to use your smart device as a camera remote control, an option that the D3400 doesn't support.

Because the Help site information is very thorough, I won't waste any more space in this book explaining the myriad SnapBridge features. However, I do want to explain the SnapBridge-related menu options on your D3400, which also affect how your camera and smart device interact. The next section has that information.

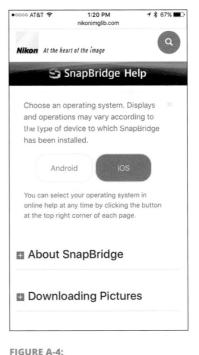

On the Info/Settings screen, tap Instructions to quickly access an online Help site devoted to SnapBridge.

Understanding SnapBridge-Related Camera Options

Figure A-5 shows the fourth page of the D3400 Setup menu, where you find all the camera-based options related to using SnapBridge. (Some options don't become available until after you connect your camera to your device for the first time.)

Here's what each option does:

Location data: Enable this option if you want the SnapBridge app to tag photos with your current location. The app uses the location-data service of your smart device. To start

	SETUP MENU	
	Location data	
• 9	Airplane mode	0FF
I	Connect to smart device	
é	Send to smart device (auto)	ON
	Bluetooth	ON
	Conformity marking	
	Slot empty release lock	LOCK
	Reset all settings	

FIGURE A-5:

These Setup menu options provide ways to customize the camera's interaction with your device.

tagging photos, you must first connect the camera to the device. Location data is then added to any pictures you take within 2 hours.

Airplane mode: By default, the camera broadcasts a Bluetooth signal at all times. If you're on a plane that doesn't allow Bluetooth transmissions or you need to disable the feature for other reasons, set this option to On.

Because the camera uses low-energy Bluetooth, you don't have to worry about the signal draining too much power from your camera battery. Still, if you're running short on battery juice, it makes sense to turn on Airplane mode.

Turning on Airplane mode also shuts down the wireless transmission feature used by Eye-Fi memory cards.

- Connect to smart device: Choose this setting to start the process of connecting your camera to your phone or tablet. Follow the instructions that appear on the camera monitor and found in the online SnapBridge Help site to complete the connection.
- Send to Smart Device (Auto): Select On if you want the camera to automatically send all new photos you shoot to your smart device. Turn this feature off if you prefer to select specific pictures to send to the device.

To tag specific pictures for transfer, open the Playback menu and choose Select to Send to Smart Device. On the next screen, shown in Figure A-6, you see two options: Select Image(s) and Deselect All. Choose Select Images to view photo thumbnails. Use the Multi Selector to move the yellow selection box over a photo you want to transfer and then press the Zoom Out button to apply the Send to Smart Device tag, labeled in the figure. To remove the tag, press the button again. Or, to remove all tags, choose Deselect All from the screen shown on the left in Figure A-6.

Alternatively, put the camera in Playback mode, display a photo you want to tag for transfer, press the *i* button, and choose Select to Send to Smart Device/Deselect. The transfer symbol appears on the photo. To remove it, repeat the process.

Either way, the next time you initiate a transfer of photos to your smart device, only selected photos are sent.

Bluetooth: Choose this option to turn Bluetooth functionality on or off, to see a list of devices currently paired with the camera, and to choose whether you want the connection to remain on even after you turn off the camera. (By default, transmission of photos does take place when the camera is off or has gone into sleep mode.)

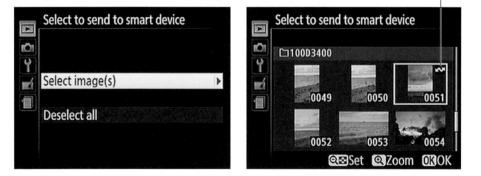

FIGURE A-6: Instead of sending all photos to your device automatically, you can use this Playback menu option to select only your favorites for transfer.

Again, for complete details about these and other aspects of using the Bluetooth and SnapBridge features, visit the SnapBridge Help site, as covered in the preceding section. The camera instruction manual, which you can download from the Nikon support pages for the D3400, also has basic information about the camera menu options. Be sure to download the full manual, named *Reference Manual*. The document named *User's Manual* is an abbreviated version of that manual.

Send to Smart Device tag

Glossary of Digital Photography Terms

Turn here for a quick refresher on that digital photography term that's stuck somewhere in the dark recesses of your brain and refuses to come out and play. For more information about a topic, check the book's index.

24-bit image: An image containing approximately 16.7 million colors.

Adobe RGB: One of two color space options available on your camera; determines the spectrum of colors that can be contained in the image. Adobe RGB includes more colors than the default option, sRGB, but also involves some complications that make it a better choice for advanced photographers than beginners.

AEB: *Auto Exposure Bracketing,* a feature that automatically records multiple exposures using different exposure settings.

AE lock: A way to prevent the camera's autoexposure (AE) system from changing the current exposure settings if you reframe the picture or the lighting changes before the image is recorded.

aperture: One of three critical exposure controls; an opening in an adjustable diaphragm in the camera lens. The size of the opening is measured in f-stops (f/2.8, f/8, and so on), with a smaller number resulting in a larger aperture opening. Aperture also affects depth of field (the distance over which focus remains acceptably sharp).

aperture-priority autoexposure: A semiautomatic exposure mode, represented by the A on the Mode dial. The photographer sets the aperture and the camera selects the appropriate shutter speed to produce a good exposure at the current ISO (light-sensitivity) setting.

autoexposure: A feature that puts the camera in control of choosing the proper exposure settings.

bit: Stands for binary digit; the basic unit of digital information. Eight bits equals one byte.

bit depth: Refers to the number of bits available to store color information. More bits means more data.

bulb mode: A shutter speed setting that keeps the shutter open as long as you hold down the shutter button. Available only in the M (manual) exposure mode.

burst mode: Another name for the Continuous shooting Release mode settings, which record several images in rapid succession with one press of the shutter button.

byte: Eight bits. See also bit.

Camera Raw: A file format that records the photo without applying any of the in-camera processing or file compression that is usually done automatically when saving photos in the other standard format, JPEG. Also known as *Raw*. Indicated by the file extension .NEF on Nikon cameras.

color model: A way of defining colors. In the RGB color model, for example, all colors are created by blending red, green, and blue light.

color space: A specific spectrum of colors that can be rendered by a camera or other digital device. *See also* sRGB and Adobe RGB.

color temperature: Refers to the color cast emitted by a light source; measured on the Kelvin scale.

compression: A process that reduces the size of the image file by eliminating some image data.

contrast: The amount of difference between the brightest and darkest values in an image. High-contrast images contain both very dark and very bright areas.

crop: To trim away unwanted areas around the perimeter of a photo, typically done in a photo-editing program.

depth of field: The distance from the subject over which focus appears acceptably sharp. With shallow depth of field, the subject is sharp but distant objects are not; with large depth of field, both the subject and distant objects are in focus. Manipulated by adjusting the aperture, lens focal length, or camera-to-subject distance.

diopter adjustment control: The wheel next to the viewfinder that enables you to adjust the viewfinder to your eyesight.

downloading: Transferring data from your camera to a computer.

dpi: Short for *dots per inch.* A measurement of how many dots of color a printer can create per linear inch. Higher dpi means better print quality on some types of printers; on other printers, dpi is not as crucial.

DPOF: Stands for *digital print order format*. A feature that enables you to add print instructions to the image file and then print directly from the memory card. Requires a DPOF-capable printer.

dSLR: Stands for *digital single-lens reflex;* one type of digital camera that accepts interchangeable lenses. **dynamic range:** The overall range of brightness values in a photo, from black to white. Also refers to the range of brightness values that a camera, scanner, or other digital device can record or reproduce.

edges: Areas where neighboring image pixels are significantly different in color; in other words, areas of high contrast.

EV compensation: A control that slightly increases or decreases the exposure chosen by the camera's autoexposure mechanism. EV stands for *exposure value;* EV settings appear as EV 1.0, EV 0.0, EV–1.0, and so on.

EXIF metadata: See metadata.

exposure: The overall brightness and contrast of a photograph, determined mainly by three settings: aperture, shutter speed, and ISO.

exposure compensation: Another name for EV compensation.

file format: A way of storing image data in a digital file; your camera offers two formats, JPEG and Camera Raw (NEF).

fill flash: Using a flash to fill in darker areas of an image, such as shadows cast on subjects' faces by bright overhead sunlight or backlighting.

firmware: The internal software that runs the camera's "brain." Nikon occasionally releases firmware updates that you should download and install in your camera (follow the instructions at the download site).

flash exposure (EV) compensation: A feature that enables the photographer to adjust the strength of the camera flash.

formatting: An in-camera process that wipes all data off the memory card and prepares the card for storing pictures.

frame rate: In a movie, the number of frames recorded per second (fps). A higher frame rate translates to crisper video quality.

f-number, **f-stop**: Refers to the size of the camera aperture opening. A higher number indicates a smaller aperture opening. Written as f/2, f/8, and so on. Affects both exposure and depth of field.

gamut: Say it *gamm-ut*. The range of colors that a monitor, printer, or other device can produce. Colors that a device can't create are said to be *out of gamut*.

gigabyte: Approximately 1,000 megabytes, or 1 billion bytes. In other words, a really big collection of bytes. Abbreviated as GB.

grayscale: An image consisting solely of shades of gray, from white to black. Often referred to generically as a *black-and-white image* (although, in the truest sense, an actual black-and-white image contains only black and white with no grays).

HDMI: Stands for *High-Definition Multimedia Interface.* A type of port for connecting your camera to a high-definition television.

HDR: Stands for *high dynamic range* and refers to a picture that's created by merging multiple exposures of the subject into one image using special computer software. The resulting picture contains a greater range of brightness values — a greater dynamic range — than can be captured in a single shot.

histogram: A graph that maps shadow, midtone, and highlight brightness values in a digital image; an exposure-monitoring tool that can be displayed during image playback.

hot shoe: The connection on top of the camera where you attach an auxiliary flash.

image sensor: The array of light-sensitive "buckets" (technically called *photosites*) in your camera that collect light corresponding to three primary wavelengths: red, green, and blue. The amount of light collected is converted into digital information.

ISO: Traditionally, a measure of film speed; the higher the number, the faster the film. On a digital camera, it means how sensitive the image sensor is to light. Raising the ISO allows faster shutter speed, smaller aperture, or both, but also can result in a noisy (grainy) image. Stands for *International Organization for Standardization*, the group that devised the ISO standards.

jaggies: Refers to the jagged, stairstepped appearance of curved and diagonal lines in low-resolution photos that are printed at large sizes.

JPEG: Pronounced *jay-peg.* The primary file format used by digital cameras; also the leading format for online and web pictures. Uses *lossy compression*, which eliminates some data in order to reduce file size. A small amount of compression does little discernible damage, but a high amount destroys picture quality. Stands for *Joint Photographic Experts Group*, the group that developed the format.

JPEG artifact: A defect created by too much JPEG compression.

Kelvin: A scale for measuring the color temperature of light. Sometimes abbreviated as *K*, as in 5000K. (Note that in computer-speak, the initial *K* more often refers to kilobytes, as described next.)

kilobyte: One thousand bytes. Abbreviated as *K*, as in 64K.

Live View: The feature that enables you to use the camera monitor instead of the view-finder to compose your shots.

lossless compression: A file-compression scheme that doesn't sacrifice any vital image data in the compression process, used by file formats such as TIFF. Lossless compression tosses only redundant data, so image quality is unaffected.

lossy compression: A compression scheme that eliminates important image data in the name of achieving smaller file sizes, used by file formats such as JPEG. High amounts of lossy compression reduce image quality.

manual exposure mode: An exposure mode that enables you to control both aperture and shutter speed; enable it by setting the Mode dial to M.

manual focus: A setting that turns off autofocus and instead enables you to set focus by rotating the focusing ring on the lens.

megabyte: One million bytes. Abbreviated as MB. See also bit.

megapixel: One million pixels; used to describe the resolution offered by a digital camera.

metadata: Extra data that gets stored along with the primary image data in an image file. Metadata often includes information such as aperture, shutter speed, and EV compensation setting used to capture the picture, and can be viewed using special software. Often referred to as *EXIF metadata*; EXIF stands for *Exchangeable Image File Format*.

metering mode: Refers to the way a camera's autoexposure mechanism reads the light in a scene. Modes available on your camera include *spot*, which bases exposure on a small area at the center of the frame; *center-weighted*, which reads the entire scene but gives more emphasis to the subject in the center of the frame; and *matrix*, which calculates exposure based on the entire frame.

monopod: A telescoping, single-legged pole on which you can mount a camera and lens in order to hold it more stably while shooting. It will not stand on its own, unlike a tripod.

NEF: The acronym used for the Nikon Camera Raw format; stands for *Nikon Electronic Format*.

noise: Graininess in an image, caused by a very long exposure, a too-high ISO setting, or both.

NTSC: A video format used by televisions, DVD players, and VCRs in North America, Mexico, and some parts of Asia (such as Japan, Taiwan, South Korea, and the Philippines). Many digital cameras can send picture signals to a TV, DVD player, or VCR in this format.

PAL: The video format common in Europe, China, Australia, Brazil, and

PictBridge: A feature that enables you to connect your camera to a PictBridge-enabled printer for direct printing.

Picture Control: Setting designed to render images using different color, sharpness, and contrast characteristics.

pixel: Short for *picture element*. The basic building block of every image.

pixelation: A defect that occurs when an image has too few pixels for the size at which it is printed; pixels become so large that the image takes on a mosaic-like or stairstepped appearance.

platform: A fancy way of saying "type of computer operating system." Most folks work either on the Windows platform or the Macintosh platform.

ppi: Stands for *pixels per inch.* Used to state image output (print) resolution. Measured in terms of the number of pixels per linear inch. A higher ppi usually translates to better-looking printed images.

programmed autoexposure: A semiautomatic exposure mode, represented by the P on the Mode dial. The camera selects both f-stop and shutter speed, but you can select from different combinations of the two and access all other camera features.

Raw: See Camera Raw.

Raw converter: A software utility that translates Camera Raw files into a standard image format such as JPEG or TIFF. Nikon Capture NX2, available free from the Nikon web site, offers this tool.

red-eye: Light from a flash being reflected from a subject's retina, causing the pupil to appear red in photographs. Can sometimes be prevented by using the Red-Eye Reduction flash setting.

Release mode: The camera setting that determines when and how the shutter is released when you press the shutter button. Options include Single Frame, which records one picture for each press of the shutter button; Continuous mode, which records a burst of images as long as you hold down the shutter button; and Self-Timer mode, which delays the shutter release for a few seconds after you press the shutter button.

resampling: Adding or deleting image pixels. Adding a large amount of pixels degrades images.

resolution: A term used to describe the number of pixels in a digital image. Also a specification describing the rendering capabilities of scanners, printers, and monitors; means different things depending on the device.

RGB: The standard color model for digital images; all colors are created by mixing red, green, and blue light.

SD card: The type of memory card used by your camera; stands for Secure Digital.

SDHC card: A high-capacity form of the SD card; stands for *Secure Digital High Capacity* and refers to cards with capacities ranging from 4MB to 32MB.

SDXC card: Secure Digital Extended Capacity; used to indicate an SD memory card with a capacity greater than 32MB.

sharpening: Applying an image-correction filter to create the appearance of sharper focus.

shutter: A light-barrier inside the camera that opens when you press the shutter button, allowing light to strike the image sensor and expose the image.

shutter-priority autoexposure: A semiautomatic exposure mode in which the photographer sets the shutter speed and the camera selects the appropriate aperture. Select it by setting the Mode dial to S.

shutter speed: The length of time the shutter remains open; or, to put it another way, the duration of the image exposure. Most often measured in fractions of a second, as in 1/60 or 1/250 second.

slow-sync flash: A special flash setting that allows (or forces) a slower shutter speed than is typical for the normal flash setting. Results in a brighter background than normal flash.

sRGB: Stands for *standard RGB*, the default color space setting on your camera (and the one recommended for most users). Developed to create a standard color spectrum that (theoretically) all devices could capture or reproduce.

Stop: An increment of exposure adjustment. Increasing the exposure by one stop means to select exposure settings that double the light; decreasing by one stop means to cut the light in half.

TIFF: Pronounced *tiff,* as in a little quarrel. Stands for *tagged image file format.* A popular image format supported by most Macintosh and Windows programs. It is *lossless,* meaning that it retains image data in a way that maintains maximum image quality. Often used to save Raw files after processing.

tripod: Used to mount and stabilize a camera, preventing camera shake that can blur an image; characterized by three telescoping legs.

UHS: A classification assigned to some SD memory cards; stands for *Ultra High Speed*. Specific speeds including UHS-1, -2, and -3, with a higher number offering faster performance.

USB: Stands for *Universal Serial Bus.* A type of port for connecting your camera to your computer. Your camera ships with the USB cable necessary for the connection.

Vibration Reduction: A feature designed to compensate for small amounts of camera shake, which can blur a photo. On the D3400, enabled for AF-P lenses via the Optical Vibration Reduction menu option.

white balance: Adjusting the camera to compensate for the color temperature of the lighting. Ensures accurate rendition of colors in digital photographs.

Index

A

A (aperture-priority autoexposure) mode Active D-Lighting setting, 119-122 aperture and shutter speed, adjusting, 110 close-up photos in, 184 depth of field, controlling, 152 exposure meter, 103-104 fill flash, 64 Flash Compensation, applying, 71–73 flash control, 63, 64 general discussion, 100-102 landscape photography in, 181 manually controlling flash output, 73-74 overview, 45 portraits, shooting in, 173 Slow-rear flash, 67 Slow-Sync flash, 66 Slow-sync with Red-Eye Reduction flash mode, 67 AC adapter, 18 action photography AF-C and Dynamic Area combination for, 134, 135-137 AF-C mode, using with, 129 Live View settings for, 145 shooting techniques, 178-180 Active D-Lighting Function button settings, 304 general discussion, 119-122 landscape photography, using in, 182 Adobe RGB color space, 163 advanced exposure modes, 100-102 AE Lock (autoexposure lock), 14, 124, 205 AE-L/AF-L button customizing, 304-305 locking focus with, 137 overview, 14 protecting files, 246, 247 AF-A (auto-servo autofocus) mode, 76, 129 AF-area mode. See also Dynamic Area mode

action photography in, 180 effect on exposure, 106 Live View photography in, 143-145 for manual focusing, 149 overview, 128 Single Point mode, 130, 133, 134-135, 136 viewfinder photography in, 130-137 AF-assist lamp, 13, 300 AF-C (continuous-servo autofocus) mode, 129, 135-137, 180 AF-F (full-time servo AF) mode, 142, 145, 148, 189 AF-L (autofocus lock), 14 AF-P lens choosing automatic or manual focusing, 126-127 features on, 30 overview, 8 switching from automatic to manual focusing, 31-32 Vibration Reduction, enabling, 32-33 AF-S (single-servo autofocus) mode Live View photography in, 145, 148 movie shooting in, 190 overview, 129, 142 still subjects, using for, 134-135 AF-S lens choosing automatic or manual focusing, 126-127 overview, 8 switching from automatic to manual focusing, 32 Vibration Reduction, enabling, 33 Airplane mode, 39, 312 all-purpose picture-taking settings, 171-172 aperture adjusting, 108-111 depth of field, 94-95, 150 exposure settings, 99-100 general discussion, 92-93 movie shooting, 204 aperture-priority autoexposure (A) mode Active D-Lighting setting, 119-122

aperture-priority autoexposure (A) mode (continued) aperture and shutter speed, adjusting, 110 close-up photos in, 184 depth of field, controlling, 152 exposure meter, 103-104 fill flash, 64 Flash Compensation, applying, 71–73 flash control, 63, 64 general discussion, 100-102 landscape photography in, 181 manually controlling flash output, 73-74 overview, 45 portraits, shooting in, 173 Slow-rear flash, 67 Slow-Sync flash, 66 Slow-sync with Red-Eye Reduction flash mode, 67 artifacting, JPEG, 57, 58 assembling parts of camera, 7-11 attaching lenses, 8 audio microphone, 16, 17, 198 Microphone setting, 197-200 recording on separate device, 189 speaker, 13, 198 volume control, 197-200, 207, 236 Auto Area mode, 131 Auto Distortion Control option, 277 Auto exposure mode, 44 Auto Flash mode, 64 Auto Flash Off mode Live View photography in, 79-81 overview, 44, 63, 75-76 viewfinder photography in, 76–79 Auto Image Rotation option, 218 Auto Info Display option, 303 Auto ISO override, disabling, 113 Auto mode Live View photography in, 79-81 overview, 75-76 viewfinder photography in, 76-79 Auto Sensitivity setting, 198 Auto White Balance setting, 154-155 autoexposure lock (AE Lock), 14, 124, 205

autofocus lock (AF-L), 14 autofocusing for action photography, 180 AF-area mode, choosing, 130-133, 143-145 in Auto mode, 76-78 in Close Up mode, 88 combination of settings for, 134, 145-146 Focus mode, choosing, 129-130, 142-143 locking focus during continuous, 137 manual focusing versus, 126-127 movie shooting, 188-190 with moving subjects, 135-137 in Scene modes, 82 setting, 31-32, 146-148 shutter release, problems with, 79 in Sports mode, 86 with still subjects, 134-135 automatic exposure modes, 44–45 automatic rotation, enabling, 217-218 automatic shutoff timing, adjusting, 216, 300-301 auto-servo autofocus (AF-A) mode, 76, 129

В

back-of-the-body controls, 14-16 backup files, 255 banding, 59 barrel distortion, correcting, 140, 277-278 basic picture settings, 171-172 batches of selected files, deleting, 243-245 battery status indicator, 26, 27 beep options, 38 bit depth, 59 bit rate, 195 blown highlights, 227, 229 Bluetooth. See also SnapBridge app Airplane mode, 39, 312 overview, 19, 251 turning on/off, 39, 313 version of, finding, 307 Bluetooth symbol, 26, 28 blur from camera shake, 96, 97, 181-182 overview, 137

waterfall shots, 182 bounced flash, 177, 178 bracketing, 183–184 brightness, monitor, 37 Brightness histogram, 228, 229, 232 buffer, memory, 27, 49 Bulb mode, 183 burst mode shooting mode, 49, 85, 180 Buttons option, 303–306 buying SD cards, 35

С

Calendar view deleting photos in, 245 playback in, 220-221, 243 protecting files in, 246 camera features back-of-the-body controls, 14-16 connection ports, 17-19 control strip, adjusting settings via, 28-29 critical picture settings, viewing, 25-28 front-left features, 16-17 Live View mode, 23-25 menus, 19-23 overview, 11 topside controls, 12-13 camera shake, 96, 97, 181-182 camera-to-subject distance, 151 Capture NX-D software, Nikon, 249, 261-264 card readers, using, 17, 250-251, 252-253 card stock, setting white balance with, 159-161 Center-weighted metering mode, 105, 107 channels, 59 Child mode, 84-85 close-ups Close Up mode, 87-88 shooting, 184-185 cloud storage, 55 Cloudy White Balance setting, 156 color. See also white balance color space, choosing, 163-164, 260 effect of flash in outdoor photography, 70 Filter Effects, 281

overview, 153 Picture Controls, 164-169 Pop effect, 290 Quick Retouch filter, 280-281 Selective Color effect, 291-292 Selective Color filter, 287-288 Super Vivid effect, 290 viewing settings in Overview display mode, 233 color channel, 230 Color Outline filter, 285 Color Sketch filter, 285 color space, 163-164, 260 color temperature, 154 combining two photos, 293-294 Command dial, 14, 15, 69 comments, adding to images, 231, 232, 295-297 composition, 174, 180 compression, lossy, 57 computer, downloading files to drag-and-drop file transfer, 257 overview, 250 starting file-transfer process, 252-253 using Nikon Transfer 2, 253-257 via USB, 251-252 Conformity marking, 39 Connect icon, SnapBridge app, 309-310 connection port door, 16, 17 connection ports, 17-19 Continuous (burst mode) shooting mode, 49, 85, 180 continuous autofocusing, locking focus during, 137 continuous-servo autofocus (AF-C) mode, 129, 135-137, 180 control strip. See also Focus mode adjusting settings via, 28-29, 61 AF-area mode, setting, 132, 144 Exposure Compensation, setting, 118 Flash Compensation, setting, 73 ISO, setting, 112 Metering mode, setting, 106, 107 Microphone setting, 199, 200 movie settings, 196 Picture Controls, setting, 167 White Balance, setting, 156, 157 Wind Noise Reduction, setting, 201

convergence, 278 cool light, 154 copyright notice, adding, 297–298 cover, viewfinder, 24, 49 critical picture settings, viewing, 25–28 crop factor, 34 cropping in–camera, 223 in Nikon Capture NX–D, 263 with Trim option, 282–284 Cross Screen filter, 284 custom image folders, creating, 298–300

D

date date stamp, 37 deleting photos by, 245 setting, 9 synchronizing with SnapBridge app, 308 viewing, 226 default settings restoring, 40-41 shooting movies using, 188-193 Delayed Remote Release mode, 51 Delete button, 14, 16 deleting files after transfer, 256 all files, 243 in batches, 243-245 one by one, 242-243 overview, 242 in playback mode, 215 Protect feature, using, 246 depth of field aperture, 94-95 close-up photos, 184 landscape photography, 84, 181 manipulating, 149-152 overview, 125 for portraits, 100 diffuser, flash, 177 diopters, 185

direct measurement, setting white balance with, 159-161 Direct sunlight White Balance setting, 156 display modes File Information, 223, 224–227 Highlights, 223, 227-228 Overview, 223, 232-233 RGB Histogram, 223, 228-230 Shooting Data, 223, 231 distortion Auto Distortion Control option, 277 barrel, 140, 277-278 Distortion Control filter, 140, 277-278 pincushion, 140, 277-278 Distortion Control filter, 140, 277-278 D-Lighting filter, 121-122, 261, 279-280 downloading files to computer drag-and-drop file transfer, 257 overview, 250 starting file-transfer process, 252-253 using Nikon Transfer 2, 253–257 via USB, 251-252 downsampling, 267 drag-and-drop file transfer, 257 dust filters, 38 Dynamic Area mode for action photography, 135-137, 180 focus point, setting, 86, 133 overview, 131

Ε

Edit Movie screen, 208, 210 Edit panel, Nikon Capture NX–D, 262–263 editing photos combining two photos, 293–294 cropping, 282–284 effects, applying, 284–288 exposure and color, adjusting, 279–282 filters, applying, 272–275 lens distortion, correcting, 277–278 overview, 271 perspective, correcting, 278–279

red-eye, removing, 275 straightening, 275-276 Effects mode flash modes, changing, 63, 293 general discussion, 288-289 overview, 46 types of effects, 290-292 email, sending photos by, 264-267 erasing files after transfer, 256 all files, 243 in batches, 243-245 one by one, 242-243 overview, 242 in playback mode, 215 Protect feature, using, 246 EV (exposure value), 71, 116 exiting playback, 206 slide shows, 235 exposure. See also aperture; Exposure Compensation; ISO Active D-Lighting, 119-122, 182, 304 advanced modes, 100-102 autoexposure lock, 124 balancing act, 99-100 bracketing, 183-184 D-Lighting filter, 279-280 landscape photography, 181 meter, 102-105 Metering modes, 105-108 movie shooting, 202, 203-205 overview, 91-94 Overview display mode, viewing settings in, 232-233 shutter speed, 96, 108-111 vignetting, eliminating, 122-123 Exposure Compensation applying, 115-119 exposure meter, 104 movie shooting, 204-205 Raw conversion, 260 Exposure Compensation button, 12, 13, 16 exposure meter, 102-105

exposure mode. See also specific modes by name choosing with Mode dial, 12-13 flash options dependent on, 62-63 fully automatic, 44-45 manual, 46 movie shooting, 201 semiautomatic, 45 specialty, 46 exposure value (EV), 71, 116 extending lenses, 8-9, 10, 30 external card readers, 250 external controls back-of-the-body controls, 14-16 connection ports, 17-19 front-left features, 16-17 overview, 11 topside controls, 12-13 external flashes, 177, 178 Eye-Fi memory cards, 36-37, 251

F

Face Priority AF-area mode general discussion, 146-147 Live View photography, 80, 81 movie shooting, 191 overview, 144 Portrait mode, 83 Face Zoom option, 222-223 fast-forwarding movies, 206 file format. See image quality; specific formats by name File Information display mode, 223, 224-227 file size, 55 files. See also deleting files; downloading files to computer; processing Raw files filenames, 225-226 Nikon photo software, 247-249 number sequence, 38-39 overview, 239-240 preparing for online sharing, 264-267 protecting, 246-247 rating, 227, 240-241 transfer process, 252-253

Fill Flash mode 64 Filter Effects, 281 filters. Retouch menu Color Outline, 285 Color Sketch, 285 Cross Screen, 284 Distortion Control, 277-278 D-Lighting, 279-280 Filter Effects, 281 Fisheye, 277, 278 Miniature Effect, 285-287 Monochrome, 281-282 Perspective Control, 278-279 Photo Illustration, 285 Ouick Retouch, 280-281 Red-Eve Correction, 275 Selective Color, 287-288 Soft. 285 Straighten, 275-276 firmware version, 39, 40 Fisheve filter, 277, 278 FL (Flat) Picture Control, 165, 166 flash. See also Flash mode for action photography, 179 adjusting output, 70-74 for close-up photos, 185 diffuser, 177 disabled by Continuous shooting mode, 49 enabling and disabling, 63-64 external, 177, 178 for indoor photography, 174, 175-176 for outdoor photography, 70, 174-175 Scene modes, 83 shutter speed and timing of, 68, 70 Flash button, 16, 62-63 Flash Cntrl for Built-in Flash option, 73-74 Flash Compensation, applying, 71–73 flash hot shoe. 13, 63 Flash mode adjusting, 16 options, 64-67 overview, 64 setting, 67-70

Flash Off mode, 64 flash output, 70-74 Flash White Balance setting, 156 Flat (FL) Picture Control, 165, 166 flower close-ups, 184-185 Fluorescent White Balance setting, 156, 157, 158 Fn (Function) button, 16, 17, 112, 303-304 focal length, 34, 150-151, 173 focal-length indicator, 13, 30, 31 focus frame in Live View display, 146 focus method, setting, 31-32 Focus mode. See also AF-S for action photography, 180 AF-C, 129, 135-137, 180 for Live View photography, 142–143, 145 movie shooting, 188-190 overview, 128 for viewfinder photography, 129-130 focus points choosing, 133, 134, 138 viewing in Nikon ViewNX-i software, 248 focusing. See also autofocusing in Live View photography, 149 manual, choosing between automatic and, 126-127 in movie shooting, 149 overview, 125-126 rangefinder, 138-139 in viewfinder photography, 137-140 folders choosing for playback, 215–216 custom, creating, 298-300 deleting photos in, 243 File Information display mode, 225 force flash, 64 formatting SD cards, 35-36, 246 Frame Number/Number Frames, 224 frame rates, 194 Frame Size/Frame Rate setting, 193–194, 197 frames, movie advancing by in playback, 207 saving as still image, 210 trimming, 207-209

framing grid, showing, 24 front-curtain sync, 66 front-left features, 16-17 f-stop depth of field, 94-95, 150 movie shooting, 204 overview, 93 for portraits, 173 Full HD, 194 full-time servo AF (AF–F) mode, 142, 145, 148, 189 Function (Fn) button, 16, 17, 112, 303-304

G

Gallery icon, SnapBridge app, 309–310 graduated neutral-density filter, 182 Graphic display mode, 302 grid, displaying, 24, 191 Guide mode, 46 guided menus, 19–21

Η

handheld shutter speed, 97 handling SD cards, 36 HD video. *See* movies HDMI CEC compatibility, 236, 237 HDMI port, 17, 18, 237 help screens, displaying, 15, 29–30 help with Nikon software, 249 hidden image comments, adding, 231, 232, 295–297 High Key effect, 292 highlights, blown, 227, 229 Highlights display mode, 223, 227–228 histograms, 223, 232 hot shoe, 13, 63

i button, 15, 28 Image Comment feature, 231, 232, 295–296 Image Dust Off Ref Photo setting, 38 Image Overlay, 273, 293–294

image quality Function button settings, 304 guided menu settings, 20 IPEG, 57-58, 60 overview, 52 Raw (NEF), 58-60 Raw conversion, 260 setting, 60-62 viewing in File Information mode, 226 Image Review option, 216-217, 243 image sensor, 92 image size Function button settings, 304 guided menus, 20 Raw conversion, 260 resolution options, 52-56 setting, 60-62 viewing in File Information mode, 226 Image Space, Nikon, 308 in-camera Raw processing, 258-261 Incandescent White Balance setting, 156 indicators, showing, 23-24 indoor photography close-up photos, 185 portraits, 174, 175-176 Info button, 12, 23-24, 25 Information display Active D-Lighting setting, 120, 121 aperture and shutter speed, adjusting, 108-109 Auto Info Display setting, 303 autofocusing settings, 128 design and color scheme, customizing, 301-302 displaying, 28 Exposure Compensation setting, 117 exposure meter, 102-104 Flash Compensation symbol, 72 Flash mode, viewing, 67-69 general discussion, 25-26 ISO settings, 111 Metering mode, 105 White Balance setting, 155 Info/settings icon, SnapBridge app, 311 initial use, preparing camera for, 7-11

ISO

Auto ISO override, disabling, 113 controlling, 111–114 exposure balancing act, 99–100 Function button settings, 304 general discussion, 93–94 Maximum Sensitivity option, 113 Minimum Shutter Speed option, 113 movie shooting, 204 noise, 96–99 Raw conversion, 260 Scene modes, 82–83

J IPEG

artifacting, 57, 58 Basic setting, 58 converting Raw files to, in camera, 258–261 converting Raw files to, in Capture NX–D, 261–264 Fine setting, 58, 60 general discussion, 57–58 Normal setting, 58 preparing for online use, 264–267

Κ

key tones, 292 keystoning, 278

L

Landscape (LS) Picture Control, 165, 166 Landscape mode, 63, 84 language, setting, 9 Large setting, 53, 56, 62 lens attaching, 8 changing, 34 choosing automatic or manual focusing, 126–127 compatibility, 7–8 diopters, 185 extending, 8–9, 10, 30 focal length, 34, 150–151, 173

general discussion, 30-35 macro, 185 removing, 33-34 lens distortion, correcting, 140, 277-278 Lens Simulator tool, 34 lens-release button, 9, 16, 17 light fall-off, 122 lights, effect on Live View mode, 25 Live View display Active D-Lighting setting, 120, 121 aperture and shutter speed, adjusting, 108-109 control strip, adjusting settings via, 28-29 Exposure Compensation setting, 117 exposure meter, 102-105 Flash Compensation symbol, 72 Flash mode, viewing, 67-69 Info button function, 12 ISO settings, 111 movie settings, 195 overview, 26 White Balance setting, 155 Live View (LV) button, 14, 15, 23 Live View photography. See also movies AF-area mode, choosing, 143-145 in Auto Flash Off mode, 79-81 in Auto mode, 79-81 autofocus combination, choosing, 145-146 autofocusing, steps in setting, 146-148 in Close Up mode, 88 Focus mode, choosing, 142-143 manual focusing, 149 Metering mode, 105 Portrait mode, 83 switching to, 23 tips for using, 23-25 turning on, 15 location data, 231, 232, 308, 312 Lock Mirror Up for Cleaning setting, 37–38 locking focus during continuous autofocusing, 137 locking SD cards, 36 long lens, 34 lossy compression, 57 Low Key effect, 292

LS (Landscape) Picture Control, 165, 166 LV (Live View) button, 14, 15, 23

Μ

M (manual exposure mode) Active D-Lighting setting, 119-122 aperture and shutter speed, adjusting, 110 exposure meter, 102-104 fill flash, 64 Flash Compensation, applying, 71–73 flash control, 63, 64, 73-74 general discussion, 46, 100-102 Rear-Curtain Sync flash, 66 macro lens, 185 magic hours, 183 magnifying photos during playback, 15, 215, 221-223 main menus, 21-23 manual exposure mode (M) Active D-Lighting setting, 119-122 aperture and shutter speed, adjusting, 110 exposure meter, 102-104 fill flash, 64 Flash Compensation, applying, 71-73 flash control, 63, 64, 73-74 general discussion, 46, 100-102 Rear-Curtain Sync flash, 66 manual focus (MF) mode, 129, 137-138, 142 Manual Focus Ring in AF Mode option, 32 manual focusing choosing automatic or, 126-127 in Live View photography, 149 in movie shooting, 149 rangefinder, 138–139 setting, 31-32 in viewfinder photography, 79, 137-140 Manual Sensitivity setting, 198, 199, 200 manual-focus override, 126-127 manually controlling flash output, 73-74 matching white balance to existing photo, 161-162 Matrix metering mode, 105, 106, 107, 108, 203 maximum recording time for movies, 197 MC (Monochrome) Picture Control, 165

Medium setting, 53, 56 megapixels, 52 memory buffer, 27, 49 memory cards. See also downloading files to computer access light, 8, 10 buying, 35 card readers, using, 17, 250-251, 252-253 Eve-Fi, 36-37, 251 formatting, 35-36, 246 handling, 36 inserting, 8, 10 locking, 36 read/write speed, 35 removing, 36 types of, 8 working with, 35-37 memory-card access light, 8, 10 Menu button, 14, 15 menus date, setting, 9-10 guided, 19-21 language, setting, 9-10 main, 21-23 overview, 19 time, setting, 9-10 time zone, setting, 9-10 metadata, 10, 37, 248, 296 Metering mode Center-weighted, 105, 107 choosing, 105-108 Matrix, 105, 106, 107, 108, 203 overview, 104 Spot, 105-106, 107, 133 MF (manual focus) mode, 129, 137-138, 142 microphone, 16, 17, 198 Microphone setting, 197-200 midtones, 292 Miniature Effect filter, 285-287, 291 Mode dial, 12-13, 19-20 monitor brightness, 37 Monochrome (MC) Picture Control, 165 Monochrome filter, 281-282

motion blur, 96 mounting index, 8, 9 MOV format, 188 movie indicators, showing, 24 Movie Quality setting, 193-194, 195, 197 Movie-Record button, 12, 13 movies. See also downloading files to computer AF-area mode, choosing, 143-145 audio, controlling, 197-201 autofocus combination, choosing, 145-146 autofocusing, steps in setting, 146-148 deleting, 242-245 exposure, 203-205 Focus mode, choosing, 142-143 Frame Size/Frame Rate setting, 193–194, 197 grid, displaying, 191 hiding onscreen data, 191 manual focusing, 149 maximum recording time, 197 Movie Quality setting, 193-194, 195, 197 other recording options, 201-203 overview, 187-188 protecting, 246-247 rating, 240-241 saving frames as still images, 210 shooting using default settings, 188-193 stopping recording, 193 trimming, 207-209 video settings, adjusting, 193-197 viewing, 188, 205-207 moving subjects AF-C and Dynamic Area combination for, 134, 135-137 AF-C mode, using with, 129 Live View settings for, 145 shooting techniques, 178-180 Multi Selector/OK button, 14, 15-16

Ν

NEF (Nikon Electronic Format) file format general discussion, 58–60 preparing for online use, 264–267

processing, in camera, 258-261 processing, in Capture NX-D, 261-264 Neutral (NL) Picture Control, 164, 166 neutral density filter, 182 Night Portrait mode, 88 Night Vision Effects mode, 127, 290 nighttime city photos, 183 Nikon Electronic Format (NEF) file format general discussion, 58-60 preparing for online use, 264-267 processing, in camera, 258-261 processing, in Capture NX-D, 261-264 Nikon Image Space, 308 Nikon software. See also SnapBridge app Capture NX-D, 249, 261-264 help with, 249 Transfer 2, 253–257 ViewNX-i, 188, 247-249, 253 NL (Neutral) Picture Control, 164, 166 noise, 25, 96-99, 114 Noise Reduction filter, 114 Normal Area AF-area mode, 143, 146, 147 normal lens, 34

0

online photo sharing, 56, 264-267 On/Off switch, 12, 13 Optical VR feature, 182 orientation, automatic rotation of, 217-218 Other icon, SnapBridge app, 310-311 outdoor photography close-up photos, 185 flash with, 70 landscapes, 63, 84 nighttime city photos, 183 portraits, 174-175 sunrise/sunset photography, 182 waterfall shots, 182 output resolution, 236 Overview display mode, 223, 232-233

Ρ

P (programmed autoexposure) mode Active D-Lighting setting, 119-122 aperture and shutter speed, adjusting, 109 exposure meter, 103–104 fill flash, 64 Flash Compensation, applying, 71-73 flash control, 63, 64 general discussion, 100-102 manually controlling flash output, 73-74 overview, 45 Slow-Rear flash, 67 Slow-Sync flash, 66 Slow-sync with Red-Eye Reduction flash mode, 67 pausing playback, 206, 235 perspective, correcting, 278-279 Perspective Control filter, 278-279 Photo Illustration effect, 290-291 Photo Illustration filter, 285 photo indicators, showing, 23, 24 photos. See also deleting files; downloading files to computer comments, adding, 231, 232, 295-297 copyright notice, adding, 297-298 preparing for online sharing, 264-267 protecting, 246-247 rating, 227, 240-241 resizing, 265-267 transferring with SnapBridge app, 308 PictBridge, 17 **Picture Controls** customizing, 167-169 movie shooting, 202 Raw conversion, 260 types of, 164-167 pincushion distortion, correcting, 140, 277-278 pixel dimensions, 52 pixelation, 53, 54 pixels, 52, 53 playback. See also display modes automatic rotation, enabling, 217-218 in calendar view, 220-221 choosing images to view, 215-216

deleting photos, 215 general discussion, 213-215 magnifying photos during, 15, 215, 221-223 of movies, 205-207 rating photos and movies, 241-242 shutoff timing, adjusting, 216 slide shows, 234-236 on television, 236-237 thumbnails display, shifting to, 15, 219-220 timing, adjusting, 216-217 Playback button, 14, 15 Playback menu deleting photos, 243-244 navigating, 21-23 ratings, 240-241 Pop effect, 290 Portrait (PT) Picture Control, 165, 166 Portrait mode, 83-84 portraits depth of field, 100 Face Priority AF-area mode, 80, 81 Night Portrait mode, 88 Portrait mode, 83-84 shooting, 172-177 posterization, 59 preparing pictures for online sharing, 264-267 Preset White Balance setting, 156 presets, white balance, 157, 159-162 print size, 53-54 printing pictures overview, 17 print size, 53-54 and using online, 56 processing Raw (NEF) files in camera, 258-261 in Capture NX-D, 261-264 overview, 257-258 programmed autoexposure (P) mode Active D-Lighting setting, 119-122 aperture and shutter speed, adjusting, 109 exposure meter, 103-104 fill flash, 64 Flash Compensation, applying, 71–73

programmed autoexposure (P) mode *(continued)* flash control, 63, 64 general discussion, 100–102 manually controlling flash output, 73–74 overview, 45 Slow–Rear flash, 67 Slow–Sync flash, 66 Slow–sync with Red–Eye Reduction flash mode, 67 progressive video format, 195 Protected symbol, 226 protecting photos and movies, 14, 36, 240, 246–247 PT (Portrait) Picture Control, 165, 166

Q

Qual option, 196 Quick Response Remote Release mode, 51 Quick Retouch filter, 280–281 Quiet Shutter release mode, 48–49

R

rangefinder, 138-139 rating photos and movies, 227, 240-241 Raw converter, 59 Raw files general discussion, 58-60 overview, 257-258 preparing for online use, 264-267 processing, in camera, 258-261 processing, in Capture NX-D, 261-264 Raw+IPEG Fine option, 60 read/write speed, 35 Rear-Curtain Sync flash mode, 66 Recent Settings menu, 21-23 recording movies. See movies red-eye, removing, 65, 67, 275 Red-Eye Correction filter, 275 Red-Eye Reduction mode, 65, 67 reference card, setting white balance with, 159-161 release mode Continuous (burst mode), 49, 85, 180

overview, 47-48 Ouiet Shutter, 48-49 for Scene modes, 83 Self-Timer, 50-51 Single Frame, 48-49 wireless remote control modes, 51-52 Release Mode button, 14, 16 remote control, wireless, 18, 51-52 removing lens, 33-34 removing SD cards, 36 Reset all settings, 41 Reset setup options, 40 Reset shooting menu, 40, 41 resizing pictures, 265-267 resolution general discussion, 52-56 HD playback, 236 for movies, setting, 194 restoring default settings, 40-41 Retouch icon, guided menu, 20 Retouch menu. See also filters, Retouch menu cropping photos, 282-284 effects, applying, 284-288 exposure and color, adjusting, 279-282 Image Overlay, 293-294 lens distortion, correcting, 277-278 navigating, 21-23 NEF (RAW) Processing option, 258-260 overview, 271 perspective, correcting, 278-279 red-eye, removing, 275 resizing pictures, 265-267 Side-by-Side Comparison option, 274-275 straightening, 275-276 Retouch symbol, 226-227 retractable lenses, extending, 8-9, 10, 30 retractable-lens barrel button, 10, 30 rewinding movies, 206 RGB histogram, 223, 228-230 Rotate Tall option, 218 rotation, enabling automatic, 217-218

S

S (shutter-priority autoexposure) mode Active D-Lighting setting, 119-122 aperture and shutter speed, adjusting, 109 exposure meter, 103-104 fill flash, 64 Flash Compensation, applying, 71–73 flash control, 63, 64, 73-74 general discussion, 100-102 overview, 45 Rear-Curtain Sync flash, 66 saturation, 230 saving movie frames as still images, 210 Scene modes autofocusing, 82 automatic shifting to, 81 Child, 84-85 Close Up, 87-88 flash settings, 63, 83 ISO sensitivity, 82-83 Landscape, 84 Night Portrait, 88 overview, 44, 82-83 Portrait, 83-84 Sports, 63, 85-87 scenic vistas, shooting, 181-184 screen display size, 55 screening movies, 205-207 SD (Secure Digital) memory cards. See also downloading files to computer access light, 8, 10 buving, 35 card readers, using, 17, 250-251, 252-253 formatting, 35-36, 246 handling, 36 inserting, 8, 10 locking, 36 read/write speed, 35 removing, 36 types of, 8 SD (Standard) Picture Control, 164, 166 SD speed class, 35 SDHC memory card, 8, 35

SDXC memory card, 8, 35 Secure Digital (SD) memory cards. See also downloading files to computer access light, 8, 10 buying, 35 card readers, using, 17, 250-251, 252-253 formatting, 35-36, 246 handling, 36 inserting, 8, 10 locking, 36 read/write speed, 35 removing, 36 types of, 8 Selective Color effect, 291-292 Selective Color filter, 287-288 Self-Timer shooting mode, 50-51 semiautomatic exposure modes, 45 Send to Smart Device symbol, 227 Set Up icon, guided menu, 20 Setup menu Airplane mode, 39 Auto Info Display option, 303 Auto Off Timers option, 300-301 beep options, 38 Buttons option, 303-306 Conformity marking, 39 Copyright Information, 298 date stamp option, 37 File Number Sequence, 38-39 firmware version, 39, 40 Image Comment feature, 295–296 Image Dust Off Ref Photo, 38 Info Display Format, 302 Lock Mirror Up for Cleaning, 37-38 Manual Focus Ring in AF Mode option, 32 monitor brightness, 37 navigating, 21-23 rangefinder setting, 138-139 remote control duration, 51 Reset all settings, 41 Reset setup options, 40 Slot empty release lock, 39 Storage Folder, 299-300

setup of camera assembling parts, 7-11 customizing, 37-40 Shade White Balance setting, 156 sharing photos online, 56 sharpening, 164 Shoot icon, guided menu, 20 Shooting Data display mode, 223, 231 Shooting menu AF-area mode, setting, 132, 145 AF-assist lamp, turning off, 300 color space, changing, 163-164 Flash Cntrl for Built-in Flash option, 73-74 Focus mode, setting, 129, 130, 143, 190 image settings in, 62 ISO settings, 112-113 Metering mode settings, 106, 107 Movie settings, 193-195, 199, 201 navigating, 21-23 Picture Controls, setting, 167 Reset shooting menu, 40, 41 switching from automatic to manual focusing, 31 Vibration Reduction, enabling, 33 Vignette Control feature, 123 White Balance setting, adjusting, 156, 157 shots remaining, 26, 27 shutoff timing, adjusting, 216, 300-301 shutter button, 12, 13, 26, 79, 305-306 shutter speed action photography, 178-179 adjusting, 108-111 exposure settings, 99-100 flash timing, 68, 70 general discussion, 93 motion blur, 96 movie shooting, 203-204 nighttime city photos, 183 shutter-priority autoexposure (S) mode Active D-Lighting setting, 119-122 aperture and shutter speed, adjusting, 109 exposure meter, 103-104 fill flash, 64 Flash Compensation, applying, 71–73

flash control, 63, 64, 73-74 general discussion, 100-102 overview, 45 Rear-Curtain Sync flash, 66 shutter-release mode Continuous (burst mode), 49, 85, 180 overview, 47-48 problems with shutter release, 79 Ouiet Shutter, 48-49 Self-Timer, 50-51 Single Frame, 48-49 wireless remote control modes, 51-52 Side-by-Side Comparison option, 274-275 silent wave focusing motor, 8 Silhouette effect, 292 Single Frame Release mode, 48-49 Single Point mode, 130, 133, 134-135, 136 single-servo autofocus (AF-S) mode for Live View photography, 145, 148 movie shooting, 190 overview, 129, 142 still subjects, using for, 134-135 Skylight filter, 281 slide shows, 234-236, 240 Slot empty release lock, 39 Slow-Rear flash mode, 67 Slow-Sync flash mode, 66, 176-177 Slow-sync with Red-Eye Reduction flash mode, 67 Small setting, 53 smart devices, connecting to, 312-313 SnapBridge app camera-based options related to, 312-313 features, 309-311 Help site, 313 overview, 40, 239-240, 307 supported functions, 308–309 Soft filter, 285 software, Nikon Capture NX-D, 249, 261-264 help with, 249 Transfer 2, 253–257 ViewNX-i, 188, 247-249, 253

sound microphone, 16, 17, 198 Microphone setting, 197-200 recording on separate device, 189 speaker, 13, 198 volume control, 197-200, 207, 236 speaker, 13, 198 specialty exposure modes, 46 Sports mode, 63, 85-87 Spot metering mode, 105-106, 107, 133 sRGB color space, 163 Standard (SD) Picture Control, 164, 166 Standard HD, 194 stepping motor, 8 still images, saving movie frames as, 210 still subjects focusing on, 129, 134-135 Live View photography, 145-146 shooting, 172-177 stops, exposure, 104 Straighten filter, 275-276 straightening photos, 263, 275-276 Subject Tracking AF-area mode, 144, 145, 147 sunrise/sunset photography, 182 Super Vivid effect, 290 sync modes, 66-67 synchronizing date and time, 308

T

Tagged Image File Format (TIFF), 257–258, 261–264 telephoto lens, 34 television, playback on, 236–237 text–entry techniques, 297 3D Tracking mode, 131, 133 thumbnails display, shifting to, 15, 219–220 TIFF (Tagged Image File Format), 257–258, 261–264 time, setting, 9, 226, 308 time zone, setting, 9 timing of playback, adjusting, 216–217 of shutoff, adjusting, 216, 300–301

tonal range, 119-122, 229 topside controls, 12–13 Toy Camera effect, 291 Transfer 2 software, Nikon, 253-257 transferring files drag-and-drop file transfer, 257 overview, 250 with SnapBridge app, 308 starting process, 252-253 using Nikon Transfer 2, 253-257 via USB, 251-252 wirelessly, 251 Trim option, 282-284 trimming movies, 207-209 tripod socket, 18 tripods, 181-182 TTL setting, 69, 74 Type C mini-pin HD cable, 236

U

upsampling, 54, 55 USB, transferring files via, 250, 251–252 USB port, 17, 18

V

VI (Vivid) Picture Control, 165, 166 Vibration Reduction, enabling, 32–33, 97, 182 videos. See also downloading files to computer AF-area mode, choosing, 143-145 audio, controlling, 197-201 autofocus combination, choosing, 145-146 autofocusing, steps in setting, 146-148 deleting, 242-245 exposure, 203-205 Focus mode, choosing, 142-143 Frame Size/Frame Rate setting, 193–194, 197 grid, displaying, 191 hiding onscreen data, 191 manual focusing, 149 maximum recording time, 197 Movie Quality setting, 193-194, 195, 197

videos (continued) other recording options, 201-203 overview, 187-188 protecting, 246-247 rating, 240-241 saving frames as still images, 210 shooting using default settings, 188-193 stopping recording, 193 trimming, 207-209 video settings, adjusting, 193-197 viewing, 188, 205-207 View/Delete icon, guided menu, 20 viewfinder adjusting to eyesight, 10-11 covering when in Live View mode, 24 covering when in Self-Timer mode, 49 Exposure Compensation setting, 117 viewing settings in, 26 viewfinder adjustment dial, 14 viewfinder photography action, shooting, 178-180 AF-area mode, choosing, 130-133 in Auto Flash Off mode, 76-79 in Auto mode, 76-79 autofocus combination, choosing, 134 basic picture settings, 171-172 close-ups, shooting, 88, 184-185 control strip, adjusting settings via, 28-29 Focus mode, changing, 129-130 Info button, 12 Information screen, 25-26 landscapes, shooting, 181–184 locking focus during continuous autofocusing, 137 moving subjects, autofocusing on, 135-137 portraits, shooting, 83, 172-177 remote control duration, setting, 51 in Sports mode, 86 still subjects, autofocusing on, 134-135 viewing images. See playback ViewNX-i software, Nikon, 188, 247-249, 253, 265 Vignette Control feature, 122-123, 260 vignetting, eliminating, 122-123

Vivid (VI) Picture Control, 165, 166 volume control, 197–200, 207, 236

W

Warm filter, 281 warm light, 154 waterfall shots, 182 white balance changing, 155-158 direct measurement, setting with, 159-161 fine-tuning, 158-159 Function button settings, 304 matching to existing photo, 161-162 movie shooting, 202 overview, 153-155 presets, 159-162 Raw conversion, 260 Wide Area AF-area mode Live View photography in, 145, 146, 147 movie shooting in, 191 overview, 143 viewfinder photography in, 80 wide-angle lens, 34 wind noise, reducing, 200-201 wireless remote control, 18, 51-52 wireless transfer of files, 251

Ζ

Zoom In button Calendar view, navigating, 221 magnifying images with, 222 overview, 14, 15 thumbnails of photos, viewing, 219 zoom lens, 30 Zoom Out button Calendar view, navigating, 220–221 functions of, 15 overview, 14 reducing magnification with, 222 thumbnails of photos, viewing, 219 zoom ring, 30

About the Author

Julie Adair King has been teaching and writing about digital photography for more than two decades. Along with this bestselling book, her other titles include a series of *For Dummies* guides to Nikon, Canon, and Olympus cameras. Other works include *Digital Photography Before & After Makeovers*, *Digital Photo Projects For Dummies*, and *Julie King's Everyday Photoshop For Photographers*. A native of Ohio and graduate of Purdue University, she resides in West Palm Beach, Florida.

Author's Acknowledgments

I am deeply grateful for the chance to work with a wonderful publishing team, which includes Rebecca Senninger, Steve Hayes, and Mary Corder, to name just a few. I am also indebted to technical editor Theano Nikitas, without whose insights and expertise this book would not have been the same.

Publisher's Acknowledgments

Executive Editor: Steven Hayes Project Editor: Rebecca Senninger Technical Editor: Theano Nikitas Editorial Assistant: Serena Novosel Sr. Editorial Assistant: Cherie Case Production Editor: Vasanth Koilraj Front Cover Image: Julie Adair King